HEAD CASES

COLUMBIA THEMES IN PHILOSOPHY, SOCIAL CRITICISM, AND THE ARTS

Columbia Themes in Philosophy, Social Criticism, and the Arts presents monographs, essay collections, and short books on philosophy and aesthetic theory. It aims to publish books that show the ability of the arts to stimulate critical reflection on modern and contemporary social, political, and cultural life. Art is not now, if it ever was, a realm of human activity independent of the complex realities of social organization and change, political authority and antagonism, cultural domination and resistance. The possibilities of critical thought embedded in the arts are most fruitfully expressed when addressed to readers across the various fields of social and humanistic inquiry. The idea of philosophy in the series title ought to be understood, therefore, to embrace forms of discussion that begin where mere academic expertise exhausts itself, where the rules of social, political, and cultural practice are both affirmed and challenged, and where new thinking takes place. The series does not privilege any particular art, nor does it ask for the arts to be mutually isolated. The series encourages writing from the many fields of thoughtful and critical inquiry.

For a complete list of titles, see page 247.

HEAD CASES

JULIA KRISTEVA

ON PHILOSOPHY AND ART IN DEPRESSED TIMES

ELAINE P. MILLER

COLUMBIA UNIVERSITY PRESS / NEW YORK

COLUMBIA UNIVERSITY PRESS
PUBLISHERS SINCE 1893
NEW YORK CHICHESTER, WEST SUSSEX
cup.columbia.edu

Library of Congress Cataloging-in-Publication Data
Miller, Elaine P., 1962–
Head cases : Julia kristeva on philosophy and art in depressed times / Elaine P. Miller.
pages cm — (Columbia themes in philosophy, social criticism and the arts)
Includes bibliographical references and index.
ISBN 978-0-231-16682-9 (cloth : alk. paper) — ISBN 978-0-231-53711-7 (e-book)
1. Kristeva, Julia, 1941– 2. Psychoanalysis and the arts. I. Title.

B2430.K7544M55 2014

194—dc23 2013024130

Columbia University Press books are printed on permanent and durable acid-free paper.

This book is printed on paper with recycled content.
Printed in the United States of America
c 10 9 8 7 6 5 4 3 2 1

JACKET IMAGE: ©MAN RAY, *NOIRE ET BLANCHE*, 1926
THE ISRAEL MUSEUM, BRIDGEMAN ART LIBRARY/ARS
JACKET DESIGN: CHANG JAE LEE

References to websites (URLs) were accurate at the time of writing. Neither the author nor
Columbia University Press is responsible for URLs that may have expired or changed since the
manuscript was prepared.

For Sofi and Leyla
In loving memory of my mother,
Susan Krahn Miller

Of all beings on earth, after birds, I prefer trees. Flowers that have grown and grown; not content to defy beauty, they defy the storms of time. They seem to embody the best of what humans desire. *Topiary IV* is a tree-woman, the perfect anti-siren. Instead of exchanging the lower half of her body for a fish-tail dreaming of fresh water, the tree-woman knows that one day her legs will fail; she will need a crutch before dying. But she keeps the lower half of her body as it was; she even dresses it, with the satin dress of a young girl blossoming into puberty—and adds a proliferating head. Her sap has risen to the top and, defoliated though she now is, this tree-woman can seduce nonetheless through the tufts of jewels put forth from the tips of her branches. . . . The artist is man or woman—but certain women artists easily attain the psychic plasticity that transforms their age-ing body into a blossoming tree. . . . The trunk and branches may be dry, but the thing proliferates nonetheless, ascends, ramifies, buds—not in juicy flavours, but in emerald jewels. The seduction of crystallization.

—Julia Kristeva, "Louise Bourgeois: From Little Pea to Runaway Girl"

CONTENTS

Acknowledgments xi

Introduction: Losing our Heads 1

1. Kristeva and Benjamin:
 Melancholy and the Allegorical Imagination 21

2. Kenotic Art:
 Negativity, Iconoclasm, Inscription 53

3. To Be and Remain Foreign:
 Tarrying with *L'Inquiétante Étrangeté* Alongside Arendt and Kafka 87

4. Sublimating *Maman*:
 Experience, Time, and the Re-erotization of Existence in Kristeva's
 Reading of Marcel Proust 121

5. The "Orestes Complex":
 Thinking Hatred, Forgiveness, Greek Tragedy, and the Cinema of the
 "Thought Specular" with Hegel, Freud, and Klein 153

Conclusion:
Forging a Head 183

Notes 191
Bibliography 225
Index 233

ACKNOWLEDGMENTS

THIS BOOK WAS WRITTEN OVER A LONG PERIOD OF TIME AND with the help of a large number of people, some of whom I knew before I ever began to study philosophy and who are probably unaware of the inspiration they gave me. As a "*Mädchen aus der Fremde*" myself, at home in no particular country, the works of Julia Kristeva (in particular her readings of Louise Bourgeois and Hannah Arendt) gave me a framework for thinking about my own situation, one of philosophizing from out of an indeterminate origin as a foreigner who is also not a foreigner; in the throes of a disorienting melancholia, I was drawn to her discourse about art and aesthetics because it recognizes both the inhibitions and also the potential positive creative force of such a state of mind.

In 2006 I took a trip to Berlin (funded by a Miami University summer research award, for which I am grateful) to study countermemorials, sites commemorating the horrific events surrounding World War II in Germany, in a project that explored the conjunction of memory, loss, and art. That research eventually expanded to include psychoanalysis and the distinction between mourning and melancholia in our relation to the past, and from there to Kristeva, whose articulation of what I came to think of as a melancholic aesthetics seemed to fit perfectly into my earlier project. A 2008 Assigned Research Appointment from Miami University gave me the time I needed for putting together the first draft of the book.

Some of the chapters here began in very different form as invited lectures or essays. Thanks to Jeffrey Bernstein for inviting me to contribute to a special issue of *Idealistic Studies* an essay on iconoclasm, a subject I would probably never have reflected on otherwise but that ended up inspiring a whole new way of thinking about art. Mary Rawlinson invited me to give a keynote lecture at the Irigaray Circle, where juxtaposing Irigaray and Kristeva's theories on art gave me valuable perspective and feedback as well as a warm, generous, and challenging interlocutor in Mary herself. Fanny Söderbäck invited me to participate in an amazing roundtable discussion with Sara Beardsworth, Pleshette DeArmitt, Kelly Oliver, and Charles Shepherdson on Kristeva's *The Severed Head* at the inaugural meeting of the Kristeva Circle in 2012. Dilek Hüseyinzadeğan and Joe Weiss invited me to give the keynote lecture at the DePaul University graduate student conference in 2008, leading to rich discussion with them, Sina Kramer, and the other graduate students present; the dialogue contributed immensely to my thought process and revisions. Michael Naas, who was also present there and who has been a mentor since my graduate student days, contributed incalculably to the tightening up of conceptual distinctions in my discussion of photography (also the subject of a special issue of the *Oxford Literary Review* that he edited, inviting me to contribute an early version of parts of one chapter of this book) and pointed out new connections to Proust. I cannot thank him enough for all the inspiration, guidance, and friendship he has so generously given me over the years.

My editors at Columbia University Press, Wendy Lochner and Christine Dunbar, were a constant source of support, precision, care of the writing, and understanding. I am grateful to Lydia Goehr and Gregg M. Horowitz, the series editors, for seeing merit in the manuscript. Kelly Oliver, whose brilliant work on Kristeva gave me a paved road to run down, has been a mentor, supporter, and inspiration for many years; she and Ewa Płonowska Ziarek, the quality of whose work on aesthetics I can only aspire to, read the manuscript meticulously and generously and suggested revisions that made it much better. Sheila Croucher's encouragement and advice along the way got me through many times of self-paralyzing doubt. Nöelle McAfee helped me with the book submission process.

Rebecca Comay and Angelica Nuzzo are philosophical exemplars that all my work strives to emulate, and I thank them for their encouragement and friendship. My colleagues in the Philosophy Department make both research and teaching a space of intellectual flourishing; I would like in particular to thank Emily Zakin, without whom this entire project never would have entered into my realm of possibility (and who came up with a new title in record

time when my first one was rejected), Gaile Pohlhaus, Pascal Massie, Kristina Gehrman, and Keith Fennen. The graduate students in my aesthetics seminars inspired and challenged me, pushing me in directions I needed to grow. Thanks to Daniel Allen, David Atenasio, Christian Black, Sam Gault, Sarah Gorman, Amanda Holmes, Adam Rensch, Chris Schneck, Alex Shillito, Brian Sopher, Ryan Van Nood, and Matt Wester.

My friends helped me through many a rough patch when I thought this book would never finish. Joann Martin, Sheila Croucher, Carolyn Haynes, Emily Zakin, Gaile Pohlhaus, Madelyn Detloff, Kristina Gehrman, Nancy Averett, Jim Coyle, Kelly Oliver, and Mary Rawlinson gave me an intellectual, social, and support network that allowed me to write. Meeting up with the wonderful women philosophers of the Luce Irigaray Circle and *philoSO-PHIA* every year brings back to mind why we engage in this kind of intellectual work in the first place. My dear Woodstock friends spread all over the world, in particular Beth Norford and Elizabeth Webster in memoriam, remind me of the intellectual and emotional loop between past and present. Ferit Güven's obstreperous intellect was a rock to rage against, often productively. Joel Johnston, Nathan Morris, and Suzanne Hardacre literally made it possible for me to write.

My family was supportive even when they didn't understand me or my withdrawal into my intellectual work. Thanks to my sisters, Lois Miller and Marjorie McKenna, and to my mother, Susan Miller, for not giving up on me.

Finally, my two brilliant and beautiful daughters, Sofi and Leyla, who will hopefully some day find their mother in language and in art, give me the love without why that makes everything else possible.

HEAD CASES

INTRODUCTION
LOSING OUR HEADS

Does decapitation become the emblem of social and historical division? Or rather the brutal admission of our internal fractures, of that intimate instability that prompts movements, but also crises? Self-perception of a fundamental imbalance, of that "dark work" that is the speaking being, divided and unreconciled?
— Julia Kristeva, *The Severed Head*

AT SLEEPOVERS OR AROUND CAMPFIRES CHILDREN LIKE TO tell each other spooky stories, including the story of the woman who always wore a red (or green or black) ribbon around her neck. In this story the woman refuses to comply with the repeated requests of her persistent lover—which continue over the course of their life together—to tell him why she will never take the ribbon off, day or night. This situation lasts until the very moment of the woman's imminent death, when she tells her lover that he may, at last, remove the ribbon. When he does, the woman's head falls off.[1]

The tale of the woman with the ribbon around her neck is a story not just about one unfortunate person but about all of us. This story resonates with us and causes a silly shiver and an uncomfortable laugh because, despite its incongruity, we are all aware, however obscurely, of something secret within us that we may not be able to share even with those closest to us—the decapitated truth of our identity. The ribbon both severs and binds—it is the mark of both our loss and our self-creation. Its uncanny effect arises from the way in which it unmasks for a moment the stranger within our most familiar selves.

Julia Kristeva's arresting aesthetic image or figure for addressing, unmasking, or combating a "new malady of the soul" that affects modernity, namely, depression, is the decapitated head. Kristeva links the figure of decapitation to the "decisive moment in our individuation: when the child gets free of the

mother . . . it loses her in order to be able to conceive of her." As she describes it in the catalogue for *Visions capitales* (*The Severed Head*), the 1998 Louvre exhibit she organized that consisted entirely of artistic representations of severed heads from antiquity through the present, decapitation refers to the separation of the infant from the mother in weaning, a separation, that is, from the one who has heretofore given it warmth and food and who has seen to its every need.[2] This gives decapitation a gendered and even matricidal connotation, but it is a process that both sexes must undergo. Since this separation is enjoined by the Oedipal or paternal law, decapitation also mirrors the Lacanian understanding of castration as an entrance into the universal, where the adoption of the signifier entails a renunciation of *jouissance*, or the complete commensurability of individual desire to desideratum.

However, in addition to this symbolic dimension described by Lacan, which defines subjectivity as entrance into a universal order that precedes it and makes it possible and which is achieved through the appropriation of language and intellectual activity, Kristeva argues that a productive use of the imagination, through the aesthetic image or aesthetic activity, can also help the child create a singular "head" or self: "For this capital disappearance I substitute a capital vision . . . imagination, language, beyond the depression: an incarnation?"[3] This "head," though crucial to the navigation of the depressive stage, will always remain provisionally and tenuously attached, as in the story of the girl with the ribbon. This process aims to increase the symbolic and imaginary capacities of individual subjects and of intersubjectively accessible media such as literature and art *through* the experience and practice of these aesthetic media themselves. Since the severed limb is one of the examples par excellence of the Freudian concept of the uncanny, one might argue that this kind of decapitating art is an art of the uncanny,[4] an art in which each of us must, literally, forge a head in order to forge ahead.

There are thus two counterparts of decapitation as a figure for contending with depression. On the one hand, decapitation literally involves separation; however, equally important to the process is sublimatory activity or artistic creation, which creates something new in the very place of the loss, not to mimic or exactly substitute for what it replaces but to signal a moving beyond. For example, in the third volume of her Female Genius trilogy, Kristeva notes that the French writer Colette's imagination was stirred by images from ancient works depicting severed heads, to the point that she choreographed a ballet featuring the dance of a decapitated sultana. Kristeva calls this process an "Orestian matricide, a decapitation." Kristeva speculates that the sultana

could refer to Colette herself (who called her second husband "the Sultan") or to Colette's mother, for whose matricide she had unconsciously to assume responsibility, "so as to give free rein—and only on that condition—to her polymorphous body and her sublimations."[5] Here decapitation is not an expression of lack so much as a condition for the possibility of creativity on Colette's part. Could the girl with the ribbon around her neck be a figure for someone who has successfully navigated and emerged from depression?

When Kristeva discusses depression, in addition to considering the psychic disorder, she also is always referencing the psychoanalyst Melanie Klein's articulation of the "depressive position" at the origin of the subject's entrance into language and culture. As Kristeva describes it, in the normal course of individual psychic development, "the ego takes shape by way of a depressive working through."[6] Depression, in this version of standard child development, is caused by the child's gradual and necessary separation, as it grows older, from its "mother," or primary provider, and its subsequent assumption of a subjective identity in the "father's" realm of language and social interaction. As Kristeva puts it, "there is no meaning aside from despair." Because in order to function in the world we necessarily assume a position within the universal sphere of language and law, there is no going back, for the child, to the intimate fused sphere of maternal love. Such closure is both exhilarating and anguish provoking. The individual cannot return to the position of fusion with the mother, but she can and does attempt to recuperate her, along with other objects, in imagination and, later, in words.[7] The depressive position, as Klein named this transition, is thus necessary, but, in the course of normal development, its anguish is also possible to overcome.

But why decapitation and recapitation as a figure for this process? Decapitation has long been associated with castration in the literature of psychoanalysis. Freud analyzed the head of Medusa, which the goddess Athena wore as an image on her breastplate, as the sign of the female genitals, lacking a phallus. As a figure for castration, decapitation can also be linked to Freud's postulation of the Oedipal complex, in which, as we have seen, the child must repudiate the mother, who lacks the phallus, in order to take part in the father's law. However, Kristeva reads the decapitated head in a more complex way, as part of the Orestian, rather than the Oedipal, conflict. According to Kristeva's reading, Orestes' ordeal in Greek tragedy symbolically and imagistically represents the necessary development of the child away from the mother (through an "Orestian matricide") and a rediscovery of *her*, in addition to the father, *within* symbolic and semiotic life. This process is illustrated in its most

archaic form by the tragic artwork recounting the establishment of the court of law by Athena that emerges, out of the violence of retributive justice and matricide, at the end of Aeschylus's *Oresteia* trilogy.[8]

Hélène Cixous describes decapitation as the feminine correlative to castration, a threat that emerges within patriarchal culture. Freud writes that decapitation is a symbol of castration, but Cixous considers it to be the inferior substitute accorded to feminine subjectivity that lends it only a muted entrance into history and the symbolic order.[9] In her 1981 essay "Castration or Decapitation?" Cixous describes two economies, masculine and feminine, in which the masculine is "governed by a rule that keeps time . . . exactly as it should be," while the feminine continually disrupts that perfect timekeeping, resulting in a culture in which the feminine is inculcated by "an education that consists of trying to make a soldier of the feminine," a soldier who will march to the masculine rhythm under threat of decapitation if she refuses (Cixous illustrates this interpretation with a Chinese fable of a king who wished to make soldiers of his wives and the difficulties that ensued from this effort).[10] Feminine disorder and laughter, with its inability to take the drumbeats seriously, is thus submitted to the threat of decapitation, just as masculinity is, on Freud and Lacan's terms,[11] ordered and shaped by the castration complex.[12]

Within this order, Cixous argues, women are said to talk but not to speak; they are said to chatter endlessly but to have nothing to say. The mere threat of decapitation renders them already acephalous, mute. Silence is, accordingly, the mark of hysteria and also of decapitation: "They are aphonic, and at times have lost more than speech: they are pushed to the point of choking, nothing gets through. They are decapitated, their tongues are cut off and what talks isn't heard because it's the body that talks, and man doesn't hear the body."[13] Cixous thus links learning to speak, or the feminine labor on herself that must be undertaken in order to produce herself as woman, to the forestalling of decapitation, the sheltering of the head from the demands of cultural decapitation.

This is not Kristeva's line of thinking, although there is an implicitly gendered nature to her discussion of decapitation as well. For Kristeva, decapitation is aligned in particular with art and especially with imagistic (though not necessarily representational) art. In a conversation in response to open questions held at a 1996 conference on her work, Kristeva gives us a helpful introduction to ideas that orient her thinking around the topic of art and aesthetics, activities that often involve metaphoricity and its presentation of the ineffable in terms originating in the world of appearances. Here she returns to a question that has interested her since the beginning of her published philo-

sophical thought and that relates to the idea of the intellectual as dissident. She explicates the word "revolt" or "revolution," terms that formed the central focus of her early *Revolution in Poetic Thinking*, as a way of conceptualizing life as thought, as return and displacement, and as a search for the past, in a Proustian sense, an attempt at anamnesis in which "language . . . returns to the past, in order to displace us towards progress. It is the past which prepares a renaissance, a rebirth." Here there is an implicit reference to Arendt's Augustinian conception of natality as a second birth into the world, language, and historical time.[14]

Revolt is a necessary part of human thought and language, but it is particularly called for in today's "technological media universe of the image," in a time that repeatedly "erupt[s] in brutality and vandalism, localized warfare, crime."[15] These tendencies, along with the loss of signification, have resulted, according to Kristeva's argument, in a depressive civilization. Although she maintains the greater importance of diagnosing, rather than immediately prescribing a remedy for, this depression, she nonetheless catalogues several practices that might keep open the possibility of "remaining optimistic within this depressive moment."[16] Among these practices, psychoanalysis, art, and writing hold privileged positions. The primary intellectual value that remains as universal ethical and religious values fade is that of curiosity. Art, whether poetry, music, painting, sculpture, photography, film, or even detective fiction (which Kristeva writes), maintains this value of curiosity on both a symbolic and an imaginary level. What is called for is a psychic disposition that would neither dismiss the primary loss that depression circles around nor be consumed by it. Psychoanalysis is exemplary of a nonconsumptive engagement with loss, as a practice that promotes "the return of memory, and . . . a practice of subjective rebirth."[17] Above all, writing as a theoretical and a personal praxis is a form of revolt, both explicitly and implicitly. This includes philosophical writing or conceptual language, poetic writing that foregrounds the musical or prelinguistic aspects of language, such as rhythm and timbre,[18] and writing that evokes images.

Kristeva's relationship to the imaginary or imagistic psychoanalytical order is complex. She concurs to a certain extent with Lacan's view that the imaginary is always deceptive and misleading.[19] Therefore, on the one hand, she consistently critiques what she calls, echoing Guy Debord, the "society of the spectacle."[20] By this phrase, Kristeva refers to Debord's Marxist analysis of modern societies dominated by technological and increasingly global modes of production, in which the predominant form of social relation is always mediated by images detached from their source. Debord calls this a weltanschauung

that has become objectified; that is, it is not simply a matter of a perversion of the image through techniques of mass production and dissemination but an actual transformation of social relations in a material, real sense. The predominance of the image in advertisement and entertainment, information and propaganda, forms the "omnipresent affirmation" of a choice that has already universally been made in advance. This affirmation solidifies a separation between reality and image, inverting the usual hierarchy between these two and making the spectacle appear to be the goal rather than a means to an actually lived reality. The spectacle, completely the result of the domination of the economic order and modern process of production, subjects human beings to a false objectivity.[21] Rather than really living, humans experience their lives as already lived or as being lived through the preexisting matrix of images that form an apparently objective social reality.

But it is what makes images dangerous that also makes them such potentially rich sources of meaning. Kristeva turns to the productive capacity of the imagination—the place at the border between images and language that Immanuel Kant designated the "aesthetic idea," where the free use of the imagination can "quicken" our cognitive powers and connect language, "which otherwise would be mere letters, with spirit," in order to provide a critique of the spectacle.[22] Kristeva argues that an early version of the critique of the spectacle that itself is imagistic can be found in Marcel Proust's *In Search of Lost Time*. In Proust, there is an exposé of the ways in which "Being is subsumed in Opinion, which is a demonic array of transferences and metaphors,"[23] or images of images, in a perverse logic of mimesis that echoes the Platonic critique of all art. In our own time, at the outset of the twenty-first century, Kristeva remarks on the increasingly explicit *violence* of the spectacle. Where Proust exposed social falsity and Debord unmasked the totalitarian violence at the heart of (but hidden by) the multiple nodes of commodity production, Kristeva argues that violent images in newspaper reports and on movie screens are today's "opiate of the people," a way of cathartically exhausting aggressive and perverse drives. The curiosity of the intellectual should ask, among other things, why it is that, after a hard day's work, we choose to unwind to the images of "carnage made visible."[24]

The question at the heart of this inquiry, as she puts it baldly, is: "what are the subjective benefits which accrue to the spectator or the artist in descending into hell, and making visible in the image the most dramatic drives towards the dissolution of identity?"[25] This is an important part of Kristeva's project. Rather than simply exposing the society of the spectacle, she is interested in understanding its psychic attractions and in articulating modes of the

very image production she is critiquing, modes that might contend with and transform, rather than simply perpetuate, the explosion of violent images. Kristeva locates the violent image not only in popular culture and information technology but also and equally in contemporary art. Yet in art there remains a possibility that the pulverization of identity might be transformed into intellectual fruitfulness in the same way that, in Proust, sorrows are transformed into ideas that thereby lose the power to hurt us. It is in this spirit that Kristeva has turned to the writing of detective fiction.

Thus at the same time that she critiques the proliferation of images without content, images that, so to speak, make the temporality of everyday existence skip eternally like a needle on a record, repeating without progressing, Kristeva nonetheless diverges from Lacan and Freud when she argues that the image can also generate recuperative, if not redemptive, iterations of meaning. Kristeva notes that both Freud and Lacan imply that literary writing is a form of denial of trauma.[26] Lacan characterized the imaginary as an avoidance of truth; Freud considered literature to be dominated by the pleasure principle. By contrast, Kristeva accords the artistic image a potentially liberatory effect when she writes that "the power of sublimation is often neglected as a retake of the trauma, emptying out and evidencing trauma."[27] To explore this possibility of addressing trauma through art, Kristeva has been involved in the curating and cataloguing of several museum exhibitions of visual art. For example, in an interview in a catalogue for a photographic exhibit, *Inferno/Paradiso*, featuring a series of images by well-known photographers that document the worst and the best in human life globally, Kristeva refers to the image as potentially opening up a new way of conceiving the Arendtian conception of natality, taken from St. Augustine's notion of second birth. Here Kristeva discusses "the very character of human existence in the world" as "the repetition of the *principium* [God's creation of the world]," a "definition of freedom as self-beginning."[28]

Although the imaginary is often linked with a period of childhood when children are particularly susceptible to self-deception, so that a return to the image might be seen as a kind of blind attempt to return to an earlier stage where identity was mistakenly taken to be unified and coherent, here we see that what could be conceived of as a return to the "mother" or origin through art is actually a kind of *second* birth, a birth to self-expression and self-reliance that repeats (in a way that revolutionizes) the initial creative act. Kristeva links this second beginning to the Jewish idea of promise and the Christian idea of birth.[29] In the catalogue for the Louvre exhibit *The Severed Head*, Kristeva calls the image "perhaps our only remaining link to the sacred."[30]

The image interrupts, reorganizes, and thereby provides the condition for the possibility of a "second birth." This is art's heritage, one that it takes over from religion,[31] and it is also the possibility of the image's resuscitation under the condition of an intense scrutiny of and skepticism toward its superficial claims to self-identity.

Kristeva writes that contemporary artworks that foreground ugliness and nonidentity "function as forms of fragmentation" that expose or make visible a fragmenting tendency that is already at work in contemporary life but that is masked by the prevalent search for identity that would project the image's deceptive claim to a seamless unity. She argues, "When we encounter [fragmenting artworks] in the museum, they are not mere provocation. They touch parts of our personalities which are themselves already pulverized and dissolving." She references St. Augustine's observation that images have the power to give solace and inverts a quotation from *On the Trinity* (which in turn rephrases Psalm 39:6): "Although we walk in the image, we walk no more. We ask questions about the image. We have a critical attitude toward the image, and that is what a museum of contemporary art should show us, or what art criticism should reveal."[32] In another interview, Kristeva states unequivocally that she agrees with the ancient Greek idea of art as the source of a potential catharsis, in this case of very "sick" states of mind that it might seek to expose or mimic, and adds to this the idea of art as a "sublimation for the 'borderline' [psychic] states in the broadest sense of the term, that is . . . those characterized by fragility,"[33] in particular perversion and depression.

Sublimation here would take a potentially debilitating condition resulting from the activity of unrestrained drives, in this case, the fragility of the pulverization of identity, and transform it into a life-affirming or intellectually productive state.[34] Indeed, the artist and writer herself must creatively assume "the logic of the borderline" and enter into "the sado-masochistic logic of society" precisely "in order to unveil its violence."[35] Such a project involves deliberately choosing or pursuing nonidentity over identity, aligning Kristeva's aesthetics with that of Theodor Adorno. Beauty, in this case, must "pay the price."[36]

Further complicating her discussion of depression is the fact that Kristeva claims at times that we, at least in the West, live in a depressed or depressive time, that is, that Western culture in the late twentieth and early twenty-first centuries *itself*, and not just the individuals within it, is depressed. This depression, she argues, is disguised in an exuberant proliferation of repetitious images. These two arguably "prelinguistic" registers—media image and melancholic affect—contradict each other to such a degree that they can never be

reconciled; though they occur simultaneously, they are never named together. For the most part, depression as a cultural phenomenon is masked in frenetic activity or busyness, and as such melancholia and the spectacle that obscures and perhaps exacerbates it both remain unbound and free to proliferate: we are distracted. This dual phenomenon is manifest in compulsive scheduling and hyperbolic productivity, self-medicated in the proliferation of familiar and novel entertainment conduits, or vented in vicarious or direct expression of violence in video games, film, staged fights, or predator games. Many of us are thus unaware of our culture's depression.

We are very familiar, of course, with the psychological term "depression," but we usually only predicate it of human individuals. Symptoms of depression include a withdrawal from interpersonal relations, a lack of desire to speak, and feelings of worthlessness, emptiness, and helplessness. Depression as we customarily conceive it involves the comportment of an individual, considered as a psychic totality, vis-à-vis its world, and it is primarily described in terms of that individual's ability to cope, work, or interact in a so-called normal manner. However, Kristeva's argument does not merely indicate the number of individual cases of depression that occur today but extends to a claim that today's Western civilization is depressed or depressive.

As the tenth anniversary of September 11, 2001, approached, American journalists and artists were obsessed with the question of properly representing the loss and melancholia brought about by the attacks on the World Trade Center. For the past few years, as a contemporaneous backdrop, the news media has been skirting around a declaration of economic depression in the United States. These two discourses of cultural depression intersect at the questions of what values America stands for and in which direction it is heading, questions that divide the political landscape quite decisively into right and left depending on their attempted answers.

What does it mean, then, if our nation, society, or culture can be said to be depressed? Is there an analogous development of a civilization through a depressive position? Can normal development go wrong for cultures or nations just as it can for individuals? Certainly it seems that something within symbolic life must be out of order if depression continues, either at the individual or the cultural level, despite individuals' entrance into linguistic and political life.

In *Revolt, She Said*, written almost a decade ago, Kristeva explicitly diagnoses the nation of France as "suffering from depression on a national scale, analogous to the one private people have," because of the loss of a self-image of great power.[37] As France's voice is less and less heard even within Europe,

not to mention in competition with the United States, and as the increase in immigration and its accompanying difficulties continue to create a sense of national insecurity, "the country is reacting no differently than a depressed patient."[38] People withdraw, shut themselves away at home, metaphorically and literally don't get out of bed, don't participate in public life or in politics, and complain constantly. Patriotism is transformed into an overly easy contempt for others, creating an atmosphere of isolation, lack of interest in the outside world, and lack of energy to engage in worthwhile activities. French people today, on her account, are both arrogant and self-deprecating or lacking self-esteem because of the "tyrannical ideals" of the inflated ego of the depressed.[39]

It is not difficult to diagnose the contemporary political context of the United States in a similar way. Arguments over immigration, widespread investigations into suspected terrorist plots at the expense of individual civil liberties, involvement in foreign governments and wars, and promotion of free trade above all else have left their mark. Opposition to unpopular power structures appears impotent; suspicion of foreigners is rampant; intellectuals on the left and even discourses of resistance seem to be paralyzed in a kind of inertia, repeating empty formulas, engaged in fruitless effort, in a kind of performance of the asymbolia or absence of real, signifying language that Kristeva describes when enumerating the depressive patient's symptoms. Even the aggression of war and the restless search for suspected terrorists can be linked to cultural depression: "Depressives . . . find consolation for their pain by reacting like maniacs: instead of undervaluing themselves, lapsing into inertia, they mobilize, sign up for war—holy wars, inevitably. Then they hunt down enemies, preferably phony ones."[40] Though Kristeva here alludes to the National Front's racist political positions in France, similar movements are recognizable in the United States.

Sigmund Freud distinguished between mourning and melancholia as healthy and pathological responses, respectively, to the loss of a beloved object.[41] Mourning, according to Freud, is a natural psychic process in which an individual gradually works through a great loss in order ultimately to leave it behind. Melancholia, by contrast, is a process whereby an individual refuses to let go of a lost object. Instead of gradually working through attachment in order to leave the lost thing behind, he or she psychically incorporates the particular loss in such a way that the suffering it causes is directed inward, which eventually erodes the inner psychic life of the individual, causing an inability to act and even to speak. This is what we know as depression.

The more archaic condition of melancholia, from which the psychic disorder of depression conceptually originates, has a longer, richer, and ultimately more positive history. The melancholic, whose character was attributed in ancient times to an overproduction of black bile, was linked by the Greeks to genius and prophetic power as well as to a propensity for madness not unconnected to the other potentialities. If medieval scholars saw melancholia as a form of (possibly demonic) possession, they nevertheless acknowledged its contribution to art and to philosophical thinking. Albrecht Dürer's famous engraving *Melancholia* depicts a thinker surrounded by symbols of philosophical and creative power, almost a world creator. But, as with many other historical intellectual shifts, the scientific revolution and age of Enlightenment, whose roots extend as far back as the seventeenth century, began to associate melancholia with mental illness and with the hindrance of normal activity, a connotation that depression continues to carry today. With the publication of Freud's "Mourning and Melancholia" in 1917, melancholia became established as a medical and scientific concept rather than continuing to be associated with art and philosophy. It was during the nineteenth century as well that the term "melancholia"—from the ancient Greek *melanos* (black) and *khole* (bile), referring back to the theory of the four bodily humors—began to be replaced with the clinical diagnosis of "depression."

Writing in the late twentieth century, Kristeva returns to a conception of melancholia that resonates with its original signification, namely, melancholia as a kind of world-forming activity. She argues that the concept of melancholia, although it certainly can be and is a medically diagnosed individual disorder, transcends the individual and must be understood as a relation between self and world that cannot be "cured" simply by altering the constitution of the melancholic's psyche through medication. Necessarily, the "world" of the individual must be transformed as well in order to effect a parallel transposition out of the melancholic state.

The idea of a depressed collective, which Kristeva periodically asserts, has little precedent in psychoanalytic literature, although Frantz Fanon explored a similar phenomenon in the early twentieth century in terms of the collective psyche of the colonized.[42] As a rule, only an individual can have and be treated for a psychic disorder. Nonetheless, there have been some other thinkers who have postulated the notion of a depressed culture.[43] Even Freud had an interest in this broader interpretation of melancholia; this is attested to not only by his essays on war and his open epistolary exchange with Albert Einstein but also by the more well-known *Civilization* [Kultur] *and Its Discontents*.[44]

Kristeva, expressly referencing this Freudian text, exhorts intellectuals to seek out the causes of our current "discontent." She writes that ours is not a time for advice but rather for diagnosis and that before advice can be sought we must face up to the problems confronting our age.[45] She calls on intellectuals to act as "dissidents" in their capacity to make multiple "sublations" of "the unnamable, the unrepresentable, the void" through the activity of thinking, an activity that she understands similarly to Hannah Arendt.[46] Arendt writes of the metaphorical relation between thinking, which is invisible and withdrawn, and intuitions drawn from the world of appearances, or the sphere of action and public life,[47] and she argues that philosophy arises out of this relationship between metaphor and the ineffable.[48] How this activity is generated is of central importance to both Arendt and Kristeva, who concur that these are the "threads by which the mind holds on to the world . . . and they guarantee the unity of human experience."[49]

Kristeva believes that to heal society, one must first heal one's own inner wounds, which alone will render one capable of effective social action.[50] In other words, although as a whole a society or nation or culture may be considered to be depressed, nevertheless, the depressed and depressive state of society cannot be collectively psychoanalyzed or addressed and cured on a mass subjective level. It can only be combated through individual, creative action. Kristeva takes Arendt's figure for thinking as a "two in one" and transforms it through the psychoanalytic figure of the subject split between a conscious and unconscious self. Such a transformation allows for a new way of considering Kantian aesthetics and Arendtian politics, in particular addressing questions of encountering and accounting for difference of all kinds—ethnic, religious, racial, sexual—within a given society.[51] To do so, Kristeva depends more on judgments of the sublime than on the judgments of beauty that inspired Arendt in Kant's work.[52] Sublime judgment, with its momentary flash of disintegration of the conditions for the possibility of subjectivity, parallels a kind of controlled experience of psychosis that may take place in the encounter with a kind of art that may pulverize the identity of the spectator.[53]

Kristeva illustrates this perspective in her discussion of the life of the French/American artist Louise Bourgeois, which Kristeva calls "survival therapy." Abandoned at a young age by her father (who first had an extended affair with the family's live-in nanny) and witness to two world wars, Bourgeois's memory was one of lifelong trauma.[54] She moved to the United States after marrying an American, and her artistic oeuvre can be seen as a series of new beginnings, which Bourgeois herself associated with the move to a new country and culture. She therefore embodies the spirit of the voluntary foreigner

that Kristeva greatly admires.[55] In her diaries, of which she kept three versions—written, audio recorded, and pictorial—Bourgeois provides a wealth of information on her personal life and how it directly affected her art. Kristeva chooses to focus on Bourgeois's extraordinary ability to sublimate, to turn sorrows into ideas and images, and to reinvent herself constantly, from her early self-description as a "little pea," a girl so shriveled by loss of love that she shrinks to the size of a pea, to a "runaway girl" who uses sculpture in particular to "take flight" incessantly, to "recommence," in the sense of revolution that Kristeva so strikingly describes in her earliest work.[56] In her diary, Bourgeois writes, "I left France because I freed myself or escaped from home. I was a runaway girl. Let's say it in English now . . . I was a runaway girl. I was running away from a family situation that was very disturbing."[57]

Kristeva writes that Bourgeois and other creators (both men and women) have a "peregrine fate," a need to constantly cross frontiers in an attempt to free themselves of themselves. This is particularly true for young girls "who, like Athena, were born of the head of Zeus, the god said to have devoured Athena's mother, Metis (Cunning or Prudence). But on condition she never stop crossing boundaries."[58] The originary loss of the mother is, in Bourgeois's case, both literal and metaphorical, the origin of both melancholia and melancholic art.[59] Being "born of the head of Zeus" rather than a mother also suggests the necessity of fashioning or crafting a substitute (head) when one loses one's mother (or motherland).

In this book I will discuss artworks of various media, some taken from Kristeva's own references but also others that I think are relevant to her discussion, I will return in particular to the medium of photography, both in terms of theoretical descriptions of the art of photography and in actual examples from photographers. I choose to focus on this medium for two reasons. First, the photograph, especially in its inception as a technical medium, has a unique temporality. Early photographs took time both to capture and develop into an image. Freud likened photographic negatives to inscriptions on the unconscious that may come to consciousness a short time later, a long time later, or not at all.[60] As such, the photograph can be encountered differently at different times. If a photograph of a familiar subject is taken only a short while ago, or taken when we are already fully developed as adults, we can relate to it fairly easily, as it is still familiar. However, a photograph from our childhood or a photograph of a loved one taken before we knew them, perhaps even before our own birth, comes to us from a past that we have never really experienced. This would be even more true for a photograph of something entirely unrelated to our own lives. At least two time periods touch in

every human encounter with a photograph. And because the photograph actually records exactly a moment in time, it forms, as Walter Benjamin says, a kind of crime scene in which often we must or can decipher the meaning only from the remaining fragmentary evidence, when the context is long past.[61] As such, the photograph can be a cipher for the psychoanalytic concept of *Nachträglichkeit*, or afterwardness. And so I think both that the theory behind photography is an appropriate subject to discuss within this inquiry into Kristeva's aesthetics and that photographs themselves may be the privileged medium in terms of artworks to illustrate her ideas.

The concept of *Nachträglichkeit* implies that one cannot encounter events from the past with the assumption that these events are unmediated by either the experiences of the person whose past is in question or the experiences of the audience or interlocutor (whether this be a psychoanalyst or a spectator of an artwork). As one commentator puts it, "trauma is less significant as an event that can be fixed at a prior date than in its posterior resubjectifications and the restructuring of the subject that is the consequence."[62] It is to these various forms of restructurings of the subject through art that the following chapters will turn. In particular, I will consider the Kristevan idea that art can provide an intermediate potentially signifying space between the asymbolia of depression and full coherence within the language of universals. Though singular, artworks can potentially perform the metaphoricity that connects the invisible, withdrawn space of thinking and affect to the public sphere of action and intersubjectivity, the disembodied realm of images in popular culture to the corporeality of real signifying images. Art in this way provides a safe space for reopening the depressed subject or culture up to signification and creation.

Two recent popular films illustrate, with a somewhat cheaply attained narrative arc and happy ending, the phenomenon of creating a "head" that forms a bridge back from depression. The low-budget indie film *Lars and the Real Girl* and Jodie Foster's *The Beaver* are both about using transitional objects—in Lars's case, an inflatable life-size doll, in the Beaver's, a beaver puppet—to enable the protagonists' return from seclusion and inability to communicate and function in the world of familial and social relationships.

The psychoanalyst D. W. Winnicott was concerned with enumerating the characteristics specific to works of art, which, he argued, cannot be adequately articulated according to the criteria of the judgment of existence since they are neither, strictly speaking, real nor nonexistent. Winnicott postulates art as a "salvaging" of an object (in the case of both the films just mentioned, the lost object is the subjective integrity of the protagonists) on the periphery between

inside and outside, at the very point at which it might disappear. Just like a blanket or other transitional object a small child clutches as something whose appearance and disappearance, unlike that of his mother, he can control, the artwork functions as a transition between an internal realm of fantasy and the external world or between subjective and objective reality. Transitional phenomena, including babbling and other prelinguistic oral activities (activities Kristeva also foregrounds in considering the nonsignifying aspects of poetic language and the nonrepresentational aspects of visual art), "start each human being off with what will always be important for them, i.e. a neutral area of experience which will not be challenged." This intermediate area of experience "is retained in the intense experiencing that belongs to the arts and to religion and to imaginative living, and to creative scientific work."[63]

In *The Beaver*, Walter is a clinically depressed father, husband, and CEO of an American company; his depression has worsened to the point that he spends his life either sleeping or in a medicated stupor. The discovery, at his lowest psychological point, of a beaver puppet that seems to take on a fantasy life in his hands gives him a way to renegotiate his life by allowing him to stake out a distance from his everyday relationships and the expectations placed on him by his various familial and work roles. The British accent he uses when speaking "through" the beaver puppet further facilitates his distance from the mundane world, a distance that paradoxically also enables him to transition back into that world from his former position of paralyzing internal turmoil.

In *Lars and the Real Girl* the main character suffers from a kind of persistent trauma brought on by the knowledge that he caused the death of his mother in childbirth, a memory impressed on him by his depressed and emotionally abusive (as a result of depression) father. Lars is unable to interact meaningfully with anyone until he finds a "girlfriend" in the shape of an inflatable, life-size sex doll whom he introduces (fully dressed) into society as Bianca, the reclusive and disabled daughter of missionaries. Like Walter, Lars uses Bianca as a transitional object to enable his reinsertion into the external world from a sequestered inner life.

Both films portray cases of individual depression and other psychological pathologies. In the case of distress from collectively experienced events, such as the trauma that the September 11, 2001, attacks provoked both in both the residents of New York City and the citizens of the United States as a whole, artworks such as memorials can provide such a transitional object on a mass level. For this reason memorials become the subject of great public concern and controversy, and the selection of the "right" design comes to be of paramount

importance. The number of both traditional and countertraditional memorials to the victims of National Socialism in Europe attests to the importance of this phenomenon.[64] However, it is easy to discern immediately a striking difference between the European and the U.S. versions of such memorials, at least those that commemorate a self-inflicted trauma.

The question such memorials face is how something so horrific as to be in retrospect deemed unforeseeable, unthinkable, and unforgivable can be brought to presence in a way that does not simply reopen the wound of memory, resubject the victims to trauma, and render the historical inheritors of the wound paralyzed with guilt? How can the loss be witnessed or exposed, rather than repressed, but in such a way that at the same time the healing process and political transformation can begin? In the United States, the process, when it is undertaken at all, seems to be one of disavowal and repression. Either the phenomenon—we might take slavery as an example—is not memorialized at all, or it is commemorated through a grandiose act of atonement that crudely exalts the victims rather than acknowledging the mistakes behind their victimization. An example of this latter tendency is the gigantic unfinished Crazy Horse statue in South Dakota, a memorial that has been under construction since 1948 and that has been surrounded by controversy. In part a reaction to and attempted mollification of American Indians' protest over the sculptures of U.S. presidents carved into Mount Rushmore, the sculpture boasts a larger-than-life likeness of a man who refused throughout his life to be photographed and who even asked that his grave remain unmarked. The "memorial" further desecrates the nature whose destruction was an integral part of the critique of Mount Rushmore in the first place.

The memorial chosen to commemorate the victims of September 11, however, commemorates an event that is ambiguous in its meaning. Because they targeted a prominent symbol of cultural dominance in the global market, the attacks on the World Trade Center produced both victimization and, in some cases, self-recrimination. The memorial to the events, rather than providing a therapeutic synthesis, seems to perpetuate this ambiguity in its design, which manifests an oppositional split between spectacle and raw affect. Because of the simultaneous desire to acknowledge absence and loss while also remaining defiant in the face of the perpetrators of the attacks, the memorial and its counterpart, 1 World Trade Center (formerly known as the "Freedom Tower"), seems destined to oscillate between the spectacle and depression. The memorial, *Reflecting Absence*, pays homage to the victims and acknowledges a loss that can never be fully mourned. The skyscraper, simultaneously, exerts an

image of American dominance and undaunted pride by towering even higher than the symbolically and literally lofty buildings it replaces.

In this book I will consider what Kristeva would offer as an aesthetic alternative to this oscillation between the extremes of depression and spectacle, traumatization and a feeling of complicity or culpability. To do this, it is necessary, first, to examine at length her discussions of depression at both an individual and a cultural level and of aesthetic activity as a possible way of effecting recovery or reclamation of a meaningful existence. This is the subject of chapter 1, which ties the discussion of depression as a pathology to the necessary developmental stage of separating from the mother, Klein's "depressive position." I continue by examining, in turn, five different aspects of Kristeva's approach to aesthetics: melancholic art, iconoclastic (in a specific sense) art or the art of negativity, uncanny or foreign art, Proustian sublimation, and matricidal or decapitating art.

Chapter 1 considers Kristeva's writings on melancholia, bringing together her earlier engagement with individual melancholia in *Black Sun* and her more recent discussions of national depression and the "new maladies of the soul." Kristeva considers the high incidence of depression in modernity and argues in *Black Sun* that many intellectuals, writers, and artists have successfully emerged from or at least achieved an ability to live with melancholia, an ailment that otherwise often results in an incapacity to express symbolically. The interesting fact that she points out is that these artists succeeded in combating melancholia through the very act of melancholic writing or creating. This act of treating a potentially debilitating psychic ailment with a smaller, less lethal dose of the same affliction is what I dub "spiritual inoculation." The chapter traces this idea through Kristeva, Benjamin, and Adorno, with particular attention to the passages in *Black Sun* where Kristeva draws on Benjamin's analysis of allegory, contributing to her enigmatic claim that the structure of the imagination may be allegorical. I contrast the structure of melancholic imagination to overly successful mourning (exemplified in the philosophy of Hegel), just as the construction of traditional memorial art (commemorating, most often, war) can be contrasted with the contemporary creation of "countermemorials" to traumatic events. I also consider Rachel Whiteread's casting of negative space as an example of melancholic art.

Chapter 2 argues that in Kristeva's concept of negativity, the recuperation through transformation of a traumatic remnant of the past, we can find a parallel to what Adorno, following Benjamin, calls a new kind of nonidentical mimesis that is able to remain faithful to the ban on graven images interpreted

materialistically rather than theologically. Adorno's claim that a ban on posi-
tive representations of utopia leads to an artistic practice of exposing the injus-
tices of modern life suggests that there is a connection between negativity and
the theological ban on images. Both Adorno and Kristeva believe that con-
temporary art has a capacity to critique modernity and envision a better
world, and both insist that this art must not *represent* what it indicates. Kristeva
pursues this line of thought in her writings on icons in the European Eastern
Orthodox theological tradition as well as in *The Severed Head*, her catalogue
for the Louvre exhibit. To illustrate this claim, I also examine Benjamin's
writings on photography at length and argue that a radical sense of mimesis,
namely, one that respects the ban on graven images, moves us beyond the
systematic optimism of the Hegelian dialectic and extends the philosophy of
history into the unknown of the unconscious. I also consider Kristeva's discus-
sions of the cinema of the "thought specular," a kind of translation of Kant's
"aesthetic ideas" into the medium of film, as a contemporary version of this
peculiar kind of iconoclasm.

Chapter 3 examines Kristeva's discussion of foreignness on both an individ-
ual and a societal level, together with her consideration of contemporary art
as uncanny, and of Hannah Arendt's philosophy. In his lectures on aesthetics,
Hegel calls art's role the attempt by the human being to do away with foreign-
ness, both in herself and in the natural world that inflexibly surrounds her, in
order to "enjoy in the shape of things only an external realization of him-
self."[65] I argue that Kristeva views art in a contrary manner: as the attempt to
safeguard the foreignness at the heart of our existence and our context. I also
argue that in implicitly taking the Kantian sublime, rather than the beautiful,
as a starting point for a consideration of the political (in a manner that is both
derivative of and in opposition to Arendt's attempt to cull a political philosophy
from Kant's *Critique of Judgment*), Kristeva gives us a way of thinking alterity as
not simply an inevitable feature of human psychic identity and global citizen-
ship but a quality to be cultivated and preserved, a sense of always being strange
to ourselves. This results in a double-edged aesthetics of the uncanny where
what must be achieved is the ability to see our own culture from the perspec-
tive of the foreigner. I suggest that such a stance might provide resources for
the current struggle toward global identity and the controversy over immigra-
tion as one of the triggers of cultural depression.

Chapter 3 considers Kristeva's reading of Proust in connection to the themes
of melancholia, working through, and, in particular, sublimation. Proust's *In
Search of Lost Time* ends where it begins, in the author's childhood memo-
ries, creating a loop of time that has been called Hegelian by some commen-

tators. However, Kristeva contends, against the claim that in Proust's texts "recall without remainder is presumed," that the modernity of Proust's temporality is that of "irreconcilable fragments of time that are pulling us in all directions more fervently and dramatically than before."[66] In this chapter I articulate and defend Kristeva's portrayal of Proust's novel as a critique of modernity, including especially an implicit critique of the presumed unity of identity, self-presence, and time in what is known as "the spectacle." Kristeva credits Proust with the inauguration of a new, melancholic sense of modernity, the same impulse that gave rise to abstract expressionism in visual art and that Benjamin identified in Baudelaire's writings. Kristeva argues that Proust endeavors, as closely as possible, to give expression through language to the inexpressible, that is, to the feelings and drives that motivate him even as he strives to protect himself against them. It is in this sense that the work of art is a sublimation; like the theory of the sublime in eighteenth- and nineteenth-century aesthetic theory, sublimation makes present, through means that mask and are necessarily inadequate to it, what in principle is unpresentable. At the same time, Kristeva presents sublimation, counter to Freud, as a re-erotization of creative drive that has become frozen and stuck. I analyze Kristeva's conception of sublimation through its psychoanalytic genealogy in thinkers whose work has influenced her, in particular Melanie Klein and Andre Green.

Chapter 5 concludes the book by considering a topic that permeates Kristeva's latest publications that have been translated into English. Although usually translated as "forgiveness," I draw attention to the etymology of the French *pardonner*, which Kristeva makes explicit by hyphenating the verb: "par-don." As such, pardoning means "completely giving" or "a thorough giving." Following Augustine and Arendt, Kristeva considers "pardon" to be a second birth that gives rise to a new temporality and a new self. I focus in particular on the theme of temporality and rhythm, which is also an important part of all of the chapters of this book. As a way of understanding how Kristeva conceives of forgiveness, I examine the trope of pardon as a key structural transitional device in Hegel's dialectic, in particular in the *Phenomenology of Spirit*. Although Hegel's explicit discussion of forgiveness toward the end of the *Phenomenology* has been much discussed, little attention has been paid to two other essential transitions in the same book where forgiveness or pardon plays a crucial role. I juxtapose Hegel's and Kristeva's notions of par-don in order to highlight the crucial differences that the psychoanalytic context allows Kristeva to unveil and pursue. I also consider what a "second birth" might look like in light of the Kristevan attempt to operate psychoanalytically at the

level of history and culture rather than at that of individual experience. Using the story of Aeschylus's *Oresteia*, a tragedy in which Orestes kills his mother but then through his feeling of recrimination ultimately provides the impetus for the creation of a legal system that will obviate violently retributive justice, I unveil the parallels between Hegel and Kristeva's project of movement from immediacy to mediation, recognizing that their endpoints are significantly different. In particular, Kristeva's foregrounding of the image complicates the Hegelian assumption that mediation is always higher than immediacy and puts forward a new understanding of a "second immediacy" that I refer to as the forging of a new "head."[67]

Throughout the book I return to the question of what it might mean to forge a new head, a head that replaces the one we are born with. Kristeva's contribution to psychoanalytic accounts of coming to subjectivity considers the role of the image in its potential to give rise to aesthetic ideas—in painting, sculpture, photography, and film—in constituting a healthy psyche in the age of the spectacle, when images always appear potentially to deceive us in their repetitive, uniform proliferation.[68] Art puts forward a new, singular kind of image: one that might be thought of as melancholic, negative or iconoclastic, uncanny or foreign, sublimating without de-eroticizing, and forgiving, pardoning.

1
KRISTEVA AND BENJAMIN
MELANCHOLY AND THE ALLEGORICAL IMAGINATION

Let's imagine you suffer from anxiety; this is a pathological state. Or you are no lon-
ger anxious and you become a consumer, a totally stabilized individual that can be
manipulated like a robot. Midway between these two solutions, lie intellectual works
and art. These are the actual sites of this anxiety and revolt. The artist's goal is to find
the representation of this state of anxiety.

—Julia Kristeva, *Revolt, She Said*

Can the beautiful be sad? Is beauty inseparable from the ephemeral and hence from
mourning? Or else is the beautiful object the one that tirelessly returns following
destructions and wars in order to bear witness that there is survival after death, that
immortality is possible?

—Julia Kristeva, *Black Sun*

KRISTEVA ARGUES, PERHAPS UNCONTROVERSIALLY, THAT
melancholia is a malady that affects individuals in modernity to a greater extent
and in a different and more debilitating way than at any other point in history.
Whereas in the past melancholia was associated with the solitary philosophical
temperament and with artistic creativity, that is, with the exception rather than
the norm, today melancholia or depression is a widespread mental and physi-
cal affliction that manifests itself in its most acute form as an inability to act or
speak or even to feel. In the opening paragraph of *Black Sun*, Kristeva refers to
melancholia as an ever-widening "abyss of sorrow" that, often on a long-term
basis, makes us "lose all interest in words, actions, and even life itself." Even
short of this complete loss of interest there may occur a "modification of signify-
ing bonds" in which language functions as a source of anxiety and in reaction
thinking slows down.[1]

It is her preoccupation with the loss of language in depression and the
need she prescribes, before there can be any kind of "talking cure," to first
reestablish the bond with symbolic life, that Kristeva thinks distinguishes her
theoretical consideration of melancholia most notably from Freud's. She
writes, "In certain cases, the discourse of the melancholic is so impoverished
that one wonders on what could one base an analysis."[2]

Kristeva postulates that creative endeavors can provide a tenuous bridge between the depressive refusal of language and the ability to talk about one's depression to an analyst or to show any interest in returning to normal symbolic life. The recovering or reawakening depressive, through writing, painting, composing, or responding to art, can potentially be captured by an indeterminate region that slowly emerges between two extreme poles. On the one side lies transcendence or the life of signs, which is a realm of assumed shared meaning in which, as a result of depression, she has for a time refused to participate. On the opposite side lies severest depression, which is silent, withdrawn, and completely lacking in expression, a kind of pure immanence. Kristeva discusses the process of the melancholic's being drawn out of the inertia of apathy and asymbolia and toward a tentative interest in the "life of signs." The intermediary region that seems to have emerged for artists like Fyodor Dostoevsky and Hans Holbein, who suffered from depression, could be described as a movement toward signification that nonetheless still refuses to commit fully to the determinate order of law and language that shapes human action and human life. It is necessary for the melancholic to emerge from the absence of language in order to regain a foothold on life, yet she naturally hesitates to participate fully in the structure that gave rise to her depression in the first place. Beauty, Kristeva writes, appears as something that may "grab hold" of the melancholic to bring her slowly back from suffering toward language.[3]

In this chapter I will examine this intermediary realm of melancholic art and literary writing. I argue that melancholic work in the form of creative endeavors can be thought of as a form of spiritual inoculation, a term that allies Kristeva's work on this subject with the thought of Walter Benjamin. By the term "spiritual inoculation" I refer to the intentional exposure to a small dose of an otherwise lethal malady (in this case, melancholia or depression), in order to stave off a more disabling form of the same woe—also the principle behind homeopathy.[4] Although the figure of inoculation suggests the prevention of the onset of a disease, I will instead be considering it with reference to an already existing sadness, not a trauma whose origin can be pinpointed at any specific moment in historical time but one that follows a nonlinear temporality involving the unconscious as well as the memory and the imagination. I will examine the ways in which Kristeva and Benjamin speculate on the use of philosophy and art as a means of staving off, promising an alternative to, and contending with the maladies of modernity.

For Kristeva, like Benjamin, modernity has proved detrimental to the human psyche. In *New Maladies of the Soul*, Kristeva writes that "today's men

and women—who are stress-ridden and eager to achieve, to spend money, have fun and die—dispense with the representation of their experience that we call psychic life."[5] By "representation" Kristeva refers to a capacity to register impressions and their meaningful values for the subject.[6] Drugs for various conditions from insomnia and anxiety to depression, television and other forms of mass media, and products or commodities of manifold kinds stand in temporarily for this kind of representation, but more and more people seek the help of therapists and psychoanalysts because of a general feeling of malaise, an experience of language as artificial, empty, or mechanical, and a difficulty in expressing themselves.[7] Such a deficiency in psychic life can affect all facets of life: intellectual, sexual, sensory, interpersonal. The analyst is then asked to restore a full psychic life to the individual. Kristeva suggests that these new patients manifest symptoms of the ailments affecting contemporary life, and although each patient has a unique form of the disease, we might call this phenomenon a malady of the soul affecting our time in particular.[8]

In works such as *Revolution in Poetic Language*, *Black Sun*, and *The Severed Head* Kristeva is particularly interested in aesthetic ways of addressing the human need for a full psychic life, or meaningful representation of experience, the lack of which engenders depression and anxiety. Melancholia and depression are not identical, she writes, but are sufficiently related to be able to discuss them together, since both concern the "impossible mourning for the maternal object."[9] Melancholia is the "somber lining of amatory passion,"[10] in that the child must undergo the "depressive position" in order to accede to language,[11] but once this has been effected, the loss causes her desperately to seek the mother again, "first in the imagination, then in words."[12] All love is an impossible attempt to return to the mother through the acquired paternal mode of language. Kristeva notes that "if there is no writing other than the amorous, there is no imagination that is not, overtly or secretly, melancholy."[13]

In the Kleinian psychoanalytic paradigm, as we have seen, the child learns language as a means to try to rediscover the lost mother from whom she has been separated through weaning and maturation,[14] and therefore "there is no imagination that is not, overtly or secretly, melancholy."[15] Nonetheless, this depressive position must eventually be overcome in order for individuals to become fully actualized subjects. When this does not happen, or when the compensation for separation from the mother does not correspond to the lack created by the scission, depression in the pathological sense results. Today there are multiple familiar paths to combating depression on an individual level: diet, exercise, psychotherapy, medication. But Kristeva's interest in *Black*

Sun lies in a treatment of depression that can be discerned in and through writing and art, that is, in a kind of return to the archaic conception of melancholia.

Historically, melancholia has been associated with intellectual thought, in particular with philosophy and artistic creativity. Philosophy emerges in the doubtful moments of the speaking being; melancholia "is the very nature" of the philosopher.[16] Mood itself can be considered a language, Kristeva argues: "moods are inscriptions, energy disruptions, and not simply raw energies. They lead us toward a modality of significance that . . . insures the preconditions for . . . the imaginary and the symbolic."[17] And literary creation transforms this affect into "rhythms, signs, forms" that both are melancholic *and* speak.

Kristeva calls art a new kind of language, or a "language beyond language," one that "secure[s] for the artist and connoisseur a sublimatory hold over the lost thing."[18] The lost thing, or lost mother, lost when the child enters into symbolic life, is the beyond of signification; it cannot even be imagined, yet it is always sought after. In *Revolution in Poetic Language*, Kristeva had described language as originating in the body of the not yet constituted subject, the subject still fused with the mother:

> Discrete quantities of energy move through the body of the subject who is not yet constituted as such and, in the course of his development, they are arranged according to the various constraints imposed upon this body—always already involved in a semiotic process—by family and social structures. In this way, the drives, which are "energy" charges as well as "psychical" marks, articulate what we call a *chora*: a nonexpressive totality formed by the drives and their stases in a motility that is as full of movement as it is regulated.[19]

With the entrance into language, the semiotic underbelly of language is covered over, but it does not disappear. In poetic language, and in particular in the nonsignifying linguistic modes of rhythm, alliteration, assonance, and timbre, these energy charges reappear in the form of a "second-degree thetic," that is, always only indirectly, through the very medium of symbolic language that obscured it in the first place.[20]

Art "inserts into the sign the rhythm and alliterations of semiotic processes," those precognitive modalities of significance in which the sign is not yet constituted as the absence of an object or as the product of the distinction between the real and the symbolic. In so doing, it presents a polyvalence of

sign and symbol, which builds up a plurality of connotations around the sign. Thus the language of art is other than the language of propositional discourse in that it presents the latter as re-erotized. This symbolic register is re-erotized both in the sense of reactivating the semiotic register within the symbolic as well as in proliferating connotations of words, phrases, and images.

The idea of re-erotizing the symbolic order emerges out of Kristeva's analysis of traditional philosophies of language as the "thoughts of necrophiliacs."[21] The idea of language as death is an extension of Freud's theory that consciousness itself is a product of the death drive, a protective layer that builds up in order to preserve the psyche from overstimulation. Kristeva argues that language acts in the service of the death drive, diverting it and confining it in order to preserve the self.[22] In turn, social structures are built upon the acts of primal murder and sacrifice, with art operating as a kind of ritual atonement for the original crime that founded civilization. Language itself, in which the sign stands in for the absent thing, substitutes death for life.

Art, she writes, crosses the inner boundary of the signifying process, making itself into a kind of scapegoat, the bearer of death. However, in doing so, it exports semiotic motility across the border on which the symbolic is established, allowing for a re-erotization of dead structures. Poetic language of the kind Kristeva analyzes in her early work revisits and reactivates the living origins of language in energy discharges and drive articulation, effectively re-erotizing dead language, just as art and the psychoanalytic talking cure might thaw frozen psychic structures. In returning through the event of death the artist "sketches out a kind of second birth," a "flow of jouissance into language."[23]

There are three levels of linguistic function in Kristeva's discussion of melancholia: (1) symbolic language, or ordinary discourse, identified with judgment and the grammatical sentence; (2) semiotic or poetic language, characterized by a connection back to the origins of linguistic acquisition, paying attention or even foregrounding the nonsignifying elements of language, which are related to the primary processes of condensation and displacement; and (3) the absence of language, asymbolia, a symptom of severe depression.[24] Poetic language, or the language of creative art, thus represents an intermediary link between silence and the language of either ordinary life or intellectual discourse.

Part of the meaning of the depressive position, which lies at the origin of symbolic life, is that "there is meaning only in despair."[25] Artists and literary writers often seem to be most aware of this precondition for meaning, but there have also been philosophers who recognize it. For example, Blaise Pascal

claimed that "man's greatness resides in his knowing himself to be wretched," and the novelist Céline wrote that we seek "the greatest possible sorrow" throughout life, in order "to become fully ourselves before dying."[26] What distinguishes Kristeva's argument in *Black Sun* from the ancient conception of melancholia is her recognition of the pervasive and often paralyzing effect of depression. What distinguishes her approach from that of many contemporary therapeutic treatments of melancholia is her attention to the way in which depression might be reconsidered by incorporating some aspects of the ancient insight into the condition, notably the awareness that many sufferers of the ailment are also highly creative or intellectually insightful. For some sufferers of melancholia, artistic or intellectual creation can provide a way out of the paralysis of this "incommunicable grief" toward a new life in language. Kristeva analyzes this self-generated treatment that historically some individuals, usually artists or writers, undertook without the intervention of a therapist or medication.

Importantly, this process succeeded not by completely leaving melancholia behind but precisely by incorporating it into the methodology and subject matter of the work itself. Kristeva herself suggests the impetus that has led me to juxtapose her work with that of Walter Benjamin when she places him within "a specific economy of imaginary discourses as they have been produced within the Western tradition," discourses that "are constituently very close to depression and at the same time show a necessary shift from depression to possible meaning."[27] She indicates Benjamin's work on *Trauerspiel*, and specifically on allegory, as among those that best achieve "melancholy tension."[28]

Kristeva argues that allegory is "inscribed in the very logic of the imagination" and thus that the imagination itself might be conceived of as allegorical. The question that arises from both Kristeva and Benjamin's work is: how might humans, if not overcome by this melancholia, reach the stage where we again become interested in the life of the sign, the symbolic life of culture? I will examine melancholia and allegory (which Benjamin aligns with melancholia and Kristeva with melancholic imagination) together, considering the idea of art as holding promise for addressing melancholic modernity. In particular, I will contrast Kristeva and Benjamin's allegorical approach to the negativity of depression to Hegel's idea that the melancholic "prose of the world" is only a determinate negation that, while pervasive and persistent, will ultimately be overcome and left behind, in a logic more akin to mourning. Mourning and melancholia are more than contingent psychic processes for

these thinkers. Rather, they determine the direction in which self-conscious being develops.

MOURNING AND MELANCHOLIA

The distinction between melancholia and mourning was explored by Freud in his 1917 essay "Mourning and Melancholia." In mourning a loss, Freud writes, "normally, respect for reality gains the day. Nevertheless its orders cannot be obeyed at once. They are carried out bit by bit, at great expense of time and cathectic energy, and in the meantime the existence of the lost object is psychically prolonged."[29] This drawn-out process of separating oneself from an object to which, though separate and distinct from oneself, one nevertheless feels an intense attachment, is called *Trauerarbeit*, the work of bereavement, and it normally results in an ego that is free and uninhibited. By contrast, melancholia concerns attachment to and loss of an object that is loved—and hated—not as distinct from oneself but as a part of oneself. This process can result in suicidal depression or asymbolia, the inability to link signs to meaning that Kristeva describes.[30]

Both mourning and melancholia are reactions to the loss of a loved object, either of a loved person—most originarily, of course, the lost mother—or, as Freud says, to the loss of "some abstraction which has taken the place of one, such as one's country, liberty, an ideal, and so on."[31] Melancholia is further distinguished from mourning in that whereas in mourning the lost object is consciously lamented and can be clearly identified, in melancholia the sufferer may not be able to identify the source of her grief, which often remains unconscious.

In melancholia, Freud writes, "the ego can kill itself only if . . . it can treat itself as an object—if it is able to direct against itself the hostility which relates to an object and which represents the ego's original reaction to objects in the external world."[32] The ego "wishes to incorporate" the lost object, toward which it feels an ambivalent mixture of sorrow at losing it—and perhaps even before losing it—and anger at it for deserting the ego; the method by which it would do so, Freud writes, "is by devouring it."[33]

Kristeva describes melancholia as the incorporation of the lost object and the resulting self-identification with it. The repeated self-accusation that is a result of the unconscious identification with the lost object combined with anger at it for leaving and ambivalence about it in the first place is a symptom of melancholia. The explanation for the melancholic's withdrawal into silence

lies in her recognition that language is complicit with the paternal order that sanctioned the loss in the first place.

Freud's analysis seems to limit melancholia to specific individual cases. In *The Ego and the Id*, however, he revised his theory of melancholia, which had previously been reserved for the analysis of severely depressed individuals. In the later analysis, Freud suggests that melancholia may be constitutive of subjectivity itself. Freud writes that as a person develops, he or she is continually forced to give up sexual objects, and therefore the id must be compensated for this loss. Freud describes an "alteration of the ego": the ego sets the lost object up inside of itself and then appeals to the id, trying, Freud writes, "to make good the id's loss by saying 'Look, you can love me—I am so like the object.'"[34] This identification of the ego with the lost object may be the sole condition under which the id can give up its attachments, and, Freud postulates, this process, especially in the early phases of development, "is a very frequent one, and it makes it possible to suppose that the character of the ego is a precipitate of abandoned object-cathexes and that it contains the history of those object-choices."[35] That is to say, the very constitution of the ego is melancholic, since it is composed of a series of settings-up of lost objects. Kristeva and Benjamin go further than this, suggesting that specific historical configurations of cultures are so constituted and, as a result, can be described as depressed.

National Depression

The idea of melancholia or depression on a collective or national level, which Kristeva puts forward in different ways in *New Maladies of the Soul*, in *Revolt, She Said*, and in *Contre la dépression nationale*, is a controversial one. Clearly, Freudian theory posits melancholia as a disorder that affects an individual, not a group or collective. However, Freud's *Civilization and Its Discontents*, whose original German title evokes the whole of human culture and its unhappiness (*Das Unbehagen in der Kultur*) rather than that of any specific civilization, might be considered in this vein. Kristeva's analysis has a more exact precursor, however, in the work of the existential psychologist Frantz Fanon, who diagnosed the colonized of the Antilles as suffering from an inferiority complex not on an individual but on a collective level.

In *Black Skin, White Masks* Fanon argues that for Europe and for "every country characterized as civilized or civilizing," the family is a miniature version of the nation and that, conversely, the characteristics of the family, in particular its paternal structure of authority, are projected onto the social environment.[36] This ensures, on Fanon's view, a seamless transition from famil-

ial to civic life for any subject who has been raised in a functional family. For black culture, however, Fanon writes, it is almost exactly the opposite. A black child, having grown up in a normal, functional family, "will become abnormal on the slightest contact with the white world."[37] This abnormality is provoked not by a return on any level to familial psychic traumas that shaped the child in infancy or childhood but rather to injections of popular white culture—which present villains, savages, and evil spirits as black—into black culture during childhood, injections that only have their full effect at a later date, when the black subject enters in a full-fledged way into the white man's world. When the black child—who has identified, just like any white child, with the white hero and explorer who fights the villain or evil in books and films thus who subjectively interiorizing the white man's attitude without realizing it— goes to Europe, he will tend to cast his own family structure, which is now identified with what society rejects, back into the "id" and identify his political or subjective state with white culture.[38] This causes profound dissonance at the level of egoic identification.

Kristeva analyzes a level of social depression that affects everyone equally, more or less, yet its root is the same "capitalistic and colonist society" that Fanon identified.[39] In her *Contre la dépression nationale*, Kristeva identifies the relationships between French citizens and immigrants and the problems left over from the dysfunctional French colonial enterprise as a source of French "national depression" and advocates a greater openness to immigrant others as one method of combating this kind of depression. Kristeva began to write about depression as a national or Western phenomenon in the late 1980s, when she noted an enormous increase in the number of patients with depression in her psychoanalytic practice.[40]

In the current climate of global warfare, ethnic and religious division, and mutual suspicion, we can perceive an analogous melancholic process on a cultural level throughout the West. The loss of orientation toward the Kantian ideals of perpetual peace and cosmopolitanism, with national identity constituted only negatively against that of racialized others and given over to a commercially and militarily dominated confrontational globalism, has led to a melancholic condition that transcends individuals. As Adorno writes in the introduction to *Minima Moralia*, "What the philosophers once knew as life has become the sphere of private existence and now of mere consumption, dragged along as an appendage of the process of material production, without autonomy or substance as its own."[41]

Kristeva imagines the constitution of culture itself, like Freud's ego, as a string of lost objects, traces of which we can see in the historical chain of

memorials to great individuals, official records of world-historical events, and the trauma of war and loss. In the normal process of cultural formation, these monuments memorialize the past, building it up from within through abandoned object cathexes, whereas when a culture is pathologically melancholic, as Kristeva contends that European and North American cultures of the twentieth and twentieth-first century are, it is in need, just as is the individual who has lost all desire to communicate, of some sort of force of re-eroticization. The creative drive can be seen as a move from the death drive to Eros, and Kristeva envisions this possibility primarily through art, through revolution in a very particular sense, and through psychoanalysis.

Benjamin goes even further in arguing that melancholia is a modern ailment that directly stems from objective material conditions. In his analysis of German tragic drama, Benjamin points out that the common tendency is to think of melancholia as a subjective ailment solely concerning the feelings of an individual. To think this way is to disregard the objective structures and material conditions that gave rise to melancholia in the first place. He writes:

> Melancholia is the state of mind in which feeling revives the empty world in the form of a mask, and derives an enigmatic satisfaction in contemplating it. Every feeling is bound to an *a priori* object, and the representation of this object is its phenomenology. . . . For feelings, however vague they may seem when perceived by the self, respond like a motorial reaction to a concretely structured world. . . . The representation of these laws does not concern itself with the emotional condition of the poet or his public, but with a feeling that is released from any empirical subject and is intimately bound to the fullness of an object.[42]

Freud addressed the individual's feeling of being "bewildered in his orientation, and inhibited in his powers and abilities" in a time of war, particularly in a historical period when humanity thinks it has reached a high level of civilization.[43] Although Freud considered warfare to be an almost inevitable outcome of extended human interaction, attributable to our basic animal nature, he also expressed hope, in his epistolary exchange on the experience of war with Albert Einstein, that pacifists, among whom he numbered himself, might take hope from the cultural disposition of human beings but also develop "a well-founded dread of the form that future wars will take."[44] Had he lived to see contemporary forms of warfare, he might well have expressed agreement with Kristeva that the immense destructive capacity of technological warfare in which the world seems to be enmeshed, the fact that this brutality can be un-

leashed from a safe distance by global superpowers, and individuals' seeming impotence vis-à-vis international conflicts could result in a depression (or "inhibition of powers and abilities") that is "utterly intolerable."[45]

At the same time, the detached nature of citizens' relationship to current wars within which we are nonetheless implicated can lead to a maniacal attitude vis-à-vis social action on both sides of a conflict, in which individuals can express their aggression or death drive without restraint. Xenophobia and religiously informed racism provide a means for individuals to act out the manic inversion of their depression.[46]

This kind of reaction exhibits the peculiar tendency of melancholia "to change round into mania—a state which is the opposite of it in its symptoms."[47] Kristeva judges that this tendency characterizes late modernity. She speculates, in an online essay, that the very global cosmopolitanism of which Western societies are most proud leads them to commit countless acts of almost imperceptible impoliteness, which indirectly aggravate "national depression." Terrorism, fundamentalism, and right-wing intolerance are all symptoms of this depression shifted in various directions:

> If the depressed person does not commit suicide, he finds some relief for
> his pain in a manic reaction: the depressed person mobilizes himself in
> pursuit of some enemy, preferably imaginary, rather than berate himself,
> restrain himself, or shut himself up in inaction, then engages in wars, in
> particular holy ones. You will have recognized the National Front . . . [48]

So the work of mourning, in order to navigate between denial and a position that too easily transforms negativity into a positive and potentially reductive moment that allows for time to go on, must be informed by a certain sense of temporality, finitude, and the possibility for discourse or conceptualization, however limited and provisional its signification may be.

SPIRITUAL INOCULATION

The re-eroticization or recharging of psychic life that would lead to a renewed capacity to register impressions and their meaningful values for the subject must itself, to be successful, reflect the nature of the world whose problems it seeks to expose. What I have called "spiritual inoculation" manifests Kristeva and Benjamin's belief that through a specific sense of melancholia, or, more accurately, of writing or art that translates the melancholia of modernity into a style, rather than an explicit theme or affect, the depression that has

crippled psychic life in the twentieth and twenty-first centuries can be addressed. To see what this "inoculation" might look like, let us consider Benjamin's autobiographical "Berlin Childhood Around 1900," written in Paris in 1932, which begins with the recollection that it started as a project of inoculation against homesickness.

In 1932, Benjamin was in Spain and Italy. The political situation in Germany was worsening and, as he writes at the beginning of the passage, "it began to be clear to me that I would soon have to bid a long, perhaps lasting farewell to the city of my birth."[49] He proceeds to call up willfully all the images of his childhood in Berlin in order to initiate a feeling of longing that, while it would cause pain, "would no more gain mastery over my spirit than a vaccine does over a healthy body."[50] Not limiting his reverie to his own childhood, he also seeks insight into the irretrievability of the past per se, "not just the contingent biographical but the necessary social irretrievability,"[51] signaling his project to be a continuation of Proust's *In Search of Lost Time*, but on a social and political level.

This image of spiritual inoculation seems to me to be an apt one for describing not only the project of the "Berlin Childhood" essay but also the interest in and importance Benjamin ascribes to the figure of the allegory in his monograph *On the Origin of German Tragic Drama*. Like the intentional pain that reminiscing about an irretrievable past can invoke, the melancholy and fragmentary nature of allegory not only provides an alternative to idealist accounts of art but also lends itself paradoxically to the overcoming of melancholia understood as a debilitating collapse into asymbolia.[52] The trope of allegory may be thought of as a complication of the binary opposition found in conventional psychoanalysis between mourning—which aims primarily at leaving the past behind—and melancholia, the disabling inability to separate from a lost object. Like memories of childhood willfully invoked, allegory serves as a kind of spiritual inoculation against a more overwhelming and paralyzing attitude toward the past as well as providing a way of imagining a future that might be otherwise. Just as Proust creates a beautiful work of art in conjuring up traumatic memories of the past, the future of a society, nation, or culture might be imagined otherwise through the lens of writing or art.

In *Stranded Objects*, Eric Santner reflects on discourses concerning the mourning of the Holocaust. Santner gestures to an alternative sense of mourning, one that would neither imagine that we could work through the past in order to simply put it behind us nor use it for strategic purposes. Although Santner refers to this process as a kind of mourning, I think it shares common ground with the intermediary stage Kristeva discusses between the absence of

signification and a fixed meaning. Indeed, Santner argues that melancholia emerges "out of the struggle to engage in the labor of mourning in the absence of a supportive social space."[53] Santner points out that there must be a social dimension to the labor of mourning if it is to be successful and that part of the social dimension of mourning is the development of the capacity to feel grief for others and guilt for the suffering one has directly or indirectly caused. This depends in turn on the "capacity to experience empathy for the other *as other*" (not an attempt to put oneself in the place of the victim), something that film, theater, novels, paintings, and other artworks can accomplish more intensely and effectively than any other medium.[54]

One of the ways in which this process might be initiated, Santner writes, is through the exploration, in thought, of possibilities not pursued, imagining how it *might have been* if one had acted differently. This is an imaginative, even a literary, act. Adorno, referring to Proust, describes the temporality of politically promising artworks in similar terms, as the remembrance that "remains bound up with semblance: for even in the past the dream was not reality."[55] Because of this creative or imaginative dimension, art—in conjunction with philosophy and psychoanalysis—is one of the privileged places to which we must turn in considering the question of the possible political significance of mourning and melancholia.

Kristeva locates herself in a philosophical lineage that begins with Socrates, Plato, and Augustine and moves through Freud and Proust. What they share is a preoccupation with a "retrospective return" or "retrospective introspection," by which she refers to a combination of anamnesis and self-interrogation, a recultivation of the inner life that has been destroyed by depression, anxiety, and stress.[56] While for Plato the aim of such a process might be a reunification with one's most rational, universal self, and for Augustine, a reconciliation with the divine, for Freud, Benjamin, and Kristeva the inner rift cannot be so easily healed. It can, however, be addressed and tended, in a process of continual self- and other-instigated interrogation. For Freud, this process may have been primarily limited to the analytic situation, but Kristeva writes, "the solution to this permanent condition of conflict? Creativity."[57]

MELANCHOLIA, MODERNITY, AND ALLEGORY

In his *Lectures on Aesthetics*, Hegel describes what he calls the "prose of human existence." This chronic condition of humankind is initially and repeatedly negative but can ultimately become affirmative by overcoming and in so doing obliterating the internal opposition and contradiction that give rise to

the symptoms of sadness, boredom, and lack of direction. Here Hegel is describing the progress of history, but his analysis seems to come close to Freud's hypothesis that the very logic of human existence is melancholic in constitution:

> Now since the content of our interests and aims is present at first only in the one-sided form of subjectivity, and the one-sidedness is a restriction, this deficiency shows itself at the same time as an unrest, a grief, as some-thing negative. This, as negative, has to cancel itself, and therefore, in order to remedy this felt deficiency, struggles to overcome the restriction which is known and thought. . . . Only by the cancellation of such a negation in itself does life become affirmative.[58]

In Hegel's view, the melancholic condition is one-sided because psychologi-cal (interior) and thus merely subjective. The melancholic refuses the future and remains caught up in the loop of the past and present, choosing to "em-brace the present in the gratification of its own despair."[59] The negative can be overcome through the introduction of objective content that complements the one-sidedness of subjectivity. The ultimate triumph of affirmation in Hegel's description of human existence suggests that his theory bears a closer affinity to mourning, which, though painful, ultimately leaves behind suffer-ing and negativity in favor of an ego/ethical life that is free and uninhibited, similar to the way in which Hegel describes the organic body dealing with infection and disease. Hegel seems to assume that in most cases this process is successful.

For Benjamin, in contrast to Hegel, modernity has shown itself to be purely prosaic. Attacking the very romanticism that, for Hegel, provided the represen-tation of the highest possibility of art, Benjamin argues that the philosophy of art has been "subject to the tyranny of a usurper who came to power in the chaos which followed in the wake of romanticism."[60] The usurper is the theory of the "symbol," which Benjamin uses in a Hegelian sense as "resplendent but ultimately non-committal knowledge of an absolute." Hegel, too, had criticized the symbol for the inadequacy of its manifest form to its content, and both Benjamin and Hegel use the dismissive locution "beautiful soul" to describe the romantics.[61] Benjamin seems to indict Hegel along with romanticism, however, in his critique of the postromantic or idealist theory of the symbol, which, he writes, "insists on the indivisible unity of form and content."[62] Tra-ditional aesthetics sees beauty as a symbolic construct that "merges with the divine in an unbroken whole."[63] What makes the theory typically romantic,

according to Benjamin, is "the placing of this perfect individual within a progression of events which is . . . redemptive, even sacred."[64] It is this characterization that allows us to infer that his critique is also of Hegelian philosophy of spirit.

For Benjamin, allegory is the unacknowledged other of classicism, which in turn was the other of romanticism. Allegory was adopted by romanticism, he writes, "to provide the dark background against which the bright world of the symbol might stand."[65] According to Goethe's distinction, allegory seeks the particular from out of the general, whereas the symbol sees the general in the particular. For classicism, the term "allegory" thus expresses a conventional relationship between an image and an abstract meaning,[66] while the symbol grasps the particular in all its vitality and in so doing simultaneously grasps the general or universal. Whereas the temporality of the symbol is an almost religious moment of redemption or reconciliation, a "mystical instant in which the symbol assumes the meaning into its hidden . . . interior,"[67] allegory unfolds in a violent dialectical movement that is "untimely, sorrowful, unsuccessful."[68] It would therefore not be incorrect to align the symbol, as Benjamin discusses it, with mourning, and allegory with melancholia. He writes: "the object becomes allegorical under the gaze of melancholy."[69] And indeed, the allegorical presents the perspective of the melancholic, who possesses an intimate awareness of the unity between the world of dreams and that of meaning.[70]

Benjamin distinguishes the allegory of medieval Christianity from that of modernity. The earlier form of allegory was primarily concerned with separating the true religion and the true God from the pagan pantheon. Accordingly, early allegory "established itself most permanently where transitoriness and eternity confronted each other most closely."[71] Allegory began by being closely aligned with fallen nature, the material, and the guilt of the flesh. Because of its fallenness, nature is mute and suffers.[72] The omnipresence of death, most salient in the corpse, becomes a central figure of early allegory. Because these fallen things cannot speak, allegorical language is fragmented and suggestive, needing to be put together by the reader of the allegory.

In addition to his study of allegory within seventeenth-century German *Trauerspiel*, Benjamin also addresses allegory in his reading of Baudelaire as part of a critique of modernity, in particular of the mythic spell of commodity culture. Benjamin had planned to write a book on Baudelaire, with one of its three sections to be on Baudelaire and allegory, but only the set of notes entitled "Central Park" attests to this unfinished project. Allegory's task within modernity would be to make present what has been excluded from dominant linear and progressive ideas of history.

In modernity, the figure of the dead thing is arguably also central, but rather than representing nature and materiality, the dead thing—which, if possible, is even "deader" than the corpse (since the latter has the possibility of being "resurrected" in the spiritual realm)—is the commodity; "the devaluation of the world of things in allegory is surpassed within the world of things itself by the commodity."[73] Baudelaire's life history and work, in Benjamin's reading, form a composite image of "petrified unrest," of eternal movement that knows no development,[74] like the temporality of mass production, which eternally generates the same. Baudelaire's poetry wrenches things from their familiar context, namely from the "normal state for goods on display."[75] In so doing, Baudelaire could

> make manifest the peculiar aura of commodities. He sought to human-ize the commodity heroically. This endeavor has its counter in the concurrent bourgeois attempt to humanize the commodity sentimentally: to give it, like the human being, a home. The means used were the etuis, covers, and cases in which the domestic utensils of the time were sheathed.[76]

Unlike the baroque allegory, the Baudelairean allegory manifests traces of the "rage needed to break into this world, to lay waste its harmonious structures."[77] The dialectic of commodity production introduces a new significance to the (dead) thing, that of being eternally identically repeatable; thus "allegorical emblems return as commodities."[78] Benjamin calls allegory the "armature of modernity," seeming to accord it an even more important status in the time of technological development and commodity culture than in the era of the baroque, since "baroque allegory sees the corpse only from the outside. Baudelaire sees it also from within."[79]

Thus, while the Baroque allegory in a very real sense emerges from social and political upheaval, from decades of war, from earthly suffering, and from the imagery of fragmentation or the ruins of the ancient world, modern allegory is resuscitated by Baudelaire in a time of apparent abundance and smooth, progressive development, the golden age of industrial capitalism. The connection between these two historical periods, as Max Pensky argues, is that "allegory proceeds from *Trauer*,"[80] a state that is neither subjective nor objective but rather a subjective determination arising from and intimately connected to the objective material conditions of its context. Thus art both reflects material conditions and provokes thought on how to engage with the dominant problems of its time.

Benjamin's analysis of the German *Trauerspiel* provides insight into how the allegorical mode of linguistic representation might express both melancholia and a means, if not of overcoming it, of "remaking it better than it was." For the baroque, and also for modernity, Benjamin argues,

> meaning has its home in written language. And the spoken word is only afflicted by meaning, so to speak, as if by an inescapable disease; it breaks off in the middle of the process of resounding, and the damming up of the feeling, which was ready to pour forth, provokes mourning. Here meaning is encountered, and will continue to be encountered as the reason for mournfulness.[81]

This process initially describes the downward spiral toward asymbolia. Words and forms and meaning occur not as parts of a seamless whole, disappearing in their service to a unified meaning that brings the work together in the oneness of its significance, but as fragments, runes, part of a petrified landscape that can only be put together by an interpreter after the fact. Signification itself takes on a melancholic structure, yet there is still a possibility of recapturing, if not one unified, total meaning, then a string of fragmentary senses.

Rebecca Comay writes of allegory as a resuscitation of meaning, with an emphasis on the bodily, materialist implications of resuscitation, as compared to the spirituality of resurrection that we see in Hegelian dialectic. Contrasting Hegel (idealism) with Benjamin (as a representative of materialism), Comay writes: "Symbolic resurrection—'vision'— . . . calls up the dead as objects of consumption: the mourned object devoured or introjected as host or food for thought. Allegorical resuscitation—'theory'—throws up the dead as indigestible remainder and untimely reminder, the persistent demand of unsublimated matter."[82]

These words recall quite strikingly Freud's distinction between mourning and melancholia and underline the connection between allegory and melancholia. The distinction between vision and theory is Benjamin's. "Vision," on this reading, signifies an effacement of temporality, a movement toward the eternity of mythic time, whereas "theory" exposes the present to the past, summoning back the dead in order to interrogate them.[83] The reference to devouring or introjecting the lost object recalls Freud's discussion of melancholia and again is linked to allegorical expression.

Benjamin asserts that the allegory must resist "absorption"—a word that recalls mourning's "digestive" effect—into a unified and unchanging meaning, remaining open to a plurality of interpretations.[84] Unable to sustain the

illusion of totality, allegory must unfold in novel ways; "it is part of their na-
ture to shock."[85] If melancholy "causes life to flow out of" an object, Benjamin
writes, "then it is exposed to the allegorist";[86] it gains its significance entirely
from the work of allegory, which makes of it something different, yet it re-
mains a "key to hidden knowledge."[87] The only pleasure that the melancholic
allows herself is allegory.[88] The proper stance of the theorist vis-à-vis moder-
nity is a recognition of one's condition of being stranded in a world of mere
things with the life sucked out of them. The task of the allegorist would be
both to manifest this state of affairs and to find a way to address it without put-
ting forth false promises of redemption.

KRISTEVA AND ALLEGORY

Kristeva calls the imagination of pathological melancholia "cannibalistic."
The imagination that produces melancholic art is, by contrast, "allegorical."
This second type of imagination/language bears witness to the semiotic pro-
cess that gives rise to symbolic language and that sometimes reappears in po-
etic language or art. In calling the imagination allegorical, Kristeva indicates
that she is making a reference to Benjamin. Specifically, Kristeva refers to the
allegory as a "hypersign," as the "lavishness of that which *no longer is*, but
which regains for myself a higher meaning because I am able to remake noth-
ingness, better than it was."[89]

The melancholic, on Kristeva's view, is a "necessarily heterogeneous sub-
jectivity, torn between the two co-necessary and co-present centers of opacity
and ideal."[90] She postulates that the movement from depression to possible
meaning that is opened up for the melancholic, sometimes with the aid of art,
might be akin to the very structure of the imaginary itself, as an intermedi-
ary, or "tense link," between the Thing, or the unsignifiable, and Meaning,
between the unnamable and the proliferation of signs. The imaginary, on
this reading, contains an "infinite possibility of ambivalent, polyvalent, res-
urrections"[91] for the melancholic awakening to possible meanings. Kristeva
asks the question, "might the Imaginary be allegorical?" referring explicitly to
Benjamin's work on German tragic drama, where allegory best achieves a
melancholy tension, as Kristeva reads it, between the absence of meaning
and full signification, between the void and plenitude, between absence and
presence.

Allegory shifts back and forth from disowned meaning, which Kristeva
compares to the ruins of antiquity, to the resurrected, spiritual meaning that
a Christian reading would attribute as truth even to fallen things. She calls the

activity of the imaginary a "flaring up" of a "surplus of meaning" with which the speaking subject can play.[92] This surplus leads to the creation of the beautiful as that which, in the imagination, promises to fill in the lack perceived by the melancholic. Bringing together Freud's essay "On Transience" with "Mourning and Melancholia," Kristeva suggests that for Freud sublimation might be compensation for the originary loss. In "On Transience" Freud is inspired by a conversation with two melancholy friends, for one of whom the beautiful's transient nature leads to a decrease in its value. Freud responds in contradiction: "On the contrary, an increase!" Kristeva speculates that beauty, for Freud, might be the one thing that is not affected by the universality of death, in the sense that it makes us recognize and cherish the finitude of our existence.[93]

Kristeva goes on to ask whether the beautiful might be the ideal object that never disappoints the libido, or whether the beautiful object might appear as that which restores the deserting object,[94] the value that will never perish. She postulates that this melancholic structure of the beautiful parallels ego constitution but that it is allegorical in form, since it circles around the depressive void, standing in for that which never is, transforming loss in order for the ego to be able to live.[95] The allegorical is an intermediary form of language stretched between depression or the depreciation of meaning and "signifying exaltation."[96] Poetry, Kristeva speculates, might "bear witness to a (for the time being) conquered depression."[97]

Kristeva mentions Holbein, Dostoevsky, and Marguerite Duras as melancholics who worked against, through, and with their melancholia precisely through a melancholic process of creation. She shows that these artists transformed what otherwise would have been an endless, asymbolic lethargy into a signifying and positive mode through writing and painting, without thereby leaving melancholia completely behind or renouncing it, or by resolving it into mourning or complete closure.

Ewa Ziarek has argued that melancholia itself can be conceptualized as a kind of protest, in the form of the refusal to master alterity in terms of linguistic proficiency. Kristeva writes in *Black Sun*:

> Signs are arbitrary because language starts with a *negation* of loss, along with the depression occasioned by mourning. "I have lost an essential object that happens to be, in the final analysis, my mother," is what the speaking being seems to be saying. "But no, I have found her again in signs, or rather since I consent to lose her I have not lost her (that is the negation), I can recover her in language."[98]

This negation is a form of mourning insofar as "signs" refers to the paternal symbolic order. But melancholia, as the refusal to accept language as a compensation for the loss of the mother, and, as Ziarek puts it, "a refusal to think alterity in terms of losses and compensations,"[99] requires that melancholic art take the form not of symbolic mediation but rather, as Benjamin demonstrates, of allegorical fragments, runes, or ciphers.

Imagination presents an ideal but at the same time provides the subject with the possibility of playing and replaying it in varied forms, manifesting its illusions and disillusion.[100] Kristeva links this human imaginative capacity to the imaginary of a certain form of Christianity, to the ability to transfer meaning "to the very place where it was lost in death and/or nonmeaning."[101] Very provisionally, through dreams and words, the melancholic subject preserves idealization as a place to survive.

In her discussion of the sixteenth-century German painter Holbein, Kristeva makes clear that she is not simply interested in pointing out the biographical description of an artist as a melancholic or the empirical fact that he or she chose melancholic subjects for his or her art. Rather, she writes, speaking of Holbein:

> More profoundly, it would seem, on the basis of his oeuvre (including his themes and painterly technique), that a melancholy moment (an actual or imaginary loss of meaning, an actual or imaginary despair, an actual or imaginary razing of symbolic values, including the value of life) summoned up his aesthetic activity, which *overcame the melancholy latency while keeping its trace*.[102]

This preservation of the trace of melancholy is achieved, Kristeva argues, through artistic style rather than subject matter: "Artistic *style* imposes itself as a means of countervailing the loss of the other and of meaning: a means more powerful than any other because more autonomous . . . but, in fact and fundamentally, analogous with or complementary to behavior, for it fills the same psychic need to confront separation, emptiness, death."[103]

The death of Christ, the subject of Holbein's famous *The Body of the Dead Christ in the Tomb*, which had such an intense effect both on Dostoevsky and on his character Prince Myshkin in *The Idiot*, provides Kristeva with a trope for exploring the notion of melancholic beauty. The notion of God dying is, she writes, the ultimate depressive moment.[104] Yet Kristeva reminds us that another Christian tradition, one focusing on asceticism and martyrdom, eroticized the physical and mental pain and suffering of the Christian tradition to

the greatest extent possible.[105] To overlook this tradition would be to marginal-ize the moment of Christ's anguish on the cross, the "Father, why have you forsaken me?" that introduces, however briefly, a "caesura" between father and son, one that "provides an image . . . for many separations that build up the psychic life of individuals," namely, "birth, weaning, separation, frustra-tion, castration."[106] This gives the death of Christ a "tremendous cathartic power," bringing to light the drama in the inner life of every subject and offer-ing "imaginary support to the nonrepresentable catastrophic anguish distinc-tive of melancholy persons."[107]

In considering the death of God, Hegel focuses primarily on the resurrec-tion and on the Eucharist, moments in which "sacrifice (and concomitantly death and melancholia) is *aufgehoben*—destroyed and superseded."[108] In *The Phenomenology of Spirit*, however, he discusses the death of Christ as a cru-cial moment in religious life for the transition toward the final stage of the phenomenology of self-consciousness, absolute knowing, beyond the realm of "picture thinking" or representation that still haunts religion and of which it must be divested. Kristeva writes that "Hegel stresses the consequences of this action for representation."[109] Indeed, Hegel writes that the death of Christ is also the death of representation:

> The death of this picture-thought contains, therefore, at the same time the death of the abstraction of the divine Being which is not posited as Self. That death is the painful feeling of the Unhappy Consciousness that God Himself is dead. This hard saying is the expression of innermost simple self-knowledge, the return of consciousness into the depths of the night in which "I" = "I," a night which no longer distinguishes or knows anything outside of it. . . . This Knowing is the inbreathing of the Spirit, whereby Substance becomes Subject, by which its abstraction and life-lessness have died, and Substance therefore has become actual and sim-ple and universal Self-consciousness.[110]

In his *Lectures on the Philosophy of Religion* Hegel describes this moment of the death of Christ as concurrent with self-consciousness's assimilation of the knowledge of the absolute, "the deepest abyss of severance" for representa-tion. Kristeva writes that the heart of this severance is the simultaneity of nat-ural death and divine love, "a wager that one could not make without slipping into one or the other of two tendencies," either a Gothic or Dominican ten-dency to re-present natural death in art or an Italian or Franciscan tendency to exalt luminous bodies in an attempt to make the glory of the beyond visible

through the movement of the sublime. Holbein's *The Body of the Dead Christ* may be the sole example of a painting that goes in neither direction but is located "at the very place of the severance of representation of which Hegel spoke."[111] This "betweenness" is an interval rather than a severance, one that would be achieved artistically through the spiritual inoculation of melancholia:

> Is it still possible to paint when the bonds that tie us to body and meaning are severed? Is it still possible to paint when *desire*, which is a bond, disintegrates? Is it still possible to paint when one identifies not with desire, but with *severance*, which is the truth of human psychic life, a severance that is represented by death in the imagination and that melancholia conveys as symptom? Holbein's answer is affirmative. Between classicism and mannerism his minimalism is the metaphor of severance: between life and death, meaning and nonmeaning, it is an intimate, slender response of our melancholia.[112]

Thus the vision of the death of Christ is a way to "bring him back to life" in a material, this-worldly way.[113] The act of painting, or of viewing the painting, is "a substitute for prayer."[114] In "Motherhood According to Giovanni Bellini," Kristeva also considers style as a means of contending with loss. Here she argues that it is through luminous color that the mother is evoked; in the Orthodox conception of the virgin Mary, she is also manifested as a place of direct contact through color and configuration of space.[115] Unlike Hegel, for Kristeva the death of Christ is not the death of representation. Rather, representation comes to support the nonrepresentable and thereby to ease anguish.

CONTEMPORARY ALLEGORICAL ART

ART'S ROLE

Starting from the diagnosis of modern culture as suffering from depression,[116] Kristeva focuses on the inoculatory effect of melancholic artworks as a form of resexualization of drives frozen into a kind of monotonous repetition by the loss of a loved object incorporated rather than mourned. Art that might achieve this re-erotization would point forward rather than backward, acting in analogy to the homesickness for a past that will never reappear, but with the added promise of another this-worldly home yet to come. Rather than thinking of fragmented or anguished art as purely self-destructive, Kristeva

outlines how the creative drive, even or especially in its revised (resexualized) melancholic form, might be thought of as effecting a re-entrance into signification, a re-erotization of existence, but precisely existence that retains its origin in the melancholic.[117] She calls this process, in fact, an "erotization of suffering."[118] She argues that self-critique and critique of one's culture can become moments of ego development and creativity and that art can take anguish and transform it into a kind of libidinal energy, marking a move away from the death drive, a defense that utilizes melancholia (a more benign form of "death in life") to inoculate itself against the more debilitating potential of the death drive, namely, its destructive or fragmenting force.[119] "The depressive affect," Kristeva writes, "can be interpreted as a defense against parceling."[120] Sadness can "reconstitute an affective cohesion of the self."[121]

Among the semiotic processes that art evokes, if we imagine the symbolic order as constituted along the lines of the Enlightenment calculus of instrumental rationality, we might also include the figure of nature, which Benjamin demonstrates was the primary subject of Baroque allegory. What Kristeva and Theodor Adorno share is a conception of Nature (Adorno) or the maternal body (Kristeva) as the suffering remnants of Spirit, as that which has been excluded by the relation of mastery that the subject has vis-à-vis the object. The beauty of nature, in Adorno's account, or the beauty of the severed head in Kristeva's, becomes a figure for the promise of what could be otherwise.

Adorno and Kristeva share a concern for the historical development of the concept of nature. They are both concerned with how a dominant paradigm of discursive and instrumental reason has overshadowed any other possible access to nature and the body and how the abject other has been aligned with nature. Both speculate as to whether art might be able to give a "voice" to these suffering remnants. Kristeva, Benjamin, and Adorno have a common interest not in overcoming melancholia, since it is an important symptom manifesting the disorder of our time, but in exploring ways in which melancholia might be tempered in such a way as to point to another way of existence.

Art may possibly restore a voice to what is mute, to melancholia as asymbolia. Yet art speaks in a language that is enciphered, and it is philosophy's task to render the mute eloquent.[122] Art and philosophy thus must work hand in hand. Philosophy itself must retain the melancholic aspect of the artwork in order to do justice to it, and this involves preserving a fundamental ambiguity or indecision that would problematize the idea of a master interpretation. Adorno explicitly and Kristeva implicitly push this problematization so far as to question the boundaries between art and philosophy.

Like melancholia, which Ziarek calls a "powerful critique of the desire to master alterity through the order of representation,"[123] nonrepresentational art alone can do justice to the beauty of nature's power to escape the matrix of calculative reason. While for Adorno nonrepresentational art is purely abstract, Kristeva privileges art that, while it might be figural, suggests or inscribes rather than representing its subject.[124] Adorno insists on the fragmentary nature of politically successful modern art. If artworks achieved a unified meaning, a totalized utopian view, they would be reconciled with what they intend to critique. But:

> The ideological, affirmative aspect of the concept of the successful artwork has its corrective in the fact that there are no perfect works. If they did exist, reconciliation would be possible in the midst of the unreconciled, to which realm art belongs. In perfect works art would transcend its own concept; the turn to the friable and the fragmentary is in truth an effort to save art by dismantling the claim that artworks are what they cannot be and what they nevertheless must want to be; the fragment contains both these elements.[125]

Adorno argues that art speaks; art's language, however, is not the voice of the subjective intention of the artist but a language of the object as object—to the extent that the object speaks, the work of art is successful. The objective, that trace of materiality or nonconceptuality that refuses to be taken up into the realm of spiritual signification, is an essential feature of a meaningful work of art. "Art's linguistic quality gives rise to reflection over *what* speaks in art," writes Adorno; "this is its veritable subject, not the individual who makes it or the one who receives it."[126]

Adorno calls radical modern art progressive not merely, he says, because of its techniques but because of its truth content. It is the *language* of radical modern art that makes "existing artworks more than existence." This language can only be accessed by "the effort to purge authentic artworks of whatever contingent subjectivity may want to say through them," a task that "involuntarily confers an ever more definite shape on their own language."[127] The task of the philosophical commentator is to allow this expression to come into words without thereby reifying its meaning, a task fraught with risk. As Benjamin writes, the "ambiguity" that is the "basic characteristic of allegory" is a "fragment, a rune" whose "beauty as a symbol evaporates when the light of divine learning falls upon it."[128]

Kristeva's own admiration of modern art lies in the presence of the re-erotized or redeployed semiotic within some of these works. Her analysis therefore foregrounds the existence of something essentially unpresentable in successful works of art or, more precisely, something that can be expressed only negatively or indirectly through its absence in the work. The unpresentable manifests itself as a kind of libidinal force that is nonetheless a protolanguage expressing itself in visual art through color and tone rather than representational form, releasing an affective energy that indicates the unpresentable while simultaneously acknowledging its inability to be presented.

Art opens up a space that is atemporal but not eternal, impossible to connect to the logical order that it interrupts; it therefore expresses itself in terms of a question. Kristeva challenges the Kantian assumption of a concurring *sensus communis* undergirding aesthetic judgment. Art is needed precisely to "counterbalance the mass production and uniformity of the information age," to "demystify the idea that the community of language is a universal, all-inclusive, and equalizing tool."[129] As I will elaborate in chapter 3, Kristeva believes that art should perform an alienating, diversifying and anti-identificatory function rather than bring together a culture in complacent assumptions of judgments in common. The art that she privileges might be called an art of the uncanny far sooner than an art of the beautiful, in that it thematizes and intensifies the strangeness at the heart of what seems most familiar to us. Color, timbre, inflection, shadow, affect—those semiotic elements of poetic language—cannot hope to be universally shared.[130]

THE COUNTERMONUMENT AND RACHEL WHITEREAD

I will now consider some examples of contemporary art as illustrations of what I mean by a melancholic beauty that might be capable of addressing the melancholia of our age. Kristeva describes successful art as art that avoids succumbing to the pathological melancholia that threatens it, either by introducing erotic (life-engendering) fantasies into the narration or, by means of color and sound, effectively re-erotizing the sublimatory activity. She gives the examples of Sade, Diderot, Proust, Genet, Celine, and Joyce as authors who perform one of these two versions of re-erotization.[131]

What I have called spiritual inoculation also performs this re-erotization in willfully conjuring up memories from the past in a way that will not paralyze the present but precisely render it tangible and navigable, in the manner of Proust. I believe that artworks that can effect this inoculation are entirely in

line with Kristeva's consideration of writers and artists who overcame melan-
cholia through creating melancholic art. Such art intentionally dwells on the
melancholic constitution of the present, either through incorporating tempo-
rality into its structure or by manipulating the expected form of the artwork in
order to subvert the more damaging melancholia that threatens to overwhelm
both artist and viewer in traumatic times.

In *The Sense and Non-Sense of Revolt*, Kristeva discusses two installations
from the 1993 Venice Biennale along these lines, in order to respond to the
question whether beauty still plays a role in contemporary art. This question
is significant if we recall that in *Black Sun* she called beauty the one thing
that might still be able to speak to the melancholic, in order to bring her back
from suffering into language.[132] The installations, by Hans Haacke and Rob-
ert Wilson, can be understood in terms of their construction of a symbolic
meaning that transcends intentionality, "of which the artists who made them
may not have been aware."[133] Both installations in some way literally repre-
sented the collapse of foundations: Haacke's had visitors walk across a crum-
bling, shifting terrain; Wilson's ground sank and caved in under spectators'
feet. The art of the late twentieth and early twenty-first centuries is, writes
Kristeva, fundamentally different from that of the early twentieth century,
even though both respond to unprecedented human trauma. Whereas the
modern movement in visual art, despite its reaction against devastating world
wars, still maintained a faith in the possibility of a unifying theoretical (albeit
critical) basis, the art of today no longer has a solid foundation. Artists don't
know where to go or even whether they are capable of going anywhere any-
more: "Part of our pedestal is falling into ruin."[134] Yet this experience of the
disintegration of artistic and theoretical foundations is ambiguous, even "ex-
quisitely" ambiguous, for it is not entirely negative. "The simple fact that an
installation has been created in a place where the foundations are disintegrat-
ing gives rise to a question as well as to anxiety."[135]

Here for the first time Kristeva introduces a new sense to her now-familiar
discussion of art as revolt or revolution. Whereas in her previous works revolu-
tionary art always referred to an art that exposed the semiotic foundation of
symbolic forms, indicating and re-erotizing the sensuous and bodily elements
of language, here revolt is discussed in terms of temporality, invisibility, refusal,
and displacement. This "shifting of the collapse is deeply affecting, moving, not
a jubilation or moment of ecstasy" but "a sign of life nevertheless, a timid prom-
ise, anguished and yet existent."[136]

This new form of art, often in the form of an installation that surrounds and
envelops the experiencer rather than confronting her as a two-dimensional

flat surface, calls on the entire body to participate through sound and smell and sometimes touch as well as vision. It asks the audience/spectator not to confront an object or image but to enter a space "at the borders of the sacred." This art experience is a form of incarnation, but it is one that occurs less through a direct re-erotization of the senses and more through a revitalization of (affective) feeling. The installations include a sense of temporality and narrative; they unfold over time and reference historical events. Their temporality has an added dimension, however, in that they also displace reflection onto our own selves, our narratives as well as our regressions, our progress as well as our disruptions.

It is this psychical aspect of the experience of art that Kristeva seems to want to foreground, for she does not even mention the political context of Haacke and Wilson's installations. Haacke, whose work is explicitly and unapologetically political, foregrounded the collusion between fascism, big business, and art in his winning entry for the 1993 Biennale entitled "Germania," which exposed the Biennale's own origin in Italian fascism. Wilson's installation "Memory/Loss," while not referencing any specific political event, nonetheless confronts the trauma of the contemporary human face to face with phenomena that threaten to erase her memory. The work depicts a man submerged to his chin in sinking ground that also threatens to suck in the onlooker, undergoing a Mongolian water torture that will result in memory loss, to the narration of T. S. Eliot's "The Waste Land," a poem that exposes the sterility of modern Western culture. Kristeva does not offer any explicitly political interpretation of these works, preferring to concentrate on the effects of modernity on the human psyche that can be manifested in a tangible way through the unconscious effects of contemporary art, in particular the installation.

The first form of art I will consider, in order to add to this consideration (while also taking into account, if not foregrounding, the explicitly political content) is the countermonument. In Germany, where this art form began, countermonuments are usually constructed for the purpose of engendering discussion about the dangers of racism and fascism, but they do so in a way that also confronts the dangers of conventional monuments. Like embodiments of cultural mourning, the monument is a visible manifestation of a culture's desire to put a trauma behind it and to commemorate itself, usually in the terms of heroism. However, as Robert Musil points out, "There is nothing in this world so invisible as a monument. They are no doubt erected to be seen—indeed, to attract attention. But at the same time they are impregnated with something that repels attention."[137] A traditional monument to war both

monolithically commemorates the fighters and marks the end of conflict, giving permission to the onlookers to move on with their lives while the memorial does the remembering for them.

By contrast, in Jochen Gerz and Esther Shalev Gerz's very different Monument Against Fascism and War for Peace, installed in 1986 in Harburg, a suburb of Hamburg, the artists constructed a twelve-meter-high column plated with lead accompanied by a steel stylus, so that anyone could inscribe in the soft lead. A plaque that accompanied the monument reads, in several languages:

> We invite the citizens of Harburg, and visitors to the town, to add their names to ours. In doing so, we commit ourselves to remaining vigilant. As more and more names cover this 12m tall lead column, it will gradually be lowered into the ground. One day, it will have disappeared completely, and the site of the Harburg monument against Fascism will be empty. In the end, it is only we ourselves who can rise against injustice.

Over the course of the next seven years, the monument was lowered, in five-foot increments, into the earth. The only thing to remain visible is a plaque marking the spot of what once was there, just as a gravestone marks the end of a human life. The monument literally changed with each visitor. At the same time, it disappeared into a very mundane context, a pedestrian shopping mall where it can easily be overlooked. This countermonument incorporates a sense of time and, by extension, of decay and ruin. It nonetheless retains a material or objective remainder or reminder, though in the form of a fragment. And it includes a conceptual component that suggests the work's meaning but does not claim to render it fully transparent, that cedes the primary voice to the objective remainder and allows it, rather than the artists, to speak to its interlocutors, who must seek it out. Here we see Santner's "it might have been" at work; as Nietzsche writes, "it is an attempt, as it were, *a posteriori* to give oneself a past from which one would like to be descended in opposition to the past from which one is descended."[138]

In *For They Know Not What They Do*, Slavoj Žižek considers the relationship of a culture to its traumatic past in a way that can be applied to the question of countermonuments. He writes, implying a critique of traditional memorials:

> The point is *not* to remember the past trauma as exactly as possible: such "documentation" is a priori false, it transforms the trauma into a neutral, objective fact, whereas the essence of the trauma is precisely that it is too

horrible to be remembered, to be integrated into our symbolic universe. All we have to do is to mark repeatedly the trauma as such, in its very "impossibility," in its non-integrated horror, by means of some "empty" symbolic gesture.[139]

In this quotation we can discern the contrasting logics of mourning and melancholia. The kind of monument that would seek to be perfectly faithful to the past would end up betraying it by integrating it in a false symbolization into which it would disappear. This is the negative counterpoint of Adorno's argument that to seek to represent the emancipation that the beauty of nature signals pictorially will only collapse that promise into the commodity culture that it attempts to resist, a landscape to be purchased and displayed.

That the kind of memory Žižek refers to is allegorical in Kristeva's terms can be seen in the language he uses to describe it. Like Kristeva discussing the beautiful's role in circling around the depressive void, standing in for that which never is, transforming loss in order for the ego to be able to live, Žižek characterizes the task of the Left as that of the drive in Lacanian psychoanalysis: "the compulsion to *encircle*, again and again, the site of the lost Thing, to *mark* it in its very impossibility—as exemplified by the embodiment of the drive in its zero degree, in its most elementary, the *tombstone* which just marks the site of the dead."[140]

Referring to the resistance to a neo-Hegelian conservatism, Žižek writes:

This . . . is the point where the Left must not "give way": it must preserve the traces of all historical traumas, dreams, and catastrophes which the ruling ideology of the "End of History" would prefer to obliterate—it must become itself their living monument, so that as long as the Left is here, these traumas will remain marked. Such an attitude, far from confining the Left within a nostalgic infatuation with the past, is the only possibility for attaining a distance on the present, a distance which will enable us to discern signs of the New.[141]

Leaving history open for renegotiation, this new form of preservation is not monumental in the traditional sense. Rather, these "countermonuments" are allegorical in that they say something other (*allos*) in a public way (*agorein*); they are melancholic in their refusal to leave the past behind, even in the form of a consecrated memory.[142] They strive to achieve the melancholic tension between plenitude and absence, between meaning and nonmeaning, between eternity and time.

Recently, another countermonument of some interest has been erected. Rachel Whiteread's Holocaust Memorial in Vienna was constructed in 2001 after a lengthy design competition and resistance from the public against the design and the implications of the project. Whiteread's monument is the negative form of a library. The concrete structure contains the imprint of rows of books, spines facing in, lining the outer walls. Inscribed around the base are the names of Nazi concentration camps. The work's facade bears a dedication in German, Hebrew, and English to the sixty-five thousand Austrian Jews killed in the Holocaust.

Whiteread has been casting the "negative space" in the interior of closets, under chairs, within bathtubs, and even the insides of entire houses for years. Her sculptures bring to presence the spaces that objects occupy or the traces of space they leave behind. Her countermemorial is arguably the least radical of her works, although it is the most visible. I argue that all of Whiteread's works, not just the explicitly political ones, address the themes of cultural and personal melancholia that we have been considering here. Her work has been described as the engraving of invisibility, the bringing to presence of absence as absence,[143] evoking the abjection of the body turned inside out.

Rosalind Krauss describes Whiteread's work by way of Roland Barthes's description of the photograph as a traumatic death mask, both structured and asymbolic. Barthes writes that in the face of photography, "I have no other resource than this *irony*: to speak of the 'nothing to say.' "[144] Krauss finds the same presence of structure and asymbolia in Whiteread's sculptures, which both signify, in that they cast an actual site, yet work against the universalizing of the cast, whose usual function is a serial run of objects.[145] The cast of the interior of the object gives birth to a singularity that lies somewhere between silence and the universality of the concept. In this sense her work is melancholic, maintaining a tension between opacity and possible meaning, between the articulation and dearticulation of significance. The solidification and objectification of the interior space creates an uncanny experience of what is usually considered off limits, the private, an experience that Whiteread herself describes as akin to "exploring the inside of a body, removing its vital organs."[146] It is also an exploration of the remnants of the symbolic order, of the maternal body, of nature. The work references a loss of language that might lead to a transformation of language, logos, the symbolic. The object speaks—but it speaks the impossible language of the private, the domestic, the feminine. The works *House* and *One Hundred Spaces* evoke the temporality of both memory and imagination; both the constricted past and a future struggling for freedom. Whiteread turns the space of domesticity into a map

of art, that does not simply expose the hidden condition for the possibility of representation (negative space) but transposes it into something crafted, created. Whiteread's work is a perfect example of what Kristeva calls the "second degree thetic," expressing the language of the semiotic from out of the position of the symbolic. The works do not simply commemorate what has always already been there but in a real sense create it, by bringing it into tangible being. The negative space made solid in Whiteread's work brings the hidden semiotic underbelly of symbolic language to the fore in such a way that it becomes not only visible but visibly obtrusive, impossible to ignore and seductively captivating. We recognize and are drawn to this semiotic space without being able to name it, precisely because it silently and invisibly accompanies every aspect of our symbolic life.

CONCLUSION

In this chapter I have suggested that Kristeva, Benjamin, and Adorno's writings on melancholia, allegory, and nature can be fruitfully juxtaposed in order to think an alternative to a paralyzing, leveling malady, whether it be the melancholia of a depressive, the frustration of a political theorist vis-à-vis the hegemony of consumer capitalism, the impasse of a philosopher face to face with the death of god, or a culture pushed to its breaking point. What all of these approaches share is an interest in the work of art as a gesture of resistance to silent acquiescence or asymbolia, a promise that some day, things might be different. The allegorical work of art makes tangible the silent choric interstices of language, the material backbone of the visible.

In *The Sense and Non-Sense of Revolt*, Kristeva emphasizes the dependence of melancholia on the isolation of the death drive. Freud discovered the link between sublimation, which "disentangles the mixed drive," and the extrication of the death drive, which "exposes the ego to melancholia."[147] While this melancholic condition often is linked, as we have seen, with an artistic stance, one must nevertheless caution that such a condition is neither to be intentionally sought nor necessarily desired, for "how does one avoid succumbing to it?"[148]

The provisional answer that Kristeva gives is the sexualization or erotization of the sublimatory activity, the emphasis on the color, texture, and rhythm of language and the use of plastic representation. This sexualized sublimatory activity exposes the speaking subject to the death drive while tempering its aggressive force in a form of spiritual inoculation. This seems to be achieved, Kristeva suggests, by allowing language a broader latitude than it has in

propositional communication, including a consideration of the unrepresentable or ineffable within language.[149] This is a facet of language that is also present in unconscious transference and countertransference in the psychoanalytic situation. Kristeva reminds us that this nonrepresentable "other" of language, with which the speaking subject needs to be reconciled, was called the *logos* for the pre-Socratics and Being for later philosophers.[150] If being can be sexualized in language, it is because, as Freud showed, the fate of meaning is linked to the "destiny of negativity."[151] It remains to be seen what the contours of this negativity will be, and it is to negativity that we will turn in the next chapter.

2
KENOTIC ART
NEGATIVITY, ICONOCLASM, INSCRIPTION

The depressive phase thus effects a displacement of sexual auto-erotism onto an auto-erotism of thought: mourning conditions sublimation. Have we really taken account of the degree to which our languages, called maternal, are of a double sort, both mourning and melancholia? That we speak out of depression as others dance on a volcano? A body leaves me: its tactile warmth, its music that charms my ear, the view given to me by its head and its face are lost. For the "capital" disappearance I substitute a capital incarnation? The one that keeps me alive, on condition that I represent, ceaselessly, never enough, indefinitely, but what? A body that has left me? A lost head?

— Julia Kristeva, *The Severed Head*

TOWARD THE END OF *STRANGERS TO OURSELVES*, KRISTEVA extends Hegel's historical dialectic to include the emergence of Freudian psychoanalysis, even tracing Freud's discovery of the unconscious to the preparatory historical stage described in Hegel's account of the restless and productive tarrying of Spirit with its negative Other.[1] Drawing a line from Kant to Herder to Hegel to Freud, Kristeva then traces her own thought of negativity as the driving dynamic of human psychic development through its inception in German idealist philosophy and Freudian psychoanalysis.[2]

This extension of the historical dialectic past Hegel and past the unity of substance and subject in Absolute Spirit is paralleled, I argue, in Kristeva's articulation of a spiritually essential art beyond religion and philosophy, subverting the Hegelian claim that art in its highest vocation is for us a thing of the past. The dissolution or inadequacy of art for our spiritual needs, in Hegel's account, has its beginning in romanticism, when the commensuration of form and content characteristic of classical art was ruptured through Spirit's self-actualization. Kristeva argues that what distinguishes the art of the late twentieth and early twenty-first century from the art that preceded it, even from surrealism, is its foregrounding of the semiotic unconscious. Kristeva's philosophy of art is at least in part a phenomenology of the unconscious or the bodily repressed insofar as it momentarily manifests itself in certain forms of

art. Modern and postmodern art and literature can become transformational signifying practices that work against philosophical systems of absolute knowledge and counter to the artistic metaphysics of representation, precisely because they lie at the borderline between soma and psyche.

I will argue in this chapter that Kristeva's concept of negativity, articulated most extensively in *Revolution in Poetic Language,* can be productively read alongside Theodor Adorno's articulation of nonidentical mimesis, a form of mimesis that he claims can remain faithful to the ban on graven images.[3] A connection between negativity/negation and iconoclasm is suggested in Adorno's claim that the ban on positive representations of utopia leads to the possibility of exposing the injustices of modern life, just as negative expression in psychoanalysis can lead to a revelation of repressed content.[4] Kristeva's account of iconoclasm also engages with the Freudian theory of negation, which, she argues, fundamentally transforms Hegelian negativity; in this way, the ban on graven images emerges as a way of blocking the spectacle. In saying "no" to images, that is, Kristevan iconoclasm affirms the image/icon in a more revolutionary sense.

Adorno and Kristeva agree that iconoclasm must be understood as a ban on representation. Whereas Adorno's iconoclasm led him to embrace art movements that eschew figuration altogether, in particular abstract expressionism, championing an unintelligibility that shatters traditional hierarchies of understanding, Kristeva articulates an iconoclasm that inscribes the figurative rather than representing it. To understand this distinction concretely and illustrate it, I will consider Walter Benjamin's and Kristeva's writings on photography and film along with some examples of contemporary art. A mimesis that respects the ban on graven images moves art history beyond the systematic movement of the Hegelian dialectic that culminates in the Absolute, extending it in the direction of dynamic differentiation without resolution, as well as into the unknown of the unconscious, decentering the trajectory of self-consciousness.

Hegelian Aesthetics

For Hegel, the philosophy of art coincides with the investigation of the concept of beauty, both its meaning and its progressive instantiation in history. Hegel's conception of beauty, in turn, rests on the image insofar as it coincides with the Idea; that is, beauty represents the ideal, bringing it to presence in sensuous form. Art gathers together and harmonizes the two sides of concept and sensuous material, giving itself the task of presenting ideal content to

immediate perception in a sensuous shape, such that the two "appear fused into one."[5] For this reason, Hegel claims that art must be concrete, that is, equally subjective and objective, simultaneously spiritual (and thus universal) and at the same time fully actualized and particular.[6] Giving an analogy to conceptions of the divine, Hegel claims that a purely abstract concept of God is not fully actualized because it is one-sided. Jews and Turks, he writes in his *Lectures on Aesthetics*, "cannot represent their God in the positive way that Christians have" because of the ban on graven images in Judaism and Islam. The Christian God, by contrast, is "set forth in his truth," because the incarnated Christ, like art, represents "essentiality and universality and particularization together with their reconciled unity."[7] Art proper must manifest such embodied ideality.

It is thus ancient Greek art that marks the apotheosis of visual art according to Hegel's reading. Art's aim is, above all, to "make the Divine the center of its representations," and Greek religion presents a complete commensurability between the sensuous and the ideal, portrayed most strikingly in sculpture. The incarnation of God in Christ does this too, initially, and this embodiment has been represented in early Christian art, but the truth of Christianity in its fully actualized form cannot be contained in a representation; it bursts the bounds of sensuous encapsulation. Poetic lyric alone could "strike the note of praise of [the divine's] power and his glory,"[8] and religious philosophical texts might do this even better once the constraints of sensuous form, having been fully exhausted, are shed. For this reason, art, "considered in its highest vocation," is, for us, a thing of the past.[9] It has lost its genuine truth and life and has conceded its place to ideas, which require no sensuous presentation.

Art succeeds insofar as it establishes a complete reciprocal interpenetration of meaning and expression, in Hegel's view. Preclassical (that is, pre-Greek) art, which Hegel calls symbolic art and which he associates with "the East," presents corporeal and predominantly natural forms in order to convey meanings that are indeterminately spiritual. Here Hegel discerns a manifest incompatibility of content and form in the opposite direction, where ideal content remains either implicit (in primitive totems, for example) or unintelligible (as in the case of the sublime).[10] Classical art is the consummation of the realm of beauty because it idealizes the natural and transforms it into an "adequate embodiment of spirit's own substantial individuality."[11] True art must be representational, on Hegel's view, because in order for the ideal to correspond with external reality, the human being must appear to be completely at home in the world, free in relation to nature, and living harmoniously in

all relationships. For this to be possible, "the representation must be drawn up in complete fidelity to nature,"[12] with a "fullness of detail,"[13] while presenting "an essential harmony into which . . . a great deal of contingency enters . . . yet without the loss of the fundamental identity" of subject and environment.[14]

Hegel considered romantic art to be so spiritually elevated that beauty, as the perfect correspondence between external form (expression) and internal content (meaning), could no longer be "the ultimate thing."[15] Romantic art comes at a time when Spirit "knows that its truth does not consist in its immersion in corporeality" and thus withdraws from the external "into its own intimacy with itself," judging nature to be an inadequate existence to itself.[16]

CONTEMPORARY ART'S MOVE TO ICONOCLASM

The art historian Donald Kuspit has described, over a series of essays, the progression from modern to postmodern art in a way that, when pieced together, provides a contemporary version of Hegel's analysis of the history of art. Kuspit argues that the initial stage of modern art was marked by the movement to abstraction, resulting in a formalism in which, as in Hegel's account of symbolic art, the ideal content of avant-garde art was not yet adequate to its form. This resulted in a kind of mysticism in which the meaning of abstract avant-garde art clearly pointed beyond its form to a transcendent meaning, yet without any determination. Such art, according to Kuspit, displays a "will to unintelligibility" or to enigma. Though early avant-garde art clearly aspired to a critique of society, its signification was ambiguous and unclear. Kuspit clearly implies that this interpretation might also characterize Adorno's privileging of abstract art.[17]

In the 1980s, by contrast, according to Kuspit's analysis, art and society were reconciled and subsequently embraced each other. In this period, avant-garde art cynically gave up pretensions to idealism and promoted itself as a commodity.[18] Finally, in the last part of the twentieth century and perhaps leading into the twenty-first century (though the essay was published before the beginning of the new century), the content of avant-garde art began to transcend its form, giving way to a conceptualism that disdained material form, where the message, which Kuspit associates mainly with feminism and multiculturalism, overshadowed sensuousness as well as emotion or affect. In this way later avant-garde art moved toward the concept purified of the corporeal, a purity Kuspit refers to as contemporary art's iconoclasm.[19]

Both Adorno and Kristeva express versions of iconoclasm in their consideration of contemporary art. While arguing for art's political significance, they

also both resist the Hegelian idea that it is art's role to be morally didactic. Art that seeks to be activist, either in expressing an explicit political view or cloaking itself in a moral cause, seems to apologize or take on a defensive stance for existing as a "merely" aesthetic phenomenon. Worse, it risks becoming embroiled in or taking on the characteristics of the very order that it seeks to criticize. Art's role is to provide an alternative to instrumental reason, commodity culture, and the spectacle in order to provide meaningful social resistance or intellectual challenge; it is not to serve already existing goals, however worthy. Art opens up and aesthetically embodies paths of desire that are not inscribed in advance of its creation. If art has a political significance, that significance does not consist in being able to present in a different manner ideas that could be more clearly expressed in directly conceptual terms. Rather, art is a means of making conscious those myriad conscious and unconscious imaginary ways in which we negotiate the systems of meaning of our world—law, religion, family, morality, education, culture—and in the process open up the realization that they are not unconditionally or exhaustively constitutive of the human subject.[20] This is to emphasize that these systems may be criticized and, perhaps indirectly, changed. It is art's role to estrange us from familiar ways of seeing and organizing the world. This tarrying with estrangement can be related to what Keats called the "negative capability" of the poet, who cultivates the attitude of allowing herself to remain in uncertainty without immediately reaching for a readymade solution.[21]

Adorno called this possibility art's "negativity" and argued that this negativity was social in character and tied to the possibility of providing a resistance to the social misery that it makes present to us. As Diana Coole writes, the critical function of art that Adorno invokes by calling it "negativity" performs a political act: "it destabilizes illusions of perfection, presence and permanence by associating the positive with petrified and illegitimate structures of power."[22] Kristeva's conception of negativity can be tied to Adorno's and to Hegel's in this evocation of negativity, a term she especially uses in her earliest work on poetic language. Yet she also wants to engage with the Freudian sense of negation, in particular its role in the shift from the expression of the drives to signification, both in order to foreground the role of the body and the unconscious within aesthetics and to complicate the Freudian understanding of art as the purely individual product of sublimation or avoidance of suffering. Her version of iconoclasm, which privileges an art that inscribes rather than represents and that portrays an economy of interrelated similitudes rather than reproducing or miming a figure, complicates and attempts to avoid the potential pitfalls of both Hegelian idealism and Adorno's arguably mystical materialism.

ADORNO'S ICONOCLASM

In *Negative Dialectics* Adorno resuscitates the ban on graven images in a diatribe against the contemporary political realization of materialist philosophy. Materialism has "debased itself" in its rejection of the "apocryphal part of materialism," which is one of "high philosophy," exemplified in the texts of Kafka and Beckett.[23] Materialism thereby "comes to be the very relapse into barbarism which it was supposed to prevent."[24] In its "expectation of imminent revolution," the critics of high culture sought to "liquidate philosophy."[25] It becomes one of critical theory's most urgent tasks, then, to combat this decline, this "aesthetic defectiveness."

Adorno's elitism has been much deplored. Certainly, in his critique of the culture industry Adorno can be harsh and dismissive. However, arguably Adorno's message is more positive than negative. Rather than simply dismissing the contemporary obsession with jazz music and the cinema, Adorno is pointing to a loss in culture itself, that is, a refusal to hear the voice of intellectualism within aesthetics. Adorno points out that it is not solely the left that has turned a deaf ear on the high theory of certain philosophers and artists but that in doing so it repeats the disdain of bourgeois society that preceded it.

Materialism's error, according to Adorno, lies in its disregard for consciousness and epistemology. Matter without consciousness would have no dialectical movement to it. Epistemology's revenge, he writes, "has been the image doctrine." Images purport to mirror matter. Thought, by contrast, "is not an image of the thing" but aims at the thing itself.[26] Image theory "denies the spontaneity of the subject": "If the subject is bound to mulishly mirror the object—necessarily missing the object, which only opens itself to the subjective surplus in the thought—the result is the unpeaceful spiritual silence of integral administration."[27]

Only a resolutely reified consciousness would believe, Adorno writes, "that it possesses photographs of objectivity." The doctrine of the image fantasizes the possibility of immediately reproducing what it captures on film or on the canvas, moving toward the "disfigurement" of art characteristic of the Eastern bloc.[28] Theory, by contrast, conveys not immediacy, not a replica of the object, but rather the conception inherent in it. Representational thinking is thinking without reflection, nondialectical thinking.[29]

In *Aesthetic Theory* Adorno nonetheless advocates a form of mimesis, one that he calls a "nonconceptual affinity of the subjectively produced with its unposited other."[30] Art reflects the social order out of which it emerges, but it does so by opening up areas that exceed what the order itself is prepared to

disclose, and therefore it does not "mulishly mirror" its object but allows the object to speak by virtue of the very "subjective surplus" in its approach. Art accomplishes this through a method of negation that allows for the return of repressed content, speaking in a kind of sensuous code to which there is no definitive conceptual translating key.

Art that resolutely tries to mirror social problems sabotages its own project. Most strikingly, the Marxist tradition has negated its critique by embracing a crude imagistic realism. For this reason, Adorno champions nonrepresentational art:

> The materialist longing to grasp the thing aims at the opposite: it is only in the absence of images that the full object could be conceived. Such absence concurs with the theological ban on images. Materialism brought that ban into secular form by not permitting Utopia to be positively pictured; this is the substance of its negativity. At its most materialistic, materialism comes to agree with theology. Its great desire would be the resurrection of the flesh, a desire utterly foreign to idealism, the realm of the absolute spirit.[31]

Unlike vulgar materialism (sometimes exemplified in Adorno's texts by the work of Brecht or Sartre), the materialist ban on images for which Adorno calls registers thought without the "image character of consciousness"; such a process can be called demythologization.[32] Unlike idealism, which aims for the sublation of the sensuous in absolute spirit, a materialism that embraces theory and not the image invokes the resurrection of the flesh.[33]

KRISTEVA ON NEGATIVITY, ICONOCLASM, AND MIMESIS

In her early writings, Kristeva articulates the pivotal distinction between the semiotic and the symbolic and the negativity of their relationship specifically around a reading of Hegel. In particular, Kristeva is interested in Hegel's conception of negation and its possible relation to Freud's theory of what she calls "rejection," based on Freud's notions of *Verwerfung* and *Ausstossung* outlined in his essay "Negation" ("Verneinung," 1923). I will map the parallels Kristeva draws between the two thinkers in an attempt to illuminate further the dialectical lineage between Hegel and Freud mentioned at the beginning of this chapter.

In *Revolution in Poetic Language*, Kristeva is as concerned with complicating Husserl and Frege's philosophical views on language as she is with questioning

the post-Freudian psychoanalytic view of the repression of prelinguistic bodily experiences upon the subject's entrance into language. Freud's essay "Negation" elucidates a clear connection between such prelinguistic bodily experiences and the inception of logical judgment, or what he calls "the origin of an intellectual function from the interplay of the primary instinctual impulses."[34] Freud begins the essay by noting that during analysis, a patient's free association may make it possible for the content of a repressed image or idea to enter consciousness by means of negation. For example, the psychoanalyst may ask the patient what he or she would consider to be the most *un*likely imaginable outcome or interpretation of a given situation, and, if the patient, unaware, falls into the trap the analyst has laid and says what he or she thinks is most unimaginable, Freud asserts that he or she almost always makes the correct identification of the true outcome or interpretation. Likewise, in recounting a dream a patient may assert the person with whom he or she had a sexual encounter was *not* his or her mother, and Freud indicates that this claim is almost certainly the only way in which the repressed dream image of the mother can make its way into conscious thought.[35] In this moment of expression, however, only one part of the repression is freed; the image or idea enters consciousness. Until the patient recognizes the truth of the idea or image and accepts it intellectually as his or her own, the memory will not be fully "negated." Jean Hyppolite interprets this two-part process of undoing repression as a "double negation," linking it to Hegel's use of *Aufhebung*.[36]

What is significant about this process of double negation is a remark that Freud makes almost at the end of the essay, where he posits that negation not only provides a means of reversing repression and allowing a content to make its way into conscious thought but that the process of negation may be at the inception of the break between affect and intellect, at the origin of logical judgment or the very intellectual function itself.[37] Negation would, then, signify, from its inception, the psyche's process of translating affective content into thought. As Hyppolite puts it, negation would itself be the generator of thought.

The earliest form of "judgment," according to Freud, is a continuation of the original process by which the ego, in terms of the oldest, oral instinctual impulses, either takes things into itself ("I should like to eat this") or expels them ("I should like to spit this out").[38] This is what Freud calls the "judgment of attribution," and it depends on pleasurable or unpleasurable perception: "this is good" or "this is bad."[39] The second level of judgment, the intellectual level, involves an absence rather than a presence of a sensation. Intellectual judgment marks an absence, indicates "a representation that no longer has an

object that corresponds to it." In fact, "what is at stake here," Hyppolite writes, "is the genesis of the outside and of the inside."[40] Freud names what emerges from this inside/outside distinction a "judgment of existence," one that distinguishes between the representation within the subject and the existence or nonexistence of an object outside of it. Intellectual thought is dependent on the mind's capacity to reproduce a perceived thing in the absence of the external object, independently of whether it is perceived to be good or bad.

In *Revolution in Poetic Language* Kristeva identifies the origin of her concept of negativity as Hegelian. However, in connecting it with Freud's concept of negation—the bodily origin of which she names, in its function as conduit between somatic and linguistic judgment, according to the usual French translation of *Ausstossung*, or "rejection"—Kristeva is quick to qualify that the word "negativity," as opposed to Hegelian "negation," does not signify a negation of negation, or *Aufhebung*, that would result in the restoration of unity. Rather, she characterizes the negativity that she is exploring in this book, namely, the negativity of aesthetic productions, as a "reversed reactivation of the contradiction that instituted this very position."[41] The distinction between the "reversed reactivation" of a contradiction, on the one hand, and the "double negation" of an original thesis, on the other, is key to understanding the way in which Kristeva's dialectic of the history of art differs from Hegel's. This distinction in turn clarifies how the extension of the historical dialectic to Freud retroactively changes the very nature of the Hegelian dialectic of consciousness and, in particular, the Hegelian account of the end of art.

Kristeva calls negativity "the fourth term of the dialectic."[42] She approves of Hegelian logic in its linkage of the real with the conceptual, the objective with the subjective, and in that it is both concrete and dynamic. However, it is with Freud's discovery of the unconscious that Hegel's logic can become materialist, when "one dares think negativity as the very movement of heterogeneous matter, inseparable from its differentiation's symbolic function."[43] By materialism Kristeva refers to the body and the drives (the materiality of the subject) rather than exclusively to Marx's dialectical materialism. She criticizes Marx and post-Hegelian materialist theory in general for essentially eliminating Hegel's concept of negativity (one that inheres both in Subject and Substance) and conceiving of process primarily within external material conditions. Her interest in the "object" lies in the materiality of language, its shape, rhythm, and sound.

Kristeva identifies "Hegelian negativity," as opposed to negation, as "the indissoluble relation between an 'ineffable' mobility and its 'particular determination.'"[44] She chooses negativity to signify the process of becoming of the

"subject-in-process/on trial"—using the double meaning of Kafka's *Prozess* to indicate parallels between the development of the subject and of the text—because it constitutes the logical impetus behind both negation and the negation of negation (double negation) without being reducible to either one of these. Rather, "negativity is the liquefying and dissolving agent that does not destroy but rather reactivates new organizations."[45] Negativity, for Kristeva—following Freud, but going beyond what he explicitly says—lies somewhere between the prelinguistic bodily organization of drives and the symbolic constitution of language proper and the subject. It is at the crossroads, as Kristeva writes, of the biological and the social order.[46]

Kristeva's primary interest lies not in the association of ingestion with affirmation and expectoration with negation but rather in what she calls the "'second' return of instinctual functioning *within* the symbolic."[47] Whereas Freud's analysis of negation stops with the postulation that rejection is at the inception of intellectual judgment, Kristeva asserts that in poetic language negativity continues to operate within symbolic language after the "thetic position" of the subject within the symbolic order has been firmly established. Rather than a negation of a negation, the operation of negativity, which she also calls an "explosion of the semiotic within the symbolic,"[48] would be, instead, a "transgression of position, a reversed reactivation of the contradiction that instituted this very position."[49] The contradiction that would be reactivated in the aesthetic judgment, in particular that of specifically modern and postmodern art and literature, would be the bodily origin of judgment itself, this time expressed through rhythm, musical intonation, and other parts of every linguistic act that are meaningful yet do not represent or signify anything. These aspects of language make up the semiotic chora in its very opposition to yet coexistence within the representational or signifying power of language. Although these elements of language—which could be visual as well as aural, in the case of painting or other visual art—are reactivated and even foregrounded in poetic or artistic expression, nonetheless the thetic, or subject position within language, remains firm. Another way of thinking of this relationship between language and the body is as the return of the repressed under the symbol of negation.

In such a process as Kristeva visualizes it within the artwork, "rejection *re*-constitutes real objects, 'creates' new ones, reinvents the real, and re-symbolizes it,"[50] prefiguring a parallel she later draws between revolutionary artworks and psychoanalytic dialogue. The key difference between the work of rejection within the movement of analysis and within aesthetic production is that while analysis ideally effects the passage of the repressed into the symbolic

function, rejection in artworks "marks signifying material with the repressed," arranging the repressed element in a different way and taking up a position that is "positivized and erotized in a language that . . . is organized into prosody or rhythmic timbres."[51]

This relationship within poetic language between the intentional, expressed meaning of the words used and their accompanying affective tones, rhythms, and musicality can be connected to the Hegelian identification of the signifying consciousness with a conceptual order that exceeds it. Negativity designates a process in language that binds the human being "to the laws of objective struggles in nature and society,"[52] to that dimension of existence that exceeds the subject both as a conscious and as a material presence. Unlike the Hegelian dialectic, however, whose "ideational closure . . . seems to consist in its inability to posit negativity as anything but a repetition of ideational unity in itself,"[53] the dialectic in poetic language between the symbolic and the semiotic turns the One back upon itself, shattering its unity. The reintroduction of the symbol of negation into poetic language does not lead to an intellectual acceptance of the repressed, which would amount to an *Aufhebung* or cancellation of the material, but instead constitutes a "post-symbolic . . . hallmarking of the material that remained intact during first symbolization."[54] In this process the "materiality" of the sign, which was initially expelled, is brought out of the unconscious into language and consciousness not as a form of intellection but as a form of eroticization, an investment of drives organized into rhythm and timbre. Kristeva argues that such a negativity, because of its nonsubjective origin, cannot be located in a singular ego.[55]

Negativity recalls the moment of the generation of meaning without being reducible to a specific signification. Its genesis does not pave the way for the reemergence and eventual acceptance of a repressed memory but rather recuperates "lost time" in such a way that any reader, or spectator, can recognize himself or herself in it. This recuperation might be compared to a kind of transference of a painful memory into an intermediary space such that an immediate interiority can be mediately directed toward other people, stabilizing the identity of the artist and of the artwork.

The recuperation of lost time might be connected to the idea of a ban on graven images understood in a specific, nonreligious sense, in several ways. In particular, it is crucial that negativity points to some element of language or expression that is in principle unrepresentable, or not articulable in symbolic terms,[56] yet that itself provides the condition of possibility for separation that allows for language and representation to come into being. I will trace Kristeva's reading of this historical ban in its connection to purification rites as well

as in terms of her specific interpretation of the meaning of mimesis. Finally, I will consider the ban on graven images in terms of a repetition oriented toward the future, one that allows for an event to be repeated therapeutically, that is, not in an identical, pathological way that would disable and paralyze the experiencer but in such a way that she is dynamically freed, that psychic rigidities may be relaxed and reoriented. Kristeva calls this literary or artistic process a "sublimating gesture of reshaping and reconstructing" oneself,[57] a process that also takes place as working through in psychoanalysis, through the mimetic identification (through transference and countertransference) of the analyst and the analysand.

Kristeva first mentions the ban on graven images in *Powers of Horror*, as part of a historical overview of purification rites in several religious and literary discourses. Considering the connection of the sacred with sacrifice in both psychoanalysis and structural anthropology, Kristeva notes the relative absence of discussion of the second of the two taboos of totemism: murder and incest. Kristeva posits that the sacred is a two-sided formation founded, on the one hand, by murder and the social bond constituted on the basis of atonement for murder,[58] and, on the other hand, by incest, by "another aspect, like a lining, more secret still and invisible, non-representable, oriented toward those uncertain spaces of unstable identity, toward the fragility—both threatening and fusional—of the archaic dyad, toward the non-separation of subject/object, on which language has no hold but one woven of fright and repulsion?"[59]

The archaic dyad to which Kristeva refers is the mother-child bond prior to the resolution of the Oedipal crisis, the acquisition of language, and the separation of subject and object, the same archaic bond that is at the origin of the semiotic chora in language.[60] Kristeva's interest in *Powers of Horror* is in the ways that societies "code" themselves symbolically in order to temper the subject's confrontation with the feminine and reinforce the necessary separation from the mother.[61] Here we are again confronted with the genesis of the distinction between inside and outside that gives rise to judgment, in its original signification in German as *Ur-teil*, scission, or separation. Naming this border gives rise to language,[62] Kristeva argues, just as Freud had argued that the inception between inside and outside is at the origin of intellectual judgment.

In Judaism, Kristeva writes, defilement gets progressively shifted from the material to the symbolic register, as prohibitions dealing with food and the body give way to prohibitions on pronouncing the name of the divine and making images of the divine: "Defilement will now be that which impinges on symbolic oneness, that is, sham, substitutions, doubles, idols."[63] In the name of the "I" of the Lord, who speaks through the intermediary of Moses,

moral prohibitions that operate "according to the same logic of separation" between the material and the symbolic, namely, those concerning justice, honesty, and truth, also follow.[64] The dietary abomination of earlier texts gets transformed into what Kristeva calls "an inseparable lining, an inherence in the contract or the symbolic condition"; this in turn forms the material condition for symbolic prohibition. Kristeva argues that divine speech in the Old Testament contains "coiled within it" a "demoniacal reproduction of the speaking being" that the compact with God both brings into being and banishes.[65] This demoniacal reproduction would be a fantasized return to the mother as both temptation and threat, the nether side of the ban on graven images.

In another part of *Powers of Horror*, Kristeva calls this preverbal, presymbolic lining "a 'beginning' preceding the word."[66] Returning to the concept of negation, she writes that the naming of this beginning, in which there is as yet no clear distinction between inside and outside, would amount to the introduction of language.[67] Part of the impetus for poetic language is that it seeks a "reconciliation with what murder as well as names were separated from. It would be an attempt to symbolize the 'beginning' "[68] without thereby banishing it.

Jean-Joseph Goux traces a similar iconoclasm within the Greek and Roman tradition with reference to the goddess Hestia, who, unlike other pagan gods, was not considered to be representable. Possessing the sole temple without images, Hestia existed alongside a whole pantheon of gods, the proliferation of whose images otherwise suggests a completely iconophilic culture.[69] Goux writes that Hestia is accorded a primacy in time, place, and in the order of ritual and notes that "what seems to be at stake is society's time," unified around a center. He goes on to demonstrate the connection between the ban on representation and Hestia's virginity and ultimately speculates that there is a link "between the prohibition of any 'incestuous' tendency, including the adoration of a mother goddess of fertility, and the radical proscription of representation." *All* images, Goux suggests, and all imagination lead back to a desire for the mother, "not so much as a real figure as an unconscious field of meanings."[70] As the inviolable at the root of the sacred, Hestia marks the inception of the distinction between nature and culture. The ban on images of the divine and the institution of language and culture involves the abandonment of the fantasy of fusion with the mother and the inception of subjectivity and symbolic life.

One might worry, given Kristeva's early and enduring emphasis on the neglected semiotic (and maternal) aspect of language, that she would envision therapeutic art as a kind of return to a primal, material, nonsignifying poetry

of tones and rhythms. However, as she insists in *Revolution in Poetic Language*, there can be no return, either to a preindividuated fusion with the mother or to a pre-thetic stage of language. To insist on the possibility of a pure experience of the semiotic would be to fetishize an "unsayable" without limit.[71] In respecting the ban on graven images, Kristeva upholds the symbolic pact that would keep the maternal abject at bay. The ban on graven images contrasts with or staves off not only the impure but also any religious tradition that would allow for the symbolic representation of the divine. Although she discusses Christian art, as we will shortly see, she embraces the tradition of iconography in its proximity to some contemporary nonrepresentational art, clearly resisting the iconophilic tradition. What she calls repetition and eventually links to Nietzsche's eternal recurrence is a return to the semiotic *from within the symbolic* that both recuperates *and* pushes its symbolic signification to its very limits, straining it almost to its breaking point. As such, there is a possibility, indeed a need, for the semiotic to return to interrogate symbolic formations, albeit only in the indeterminate guise of its formation through the negative.[72]

What would it mean, then, to seek reconciliation with the origin, to attempt to do justice to the beginning without occluding it, to "represent" Hestia? In *New Maladies of the Soul*, Kristeva mentions in passing that the Biblical prohibition on representation applies primarily to the imagistic representation of god's love, which is felt but cannot be sensuously presented. She associates the ban on representation with the "zero-degree of symbol formation," the necessary precondition for the Oedipal complex that gives rise to language and subjectivity.[73]

The search for a nonrepresentational origin of symbolic life leads to the psychoanalytic identification of the "imaginary father of individual prehistory" mentioned by Freud in *The Ego and the Id*. According to Kristeva's analysis in *Tales of Love* of this preoedipal father of individual prehistory, the imaginary father is the guarantor of identity, the bridge by which the child succeeds in leaving behind its fusion with the mother and moving toward an identification with the formal paternal function associated with language and law. What allows for this move is the child's recognition of the desire of the mother as extending beyond the mother-child fusion.

Unlike either the mother, whose love and care threaten to engulf the child, and the prohibitive father of law, the loving "father of individual prehistory" (identification with whom Freud refers to as "primary") points toward a space of meaning for the individual separate from the mother yet preserving the affective and imaginary qualities repudiated by the symbolic order in its most

formal sense. Kristeva refers to this loving identification as "the very space of metaphorical shifting," condensing semantic features and nonrepresentational semiotic drive heterogeneity.[74] This semantic space shares elements of both the maternal and the paternal realms without being reducible to either one. Freud calls this form of identification "immediate" and "previous to any concentration on any object whatsoever"[75] yet nonetheless "always already within the symbolic orbit, under the sway of language."[76] Kristeva identifies the loving father with the desire of the mother, which points the child to a realm beyond her sway while simultaneously bringing him to the realization that he cannot be everything for her (and vice versa).

In *New Maladies of the Soul*, Kristeva calls the imaginary father a "ghostly yet secure presence of the father before [subjects] become aware of any oedipal hold on the father's love or on love for him."[77] Though this father may only exist in a hallucinatory or imaginary fashion, he nonetheless is "the keystone of the capacity to sublimate, especially through art."[78] The imaginary father of individual prehistory thus functions precisely in the way that Hestia does. Neither Hestia nor the imaginary father can be represented, though they guarantee the possibility of representation. Both are uncertainly or at least dually gendered, possessing the qualities of mother and father.[79] Both indicate the semiotic, but only from within the framework of the symbolic. Hestia and the imaginary father subtend the capacity to sublimate and occasionally punctuate, and thus have the potential to modify, the symbolic order.

In *Crisis of the (European) Subject* and *The Severed Head*, Kristeva explores iconoclasm through a contrast of the Catholic and Orthodox traditions of Christianity in Europe. Here Kristeva compares the tradition of making images of the divine family and of biblical stories, as it flourished in Catholicism, with the Orthodox icon of Byzantium. One of the causes of the split between the Eastern Orthodox and the Roman Catholic Church was the perception by the former that the latter worshiped idols. Kristeva contrasts the image or representation of the divine (Christ and Mary), as it flourished in Catholic art, with the Orthodox icon of Byzantium. She focuses on the peculiar brand of iconoclasm practiced by the Orthodox church, which functioned as the equivalent of negation in that it allowed for an imaginary element to appear that would otherwise remain hidden.

Following Marie-José Mondzain,[80] Kristeva argues that the peculiar iconoclastic theory of the Orthodox patriarch Nicephorus at the end of the ninth century negotiated an economy of divine presence that inscribed the appearance of (divine) Being as a sensible trace[81] rather than directly representing it.[82] The polysemic term "economy," on this reading, refers, on different orders of

similitude, to both the incarnation, or consubstantiation of God the father (through the body of Mary) in his son who is his image, and the figurative tradition of representing the divine in icons. Kristeva points out that the word "icon," *eikon* in Greek, is a homophone of economy, or *oiekonomia*, and that the economy of Nicephorus encompasses both divine mystery and its figurative potentiality. Orthodox iconography, on this argument, respects the ban on direct images of the divine while nonetheless preserving the traditionally representational relationships between concept, material body, and spirit. This "double articulation," according to Kristeva, allowed for a simultaneous preservation of the enigma of the divine in its incarnation and the possibility of portraying this mystery through iconography. The orthodox icon emphasizes difference and identity rather than autonomy and equality, emphasizing the fullness of each person in the polyphony of her identifications. Orthodox art explores both suffering and mercy, disappearance and reappearance.[83]

In the catalogue for *The Severed Head* Kristeva argues that the virgin Mary, too, is implicated in the authorization of the Orthodox Byzantine icon, specifically in the experience of viewing the iconic image, which refers to nothing external but instead to the passage between the orders of the invisible and the visible. Kristeva maintains that this passage between invisibility and visibility parallels the conception (in both senses) of Christ as God's incarnation through Mary's divine impregnation. The economy of the icon embodies the entire chain by which God is incarnated through the body of Mary, a process that allows the divine to be "dispensed into history" by entering into the flesh and into the visible. Iconographic representation is not mimesis in the traditional sense, on this argument, because it takes account both of birth through the maternal body and the void (the kenosis, or "self-emptying," of the incarnation). The void is thus inscribed along with the divine image, giving it birth in the visible. The void itself, she argues, "is nothing other than the sign of the sacrificial cut," the invisible divine sacrificing itself to give birth to the visible.[84] Kristeva adds to Mondzain's analysis by reading the cut as the severance from the mother that allows for the emergence of representation in image and in symbol. She further links this cut to representations of the severed head in the history of art.

The iconic tradition is related to accounts of the so-called mandylion of Abgar, a piece of cloth upon which the face of Jesus was said to be imprinted. Unlike the shroud of Turin, the mandylion's imprint is of a face, not an entire body. Tradition has it that the mandylion was sent by Jesus in a letter to King Abgar of Edessa in response to a request for healing. The important facet of the mandylion that Kristeva emphasizes, following Nicephorus's argument, is

that it is an imprint or indication rather than a representation of Christ's face. Nicephorus defined mimesis as an inscription of the divine image rather than an imitation or circumscription of it. The inscription limits the image to a sensible trace.

By contrast, the representational tradition of *figura*, the prophetic announcement of the coming of Jesus, as described by Erich Auerbach, supports the growth of the economy of representation: the sacrifice of Isaac prefigures that of Christ, Adam's fall prefigures Christ's sacrifice of himself for all sinners, and so on. Such a conception of figuration sees a continuity in the Judaic and Christian traditions as well as a continuity between the unpresentable nature of God and his figuration in the material presence of Christ.[85] Representation can be associated with mimesis in the traditional sense of copying or circumscribing and lends itself to a continuing tradition of iconophilia. This version of mimesis lends itself to the growth of a representational continuum where the invisible economy of the icon is replaced by a network of signs of prefiguration. Every event of the tradition is rendered visible in its role as the herald of the next, such that no absence or void remains. Kristeva discusses this separation between economy and figure as the determination of two distinct destinies for representation in the West.[86] Figure, as opposed to the icon, delineates an interpretive system in which "the Risen One accomplishes, increases, and exceeds the work of his Precursor" according to the logic of the Hegelian *Aufhebung*.[87]

The word *figure*, which in French signifies "the face" in addition to its usual sense of "plastic form," comes from the root *figura*, a word that has connotations of plasticity and malleability of not just form but also substance. Accordingly, "figure" can also substitute for "metaphor" or "allegory" but conveys specifically the "corporal action of the real being."[88] Despite the active connotations of the term, however, "figurative logic does not in the least become a historical *process* in the modern sense of the term" (Kristeva seems to have Hegel in mind here) but rather "confers an element of veiled eternity to each even, which remains isolated, fragmentary."[89] Figurism "charges all forms with history and with actual bodies, and, inversely, it incarnates the experience of history and bodies into forms,"[90] allowing for the momentary revival of ancient stories and images in the manner Kristeva herself enacts in this exhibition and its catalogue.

Kristeva considers the gradual introduction of the term *visage* to mean "face" in French, a usage that did not entirely usurp but nonetheless rendered superfluous the older word "figure." *Visage*, from *vis-* or "vision," indicates the corporeal specificity of the head (and its "gateways to the soul," the eyes) as

opposed to *figure*, which can also designate the (appearance of the) entire body. Kristeva speculates that it was Diderot who inscribed the "prophetic latency" of the word *figure* into the word *visage*—perhaps somewhat in the way he inscribes the foreigner or the mad nephew into the rational man of the Enlightenment[91]—through his defense of a style of painting that neither copies nor mimics but rather exaggerates, weakens, or corrects its model.[92]

Diderot admired the painting of Jean-Baptiste Greuze, who portrayed modern, everyday heroes in classical settings, giving rise, in their interaction, to a new uncanny pleasure. Kristeva argues that "a new conception of the sublime was underway in these 'figure' heads that is neither ecstasy nor purity but the immersion of the terrible into the great, of passion into reason that *figures* forth a face."[93] Figure, then, lashes past to present[94] and in so doing manifests a dynamism in the human face that Diderot describes as a "canvas that shifts, moves, stretches, relaxes, turns pale, blanches according to the infinite multitude of alternatives of that light, mobile breath we call the soul."[95] Such a transformation "humanizes transcendence."[96]

The Orthodox tradition of inscription that Kristeva describes in her later works can be associated with her discussion, in *Revolution in Poetic Language*, of a mimesis that is very different from the one Auerbach describes. In the earlier work she defined mimesis in literary signification as "the construction of an object, not according to truth but to *verisimilitude*."[97] By verisimilitude she means that the object is posited but not denoted; rather, it is connoted or allowed to proliferate in multiple significations.[98] In turn, the object is dependent on a subject of enunciation, but this subject is "unlike the transcendental ego in that [s]he does not suppress the semiotic *chora* but instead raises the *chora* to the status of a signifier, which may or may not obey the norms of grammatical locution."[99] This kind of mimesis partakes of the symbolic order, but only partially, by reproducing some of its constitutive rules. In so doing, the positing of the symbolic is subverted, and even the positing of the enunciating subject is disrupted.[100]

What is important about this form of mimesis and what distinguishes it from mere glossolalia, or infantile babbling, is that it operates within the linguistic order and thereby communicates and is social or intersubjective. Moreover, although poetic mimesis does not actually call into question the subject position that it requires to be signifying language, it prevents it from becoming "theological."[101] Poetic mimesis shows the possibility for a different configuration of the social and thus has the power to critique culture. Kristeva writes that "both mimesis and poetic language with its connotations assume the right to enter into the social debate, which is an ideological debate."[102] They

have the power to question "theology" or accepted ideology, "both its necessity and its pretensions":

> In other words, poetic language and mimesis may appear as an argument complicitous with dogma—we are familiar with religion's use of them—but they may also set in motion what dogma represses. In so doing, they no longer act as instinctual floodgates within the enclosure of the sacred and become instead protests against its posturing. And thus, its complexity unfolded by its practices, the signifying process joins social revolution.[103]

Certain forms of contemporary art—Kristeva mentions, as an example, the works of the Italian artist Lucio Fontana, which inscribe a gesture, literally cutting through paper rather than directly representing anything—implicitly rediscover the iconic Byzantine economy. Fontana's artworks often consist of incisions into paper or other media. She writes: "he is inviting us to a participation in the visible that is not limited to the gaze alone but engages our entire affectivity. The icon's oscillation between visible and invisible is thus unconsciously sought."[104] Here the "invisible" would refer not to the divine but rather to the unconscious, the entire unrepresented realm of affects and drives, as well as to the semiotic underbelly of symbolic life. The cut indicates the necessity of great artworks' relation to a founding emptiness, the link it provides between the spectator and "their invisible center." All great art, writes Mondzain, is "kenotic."[105]

Fontana's inscription is literal, but I will argue that a counterpart to it can be found in a certain kind of photography, one that is discussed by Walter Benjamin in his essays on that art. The "resurrection of the flesh," in Kristeva's words, presents without representing, for "representational thinking would be without reflection," and "without reflection there is no theory," as Adorno put it.[106] It is counterintuitive to think of the photograph as an art form that can exemplify iconoclasm, but we can understand this claim in reference to Mondzain and Kristeva's discussions of the orthodox icon.

PHOTOGRAPHY AND THE IMAGE IN BENJAMIN

Walter Benjamin's meditations on the relatively new art of photography are both brief and occasionally enigmatic.[107] What seems clear is that Benjamin associated the moment of capturing and freezing a photographic image both with a temporality that is distinctive of modernity and with a new, redemptive

possibility that would move beyond the critique of modernity and suggest possibilities for future change. This possibility has something to do both with the photograph's capacity to capture the optical unconscious, beyond the explicit intentions of the photographer, and for its capacity to preserve a moment of lost time, but in such a way that it does not merely retrieve it or repeat it identically.

Benjamin's essays on photography and film are most often associated with their analysis of the historical effect of technological reproducibility on art and in particular with the identification of the loss of the aura with the invention of photography. Although he is not extremely precise in his definition of the term, sometimes even claiming that all objects, including natural ones, have an aura, Benjamin usually predicates it of artworks as unique and singular objects possessing a specific history. As Benjamin uses the term in discussing photography and nature, however, aura is also a "strange weave of space and time; the unique appearance or semblance of distance, no matter how close it may be."[108] One could speak of the aura of a city, such as Paris, or the aura of a person that pervades her clothing and surroundings without being reducible to any of their particularities. Benjamin describes the photographers' client as "a member of a rising class equipped with an aura that had seeped into the very folds of the man's frock coat or floppy cravat."[109] Benjamin traces the strange genealogy of the photograph from its origin as an art form with a new form of aura, to the decline of aura through new lighting techniques, to the photographic industry's eventual attempt to simulate an aura, and finally to the photographs of Eugène Atget that "suck the aura out of reality like water from a sinking ship."[110]

Photography is defined continually against more traditional forms of art, particularly with reference to the question of whether it is art's role to imitate nature. Early photographs were associated with fairgrounds rather than with business; it was only with the invention of the visiting-card picture that photography became an industrial phenomenon.[111] Though these early photographs had a kind of aura given the darkness that surrounds their subjects, who emerge from them full and serene, framed by a "breathy halo" that is the product of technology, their aura is nonetheless very different from that of the painterly portraits that preceded them.

When advances in optics allowed for the faithful recording of appearances as in a mirror, photography fell into the traditional role of art as imitation of nature. And theoreticians of photography begin to "attempt to legitimate the photographer before the very tribunal he was in the process of overturning."[112]

The reproducibility of the industrialized photograph eventually negated its simulated aura, for, as Benjamin writes in "The Work of Art in the Age of Its Technological Reproducibility," aura traditionally signifies the singularity of the original, its history and its authority. Film and commercial photography substitute for the original a plurality of copies, allowing a multiplicity of viewers to encounter the image, each in his or her own particular situation: "it substitutes a mass existence for a unique existence."[113] As Benjamin notes in the photography essay, the earliest photographic plates were one of a kind, frequently kept for safekeeping in a jewelry box.[114]

Nevertheless, the essay on photography does not nostalgically long for the photographs of the past. Rather, Benjamin is concerned with distilling the real artistic essence of photography, with what makes it distinct as an art form. When photography seeks to imitate nature or traditional forms of representational art, it is not true to its nature. The two aspects of photography that Benjamin finds most distinctive and significant are its incorporation of the unconscious and its temporality. Both of these aspects seemingly are in some way erased or at least minimized in industrialized photography, the period that Benjamin describes as the "decline" of photography. However, both come to the fore strikingly in some forms of postindustrial photography.

Benjamin first indicates the presence within photography of a "space informed by the unconscious," as well as the flashlike complexity of the photograph's temporality, in his discussion of the earliest photographic plates. Unlike painting or other traditional art forms, photography evokes an irresistible urge on the part of the beholder to discern within it a "tiny spark of contingency, of the here and now" that the photograph has "seared" into the subject.[115] This spark is described by Benjamin as "an inconspicuous spot where in the immediacy of that long-forgotten moment the future nests so eloquently that we, looking back, may rediscover it."[116] This is precisely the temporality of Proust's madeleine[117] and of Freud's *Nachträglichkeit*.[118]

Benjamin goes on to claim that no matter how carefully the photographer has attempted to capture nature faithfully, as in a mirror, "it is another nature which speaks to the camera rather than to the eye: 'other' above all in the sense that a space informed by human consciousness gives way to a space informed by the unconscious."[119] This "optical unconscious" is revealed by the techniques photography has access to, of freezing and then enlarging a particular view, and, in the case of film, of slowing motion down so that we may become aware of its component parts, that fraction of a second when a person takes a step or shifts a limb.[120] "It is through photography," Benjamin writes, "that we first discover the existence of the optical unconscious, just as we

discover the instinctual unconscious through psychoanalysis."[121] Photography can reveal things that are not available to the ordinary eye. It is precisely in being frozen and cut off from their context (and recall that the context is an integral part of the aura) that the optical unconscious can be accessed. Photography thus functions in a manner analogous to negation.

As an example, Benjamin points to an early photograph of the photographer Karl Dauthendey, who posed himself beside his fiancée, a woman who would commit suicide shortly after the birth of her sixth child. Though Dauthendey seems to be holding on to his fiancée, "her gaze passes him by, absorbed in an ominous distance."[122] Here again we see a moment in time frozen that, from the perspective of knowledge in the present, seems to have nested within it an indication of something unconscious that suggests future events. Roland Barthes identifies death as the *punctum* of every photograph— not the *studium*, or subject of the photograph, but the point in the photograph that "pierces" us and draws us out of it, a point that is active rather than passive. A photograph that was only *studium* and not *punctum* would be a representation. Because a photograph records an actual moment of life, in the case of a portrait, what is captured is a moment in the flow of self-consciousness, immobilized and presented for observation, rather than the imagination of the artist, as in the case of a painted portrait, for example.[123]

Photography thus must be understood as the severance and isolation of a moment of time as opposed to an instant in a seamless narrative or one partial image that contributes to a whole. It has a "flashlike" or "explosive" temporality that is akin to the "flash" of mimesis itself and language as its bearer.[124] The point is not to redeem the image by inserting it into a narrative that would explain and complete it but to recognize the "now time" of interpretation in its relationship to the past, for a photograph, in the words of Barthes, sets up "not a perception of the *being-there* of an object . . . but a perception of its *having-been-there*. It is a question of a new category of space-time: spatial immediacy and temporal anteriority."[125] What photography does is not to duplicate a moment but to "mime" it, where what results is ambiguous, suggesting a "magical correspondence" between past and present akin to the correspondences familiar to ancient people, for example, a similarity between a constellation of stars and a human's character and future. Language is required to "fill out" this correspondence, as Benjamin writes in "Doctrine of the Similar":

The perception of similarity is in every case bound to a flashing up. It flits past, can possibly be won again, but cannot really be held fast as can

other perceptions. It offers itself to the eye as fleetingly and transitorily as
a constellation of stars. The perception of similarities thus seems to be
bound to a moment in time. It is like the addition of a third element—the
astrologer—to the conjunction of two stars; it must be grasped in an
instant.[126]

We no longer possess the senses that made it possible to speak of a perceptual
similarity between natural and human phenomena. Nonetheless, we mod-
erns possess a "canon," Benjamin writes, "on whose basis we can attain more
clarity regarding the obscurity which clings to the concept of nonsensuous
similarity."[127] The canon is language itself.

Rebecca Comay writes that "the temporal structure of the image itself con-
verts seeing into reading, and image into text,"[128] and she quotes Benjamin to
the effect that this is the true sense of the Jewish ban on divine images.[129] In
the conversion of the ban on images (*Bilderverbot*) into a "flight from images"
(*Bilderflucht*), Comay argues, Benjamin executes a "salvage operation" of "that
kernel in the imaginary which defies idealization and which thus negotiates an
opening to the unforeseen," which is precisely what a good photograph may
also do.[130]

Comay also delineates at length the disagreement between Adorno and
Benjamin on the question of the significance of the image.[131] Nonetheless, I
want to suggest at least a possible proximity between Adorno's language of the
demythologization of materialism and Benjamin's notion of the conversion of
image into text. If we recall that Adorno castigated the vulgar materialist no-
tion that thought must "mulishly mirror the object," calling this "image the-
ory," we can see a parallel to Benjamin's critique of industrialized photogra-
phy, in which the photograph is conceptualized as an exact reproduction or
"mulish mirror" of an object, one that can be reproduced infinitely. Benja-
min's articulation of the true nature of photography in contrast to this repro-
duction can be likened to Kristeva's distinction of the icon from the image.
Recall that whereas the image was associated with figuration or representation,
assuming a continuity or commensurability between the Judaic and Christian
traditions of iconoclasm and iconophilia, respectively, the icon inscribes the
divine as a sensible trace rather than directly manifesting it.[132] This surplus
that cannot be contained within the image would refer to the unconscious or
to the void along with what is indefinitely inscribed of the divine.

The question remains as to how this conjunction of nonsensuous similar-
ity (mimesis), flashlike temporality, and opening up of a space of the uncon-
scious translates into contemporary photography. In Benjamin's discussion of

the photographer Atget, we get a sense of the possibilities he views in photog-
raphy in its postrepresentational phase. He calls Atget's Paris photos "the
forerunners of Surrealist photography" in their disruption of the stifling atmo-
sphere of conventional portrait photography.[133] These photos, which show
only details, fragments, bits of trees or lampposts or balustrades cast adrift
from their context, initiate "the emancipation of object from aura."[134] This
emancipation is necessary in the industrial age, where "even the singular, the
unique, is divested of its uniqueness—by means of its reproduction."[135] Benja-
min calls this artistic achievement a "salutary estrangement between man
and his surroundings," giving "free play to the politically educated eye."[136]
Atget's photographs are likened to crime scenes. But, Benjamin asks: "Isn't
every square inch of our cities a crime scene? Every passer-by a culprit? Isn't it
the task of the photographer—descendant of the augurs and haruspices—to
reveal guilt and to point out the guilty in his photographs?"[137] This character-
ization presents art as discomfort, as alienation, as a practice designed to dis-
lodge unsalutory habits and suggest that people or society could be different.
In freezing the moment, photography has the capacity to provide both evi-
dence of wrongdoing and the hope for justice or restitution.

A photograph can make a lost moment present. Thus Benjamin ties the
flashlike temporality of the photograph to the instant of messianic time, which
may erupt through the linear time of history at any moment. The content of
this moment is not articulable in conceptual terms, least of all as prescription
or formula. Rather, as Benjamin writes in *The Origin of German Tragic Drama*:

> "Thou shalt not make unto thee any graven image"—this is not only a
> warning against idolatry. With comparable emphasis the prohibition of
> the representation of the human body obviates any suggestion that the
> sphere in which the moral essence of man is perceptible can be repro-
> duced. . . . And from the point of view of any kind of artistic practice, this
> life, which concerns us morally, that is in our unique individuality, ap-
> pears as something negative, or at least should appear so. . . . The truth
> content of this totality, which is never encountered in the abstracted les-
> son, least of all the moral lesson, but only in the critical elaboration of the
> work itself, includes moral warnings only in the most indirect form.[138]

Here we can see a clear connection between the prohibition on representa-
tion and the desire to preserve the possibility of meaningful change. Truth
cannot be re-presented, for it has not yet appeared. If the truth is inaccessible
to knowledge, then it cannot be made present again. The articulation of

truth, like a photograph, is not an exact repetition of something that was once present. Rather, what is presented (in truth) can only be given in presentation, and there it is inaccessible to the order of cognition, which demands totality and transparency, nor can it be expressed as an explicit moral lesson.

At the end of "Little History of Photography," Benjamin, just as he is discussing the crime scene–like nature of Atget's photographs, cryptically writes that because the camera is getting smaller and smaller, and thus ever more capable of capturing "fleeting and secret images whose shock effect paralyzes the associative mechanisms," inscription will now become the most important part of the photograph.[139] Photography is a material inscription of memory; like the optical unconscious that it sometimes presents, something inaccessible to ordinary perception is made manifest through this inscription. As in Kristeva's discussion of the icon, however, the meaning presented is a sensible trace rather than a clear conceptual repetition or representation of particular content. Though it disrupts narrative signification, the image may also, in being taken out of its place in the sequential flow of time, configure new meanings. The paralysis of the associative mechanisms occurs by virtue of this removal of the image from its context in a specific place and time. Inscription, then, marks both the moment of that excision and the proliferation of new meanings that it might open up, pointing both backward and forward.

KRISTEVA ON PHOTOGRAPHY

Kristeva's theoretical writing on photography is limited to a brief passage in *Language: The Unknown* and to her interview in the catalogue for the photographic exhibition "Inferno/Paradiso." In the former, she limits her discussion of photography (and cinema) to the context of language, calling both media forms of "visual language." She notes only one peculiarity of photography, namely, that it provides us with a unique temporality, a simultaneity of "spatial immediacy and temporal anteriority," a conjunction of "here-now" and "there-then."[140] Cinema, by contrast, does not present or try to recreate a moment from the past but, even when it takes place in the past, invites the audience in to live the moment as if it were the present.

In the catalogue for "Inferno/Paradiso," an exhibit curated by Alfredo Jaar and inspired by Dante's *Divine Comedy*, Kristeva answers more general questions about her work, questions posed by an interviewer who tries to relate it to the exhibit, which asked photojournalists to be "witnesses to the great cosmic and historical drama of contemporary life, through their extraordinarily intense encounters with present day inhabitants of *Inferno* and *Paradiso*." Jaar

explains that "like Dante, the photographers are powerless to change the tragedies that they document, but are left with only language to document these experiences in all their complexity."[141]

Kristeva is interviewed for the "Paradiso" half of the catalogue. The interviewer, Rubén Gallo, presses her to compare her work to that of Hannah Arendt, specifically on the idea of natality, and, relatedly, to connect her work to the question of the child as a symbol of hope and freedom. Kristeva is careful to distance her infrequent discussion of the psychoanalysis of children from "cheapened" and "sugary" depictions of childhood (some of which might arguably be present in the exhibit) and focuses rather on the Arendtian concept of *initium* as a second beginning, a repetition of the initial act (*principium*) by which god created the earth. She seems to link the sugary, cheap image of children to the society of the spectacle that she criticizes at length elsewhere. The transformative image, by contrast, opens up a new space of freedom that "annihilates the constraint of the model-object and replaces it with the flight of thinking and the vagabondage of the imagination," much in the way Kant discusses the productive capacity of the imagination to generate aesthetic ideas.[142]

In *New Maladies of the Soul* Kristeva also refers to the "psychic apparatus" of the human being as a "darkroom" where representations and their meaningful value for the subject are registered.[143] Clearly playing with Freud's image of the unconscious as a photographic negative, she distinguishes between representations of the society of the spectacle, which shapes modern individuals and which offers neurochemical drug treatments for the distresses of modernity, on the one hand, and representations that are meaningful and valuable for psychic life, on the other. The "darkroom of the soul" would be a place whose images would not necessarily be immediately available for retrieval and dissemination and whose temporality would always be one of deferral. Such images might be retrievable through the psychoanalytic dialogical process or through the "involuntary memory" of art, where the debilitating symptoms they cause might be addressed and transformed.

Revolution as the "Click": Some Examples from Contemporary Art

Benjamin's discussions of photography, in my view, presage a development in avant-garde art that Adorno either rejected out of hand or was unable to foresee. In Adorno's dispute with Benjamin over the revolutionary potential of technologically reproducible forms of art, as in Adorno's dismissal of jazz, there seems to be an assumption that an art form that is embraced by popular

culture is categorically incapable of having political effects because it is already so caught up in what political analysis attempts to critique. Photography and film, according to this analysis, would be too implicated in the logic of instrumental rationality to be able to maintain a critical distance from it or to envision an alternative to it. Nonetheless, Adorno used the metaphor of the photographic negative to illustrate a political perspective that only art is capable of. For Adorno, negation or, as Shierry Weber Nicholson puts it, "the capacity to see things in an unearthly light" or to "present a version of the world in negative," would be the primary way in which art can have political significance.[144] However, it is contentious whether Adorno thought actual photographs could have this effect.

I want to develop this metaphor of the photograph without necessarily limiting myself to artworks that use the photographic medium. Following Benjamin's articulation of the flashlike temporality of the photograph and Goux's discussion of Hestia's role in the articulation of iconography, in conjunction with Kristeva's notion of the semiotic traces that punctuate symbolic expression, I speculate that what some artworks achieve is a momentary incision into the patterns of everyday imaginary life, opening up a vision of something other. Like flashes from the unconscious, which periodically and unpredictably punctuate conscious life, these moments are neither intentional nor controllable, though they inform and possibly transform the intentional structure from which they emerge. Kristeva's notion of art as revolution posits an analogy between the process that takes place in the analytical situation, in which, through discourse, sedimented psychic patterns may be exposed and perhaps reoriented in a healthier way, and artworks that repeat in such a way that they open up new possibilities.

The clearest examples of contemporary art that follow the logic of Kristeva's notion of iconoclasm and revolt, of nonidentical mimesis, or of the return of the repressed under the sign of negation are those artworks that take as their subject a traumatic personal or political event in the past and our current relation to it. What Kristeva's articulation of an avant-garde art of inscription, Benjamin's notion of a flashlike temporality that severs an image from its context in a linear narrative, and Barthes's conceptualization of the *punctum*, or punctual node of a photograph, have in common is the idea of art as a cutting away or through, and I want to think of the artworks I examine here in those terms, even though they do not, as in the Lucio Fontana example, literally use cutting as an artistic form. The word in French for "to cut" is *couper*, at the root of both *tout d'un coup*, the phrase in Proust that always signals the narration of the emergence of involuntary memory, and *après coup*, the

French translation of Freud's *Nachträglichkeit*. It is this notion of revolt or return through severing that characterizes the kind of art that for Kristeva signals a political repetition through difference.

A beautiful example of this kind of artistic work can be found in the series and exhibition entitled *Corte de Florero*, or "The Flower Vase Cut," by the Colombian artist Juan Manuel Echavarría. In this series, where again the title makes a veiled political reference, Echavarría references the flower vase cut, one of the mutilations practiced during the Columbian violence of the 1940s. The series depicts elaborate and beautiful botanical specimens constructed entirely out of human bones. The photographs recall botanical drawings recorded by European explorers who wanted both to document new species of plants and to entice European viewers in an attempt to encourage colonization and inhabitation of the "new world." Scientific curiosity and violent conquest are thus juxtaposed, just as the fragile beauty of the plant is presented simultaneously with the horror of human remains. Describing his work in this series, Echavarría writes: "My purpose was to create something so beautiful that people would be attracted to it. The spectator would come near it, look at it, and then when he or she realizes that it is not a flower as it seemed, but actually a flower made of human bones—something must click in the head, or in the heart, I hope."[145]

It is this click that I think draws together Kristeva's art of inscription (from the Greek *skariphasthai*, "to scratch an outline"), the iconoclasm of Hestia, and Benjamin's theory of photography. What can come to presence is not a narrative or a message but perhaps only an image cut off from its context. When the camera clicks, it severs a moment from the flow of linear time and isolates it in space. This moment can be accessed immediately, or after a long-deferred stretch of time, or even never revisited. Hestia's role is perhaps more enigmatic; however, as the goddess of the hearth, she negotiates the boundary between the body and the mind, the semiotic and the symbolic, the natural and the cultural. Hestia emerges through the moments of punctuation; she is the semiotic as it is taken up and read through the symbolic, the rhythm of their interaction, those flashes that might have the potential to reorder symbolic formations.[146]

In "The Function and Field of Speech and Language in Psychoanalysis," Jacques Lacan discusses his controversial introduction of the notion of a psychoanalytic session of unfixed duration as a means of disrupting the analysand's expected psychic patterns in the session. Lacan refers to the tempo, duration, and ultimately signification of a session, just as of a sentence, as its "punctuation":

The ending of a session cannot but be experienced by the subject as a punctuation of his progress. We know how he calculates the moment of its arrival in order to tie it to his own timetable, or even to his evasive maneuvers, and how he anticipates it by weighing it like a weapon and watching out for it as he would for a place of shelter.

It is a fact, which can be plainly seen in the study of manuscripts of symbolic writings, whether the Bible or the Chinese canonical texts, that the absence of punctuation in them is a source of ambiguity. Punctuation, once inserted establishes the meaning; changing the punctuation renews or upsets it; and incorrect punctuation distorts it.[147]

By changing the duration of a session, in particular through the implementation of "short sessions," Lacan hoped to disrupt the expectations of his patients and give birth to new revelations from the repressed unconscious of his patients. Indeed, he gives as evidence of the success of this method the following statement: "I was able to bring to light in a certain male subject fantasies of anal pregnancy, as well as a dream of its resolution by Cesarean section, in a time frame in which I would normally still have been listening to his speculations on Dostoyevsky's artistry."[148]

Art has an analogous capacity to disrupt meaning and suggest new configurations through its innovation in punctuation, and it is this capacity that Kristeva refers to as its possibility of inscription rather than representation. It can also be thought of, in art and in therapy, as a kind of modification in rhythm. In her discussion of the medium of film, Kristeva speaks of the "logic" of what she calls the "thought specular" as a kind of "skeleton."[149] We can understand this skeleton and its modifications in analogy to the rhythm of a song, the beats that give it structure. In the Pedro Almodóvar film *Volver*, for instance, the title song, which is a traditional tango, is sung instead to a flamenco rhythm. The rhythm of a tango is binary, divided into two, four, or eight beats per measure and characterized by a steady, pulsing strum.[150] Tango is thought to originate from Cuba, from the music and dance of African slaves held by the Spanish. Flamenco developed out of tango, but it has a different, more complex rhythmic structure reflecting, perhaps, the turbulent times out of which it evolved. Many of the songs of flamenco are said to arise out of the persecution of the Moors and the Jews in Spain during the Inquisition and "the spirit of desperation, struggle, hope, and pride of the people during this time."[151]

The decision to have *Volver* sung in a flamenco rather than a tango rhythm is a subtle one, one that perhaps has no conscious effect on the viewer, especially the one (who probably represents the majority of viewers) who has no

in-depth knowledge of either tango or flamenco. Yet unconsciously, or on a bodily, semiotic level, the change in rhythm delicately affects the viewer, giving rise to the simultaneous and paradoxical feelings of deep anxiety and hope. The song is sung in a formerly failed restaurant next door to her apartment building that Raimunda has impulsively reopened (she has been given the keys by the owner so she can show it to prospective renters) in order to feed a film crew who has inquired into it. In the back room of the restaurant the dead body of her husband lies in a deep freezer; he was stabbed by her teenage daughter when he tried to molest her. Raimunda's efforts to hide the crime and resuscitate her life (burdened by the recollection of her own father's sexual abuse) are tempered by the gravity of the knowledge of that hidden corpse, which weighs her down like a traumatic memory, yet the sensuous profusion of the food she creates and the cheerful bustle of the film crew suggest the possibility of rebirth from sadness. Most importantly and tellingly, of course, her relationship with her missing mother, who reappears first as a foreigner, then as a ghost, but eventually manifests herself as a real, living presence, will have to be faced and reintegrated into her new existence. Correlative to the flamenco rhythm of the song are other elements of circular rhythm found throughout the film, from images of lofty modern windmills dotting a field; to the smell and cyclical movement of an exercise bicycle used by Raimunda's mother, who throughout the film haunts it like a ghost; to the cycle of regular care of the graves of the dead and the women turning around the "principal mourners" at the funeral; to the return of the mother/daughter relationship. Like the claps that perform a staccato punctuation of the flamenco song, knives and stabbing also punctuate the film, from the opening scenes, where Paula stabs her stepfather, to the restaurant scenes of cutting vegetables, to, finally, Raimunda's act of carving an inscription into a tree beside the river where she has buried Paco. This punctuating, circular rhythm and the carving recall Kristeva's characterization of successful art as inscription, as cutting away or through, as well as Barthes's identification of death as the *punctum* of every photograph, the point that "pierces" us and draws us out of it. Just as a photograph that was only *studium* and not *punctum* would be a representation, a film that is only specularity without "thought" or a lektonic logic would be an ordinary Hollywood narrative, which Almodóvar's films are clearly not. These moments of punctuation present the semiotic as it is taken up and read through the symbolic, resulting in a rhythm of interaction, in flashes that might have the potential to reorder symbolic formations. Interestingly, Almodóvar has said of his own entire aesthetic oeuvre, entirely in keeping with this rhythm of *Nachträglichkeit*, that "we don't have confidence in the future,

but we are constructing a past for ourselves, because we don't like the one we have."[152]

This logic, which is also the logic of the "thought specular" in Kristeva's parlance, constitutes a version of the specular that distances itself from itself by both embodying fantasy and disparaging it.[153] The cinema of the thought specular puts semiotic elements of signification into play in a more direct and unavoidable way than any other medium: vision, sound, movement, and tone are not merely present in profusion, but they practically abut on the viewer's face. The interplay of these lektonic traces reflect and retrace the energies of the pulsating and desiring body,[154] in particular the semiotic element of rhythm, which accompanies us in the profusion of temporal experiences that make up human existence.

In her privileging of rhythm, Kristeva seems to follow Sergei Eisenstein, one of her favorite film directors, who links rhythm in particular to the unconscious. In a text on cinematic method, Eisenstein writes that

> everything in us that occurs *apart from consciousness* and will—occurs rhythmically: the beating of the heart and breathing, peristalsis of the intestines, merger and separation of cells, etc. Switching off consciousness, we sink into the inviolable rhythm of breathing during sleep, the rhythm of sleepwalking, etc. And conversely—the monotony of a repeated rhythm brings us closer to those states "next to consciousness," where only the traits of sensuous thought are capable of functioning fully.[155]

Note the proximity of "sensuous thought" to "thought specular." Humans are rhythmic organisms striated by the cadences of their pumping and circulating organs. Human rhythms alternate and conform to the different activities in which we engage, fluctuating naturally in multiple ways. The society of the spectacle affects not only what we see but also how we interact rhythmically with the world, imposing an identical rhythm on activities as diverse as work and play, thought and relaxation, love, anticipation, dread, and horror. One way in which aesthetic activity can intervene therapeutically is by obliging the body to engage in alternate rhythms. Film in particular can capture the entirety of bodily rhythm in a new and transformative way, seizing the viewer and turning her into a participant and collaborator with the aesthetic event, as she is literally moved by the work.

In Almodóvar's film *Talk to Her*, the spectator enters the film in the role of Marco, a masculine yet sensitive figure whom we first encounter at the ballet, silently weeping as he watches a performance choreographed by the late Pina

Bausch.[156] Recounting a similar experience, the director Wim Wenders says of watching a piece by Bausch, "I was caught by an emotion that I'd never experienced in front of any stage; any dance, theater, opera, whatever. . . . My body understood it, but my brain was lagging far behind."[157] Bausch herself is quoted as saying of her dancers (and perhaps those who watch them): "I am less interested in how people move than in what moves them."[158] This emotional and corporeal experience of being captured or moved expresses what I mean by being caught up by an alternate rhythm of bodily existence.

Bausch's dance "Café Müller," as it is presented in the film, has three dancers, two women and one man. As the two women stagger gracefully yet blindly, their faces masks of pure suffering reminiscent of ancient Greek tragedy, through a café littered with chairs, a man struggles to remain one step in front of one woman's path, removing and shifting chairs to allow her to pass. She continues on her path without even seemingly noticing him, only to crash into a wall repeatedly, falling wildly yet with controlled balletic posture. The dance seems to portray a disoriented and melancholic life-orbit, where one obstacle is avoided only to make way for another collision. The accompanying music is the elegiac "O Let Me Weep, For Ever Weep" from Henry Purcell's *Fairy Queen* (1698 and 1702), with lyrics that lament the loss of love. Despite the profound sadness and chaos of the piece, it is intensely beautiful. Pina Bausch once said in an interview that *"Mit dem 'Nur Reden' kann man ja nichts anfangen,"* or "nothing can be begun 'by speaking alone.'"[159] Her point is that the body itself has a language more primordial than and ultimately forming a condition for the possibility of symbolic language, through its movements, affects, and rhythms, a point Kristeva has also made repeatedly.

The story of *Talk to Her*, like *Volver*, is a story of punctuation and healing. It follows the journey of transformation in the character of Marco, starting from the point when Marco's girlfriend, a famous bullfighter, falls into a coma after being gored by a bull, and Marco meets Benigno ("benign"), a young man who is the nurse and almost exclusive caregiver of another young woman in a coma in the same hospital. The wound of the bull's horn is an allegorical expression of a psychic trauma, although the enactment of the therapy addressing the trauma takes place primarily in the caregivers (and the spectators).

In the alternation between punctuation and healing, rhythm and figure, we see a clear enactment of what Kristeva means by the art of inscription. John Lechte describes the semiotic sphere that Kristeva has so eloquently articulated as a realm of musicalized, timeful space,[160] articulated by Kristeva in *Revolution in Poetic Language* as the dynamic and creative Platonic chora. Here art becomes a place of therapeutic address.

Kristeva imagines an ideal, impossible film, one directed by Eisenstein and Hitchcock (another master of conflict, who allowed the fear evoked by the death drive to come to the fore explicitly), with a score by Schönberg.[161] Schönberg's opera *Aaron and Moses* enacts the very dynamic between image and iconoclasm that Kristeva finds compelling. The story follows the two brothers, Moses and Aaron, one who strictly follows the injunction against any graven images of the divine, the other who interprets the image less rigorously as a possible intermediary to the divine, in response to the people's demand for a god they can see. Schönberg investigates this dynamic with reference to the struggle going on in his own time between religious and secular Jews, the former who thought it most important to remain purely focused on theological doctrine and the latter who insisted on the necessity of statehood and citizenship for the Jewish people, allowing them to integrate more fully into public life. While Schönberg shows little sympathy for Aaron's desire to use the image as a way to approach the divine (as well as for the correlative secular Jewish desire for a state), Kristeva calls the debate between Aaron and Moses a misleading one. She writes that this is a false dichotomy, between "the jubilation of idol worshippers seduced by the golden calf (followers of the image?) and the divine threat exploding in thunder, imageless," and that this is the very dichotomy that the thought specular seeks to negotiate.[162]

CONCLUSION

Mimesis, in the sense that Adorno, Kristeva, and Benjamin use it, is not an identical repetition but rather a re-creation of what cannot be exactly reproduced or retrieved. In a very real sense it is the creation of memory. This is to say that it would not be art's role to recapture a lost sensation in the freshness of its original plentitude or in the rawness of the originary trauma. Rather, art creates memory by bringing into being words and thoughts that transport what is outside of time and language into language and time and thus into memory—and perhaps out of symptom. Art, literature, and possibly psychoanalysis, because of its emphasis on the unconscious, can thus act as the Hestias, or conditions of possibility, for imagining the order of human existence in a new way.

Kristeva conceptualizes this negative path toward thought, language, art, memory, and transformation in terms of a new interpretation of the theological ban on images. Kristeva's iconoclasm follows that of Hans Holbein, whose art she analyzes in *Black Sun*, and of Lucio Fontana, whose works repeat the Orthodox icon (as she interprets it) in that they inscribe rather than represent,

"giv[ing] form and color to the nonrepresentable"[163] or "locating representation on the ultimate threshold of representability."[164] Benjamin's discussion of the invention of the photograph and its subsequent development as an art provides a concrete means of thinking about how art can present a truth about a particular time that both freezes it so that it can be examined by later theorists just as it was in its own time, and that perhaps brings forth elements of the past that were overlooked at the time, such that their redemptive possibilities might be discerned and gleaned. Kristeva takes this discussion to the medium of film, to explore its therapeutic rhythms. The task of the thought specular is "to remain in idolatry (fantasy) while at the same time exhibiting symbolic truth." This task translates the sensibility of Kristeva's iconoclasm for the cinema.

3
TO BE AND REMAIN FOREIGN
TARRYING WITH *L'INQUIÉTANTE ÉTRANGETÉ*
ALONGSIDE ARENDT AND KAFKA

Hannah Arendt liked to identify with a line from Schiller, *Ein Mädchen aus der Fremde*, "a girl from elsewhere," "a girl out of the foreign"—a girl in quest of the father, fleeing the father; replacing the father-begetter and the intellectual master in order to re-imagine, re-postulate herself, indefinitely, without foundation; a continuous re-foundation then, a new blossoming every instant?
— Julia Kristeva, "Louise Bourgeois" (translation slightly modified)

SENSUS ALTERITAS

THE RELATIONSHIP BETWEEN FOREIGNERS AND THE SOCIETY or country to which they have immigrated, the subject of Kristeva's *Strangers to Ourselves*, is a topic that troubles peoples and nations worldwide but perhaps is nowhere so salient a political concern today as in France and in the United States. Kristeva's ultimate conclusion in this book is that the foreign is not a problem that can ever be overcome; this is because, just as foreigners will always be a "worrisome" presence in every nation-state, so, too, there is a "foreigner"—namely, the unconscious—within each of us considered as an independent unity or self/ego.[1] In *The Severed Head* and in her various discussions of contemporary art Kristeva also implies that the art of our time is an art of the uncanny (from Freud's *Unheimlich*), a word that is translated into French as *l'inquiétante étrangeté*, "worrisome foreignness." Art, according to this definition, would involve an intentional lingering with the foreignness that is a fundamental part of being human and as such is always implicitly within us and around us. In this chapter I will consider the two ideas of uncanny art and the question/problem of the foreign in conjunction with each other, as Kristeva does briefly in *Strangers to Ourselves*.

One place to examine this relationship lies in Kristeva's extended consideration of Hannah Arendt's philosophy and, in particular, of the Arendtian idea, derived from a reading of Kant's *Critique of Judgment*, that there is a place for

aesthetic judgment within the concept of the political. Arendt was inspired to
teach a course, which was recorded in *Lectures on Kant's Political Philosophy*,
by the Kantian idea that both aesthetics and politics presuppose a community
on the basis of the a priori principle of the communicability of judgments.[2]
Arendt reads Kant's "common sense" as a "sense of community," implying
that human beings are not politically autonomous: they need one another's
company for the purpose of deliberation and reflective judgment. Kristeva
plays with this reading but shifts the emphasis abruptly from "common" to
"absolutely other" in defining the relationship of aesthetics and politics in the
late twentieth and twenty-first centuries. Ewa Ziarek explains:

> Arendt turns to the pleasure in the beautiful in order to reconstruct a
> community based on identification with others—achieved "by putting
> oneself in place of everybody else" and by sharing a commitment to pub-
> lic communicability of judgments, which, needless to say, presupposes a
> certain transparency of language. Kristeva, on the other hand, derives
> the alternative sense of politics neither from the aesthetics of the beauti-
> ful nor from the sublime, but rather from the Freudian aesthetics of the
> uncanny.[3]

It is the aim of this chapter to outline what an aesthetics of the uncanny—
understood as a deliberate tarrying with the foreign—might look like with
reference to contemporary art, and in so doing to link this to an intersubjectiv-
ity based on a respect for and even cultivation of radical alterity. In particular,
to continue the juxtaposition of Kristeva's philosophy with the philosophical
exploration of photography, I will consider the idea of the photograph as a
potentially uncanny form of art. I will bring together Kristeva's discussions of
aesthetic revolution with her consideration of the foreignness that is internal
to each of us and the foreignness that surrounds us thanks to globalization
and the possibility of easy world travel. Finally, I will argue that Kristeva's no-
tion of cosmopolitanism rests upon an imperative to foster, not to overcome,
foreignness.

FROM THE FAMILIAR TO THE FOREIGN

We might begin with a quick review of Arendt's argument as to the viability of
Kant's *Critique of Judgment*, and in particular of the aesthetic judgment of
taste as the basis for a political philosophy. Arendt points out that for Kant,
free thinking and publicity are coterminous; depriving human beings of the

possibility of communicating their thoughts publicly would be tantamount to depriving them of the freedom of thought altogether. Impartiality itself can only be achieved through the process of taking others' viewpoints into consideration. Arendt writes that for Kant the faculty that makes this publicity possible is imagination, which allows us to bring to mind that which is absent or merely possible, namely, the viewpoints of others, to which we attempt to compare our own views, taking a critical distance upon our biases. The ideal result would be the "enlarged mentality" of a world citizen, arrived at through imagination, which removes the object of contemplation from direct sensation, subjecting it rather to reflection.[4] This process is analogous to the judgment of taste ("this is beautiful") because in such a judgment the spectator attempts to the best of her ability to separate herself from biases or interests brought about through mere liking or contingent past experiences and to speak in a "universal voice."[5] Arendt writes that the reason "love of beauty" can be encompassed within "political judgment" is that they share the fundamental requirement of public appearance; in other words, they both presuppose a common world: "The common element connecting art and politics is that they both are phenomena of the public world."[6]

It is perhaps more difficult to imagine a politics based on the aesthetics of the uncanny. Fundamental to the notion of the uncanny is a duality that might seem at first to emulate the double movement of Kant's sublime. In the moment of sublime judgment, the spectator, faced with a phenomenon of nature that is either extremely (Kant says "absolutely") large or overwhelmingly powerful, initially feels her own frailty and insignificance but subsequently realizes the superiority of her noumenal or supersensible self—her capacity to conceptualize infinity even though she cannot perceive it, in the case of the mathematical sublime, or her moral vocation in the case of the dynamic sublime—to any natural phenomenon.[7] The second moment of the sublime is a feeling of spiritual elevation above the initially overwhelming experience.

In the phenomenon of the uncanny, as described by Freud, there is similarly a double movement, although it is partially unconscious. Freud begins his essay on the uncanny by observing that in treatises on aesthetics, within which he unhesitatingly categorizes the "special conceptual term" of the uncanny, there has historically been "as good as nothing" written about it.[8] The uncanny, he writes, "is that class of the frightening which leads back to what is known of old and long familiar."[9] Unlike the sublime, however, the frightening aspect of the uncanny gives way not to an uplifting sense of superiority but rather to a frightening feeling that what initially appeared strange is

in fact familiar and well known (this may or may not be explicitly recognized, but the fear that is aroused is precisely because of, not in spite of, this proximity). Freud analyzes the German word *unheimlich* to locate this double sense in the roots *un-* ("not") and *heimlich* ("homey," "native"). As in his discussion of negation, Freud recognizes the prefix "un-" "as the token of repression."[10] Freud concludes that the uncanny is that class of frightening things (if only emotional impulses) that were once experienced, then repressed, and that then recur: "this uncanny is in reality nothing new or alien, but something which is familiar and old-established in the mind and which has become alienated from it only through the process of repression."[11] The uncanny is thus a species of negation, through which the repressed is allowed to reappear through the sign of the unfamiliar or the negated.

Kristeva picks up on Freud's definition of the uncanny as the return of the repressed, expressing, in *Strangers to Ourselves*, the necessity of recognizing within ourselves a fundamental foreignness, namely, our unconscious. The subject split between her conscious identity and the foreignness that, while unconscious, nonetheless continually informs or intervenes into consciousness is analogous to the ambivalent and even ruptured intersubjective relations we share with foreign others. Kristeva writes: "Freud brings us the courage to call ourselves disintegrated in order not to integrate foreigners and even less to hunt them down, but rather to welcome them to that uncanny strangeness, which is as much theirs as it is ours."[12] Rather than the brotherhood of common feeling evoked by Arendt's reading of Kant's common sense, the uncanny gives rise instead to a common awareness that not only within the community but also within ourselves a fundamental *Unheimlichkeit* reigns.

From the recognition of this fundamental uncanniness, or foreignness, Kristeva extrapolates both an ethics of psychoanalysis and a politics: "it would involve a cosmopolitanism of a new sort that, cutting across governments, economies, and markets, might work for a mankind whose solidarity is founded on the consciousness of its unconscious—desiring, destructive, fearful, empty, impossible."[13] Kristeva's meditation is clearly informed by current events: recent ethnic conflicts in Eastern Europe and Africa, global warfare in the Middle East, immigrant riots in France, and the question of immigration across Europe and in North America. Clearly distinguishing her ideas from those of Arendt, Kristeva links the idea of the nation-state, which Arendt defends, along with the specific civil rights belonging to citizens of particular nation-states, as the only means of guaranteeing human rights, to a "particularistic, demanding individualism."[14] The nation-state, Kristeva writes, is constituted on the basis of the exclusion of the foreigner, the non-national, even

as it embraces the universal and philosophically abstract values of human rights. Even when the foreigner is welcomed to such a state, it is with a view to obliterating her foreignness.[15]

By contrast, Kristeva considers, among other traditions, the archaic Jewish political stance of including the foreigner within the state. This tradition can be connected to the ban on graven images, which we considered in the last chapter, by virtue of the conceptual ties between iconoclasm and welcoming the foreigner. In both cases, there is an incommensurability between materiality and divinity or spirituality. The material cannot represent the divine, nor can the material be sublated into the spiritual. And, as Gregory Kaplan notes, this incommensurability also

> guarantees the possibility of change. For matter is not permanent but transient and, consequently, subject to human alteration. Indeed, freedom finds its source in finitude. Conversely, using this freedom to alter finite existence, material existence makes possible ethical life. Thus the ban on images leads directly to the other allegedly distinctive feature of Jewish value: its social and political stance of including the stranger in the midst of a collectivity of selves, i.e. the state.[16]

Kristeva's cosmopolitanism borrows from a mélange of traditions: Jewish respect for the stranger, Stoic and Augustinian cosmopolitanism, Enlightenment cosmopolitanism (including both Kant and Diderot), and Freudian psychoanalysis. What Freud adds to classical discussions of cosmopolitanism, according to Kristeva, is a recognition of the need to integrate into the universality of the discourse on human rights "not only the smug principle according to which 'all men are brothers,' but also the conflict, hatred, violence, and destructiveness" that the discovery of the unconscious teaches us is a "modifiable but constituent portion of the human psyche."[17] Kristeva agrees with Montesquieu's idea that the nation must ultimately give way to a higher political system, resulting in what she calls "a rejection of unified society for the sake of a coordinated diversity."[18] Diderot acknowledges a basic negativity within the universalism of the Enlightenment that Kristeva translates into a fundamental respect or appreciation of foreignness that does not attempt to bend it "to the norms of our own repression."[19]

Kristeva asks the question, clearly a meaningful one for her personally, whether one can be happy and a foreigner, *as* a foreigner. She calls this state of being one of "fleeing eternity" or "perpetual transience," a feeling that must be "maintained" as "a fragile limit, a temporary homeostasis."[20] She does not

simply advocate the politics of the uncanny as an inevitable development given the increasingly shifting borders of contemporary nations, the steep rise in immigration, and the phenomenon of commercial globalization; rather, she holds the temporality and the phenomenology of the state of awareness of being a foreigner to be a desirable state for individuals in two senses: (1) in the acknowledgment of one's own foreignness within, that is, of the unconscious, and (2) as a catalyst for artistic and intersubjective creativity. The foreigner's face "burns with happiness" and "reveals in paroxystic fashion what any face should reveal to a careful glance: the nonexistence of banality in human beings."[21]

Kristeva at one point equates "foreignness" with "negativity," "madness," and "art."[22] She further implicitly compares this state of "perpetual transience" to melancholia, given that the foreigner has "lost his mother":

> As far back as his memory can reach, it is delightfully bruised: misunderstood by a loved and yet absent-minded, discreet, or worried mother, the exile is a stranger to his mother. He does not call on her, he asks nothing of her. Arrogant, he proudly holds on to what he lacks, to absence, to some symbol or other. The foreigner would be the son of a father whose existence is subject to no doubt whatsoever, but whose presence does not detain him. Riveted to an elsewhere as certain as it is inaccessible, the foreigner is ready to flee.[23]

Here we can see the figure of the foreigner occupying the middle ground between mourning and melancholia. The foreigner has "lost his mother," yet he does not seek her. He "proudly holds on to what he lacks," perpetually seeking it *as* lack; he is unwilling to leave it behind, yet this clinging does not result in lethargy or asymbolia but rather in a "delightful bruising." His father's presence is not in doubt but also does not detain him. Kristeva contrasts this to another kind of foreigner, one who "cannot . . . get over his having abandoned a period of time," who "survives with a tearful face turned toward the lost homeland."[24] This latter would be a true melancholic. She would "confront everyone with an asymbolia that rejects civility and returns to a violence laid bare."[25] This would be a misplaced foreignness, the foreignness of one who longs only to return to the place where she is already known. Only the "foreigner" (that we all really are, though we rarely admit it) who both acknowledges yet refuses to become frozen in the lost time of the mother "country" can become a "dreamer making love with absence, one exquisitely depressed."[26] It remains to be seen what this could mean.

Kristeva writes:

Let there be no mistake about it: there are, in the way one lives this at-
tachment to a lost space, two kinds of foreigners, and this separates
uprooted people of all countries, occupations, social standing, sexes . . .
into two irreconcilable categories. On the one hand, there are those who
waste away in an agonizing struggle between what no longer is and what
will never be—the followers of neutrality, the advocates of emptiness; they
are not necessarily defeatists, they often become the best of ironists. On
the other hand, there are those who transcend: living neither before nor
now but beyond, they are bent with a passion that, although tenacious,
will remain forever unsatisfied. It is a passion for another land, always a
promised one, that of an occupation, a love, a child, a glory. They are
believers, and they sometimes ripen into skeptics.[27]

Kristeva does not say more about this contrast between ironists and skeptics,
but it seems clear that she privileges the believer/skeptic, *unless* the first kind
of foreigner becomes an ironist, and it seems worthwhile to further pursue
this distinction—made here in passing—in order to clarify it.

Irony and Self-Estrangement

In a later chapter of *Strangers to Ourselves*, in her discussion of the Enlighten-
ment, Kristeva comments on a series of texts in which philosophical fiction
acquired the foreigner as a figure who invites the reader to embark on what
she calls a twofold journey. In texts such as Montesquieu's *Persian Letters*
(1721) and Voltaire's *Zadig* and *Candide*, the reader is invited to make a jour-
ney into foreign lands both in order to encounter otherness and, more impor-
tantly, in order to subsequently return to himself in order to be able to judge
or laugh at his own limitations or peculiarities.[28] Thus: "The foreigner . . .
becomes the figure onto which the penetrating, ironical mind of the philoso-
pher is delegated—his double, his mask. He is the metaphor of the distance at
which we should place ourselves in order to revive the dynamics of ideologi-
cal and social transformation."[29]

In particular Kristeva discusses Diderot's *Rameau's Nephew*, a text that is
also the focus of Hegel's discussion of Culture in the *Phenomenology of Spirit*.
Not surprisingly, Hegel's discussion comes in a section of the *Phenomenology*
entitled "Spirit in Self-Estrangement." The text by Diderot is structured
around a conversation between "I," a philosopher defending universalist
morality and ethical conduct, and "He," the nephew of Rameau, a nihilist
and libertine, who illustrates the philosopher's ironic mask. Hegel argued that

Rameau's Nephew illuminated the emergence of a specifically modern consciousness, one that encompassed both a self-awareness of the culturally embedded nature of many of our deepest convictions and a recognition of the roles we play within society. The nephew's persistent attack on and dismantling of the philosopher's traditional positions illuminates, for Hegel, the fundamental contradiction inherent in Enlightenment consciousness between an adherence to universalist claims and the embrace of individual subjectivity—as Adorno puts it, "the Enlightenment abolishes itself by realizing itself."[30] Although this contradiction gets overcome, for Hegel, in the truth of Kantian morality, Kristeva prefers to linger with idea of the nephew as a kind of intellectual "foreigner" who cannot be simply assimilated or sublated.

For Hegel, irony is "caprice," a stance that can "make every determinacy waver and dissolve and therefore made it possible for art to transcend itself."[31] The attitude of the nephew, while it evinces a certain freedom from the purely substantial universality of the past, attesting to the birth of modern subjectivity, nonetheless has dangerous anarchistic implications for Hegel. In his *Lectures on Aesthetics*, Hegel describes romantic irony[32] as a kind of posturing resulting from an artist's appropriation of a limitless intellectual authority to herself. Such an attitude can be liberating and exhilarating, in that it implies that one can literally create a world with one's imagination, but equally potentially terrifying in that no substantial identity remains to which the subject can relate or with which it can identify itself. On this view all creations begin to have equal value, and this purely inward life becomes merely subject without substance, an equally poverty-stricken and one-sided view as the tradition-bound substantial ethical life that it had rejected.

Kristeva's conception of irony is quite different and at least potentially positive. Following Roland Barthes, who wrote that "irony is nothing other than the question which language puts to language," she conceives of irony as the task of the critic, who "participates in the process of [the writer's] writing" by putting it into question.[33] Language, according to Barthes, is a form of negativity, a problem that critics try to solve. Kristeva, alluding to themes in her earlier theoretical work on the semiotic, writes that literary language "literally pulverizes the subject as well as its individual representations."[34] Without the critic, writing is "an infinity seeking its laws," and writers are "subjects recording an always-already ancient meaning always-already exceeded, as peculiar as it is ephemeral."[35] The task of the critic is to posit the writer as a knot in this infinite unfolding, as one who has stolen from and recorded fragments of "the old text" of culture, science, and literature, and "change[d] its features according to formulae of disguise."[36] The negativity of language thus, in the work of

the critic, coexists with the posited unity and positivity of the writer. The critic "seizes" and affirms the negativity of writing as a positivity, and "by implicating himself in the negative operation that is language through the intermediary of the other (the author), the critic retains a weakened but persistent effect from the negativity of writing: the *death drive* of the writer becomes *irony* in the critic, because there is irony each time an ephemeral meaning crystallizes for a certain recipient."[37] Irony is thus provisional meaning that is seized upon and affirmed and that exposes the critic's position at the very origin of linguistic meaning.[38]

In contrast to Hegel, Kristeva focuses on the resources that emerge when one pays heed to what philosophy has traditionally excluded, in particular to the foreigner and the body, as exemplified by Diderot's *Rameau's Nephew*. She connects Diderot's contention, in his *Eléments de physiologie*, that all sensations are bound to "organic convulsions" to his depiction of the nephew as a person who reveals his thoughts through a language of spasms, convulsions, and tics.[39] She quotes Diderot to the effect that "there is not the slightest difference between a wide-awake physician and a dreaming philosopher,"[40] further establishing a connection between the body, the semiotic, and the unconscious—the foreigner within each of us, even in the most rational of philosophers—manifest in the dream. The nephew has no country of origin, does not know what it is to be a citizen. His stance is ironic in its position alongside and in opposition to that of the philosopher, without possibility of reconciliation, just as the unconscious and consciousness coexist.

Irony also plays a role in melancholic art, with reference to the impossibility of directly representing death:

Like Pascal's invisible tomb, death is not representable in Freud's unconscious. It is imprinted there, however, as noted earlier, by spacings, blanks, discontinuities, or destruction of representation. Consequently, death reveals itself as such to the imaginative ability of the self in the isolation of signs or in their becoming commonplace to the point of disappearing: such is Holbein's minimalism. But as it grapples with the erotic vitality of the self and the jubilatory abundance of exalting or morbid signs conveying Eros's presence, death calls for a distant realism or, better, *a grating irony*: this brings forth the "danse macabre" and disenchanted profligacy inborn in the painter's style. The self eroticizes and signifies the obsessive presence of Death by stamping with isolation, emptiness, or absurd laughter its own imaginative assurance that keeps it alive, that is, anchored in the interplay of forms. To the contrary, images

and identities—the carbon copies of that triumphant self—are imprinted with inaccessible sadness.[41]

The aesthetic "danse macabre" that the self performs around death, erotizing itself against the pervasive presence of the death drive laid bare by sublimation, results in a proliferation of imaginative wanderings that straddle Eros and Thanatos. Irony here signifies leaving unsublated the opposition between sense and non-sense, between the semiotic chora and symbolic meaning, between the self and the other, and between life and death.

In *Nations Without Nationalism* Kristeva further links the trope of irony to the notion of a "boundary-subject" who would have both the "luck and the responsibility of straddling body and thought, biology and language, personal identity and dissemination during childhood, origin, and judgment, nation and world."[42] The ironist, then, would be that species of "foreigner" who, though she holds on tightly to memories of the mother country, to the point of "wast[ing] away in an agonizing struggle between what no longer is and what will never be,"[43] nonetheless has the possibility of exploring an in-between that for Kristeva always marks the highest point of creative endeavors. Hegel reads Culture, or *Bildung*, in the Enlightenment as a form of self-estrangement of natural being consisting in political, social, intellectual, and economic transformation. *Rameau's Nephew* illustrates this process of self-estrangement in a very concrete and rather literal way. Kristeva endorses self-estrangement rather as a "polymorphic culture that returns everyone to his or her otherness or foreign status."[44] When self-estrangement is historically overcome, in Hegel's reading, Kristeva writes that "the polyphony of Hegel . . . gives way before the triadism of his dialectic," and the world of culture is surpassed by that of morality, religion, and finally absolute knowing. Kristeva, in this and every appropriation of Hegelian dialectic for her broader project, implies that the kind of artwork that is called for today would somehow perform a suspension of the dialectic right at the point of its highest estrangement or contradiction, allowing or forcing the spectator/audience to linger in foreignness.

Kristeva's analysis is more tenable in aesthetic than in concrete political terms,[45] and it is certainly weakened by her suggestion, at the end of the discussion of *Rameau's Nephew*, that the polyphonic notion of culture is a French one and that "culture itself might be French."[46] Given recent immigrant riots in Paris, the dispute over the wearing of the Muslim headscarf in French schools, the rise of racist French nationalist politicians like Jean-Marie le Pen, and the widespread toleration, if not approval, of the Front National's xenophobic politics, it is hard to argue that the ideal of a culture in which other-

ness is accepted and celebrated rather than obliterated is instantiated in French culture of any era.

THE RELATION OF UNCANNY *KULTURARBEIT* TO MARXIST/ HEGELIAN *ENTÄUSSERUNG*

Kristeva does not thematize art in *Strangers to Ourselves*, though she gives many examples of foreignness from literature. Yet it seems that a Kristevan argument could be made for including this discussion of foreignness—both the foreignness within and that which comes from the outside—within her broader conception of aesthetics. Anna Smith has done work on this subject in her *Julia Kristeva: Readings of Exile and Estrangement*, but she focuses primarily on literature, also Kristeva's privileged art form in her earlier works. As Smith elaborates, Kristeva has always been interested in the possibility of a deliberate self-estrangement and subsequent revolution in language, one that had resonances, in the late 1960s, with the political economy analyzed by Marx in his later writings.[47]

While Smith is correct in aligning Kristeva, along with other avant-garde writers of the late 1960s, with Marx's politics based on his writings subsequent to his break from humanism, in particular in Kristeva's case because she wants to read the subject primarily in terms of forces that exceed her consciousness, I think it might nonetheless be instructive to consider the Marx of the *1844 Economic and Philosophic Manuscripts* in reading Kristeva's link to Marxism, since the concept of estrangement, which comes out of Hegel and Marx's philosophy, is central to Kristeva's notion of foreignness.

In his early essay on the various stages of private property and communism, Marx appropriates and elaborates the Hegelian notion of property (from the *Philosophy of Right*) as the most primordial form of human self-development from nature to freedom. Here, Hegel writes that "I possess my body, like other things, only so long as I will to possess them. . . . In so far as the body is an immediate existent, it is not in conformity with spirit. If it is to be the willing organ and soul-endowed instrument of spirit, it must first be taken into possession by spirit."[48] This is the Hegelian notion of *Entäusserung*, the necessary self-actualizing human activity of appropriating the external world and making it a part of spirit. In his early writings Marx develops the notion of the necessity of the human body developing into spirit beyond the individualism of abstract right, where Hegel locates it, into the social and economic sphere. Our reductive, estranged notion of private property, Marx writes, "has made us stupid and one-sided so that [we think] the object is only ours when we

have it, when it exists for us as capital or when we directly possess, eat, drink, inhabit, use it."[49] Property genuinely defined, including the possession of one's body, must be understood as "the appropriation of human reality" or social reality.

For Marx the body, and more specifically the senses, will eventually be able, through a transformed understanding of property and a transformed political and economic life,[50] to develop in a way that will foster true aesthetic and social perception and awareness. When the one-sided sense of property as mere consumption and possession is superseded through the establishment of true communism, the senses and attributes of the human body will also be emancipated.[51] Marx writes that "only through the objectively unfolded wealth of human nature can the wealth of subjective human sensitivity—a musical ear, an eye for the beauty of form—be either cultivated or created."[52] He insists that "subjectivism and objectivism, spiritualism and materialism, activity and passivity, lose their antithetical character, and hence their existence as such antitheses, only in society."[53] Thus the creation and appreciation of a true sense of art can only develop when social, economic, and political conditions are propitious.

If "the senses of social man are different from those of non-social man,"[54] then the human body cannot be understood in isolation from its relation to society. In his early writings Marx equates naturalism with humanism and species-being with human nature. To become social, for the human being, is to become what the human naturally is, to develop human natural potential fully. It is interesting, then, to think about why Kristeva criticizes Marx for transforming the "cutting edge of negativity" taken from Hegel "into the realm of society,"[55] particularly in his later writings.

Kristeva's critique of Marx should be understood to focus not so much on the extension of his critique into the realm of the social—after all, as we have seen, she does this herself—but rather on the fact that he assumes human nature, when fully and properly actualized, to be cohesive and nonestranged; the "natural" fulfillment of humanism, on this view, would be a unified and homogeneous society. The "cutting edge of negativity" that Kristeva identifies in human nature is a negative that divides irrevocably. This is also a kind of naturalism, for the human being, according to the psychoanalytic view, is naturally split between consciousness and the unconscious. In Hegel the "negative," with reference to the human being, is consciousness itself, but in Kristeva's reappropriation of Hegelian negativity, it is impossible to understand this consciousness without the unconscious that subtends it. Thus, on Kristeva's

Hegelian-Freudian view, there will always be a remainder in consciousness's return to self. This remainder sometimes protrudes into conscious life, but it is never fully unified with it or completely present. Thus Kristeva's understanding of subjectivity is only a humanism to the extent that the human is recognized as fundamentally noncoincident with itself and with the world on which it works. This nonstatic conception of subjectivity can be seen most strikingly in Kristeva's analysis of poetic language and of color in visual art and in her phenomenology of the experience of maternity.

As we have noted, it is primarily in the Freudian notion of the unconscious that Kristeva wants to ground her conception of the foreigner. Asking the question whether human universality might not best be understood as the presence within each of us of a foreigner, Kristeva writes: "Henceforth the foreigner is neither a race nor a nation."[56] And further: "How could one tolerate a foreigner if one did not know one was a stranger to oneself?"[57] It is here that she begins a discussion of the uncanny, arguing that it opens up the idea of *Kulturarbeit* as the confrontation with the unknown both in ourselves and in others.[58]

This confrontation results not just in an "eye for beauty" but also in a kind of unconscious identification with preformal and presignificative elements of the artwork that coexist with its form and meaning. In her earliest theoretical work, Kristeva examined the fourteenth-century painter Giotto alongside her analysis of the twentieth-century novel. She argued for an experimentation with color and architecture in Giotto's work analogous to the experimentation with the semiotic side of language in the works of Mallarmé and Joyce.[59] In the relationship between the artist and what is represented, and between the contemporary viewer and the work of art, Kristeva describes an ever-present excess, a "more than name become space and color, a painting."[60] She speculates that the "artistic function" presents an economy "clearly distinct from that of communication" by "forsak[ing] the distance that kept apart 'thought' from 'drives' and 'thing-presentations.'"[61]

Kristeva takes the language of "thing presentation" and "word presentation" from Freud's theory of language. Essentially, a thing presentation is a visual presentation of a thing, and a word presentation is auditory. While the unconscious contains nothing but thing presentations, in consciousness thing presentations are bound to their corresponding word presentations. The domain of repetition that she identifies in literature, in the psychoanalytic situation, and in the icon involves an appropriation of the thing presentation by the word presentation in which the thing presentation does not entirely disappear.

This artistic economy allows the ego to experience itself without its usual clear isolation from the underlying "triple register" of thought, drive, and thing presentation:

> In a painting, color is pulled from the unconscious into a symbolic order; the unity of the "self" clings to this symbolic order, as this is the only way it can hold itself together. The triple register is constantly present, however, and color's diacritical value within each painting's system is, by the same token, withdrawn toward the unconscious. As a result, color . . . irrupts into a culturally coded pictorial distribution.[62]

The experience of viewing painting, then, results in a feeling of a kind of threat to the self or ego, but at the same time the "chromatic experience cradles the self's attempted reconstitution." The *re*constitution of the self would be a "revival of the self through and beyond the pleasure principle"; the place of aesthetic pleasure is "a turning point between the 'self's' conservative and destructive proclivities; it is the place of narcissistic eroticism (autoeroticism) and death drive—never one without the other."[63]

The language of the destruction and reconstitution of the self resembles that of Kant's description of the sublime, though without its comforting resolution. The experience of the sublime, according to Kant, involves a threat to the phenomenologically constituted self, in the form of an anticipated collapse of the imagination. This threat takes the form of a "simultaneity made intuitable" (disrupting the successive temporality of the form of intuition of time) in the case of the mathematical sublime and a threat of danger or death to the physical body in the dynamic sublime. In both cases of the sublime the self is reconstituted by virtue of an appeal to the supersensible self:

> For although we found our own limitation when we considered the immensity of nature and the inadequacy of our ability to adopt a standard proportionate to estimating aesthetically the magnitude of nature's *domain*, yet we also found, in our power of reason, a different and nonsensible standard that has this infinity itself under it as a unit; and since in contrast to this standard everything in nature is small, we found in our mind a superiority over nature itself in its immensity. . . . Hence if in judging nature aesthetically we call it sublime, we do so not because nature arouses fear, but because it calls forth our strength . . . it elevates [*erhebt*] our imagination, [making] it exhibit those cases where the mind

can come to feel its own sublimity, which lies in its vocation and elevates it even above nature.[64]

In Kristeva's description of chromatic experience the terms are inverted; what is experienced is not a supersensible self but rather a fragmentary self that predates the unitary, isolated ego. The "revival of the self" never fully succeeds "in the sense that it would constitute a subject under symbolic law," since there is an experience of the unruly drive economy that was repressed in order to form the ego, yet this experience takes place from the perspective of the already constituted subject:

> It achieves the momentary dialectic of law—the laying down of One Meaning so that it might at once be pulverized, multiplied into plural meanings. Color is the shattering of unity. Thus, it is through color— colors—that the subject escapes its alienation within a code (representational, ideological, symbolic, and so forth) that it, as conscious subject, accepts. Similarly, it is through color that Western painting began to escape the constraints of narrative and perspective norm (as with Giotto) as well as representation itself (as with Cézanne, Matisse, Rothko, Mondrian).[65]

This experience that modern art effects might be understood as a kind of transformation of the sublime into the uncanny. If the dual drive element, or the coincidence of Eros and Thanatos, is repressed in order to enter into the symbolic order, then what is experienced in chromatic, nonrepresentational art could be seen as a kind of return of the repressed. This return of the repressed strikes us as unfamiliar, but, as Freud points out in his discussion of the uncanny, it is actually what is closest to us. Like in the semiotic within language, Kristeva writes, this chromatic experience involves a "shattering of meaning and its subject into a scale of differences," but in such a way that, although they (meaning and the subject) are beyond signification, they are not so, as was originally the case, in a manner prior to language and subject formation but rather in a way that "holds meaning's surplus" or exceeds verbal signification: "As asserted and differentiating negativity, pictorial color (which overlays the practice of a subject merely speaking in order to communicate) does not erase meaning."[66] This chromatic "grid" is "heavy with 'semantic latencies' linked to the economy of the subject's constitution within signifiance." Kristeva calls this a kind of "chromatic joy" which the subject feels in "liberating himself from the transcendental dominion of One meaning (white) through

the advent of its instinctual drives, again articulated within a complex and regulated distribution."[67]

In "Stabat Mater" Kristeva considers another kind of disruption of unified subjectivity in the experience of pregnancy. In this text she juxtaposes the symbolic appropriation of maternity by Christianity alongside a phenomenological and sometimes personal reflection on the bodily experience of being pregnant, showing, in doing so, the sharp contrast between the communicative linguistic medium of Christian doctrine about maternity and the semiotically informed experience of maternity. These two discourses are separated into two columns in the text, but at times the columns merge, and one can only tell them apart by the fact that the "experiential" text is in bold type. This stylistic device allows Kristeva to drive home the fact that these discourses are intertwined and that Christianity's symbolic appropriation of motherhood is only accomplished through its repression of the nonlinguistic or protolinguistic bodily experience of giving birth. At one point Kristeva calls this latter discourse on the edges of language "word flesh," an attempt of the body to speak, to "take a chance with meaning" through "metaphors of the invisible." Such a metaphorical "language" takes place in a "flash" or in a time "without time."[68] This is the language of tears and milk, the "metaphors of nonspeech, of a 'semiotics' that linguistic communication does not account for."[69] Though not yet acceding to the historical time of narrative or the abstraction of the sign, the underbelly of signification is nonetheless a crucial part of its genesis.

Another way in which Kristeva describes this experience at the borders of communicative language is as a series of "photos of what is not yet visible."[70] The metaphor of semiotic discourse likened to bodily drives being recorded as images on an as yet undeveloped photographic film recalls Freud's comparison of the unconscious to a photographic negative that may come into consciousness (or be developed) at any point in conscious life. Kristeva writes that, apart from the unanticipated moments in which the unconscious may emerge into conscious life, it is only the artist who may, to continue the metaphor, develop these "photographic" images, or "make up for the vertigo of language weakness with the oversaturation of sign systems."[71]

In other words, the only way go "through" what Kristeva calls the "religion of the Word" is the "artists' way."[72] The symbolic representation (in particular in Christianity) of the mother as the Madonna or as idealized maternal love is a form of compensation for the weakness of language at the actual maternal site. Only "the saint, the mystic, or the writer" can possibly escape the almost inevitable tendency to hide the loss that takes place at the moment of birth. Modern art takes on this role as the "implementation of that maternal love."[73]

Freud specifically separated the uncanniness provoked by aesthetic experience from that in reality,[74] insisting that fairy tales do away with an uncanny effect because of their obvious fictional nature, which causes the reader from the start to suspend disbelief and reality testing. By contrast, Kristeva maintains that the semiotic element that much art foregrounds makes possible a return of the prerepresentational repressed unconscious and, in juxtaposing this return with a recognizable narrative, can also provoke an uncanny response.

Modern art and music, which allow for nonrepresentational swaths of color or sound, celebrate love for the retreating maternal site while also recognizing that it is not a place to which one could ever return. The photograph's medium, its delayed temporality and its capacity to register details of which the senses may not even be conscious at the time it is taken, makes it a metonym for all modern art.

KAFKA, PHOTOGRAPHY, ART

I will now turn back to Benjamin's conception of the photograph, this time in conjunction with his discussion with Adorno over whether or not photography could be considered a legitimate art form, in order to think of the photograph as a figure or metaphor for the uncanny potential of art. In so doing, it will be necessary to take a detour through Benjamin and Adorno's readings of Kafka, which in turn will lead us to Kristeva's discussion of Kafka.

First of all, it should be noted that Benjamin and Adorno did not concur over the aesthetic value of photography. While Benjamin was fascinated, as we have seen in the last chapter, with the way in which the camera can capture that which is normally invisible to the observing eye—the "optical unconscious,"—and with the peculiar temporality of photography, its capacity to freeze a moment and make present a temporal anteriority that illuminates the present, Adorno quite naturally saw in photography and in particular film an inescapable tendency to "mulishly mirror" what it depicts. Nevertheless, Adorno had an interesting conception of photography as a figure for nonphotographic art that can be read both in terms of the art of the uncanny that we have been discussing and as a counterpart to Benjamin's discussion of the photograph. Although Adorno criticized Benjamin's claim that there were redemptive and revolutionary possibilities in photography and in film as works of art, he nonetheless did concur that there was something compelling about the conceptual framework according to which Benjamin described photography. In particular, the two thinkers' views converge in an interesting way in relation to their commentary on and discussion of Kafka, with respect to

which Adorno writes to Benjamin that "our agreement in philosophical fundamentals has never impressed itself upon my mind more perfectly than it does here."[75]

Benjamin's essay on Kafka is informed by his conception of *Urgeschichte*, or primal history, whose temporality, like that of the photograph, is in the future anterior. I will argue that Benjamin's conception of the primally historical (the *ur-geschichtlich*), which he refers to in different places as "nature," "the repressed," "the unredeemed," "the past before the Law and language," and "dream images," might also be a cipher for the unconscious as Kristeva discusses it in her writings on art and maternity. Indeed, in the *Arcades Project*, Benjamin refers to a kind of collective unconscious, and his interest in surrealism also testifies to his interest in the unconscious as a figure for both the primal past and a possible vision of the future. In encounters with the primally historical, we come face to face with our own lineage in such a way that we can recognize it at some level, but at the same time it remains fundamentally foreign to us.

Illuminating unrecognized moments of the past in a movement that Benjamin describes as "flashlike," the articulation of primal history both preserves the past from oblivion and illuminates the possible future as the unredeemed or repressed consequence of those forgotten moments. To understand primal history, one must glean a conception from multiple fragmentary sources. Benjamin describes primal history and his conception of origin in *The Origin of German Tragic Drama* as analogous to Goethe's conception of the *Ur*-phenomenon in nature.[76] The moments of *Urgeschichte* that are illuminated by the philosopher or writer are moments whose significance historically went unrecognized and that are therefore in the process of disappearing from narrative accounts of the past. In redeeming these moments, their connection both to our present situation (as possibilities not pursued or achieved) and to the future (as potential redemption for the present) can be made manifest. Using what he called "dialectical images," the project of primal history opened up both the regressive elements of and the utopian possibilities within modern culture. In a well-known passage from the *Arcades Project*, Benjamin describes the dialectical image as "that wherein what has been comes together in a flash with the now to form a constellation. In other words: the image is dialectics at a standstill . . . not temporal in nature but figural."[77] The dialectical image can therefore be called a form of recollection or, given its flashlike nature, a kind of involuntary memory.

For Benjamin, Kafka is an exemplary constructor of dialectical images and, by extension, of primal history. In "Franz Kafka: On the Tenth Anniver-

sary of His Death," Benjamin writes of the "prehistoric forces that dominated Kafka's creativeness—forces which, to be sure, may justifiably be regarded as belonging to our world as well."[78] He goes on to say that Kafka did not understand the significance of the dialectical images he constructed: "Only this much is certain: he did not know them and failed to get his bearings among them. In the mirror which the prehistoric world held up to him in the form of guilt, he merely saw the future emerging in the form of judgment."[79] In other words, Kafka recognized only the failure and the condemnation inherent in the dialectical images he constructed and not their utopian intimations.

Benjamin writes of *Urgeschichte* in various contexts. In particular, in the *Arcades* project he is concerned with exposing moments of "primal phenomena" that both illuminate an origin of the decline of a particular historical period, in this case the nineteenth century, *and* give an idea of how redemption might intervene as a vision in flashlike fashion out of these same moments, in the way that the primal, ideal plant, in Goethe, can be glimpsed only out of the observation of its empirical unfoldings in physical specimens:

> I pursue the origin of the forms and mutations of the Paris arcades from their beginning to their decline, and I locate this origin in the economic facts. Seen from the standpoint of causality, however . . . these facts would not be primal phenomena; they become such only insofar as in their own individual development—"unfolding" might be a better term—they give rise to the whole series of the arcade's concrete historical forms, just as the leaf unfolds from itself all the riches of the empirical world.[80]

Like Goethe, Benjamin viewed the primal phenomenon not as a chronological beginning or as a cause of a particular empirical phenomenon. Rather, the *Ur*-phenomenon posits the structural coherence of the whole—for Benjamin in this case, the arcades as a figure for the nineteenth century (for Goethe, all of nature). Nevertheless, Benjamin did not think this whole could ever be presented in its totality to human consciousness, at least in modernity. Whatever primal history is, it can only be glimpsed in fragments, which is why it always preserves its flashlike temporality.

According to Benjamin, Goethe searched in vain for the primal phenomenon in nature. Because Goethe attempted to furnish empirical, scientific evidence for the primal phenomenon, "the primal phenomenon as archetype (*Urbild*) too often turned into nature as model (*Vorbild*)."[81] The difference between *Urbild* and *Vorbild* would be the difference between viewing a

primal phenomenon as outside of time and as a cause within time. Benjamin writes that

> only in the domain of art do the *ur*-phenomena—as ideals—present themselves adequately to perception, whereas in science they are replaced by the idea, which is capable of illuminating the object of perception but never of transforming it in intuition. The *ur*-phenomena do not exist before art; they subsist within it. By rights, they can never provide standards of measurement.[82]

Thus the primal should not be confused with an origin that can be pinpointed in time; only humanly created works, which have the possibility of being transformed in intuition, may manifest these phenomena. Rather, moments of primal history interpenetrate historical time without being reducible to it.

In "Paris, the Capital of the Nineteenth Century," Benjamin again discusses primal history, this time in terms of dream, wishes, and the collective unconscious. In the context of a discussion of new technology, building materials, and means of production that are coming to be used and known, Benjamin remarks on the emergence of new "wish images" in which "the new is permeated with the old"[83] and at the same time in which a desire is expressed to leave everything antiquated behind:

> These tendencies deflect the imagination (which is given impetus by the new) back upon the primal past. In the dream in which each epoch entertains images of its successor, the latter appears wedded to elements of primal history [*Urgeschichte*]—that is, to elements of a classless society. And the experiences of such a society—as stored in the unconscious of the collective—engender, through interpenetration with what is new, the utopia that has left its trace in a thousand configurations of life, from enduring edifices to passing fashions.[84]

Here primal history refers to a "classless" society, one realized at no point in history, that nevertheless has been stored in the archaic past, in a time before time (before consciousness), in the "unconscious of the collective."

We can compare this analysis to the way Benjamin discusses the photograph in "Little History of Photography." Recall that the photograph, too, has a flashlike temporality that is outside the linearity of historical time, for it simultaneously indicates at least two moments: the present in which it is viewed and a trace of the past that, like the lost or disappearing moment of time that

is redeemed in primal history, manifests a lineage of what might have been. In the photograph of Dauthendy and his fiancée, for example, a moment in the past emerges flashlike, transformed in the perspective of the present, and seems to contain an indication of something unconscious that suggests future events. This is precisely the temporality of the dialectical image, which Benjamin connects to primordial history in its relationship to historical time.

In order for the dream image to have dialectical efficacy, it must in some way have the capacity to influence the present or future. The dialectical image marks the efficacy of a dream image in transforming a dream, resulting in a historical awakening. One might think, like Susan Buck-Morss, of the story of Sleeping Beauty, who awakens from dream/sleep at the end of a story that is itself dream/fantasy.[85] This imaginative aspect is what places the discussion within the realm of art, perhaps even of popular culture,[86] despite the important political implications of Benjamin's theory. Benjamin argues that, like photography, the procedure of this kind of work has to be visual rather than linear or historical. His aim was to construct images according to the theory of montage, which he calls "the art of citing without quotation marks."[87] Only in such a manner, without linear continuity, could the past "touch" the present moment,[88] in the way we also saw was possible in the photograph. Moreover, such a process of "construction" equally requires "destruction."[89] Benjamin rejects the historian's attempt at a pure gaze into the past, "without involving anything that has taken place in the meantime."[90] The dialectician "cannot look on history as anything other than a constellation of dangers which he is always, as he follows its development in his thought, on the point of averting."[91] In the same way, a photograph cannot provide a pure gaze into the past.

Because of the contiguity of past and present constructed in the dialectical image, the oscillation between them being precisely what constitutes the image as dialectical, the process described in both Benjamin's mediations on history and on photography can be called a mode of recollection. In "On the Concept of History" Benjamin writes: "The true image of the past flits by. The past can be seized only as an image that flashes up at the moment of its recognizability, and is never seen again . . . it is an irretrievable image of the past which threatens to disappear in any present that does not recognize itself as intended in that image."[92] What historical materialism, according to Benjamin, seeks to do is to appropriate "a memory as it flashes up . . . to hold fast that image of the past which unexpectedly appears to the historical subject in a moment of danger."[93]

Benjamin characterizes Kafka's writings as an attempt to enact precisely this form of recollection, describing them as "simply full of configurations of

forgetting—of silent pleas to recall things to mind."[94] The forgotten assumes manifold forms; Kafka's work presents these fragments of the forgotten, mingling those moments of primal history that have disappeared or are threatening to disappear from view, and constructing new dialectical images. This amalgamation yields "countless uncertain and changing compounds . . . a constant flow of new, strange products."[95]

Out of the multitude of strange hybrids in Kafka's work, Benjamin focuses on the character Odradek in "The Cares of a Family Man" as the most singular. A flat, star-shaped spool with bits of thread wound about it, Odradek is nonetheless animated and can stand upright and move. Odradek is monstrous, uncanny, a living "form which things assume in oblivion."[96] According to Freud, "an uncanny effect is often and easily produced when the distinction between imagination and reality is effaced, as when something that we have hitherto regarded as imaginary appears before us in reality."[97] Here Kafka goes one step further, in animating a thing that would not even have occurred to our imagination prior to reading the story. Odradek is both banal and familiar, resembling a spool of thread, and weird in its animation and its oblique language. The effect is uncanny in both its proximity to and utter distance from ordinary experience.

Adorno addresses the uncanny effect of Kafka's stories with an analogy to photography. He writes, in a letter to Benjamin:

> I claimed [in an earlier interpretation of Kafka] he represents a photograph of our earthly life from the perspective of a redeemed life, one which merely reveals the latter as an edge of black cloth, whereas the terrifyingly distanced optics of the photographic image is none other than that of the obliquely angled camera itself.[98]

Shierry Weber Nicholson likens this comparison to a photograph of the Earth from space, a figure that Adorno uses elsewhere.[99]

As Nicholson points out, Adorno is primarily interested in the photographer's gaze and the "photographic negative," a phrase he uses in his essay on surrealism; that is, he is interested in the difference between what is photographed when it is seen in an ordinary way and when it is the subject of a photograph or the object of a photographer's gaze. Benjamin, by contrast, is less concerned with the perspective of the photographer and concentrates primarily on what is photographed, both in terms of how it changes as a result of being photographed and what effect it has as a photograph,[100] as well as the historical significance of the process of photography itself.[101] The photograph's

fidelity to nature has been called, by Rosalind Krauss, its indexical quality, whereas its iconic quality is its capacity to present a visual likeness.[102] While Krauss argues that what distinguishes photography from other forms of visual art is the "absolute" relationship between these two qualities, such that the symbolic intervention that usually obtains between them is "short-circuited," I would argue that Benjamin, at least, would see photography at its strongest as an ability to separate the iconic from the indexical quality. If photography is "presymbolic," for Benjamin it would not be because, as Krauss claims, no Symbolic operations find their way into photographic art through the human consciousness, because consciousness makes a direct, Imaginary connection between objects and their meaning in photographs;[103] rather, photography has an intimate connection to the optical unconscious and to the prehistorical, that place where a "tiny spark of contingency" has "seared the subject, such that in 'that long-forgotten moment the future nests so eloquently that we, looking back, may rediscover it.'"[104]

Photography is the only art through which we may view the past with the eyes with which it viewed itself.[105] This does not imply, however, that to interpret history is to return to a point in time and reproduce it. For, as Benjamin writes, citing André Monglond, it is only in the future, in the touching of past and future, that history can be understood: "If one looks upon history as a text, then one can say of it what a recent author has said of literary texts— namely, that the past has left in them images comparable to those registered by a light-sensitive plate. 'The future alone possesses developers strong enough to reveal the image in all its details.'"[106] To put it even more strongly, the truth of what is revealed is not identical to the way in which it appeared at the time of its manifestation. The image's details must be developed in the way a negative is developed into a print, with the technology, to continue the metaphor, that only the future holds.

Adorno, by contrast, saw in photography and film an almost insurmountable temptation to be mimetic in the traditional sense of the word, that is, to represent faithfully what is portrayed. Nevertheless, his use of photography as a figure for Kafka's work casts an interesting light on the political role of art that seems to depend on at least a version of Benjamin's theory of photography.

What would be the significance of a photograph of the Earth from space? Even now that such photographs are relatively common and cannot have quite the same striking effect as they must have had the first time such images of the planet from such a distant perspective were taken and disseminated, we can still recapture, even in thought, their uncanny effect. Such a photograph

allows the future (space travel, remote photography) to touch the past (the familiar geography in which we have grown up). It literally makes what is most familiar, our home or *Heim*, unfamiliar, *unheimlich*. While we know that what we are seeing is literally the place in space where we are now existing, we nonetheless experience it with a shock as something outside of us.

Adorno's exposition of this metaphor comes from a draft of his Kafka essay that cannot be accessed, though we know of its existence through his letter to Benjamin. He compares his position to Benjamin's, calling his own an "'inverse' theology,"[107] or "hell seen from the perspective of salvation."[108] In a more distressing version of the Earth-from-space image, Adorno writes that in the Middle Ages Jews were tortured and executed by being hung upside down; "Kafka," he writes, "photographs the earth's surface just as it must have appeared to these victims during the endless hours of their dying."[109] Adorno calls this perspective a form of "artistic estrangement," one in which the world is seen as "as lacerated and mutilated."[110]

In the version of the Kafka essay published in *Prisms*, Adorno compares the shock evoked by Kafka's writing to "a surrealistic arrangement of that which old photographs convey to the viewer."[111] He also notes the role of such a photograph in *The Castle*. In that work "the fund of flash photographs is as chalky . . . as a petty-bourgeois wedding by Henri Rousseau."[112] Adorno's interpretation of Kafka reveals its political implications, which, like Benjamin, he sees as obliquely present, just as an image might be present on a photographic plate, but not capable of being developed except in a time beyond Kafka's own. In Kafka's stories, "the social origin of the individual ultimately reveals itself as the power to annihilate him."[113] Kafka's "epic course" is "the flight through man and beyond into the nonhuman."[114] And perhaps most strikingly: "Perhaps the hidden aim of his art as a whole is the manageability, technification, collectivization of the *déjà vu*."[115] Here we have a glimpse into the future by virtue of the recognition of what has already been: "there are also images of what is coming, men manufactured on the assembly-line, mechanically reproduced copies."[116] Kafka "unmasks monopolism by focusing on the waste-products of the liberal era that it liquidates."[117] Like the view of the Earth from space, Kafka's works reveal to us a picture of our most intimate lives that shocks in its absurdity. His inverse theology "'feigns' the divine or angelic standpoint in order to see the fallenness of the world."[118]

Adorno also describes Kafka as one who translates the practices of expressionist painting into literature. This transfer allows his images to "petrify into a third thing, neither dream, which can only be falsified, nor the aping of reality, but rather its enigmatic image composed of its scattered fragments."[119]

This "third thing" is what Benjamin and Adorno mean by mimesis, and to portray the third thing, the "inexhaustible intermediate world," which, in Kafka's stories, "presses toward the light," is the aim of the ban on graven images.[120] Both Adorno and Benjamin, strikingly, attribute an iconoclastic fidelity to Kafka, despite the omnipresence of vivid images in his writings. For Benjamin, "No other writer has obeyed the commandment 'Thou shalt not make unto thee a graven image' so faithfully."[121] Adorno reads the ban on images, which he had earlier linked to the materialist redemption of the bodily,[122] as assuring in Kafka the "mutilated creature's inability to die,"[123] visible only in "the salvation of things, of those which are no longer enmeshed in the network of guilt, those which are non-exchangeable, useless."[124] Thus nonentanglement in images is closely linked to nonentanglement in the sphere of instrumental reason and commodity exchange.

The Space Between

I have made this digression back into the ban on graven images for the purpose of emphasizing the "third thing" or "intermediate world" between dream and reality. Both Adorno and Benjamin became fascinated with the surrealist movement in art because it seemed to portray precisely this intermediate phenomenon. It is important that the "the third thing" be recognized as a *thing*, in order to connect redemption to history and materiality, although it cannot be reduced to an object.

In an essay called "Surrealism: The Last *Snapshot* of the European Intelligentsia" (my emphasis), Benjamin calls the surrealist movement, in this case the thought of Andre Breton, "the first to perceive the revolutionary energies that appear in the 'outmoded'—in the first iron constructions, the first factory buildings, the earliest photos."[125] This capacity to convert things into energy "consists in the substitution of a political for a historical view of the past."[126] Just as surrealist literature and photography dissolve the things in which they appear, allowing them to release their energy, so too the surrealist emphasis on the dream "loosens individuality like a bad tooth."[127] Benjamin focuses on the surrealist slogan "to win the energies of intoxication for the revolution" but reinterprets intoxication as the perception of mystery in the everyday world, as reading, and as the solitary reflection on "that most terrible drug—ourselves."[128] He discerns a proximity between the surrealists and the communists: they both understand the "present commands" of the *Communist Manifesto* in that "they exchange . . . the play of human features for the face of an alarm clock that in each minute rings for sixty seconds."[129] In this

curious amalgam of human visage and clockwork, between dream and reality, lies both a critique of capitalism, which reduces the worker to a bit of machinery, and a redemptive possibility inherent in the idea of an alarm ringing out, of the human becoming machine yet in its last breath alerting the world to the danger it shares.

Adorno writes of surrealist dream images:

> no one dreams that way. Surrealist constructions are merely analogous to dreams, not more. They suspend the customary logic and the rules of the game of empirical evidence but in doing so respect the individual objects that have been forcibly removed from their context and bring the contents, especially their human contents, closer to the form of the object. There is a shattering and a regrouping, but no dissolution.[130]

Like Benjamin, he recognizes the self-negating tendencies within surrealism itself. Just as in Hegel's critique of the Enlightenment, surrealism in realizing itself defeats itself. It is "as witness to abstract freedom's reversion to the supremacy of objects and thus to mere nature" that surrealist artists create true *nature morte*,[131] images of commodity fetishes, mere things "on which something subjective . . . was once fixated" (think of the face and the clock). In its collages and montages, surrealism creates assemblages of dead things like "mementos of the objects of the partial drives that once aroused the libido."[132] And "as a freezing of the moment of awakening, Surrealism is akin to photography":

> Not the invariant, ahistorical images of the unconscious subject to which the conventional view would like to neutralize them; rather, they are historical images in which the subject's innermost core becomes aware that it is something external, an imitation of something social and historical. "Come on, Joe, imitate that old time music."[133]

These images are neither purely dream (internal) nor reality (external) but an amalgam of both. And Adorno's essay ends with a punch: "if Surrealism itself now seems obsolete, it is because human beings are now denying themselves the consciousness of denial that was captured in the photographic negative that was Surrealism."[134]

What surrealism accomplished, in Benjamin and Adorno's view, was a transformation of the familiar into the strange in such a way that it nonetheless evoked the feeling of "Where have I seen that before?"[135] This is the feel-

ing of seeing Earth from space, the affect of the uncanny. Surrealism makes manifest the uncanny way in which the things nearest to us, those that seem most animated, have become dead things, and how what we think of as closest to ourselves may somehow be most alienated from us.

For Adorno, abstract modernist art nevertheless held greater political potential than did surrealist attempts to represent the unconscious or dream images. Hegel's claim, in his *Lectures on Aesthetics*, that it is the aim of the human to "strip the external world of its foreignness" in order "to enjoy in the shape of things only an external realization of himself,"[136] is for Adorno a mark of art's desire to make commensurable to humans something that, prior to the Enlightenment, was incommensurable because of art's relation to ritual and magic. The uncanny artwork does not have to present a fairy tale or a dream image in order to effect this momentary encounter with an extrarational reality. It might rather open us up to a world that we have not been able to see because we have taken a certain configuration of what appears to be the entire range of possible appearances.

Kristeva and Kafka

This brings us back to Kristeva and to the ethics/aesthetics of the uncanny, for this figure of looking at the Earth from space can also describe the way in which the foreigner perceives us. In other words, what Kafka does, or what uncanny art in general effects, is to put us in the perspective of the foreigner *as we are looking at our own culture*. Kristeva never discusses Kafka at length, but she uses a quotation from one of his diaries as an epigraph to one section of *Revolution in Poetic Language*. Furthermore, in *Powers of Horror*, Kristeva names Kafka, along with Dostoevsky, Proust, Artaud, and others, as a representative of "great modern literature" that confronts abjection as a result of the collapse of the symbolic foundations of culture. Kristeva thus places Kafka in roughly the same relationship to the critique of culture that Benjamin and Adorno delineate, though she never discusses his writing at length. It appears that Kafka has at least a highly suggestive significance for Kristeva's consideration of the revolutionary power of writing and art.

Discussing, among others, Benjamin and Kristeva, Helga Geyer-Ryan identifies writing with the father and the body and the image with the mother.[137] Certain forms of writing, she argues, among them Benjamin's in addition to Kristeva's, attempt to retrieve images and the body not in opposition to but rather within language, resulting in "the presence of the body in the realm of signs."[138] Such a resurrection of the body through writing can occur in two

ways: as the return of the repressed under the sign of negation and as a revival of the abject position; this latter position we might associate with Kafka.[139]

Kristeva prefaces the first section of her *Revolution in Poetic Language* with a note from Hegel's journals and the second section, on negativity, with a quote from Kafka's diaries. The Kafka quote is ambiguous: "The Negative having been in all probability greatly strengthened by the 'struggle,' a decision between insanity and security is imminent."[140] A look at Kafka's diaries fills in the context only a bit. The "struggle" referred to is Kafka's own imagined struggle, in the situation in which he would have been placed had he learned a trade. In an earlier diary entry Kafka refers to the Negative as a kind of destructive force that would immediately abolish any fragile security he had managed to establish in his life.[141] We might speculate that Kristeva uses the quotation to refer to the kind of position "between schizophrenia and reification" that Adorno describes in his essay on surrealism.[142] Adorno writes: "in the face of total reification, which throws it back upon itself and its protest, a subject that has become absolute, that has full control of itself and is free of all consideration of the empirical world, reveals itself to be inanimate, something virtually dead."[143] Reification, on this interpretation, would refer to a counterfactual Kafka who had learned a trade. Schizophrenia would be a reference to Kafka's own fear of succumbing to insanity.

Kristevan negativity negotiates a path between these two dangers, avoiding the drive of the Hegelian subject to overcome foreignness while aesthetically opening itself to otherness, a path expressed in terms of the uncanny. In *Revolution in Poetic Language* Kristeva describes the movement of Hegelian self-consciousness as paranoid, "constituted through the supersession of the *heterogeneous* Other."[144] Hegel writes of the movement of Desire: "Certain of the nothingness of this other, it explicitly affirms that this nothingness is *for it* the truth of the other; it destroys the independent object and thereby gives itself the certainty of itself as a *true* certainty."[145] Kristeva interprets this "detour of negativity toward the becoming-One" as the "indispensable moment that unifies 'schizoid' pulverization in one identity."[146] Noting that paranoia would be the precondition of every subject, Kristeva nonetheless recognizes a difference between the Hegelian subject, constituted in and through the negativity of Desire, and "theological and metaphysical revivals of Hegel (that claim to be materialist),"[147] in that the latter discard the concept of negativity inherent in Hegelian self-consciousness. They thus turn a blind eye to the potential for dissolving the subject inherent within the Hegelian dialectic,[148] which as a result became restricted to the domain of aesthetics.[149] Kristeva aims to reanimate the Hegelian concept of negativity within aesthetics but also to point to

a possible correlative in politics. This, I argue, is part of the reason for her interest in, but also her transformation of, Arendt's appropriation of Kant's aesthetic judgment for a political sensibility.

KRISTEVA'S REAPPROPRIATION OF KANT AND ARENDT

Kristeva's brief consideration of Arendt's reading of Kant's third *Critique* as part of the volume on Arendt that makes up a third of her Female Genius trilogy does not, for the most part, break new ground. She takes Arendt's reading of Kant at face value, including some contentious readings of the third *Critique*.[150] She also never explicitly links her own reading of Kant and Arendt with her critique of Hegel; I am thus taking an interpretive leap in bringing these together. However, what Kristeva's own readings share is an appeal to psychoanalysis in order to understand fundamental shortcomings, of different kinds, that she discerns in both Hegel and Kant/Arendt.[151]

As we noted in the introduction, Kristeva's primary or at least her most well-known interest in Arendt lies in the latter's discussion of thinking as a constantly unsettling process and her concept of natality as a kind of second birth. What is less discussed in the literature is the subtitle Kristeva appends to her book on Hannah Arendt: *Action as Birth and Estrangement*. I want to focus on the "estrangement" part of this subtitle, a positive account of which Kristeva argues is present in Arendt herself.

Kristeva only mentions estrangement a handful of times in the Arendt book: first, estrangement is the condition of humans' relation to nature, but, unlike Marx, for Arendt this estrangement is not a perversion of humans' essential nature but rather a fulfillment of it.[152] Arendt's defense of narration in *The Human Condition* rests on her discussion of thinking, an activity that presupposes a "two-in-oneness." Consciousness itself inserts an otherness into the "one" that each of us is.[153] Likewise, when thinking takes possession of a thing, it "loses its reality and acquires a curious kind of eeriness."[154] Arendt's example of such a phenomenon is in fact Kafka's early prose pieces, which present objects as "thought-things," things taken out of their context and transformed by thought. This is the phenomenon of estrangement to which Kristeva refers; for Arendt, "difference and otherness," the phenomenon of estrangement, "are the very conditions for the existence of man's mental ego," which "exists only in duality."[155] Furthermore, there is an inherent connection between thought, action, and language in that they all presuppose a plurality of people and even a politically organized whole.[156] Kristeva thus relates estrangement to narration, for in narration the two-in-one is presupposed.

Kristeva also refers to Arendt's critique of identity politics as a "radical estrangement that pokes holes in the various sanctuaries of identities or groups"; Arendt, she writes, was "loyal to the essence of the life of the mind that consists of combining the abrasive force of solitary questioning . . . and the greater community of judgment."[157] But although Kristeva refers to Arendt's "two-in-one" as an "original duality" or "radical *split* between me and myself," she does not think it radical enough. Over and over again in recent writings Kristeva remarks on Arendt's proximity to or compatibility with the Freudian psychoanalytic doctrine,[158] in particular the analytic act of transference, in which the interior of a subject becomes known to her only through her openness to another, namely the analyst.

Kristeva writes that Arendt herself did not value psychoanalysis but that nonetheless her work opens up a way of thinking how psychoanalysis might contribute to the political process and in particular to the "restructuring of the political bond."[159] The "who" of Arendtian political theory, thought through Kant's critique of judgment, always speaks in such a way that her words are universally communicable. In making a judgment that a particular thing is beautiful, Kant writes, the logical quantity of that judgment is singular, but nonetheless its scope is universal. When I judge something to be beautiful, rather than just claiming that it is to my liking, I make an implicit appeal to the judgments of all other people, who, after all, have the identical human cognitive structure to my own. Even if, empirically, all other people may not agree with my judgment, to say something is beautiful is to appeal to others in a public manner in a way that judgments of agreeableness, which are purely private, do not.

In *The Human Condition*, Arendt addresses the work of art directly. Art is the result of human beings' overreaching themselves, producing useless things that are unrelated to material or even intellectual needs. It is no accident that the name of the mother of the ancient muses was Mnemosyne, or remembrance—something humans need only when their existence becomes more than a striving to survive. Poetry in particular transforms a biological or merely survival-oriented existence into a temporal, political, or public one by transforming remembrance into a tangible memory, "and the poet's means to achieve the transformation is memory."[160]

Kristeva makes an analogous claim about the subject's memory and consciousness in the analytical situation. Unconscious, repressed memories can only come to the surface and be transformed into language and memory with the help of the dialogical analytic situation. The human is always more hidden to herself than to the analyst, just as the aesthetic exemplar will only be

proven in its openness to the political and historical community. Arendt's po-
litical "who," always attuned toward others in the *sensus communis*, "is hidden
more to the person than to the human multitude, or more precisely to the
temporality of others' memory. It is only revealed to the multitude of memo-
ries."[161] The "who" is an identity that only makes sense in a life that is not
merely biological, and it manifests itself in action and speech as well as in art.
Poets and artists enact a story that repeats the events of life in imaginative
form, transforming into thought experiences that would not survive were it
not for their activity.[162]

Today, in a time of hyperbolic narration, where even the lowliest of expe-
riences can be recorded and repeated and broadcast to multiple ears and
eyes almost instantly through blogs, YouTube, and reality television programs,
among other media, it is not narration that artists must preoccupy themselves
with. Arendt foresaw the increasing superficiality, with modernization, of the
representation of human action, and Kristeva's critique of the spectacle inten-
sifies the focus on this problem. Kristeva implies that art's role today is to re-
estrange the overly familiar, and in this role it enacts the uncanny. This re-
estrangement reflects the split nature of the subject herself, a split that will
never be overcome but whose contours can be explored and engaged in the
work of art.

Conclusion: The Uncanny in Contemporary Art

Photographs of the Earth from outer space no longer have a distinctly un-
canny effect on us. We may, by contrast, upon viewing these photographs,
have a faux (because interested) experience of the sublime as a triumphant
sense of uplifting and achievement that overcomes the overwhelming distance
of space travel. While the perspective from space reduces human beings to
tiny insignificant specks, we nonetheless simultaneously recognize the enor-
mous leaps humans have made in technology in order to accomplish not just
visits to our moon but probes to more distant planets; satellites for the purpose
of communication, entertainment, information retrieval, and weather predic-
tion; and even space travel for those who are not expertly trained for the pur-
pose. This in turn could lead to a feeling of the inner superiority of human
beings to nature, not in scale or in power, but with reference to what Kant
called our supersensible selves.[163]

Perhaps the correlative to Kant's discussion of the "starry heavens" and
Adorno's description of the Earth seen from space would be the ordinary per-
son's perspective on the inside of his or her own body. Although the body is

the very closest thing to us, most of us are not medical students, medical examiners, or coroners, and therefore we are only abstractly aware of the internal contours of the various organ systems that form our bodies. A recent exhibition, "Bodies," gained immense controversy and a kind of popularity for affording the general public a view of dissected human body parts and fetuses and skinned corpses injected with polymers that could be cut open to expose the internal musculature and organs. The resulting exhibit is uncanny precisely by virtue of its presentation of that which is simultaneously most familiar and yet at the same time most distant. As people become more familiar with such views, the exhibit, which features mummified bodies displayed in various active positions (playing basketball, painting, or dancing), may lose some of its uncanny effect, but the ultimate inscrutability yet inevitability of death will always remain uncanny for the human being. One body in particular strikes the viewer: a female corpse smiles as she swings open the front of her torso like a door, breasts attached, to display the organs within. The uncanny effect of this particular body literally refers back to the *Heim*, or home, from which we all emerge. The mother's body, in particular the womb, but also the breasts that nurture the infant, represents the mysterious origin of plenitude from which we are forever cut off but to which all of our subsequent desires in some way refer.

Kristeva points out that for Arendt, the human body is reduced to the realm of *zoe*, or mere life, and as such is an "uninteresting generality."[164] Such an attitude allowed her (mistakenly, of course, in Kristeva's view) to dismiss psychoanalysis as revealing nothing more than what all humans have in common. Kristeva writes that for Arendt the body is frightening, and her reaction against it leads her to a sublimation into a politics that, while deserving of intense respect, nonetheless cannot appreciate the uncanny, bodily element of psychic life. The "Bodies" exhibit also seems to reduce the body to a form of petrified mere life, but its uncanny force comes from the manipulation of the corpses into animate positions (most notably, playing sports) in order to illustrate the interior activities of bodily parts in (frozen) action. Likewise, though in reverse, the photographer Robert Bueltman's art renders the bodies of living plants uncanny by running an electric current through them, revealing them in an unearthly blue light that seems to illuminate most intensely their vital force at the very zenith of a process that is destroying them.[165] His photographs intensify the life force pulsating through organisms and seem to render it visible in isolating it, even while evoking an uncanny proximity of life and death in the inevitable demise of the plants subjected to electrical incendiation. Death in life, life in death, mother from whom we all originate,

mother whom we must kill in order to become subjects: all of these processes are also engaged in Kristeva's meditation on decapitation.

In the piece "Lick and Lather," the artist Janine Antoni engages with the uncanny proximity of one's own body, with consumer culture, and with the role of the mother by playing with the mechanical reproducibility of her own body. Using alginate, a substance most of us are familiar with from trips to the dentist, Antoni made a mold of her head and shoulders, in the form of a classical bust, then cast herself multiple times in both chocolate and (separately) in soap. Antoni then proceeded to lick each of the chocolate busts in turn in distinct ways, in order to disturb their identity gradually. She then took each of the soap busts by turn into the bath with her and washed different parts of them away. In an interview, Antoni describes the process as both "tender" and self-erasing.[166] Antoni does not address the uncanny effect that even reading about the process of licking, bathing (as an object separate from oneself), or erasing one's own body creates. In discussing the soap casts, she compares them to little babies that she is washing. In discussing the chocolate casts, she acknowledges the erotic element that is evoked by both chocolate and the act of licking, yet she describes the act as a straightforwardly maternal one: "Of course chocolate is a highly desirable material and to lick myself in chocolate is a kind of tender gesture. Having the soap in the tub was like having a little baby in there. But through that process I'm slowly erasing myself."[167]

In "The 'Uncanny'" Freud discusses psychoanalysis's capacity to expose the repressed unconscious forces at work in certain maladies and disorders, both in patients and in stories or situations that have an uncanny effect. Indeed, he remarks that he would not be surprised to hear that psychoanalysis has itself come to be judged uncanny[168] as a result of this capacity to access repressed mental content. He gives the examples of stories of severed limbs that are capable of independent activity,[169] whose uncanny effect stems from their proximity to the castration complex, and the fear of being buried alive by mistake, which he calls a "transformation of another phantasy," that is, the fantasy of intrauterine existence.[170] In "Lick and Lather" we may see at work a transformation of the fantasy of a return to the autoerotic or the stage of primary narcissism, accompanied by the abject fear of self-erasure due to its origin in a later, post-Oedipal stage. In addition, the work seems to manifest the fantasy of a return to a state prior to castration, accompanied by the recognition of, or anxiety in anticipation of, one's incontrovertible lack. Such a combination of that which is most familiar and a distancing perspective on it cannot fail to have an uncanny effect. We also cannot fail to notice that what is being played with is precisely a mechanically reproduced, decapitated head.

In one of her pieces, the performance artist Kate Gilmore nudges her way through a small star-shaped hole in a piece of plywood, using only her chin to break the edges of the star in order to create a hole big enough to squeeze her head through. Gilmore's art reflects the struggles of women in the adult world (she dresses like a businesswoman and puts herself into a variety of physically challenging situations out of which she must climb or escape), but this particular piece cannot avoid also intimating the uncanny phenomenon of the birth or delivery of an adult rather than a baby. Just as the moment of birth is a mixture of pain and joy, the artist's face grimaces in pain as she forces her way through the plywood at the risk of tearing her skin. What is given birth to initially is a giant, seemingly autonomous head unmoored from a body.

As Kristeva remarks in her essay on Giovanni Bellini, a return to union with the maternal space is impossible, but it remains a fantasy.[171] Art is a way of accessing the impossible, the maternal space, creating a "perverse object" in order to escape from the incapacity to express, in order to "experience the infectious auto-eroticism we encounter when we construct a sensory fiction."[172] At the same time, the experience of maternity, too, is one in which women can experience something like the uncanny space that art opens up, a space that Kristeva calls a limit or threshold between language and the drive, between the symbolic and the semiotic.[173]

4
SUBLIMATING MAMAN
EXPERIENCE, TIME, AND THE RE-EROTIZATION OF EXISTENCE IN KRISTEVA'S READING OF MARCEL PROUST

Ideas are successors to sorrows; the moment sorrows change into ideas they lose a part of their power to hurt our hearts and, for a brief moment, the transformation even releases some joy. Successors only in the order of time, though, because it seems that the primary element is actually the idea, and the sorrow merely the mode in which certain ideas first enter our minds.

—Marcel Proust, *Time Regained*

IN THIS CHAPTER I WILL CONSIDER AT GREATER LENGTH Kristeva's reading of Marcel Proust, relating it to the idea of sublimation as re-erotization. Commentary on Proust's texts pervades Kristeva's writing, and she has devoted an entire book, *Time and Sense*, to a reading of Proust specifically and to the phenomenology of the experience of literature generally. It might initially seem counterintuitive that Kristeva considers Proust exemplary of the kind of literary writing she most admires. In her earliest writings Kristeva was primarily engaged with avant-garde literature. Even when she considers more traditional writers such as Dostoevsky, it is generally for the purpose of emphasizing certain psychoanalytic themes such as melancholia. It is significant, however, that Kristeva writes about Proust in a work otherwise devoted to the topic of the *experience* of literature, a subject she links with the recuperation of the image within the symbolic. Kristeva considers Proust to be exemplary of the process of reading and writing literature as a translation of sensory impressions and the drives that both inform and are derived from them into language, as well as for demonstrating how modifications of narrative logic reveal specific psychic states. In particular, Kristeva's reading of Proust gives us insight into the process of sublimation understood not just as a desexualization but as a re-eroticization of existence, through the translation

or transformation of the relationship between Eros and the exposed (by subli-
mation) death drive into a proliferation of (provisional) aesthetic ideas.

Although I will consider Kristeva's reading of Proust at length, I will not
spend very much time on her discussion of the details of *In Search of Lost
Time*. Rather, I will focus on the themes of experience, sensation, language,
temporality, and memory that form important parts of her analysis and that
inform her larger corpus of work. It is not until the second half of *Time and
Sense* that Kristeva explores in depth the ideas in Proust's work that seem to
have motivated her interest in it in the first place. Proust "inaugurated a new
conception of temporality and thus created the modern aesthetic."[1]

Kristeva writes that after Proust many thinkers and writers tried to emulate
his fragmentation of temporality and deconstruction of the traditional, uni-
fied novelistic style, in a manner that might be considered more transgressive
and avant-garde than their predecessor. Yet "Proust is the only figure who
maintains both the violence of marginality that drives his characters as it
drove him and the grace to construct a world, to receive communion in the
time of the world."[2]

PROUST AND PSYCHOANALYSIS

Kristeva is not the first author to write about Proust psychoanalytically, but
she sheds new light on the topic by considering Proust's writing style in anal-
ogy to the analytic situation, particularly to the transference-countertransfer-
ence relationship. In a psychoanalytic conference address on the topic of nar-
ration, Kristeva begins a consideration of Proust's writing with a story about
one of her patients, who dreads a holiday break because she will not be seeing
her analyst for a certain amount of time. The patient makes the comment that
when she misses a session, she finds herself telling anyone who will listen,
friends or colleagues, long stories about her experiences or endless accounts of
patient cases (she is herself a psychiatrist undergoing psychoanalytic training).[3]
The patient is coming to realize the importance of self-narration in her treat-
ment. Kristeva goes on to explore the relation of narration and other enuncia-
tive modalities of literary writing to mental life, in particular to the multiple
aspects of hysteria, which, she writes, taking a cue from Freud's remarks on
Dora, has a peculiar relation to temporality. In particular, the hysteric is
unable to maintain a continuous linear narration but gets bogged down in the
attempt to do so, leaving gaps and false starts, with secondary memories com-
ing in to fill the lacunae.[4]

The discourse of psychoanalysis in Kristeva's reading is primarily one of fantasy.[5] As such, it shares much in common with literary narration, with its predominant model of linear recounting following the "logic of an ordeal."[6] The ordeal proceeds along an ascending and descending line, with accompanying actions or agents that either further or hinder the action and that can be thought of as manifesting a "logic of interrogation," during which the hero or the analysand asks herself questions like "who am I?" or "where do I come from?" and "where am I going?"[7] Kristeva recalls Freud's analysis of the dependence of judgments of attribution and existence upon the symbol of negation on the one hand, and the bodily act of rejection or ejection on the other.[8] She wants to extend this analysis to include a consideration of interrogation as the primary mode of both narration and of psychoanalysis. Both modes of discourse presuppose an interlocutor, a second person to whom the questions are addressed.[9] She compares this act of narration to transference, in which the implicit statement "I assume there is a part of me in you, and I await from it the answer to the question formulated by the other part, or an adherence to the story that I create in answer to my question—unless it is a refusal"[10] forms the basis of an intense identification that can lead to self-revelation.

In the case of Proust and even more strikingly in the case of Joyce or Kafka, the narration comes to have a modified logic, one in which the linearity of the narrative becomes more and more elliptical and interrupted, interspersed with impressions and feelings, multiple metaphors and subordinate clauses. In particular in the case of Proust, the result is the alteration, as Kristeva argues, of "the pace of memory" and an "attempt to re-establish contact with regressive states, hallucinations, or dreams."[11] Proust's novel can be understood in analogy to the methodology of transference, in which the analysand attempts, to the help of the analyst, her interlocutor, to reestablish contact with her past via (both ideal and sensuous) memories, reawakened impressions, dreams, and fantasies.

Kristeva makes use of Kleinian psychoanalytic theory to articulate her understanding of narration, emphasizing the phallic stage, which she considers to be the foundation of the human questioning that is characteristic of philosophy. In particular, Kristeva examines the phallic trial that introduces the Oedipal stage. Recall that in the myth, Oedipus is faced with the riddle of the Sphinx, which in turn, according to her reading, leads to the discursive position of self-interrogation: Who am I? Where did I come from? Where am I going?[12] The phallic stage consolidates thought and symbolism and culminates in the capacity to interrogate the parents as to where children come from.[13]

But Kristeva is particularly interested in the residue of nonsymbolic indicators that remain even after one's passage through the Oedipal crisis and into the symbolic order. Narration "on the couch" is composed both of words and phrases and of affects and emotions.[14] She argues that within every narration there are "non-narrative shreds" that are closer to thing presentations than to word presentations and that their presence indicates a very specific psychical experience, namely the attempt to regain with words what for the patient are still only drives or affects. It is this process, which may be mediated through images, that she sees as particularly salient in Proust's writing.

Proust's novel provides a perfect example of the process of sublimation in its most fundamental sense. The novel begins with a memory of waiting for the mother's kiss. His mother, *maman*, is going away, and Marcel is waiting for the kiss that will make her absence bearable. The entire novel, as it unfolds from this expectation, desire, and sorrow, narrates the human condition, born fragile and dependent, nurtured by an all-powerful fulfiller of every need, and then gradually forced to separate from this plenitude and eternally seek substitutes for it, as the condition for becoming an individuated self. Marcel is probably the most self-aware of all literary sublimators as he writes that "Ideas are successors to sorrows; the moment sorrows change into ideas they lose a part of their power to hurt our hearts and, for a brief moment, the transformation even releases some joy." He loses the mother only to find her, self-consciously, in words and ideas. He loses his "head" and forges a head.

PROUST'S CONCEPT OF EXPERIENCE

The concept of experience is not a common one in Freud or Lacan's writings. Although it arguably informs an important part of psychoanalytic discourse, namely, the fantasy, Kristeva claims that Freud, and even more pointedly Lacan, neglected experience, which she aligns with the imaginary realm, in favor of an exclusively symbolic consideration of discourse. Kristeva turns to Melanie Klein's work on prelinguistic infants to explore the possibility of a kind of "protophantasy" or "quasi-narration" to be found in the baby's articulation of drives and desires toward an object—the breast, the mother—to assure its egoic survival.[15] Drawing on post-Kleinian cognitive psychology, Kristeva notes that "representations of events" have been observed in children of less than a year old, "equivalent to a primitive plot," that is, encompassing affects and logical properties of drives such as motivation, repetition, temporality, dramatic tension, and memory associations.[16] Referring to this "primitive plot" as a "pre-narrative envelope," Kristeva argues that there is an intermedi-

ary realm within the prelinguistic infant that lies between impressions ("pure experience") and the abstraction that would be needed for linguistic representation. Klein named this realm "thought phantasy," a prerequisite of thought and language, a "primary anxiety" related to the depressive position. Klein emphasized the necessity both of a preverbal and affective "narrative envelope" out of which language could emerge and of the presence of another—typically the mother, but, in the case of the reawakening of these moments in analysis, the analyst—through whose verbal solicitations a narrative of these fantasies, which would be equivalent to the emergence of fantasy itself, can eventually emerge.[17] This would involve three levels: the prenarrative affective structure in which primary desires are expressed, an acting out of fantasy, followed by actual narration in words (symbolic level). Kristeva claims that Proustian experience can be understood on all these levels.

Kristeva approaches Proust's concept of experience, mentioned only briefly in *In Search of Lost Time*, yet clearly significant to philosophers,[18] through the Heideggerian distinction between *Erlebnis* and *Erfahrung*, significantly modified for her own purposes. In *Being and Time*, Heidegger distinguishes between these two terms, both of which may be translated as "experience," in the following way: "An *Erlebnis* is not just *any* 'experience' [*Erfahrung*], but one which we feel deeply and live through."[19] The French translation of *Being and Time* renders *Erlebnis* as *expérience* or *épreuve* and *Erfahrung* as *impression*. Kristeva reads "experience" (*Erlebnis*) as "an opening-up to the other that serves to exalt or destabilize me that has "its anthropological roots in my bonds with the primary object, that is, the mother, who is an archaic focal point for needs, desire, love, and repulsion."[20] She thus clearly connects experience to the unconscious. She uses terms like "flash," "springing forth," and "sudden appearance" to describe this experience. Secularly, the search for the lost maternal space, to which there is no direct access, may take place through writing or through an artistic mastery of sound or color. When *Erlebnis* or "experience" is used in religious and philosophical discourse, it indicates a "simultaneity with the plenitude of Being," or a fusion with God.[21] *Erfahrung*, by contrast, can be conceptualized as a secondary imposition upon the initial flash or appearing of *Erlebnis* that transforms it into knowledge. Reaching its culmination in Heidegger as well as in Hegel, "philosophy has mapped out these stages of experience, of which the second (knowledge) absorbs the first (the springing-forth), such that if we were to isolate this springing-forth, it would appear to be pure nothingness."[22]

In Proust's account of experience, Kristeva argues, *Erlebnis* always has a dual structure. The narrator "searches" for lost time, for that flashing up, which

is by nature irretrievable. The plot of the novel is linear and continuous, but it unravels in order to catch those moments that cannot be predicted or known. Experience in this sense:

> Interrupts the subject's social and verbal displays and reshapes his psychic map. For this reason, it is inseparable from desire and love. Inside them and through them, experience is felt to be a conversion. Partaking of psychology *and* of representation, experience marks the fragile painful or joyous bridge between the body and the idea, which makes such distinctions obsolete.[23]

This borderline situation between the body and the idea and between the representative (the sensuous) and the psychological is what Kristeva refers to as the experience of the sense of time.[24] It refers not to symbolic time, which is sequential and uniform, but to time per se, neither the time of an individual psyche nor the time of events but the time of the narrative, which exists in an intermediary space between them.

Walter Benjamin interprets *Erlebnis* in a related manner but in almost opposite terms with respect to Proust. Benjamin is interested in the connection between experience (*Erlebnis*) and memory (*Gedächtnis*) or recollection (*Erinnerung*). He contrasts *Erlebnis*, as an isolated experience, with *Erfahrung*, as experience over time.[25] Benjamin writes that *Erlebnis* is the achievement of the intellect, which, by pinpointing specific events at precise moments in time and consciousness, creates a shock experience.[26] *Erfahrung*, which Benjamin associates with poetic experience, integrates past and future into a collective memory (*Gedächtnis*) in which elements of an individual past combine with material from the collective past.[27] On Benjamin's reading, experience in the sense of *Erlebnis* is hermetic and purely subjective, and thus unsuitable for literary composition, which is distinguished by its capacity for transforming *Erlebnisse* into *Erfahrungen*, or sequential or continuous "long experiences," and for its ability to communicate across individual experience.[28] For Benjamin, *Erlebnis* considered in isolation from *Erfahrung* is a product of modernity; it is only when individualism and secularism split the subject from her collective past that *Gedächtnis* (memory) is transformed into *Erinnerung* (recollection) and *Erlebnis* becomes the primary way of thinking about experience, as inner and subjective.

In Proust, according to Benjamin, the amalgamation between involuntary memory and the story told by the narrator gives rise to experience (*Erfahrung*) in a manner that might best be explained by means of a detour through

Freud's *Beyond the Pleasure Principle*. Before considering the details of Benjamin's argument, I will return to the doublet that Kristeva finds distinctive of Proust's *Erlebnis* and Benjamin of *Erfahrung*. It is important to note that both authors are reading Proust through German philosophers—Kristeva through Heidegger, Benjamin through Freud—meaning that the distinctions they are drawing are not found explicitly in Proust himself.

Kristeva calls Proustian experience "transubstantial,"[29] in that (1) through ideas and words memory can regain the shock of *Erlebnis*, which she reads as prior to, although retroactively constituted by, *Erfahrung*, and (2) in that Proust presents himself as a body wanting to be resurrected by a book. Kristeva calls the first of these reasons an "imaginative embodiment of the word."[30] In other words, *Erlebnis* is aligned with the imaginary, yet in such a way that it is not opposed to language but rather makes of language its instrument, "so that spatio-temporal continuity and its fragmentation are not an antithesis to pure time but its servant, the preferred means for attaining time regained."[31] Proust's writing is an embodiment of the imaginary in the terms of the symbolic. Perhaps this is true of all literary writing; what makes Proust's text exemplary is that the very experience of "regaining time" *is* the experience of the imaginary, but rather than being isolated or limited to a particular place and time:

> This strange and new experience of time regained resides in the dynamic of subject and meaning. It also causes signs, *which exist within time*, to be ordered into syntax as well as to unfold the music of metaphors into sensations, *which are on the edge of time* and which extend beyond signs and elude signs even if they can only be perceived through what is superimposed on them.[32]

If the imaginary is aligned with timelessness and the symbolic with time, this transubstantiation allows for an experience on the edge of time, on the border between both, in the way that Kristeva argues the semiotic can be reevoked from within the symbolic. Thus through literature time is being accessed metaphorically. Indeed, the idea of "imaginary experience," which Kristeva indicates we can all share with Proust's narrator, is a metaphorically conceived concept, given that we access it only through the language of the author. But metaphor should only be understood in the sense that Kristeva discusses it in *Tales of Love*:

> Here the term metaphor should not bring to mind the classic rhetorical trope (figurative vs. plain) but instead, on the one hand, the modern

theories of metaphor that decipher within it an indefinite jamming of semantic features one into the other, a meaning being acted out; and, on the other, the drifting of heterogeneity within a heterogeneous psychic apparatus, going from drives and sensations to signifier and conversely.[33]

Proust's version of experience is unique, according to Kristeva, in that the first flash of *Erlebnis* occurs always in pairs. The famous *petite madeleine*, for example, which inaugurates the entire sequence of reminiscences, exists in the context of both present and past. The narration follows the continuous sequencing of the plot, "while remaining caught in the pincers of the immediate metaphor that removes it from temporal duration and adorns it with the exhilaration of 'pure time.'"[34] This double movement, which recurs throughout the novel and which Kristeva calls a "primal metaphorical condensation," is experienced simultaneously by both the narrator and the reader.

Kristeva calls this experience one of "rapportive language," in which understanding depends on a preexisting affinity of some sort between the communicator and her audience. The primary representative of such a language is religious discourse, which to be understood requires faith. However, Kristeva argues that since religion and even morality have lost their hold on us because of their excessive restrictiveness or their inability to be heard, the novel has become the one place in modernity where rapportive language can still make a claim on us. This affinity can be understood as an imaginative identification with the narrator that occurs purely through language, without the mediation of a community or an expert;[35] that is, it is an imaginary experience that is nonetheless mediated through the symbolic.

The temporal dynamic that the identificatory appropriation characteristic of great literature serves can be understood as "the dynamic between love and hate that makes me a living being."[36] In Proust, in particular, psychic life, as translated into a narrative, is manifested in its full complexity: as simultaneously painful and ecstatic, sensuous and spiritual. It pushes the reader toward a full consideration of her own psychic/bodily life: "It opens me up to myself, pushes me as far as I can go, makes me surpass myself—and offers me a space where I can meet other people or where I can become lost. It is a chance I have to take."[37] Without this kind of rapportive language, Kristeva suggests, the current "death of values . . . may have reached a point of no return."[38] Experience, which can be regained through certain kinds of literary writing, "is the unique configuration by which we attain jouissance," at the boundaries of the body and of ideas, between love and hate.[39]

Benjamin discerns a parallel possibility in Baudelaire's description of his poetic process. In modernity, where shock has become the norm—Benjamin writes that "the shock experience which the passer-by has in the crowd corresponds to the isolated 'experiences' of the worker at his machine"[40]—*Erfahrung* can no longer quilt together *Erlebnisse* in the same way that lyric poetry did. Baudelaire puts shock "at the center of his work,"[41] the blows "opening up a path through the crowd."[42] In this discussion of Baudelaire's poetic process, Benjamin and Kristeva converge in their analyses of experience in modernity and art's role in bearing witness to the shock, performing and possibly transforming it.

Benjamin's reads the distinction between *Erfahrung* and *Erlebnis*, on the one hand, and between *Gedächtnis and Erinnerung*, on the other, with recourse to Freud's discussion of the origin of consciousness in *Beyond the Pleasure Principle*, where Freud hypothesizes a correlation between involuntary memory and the emergence of consciousness. Freud speculates that becoming conscious and leaving behind a memory trace are incompatible processes within the same system, for if permanent traces of all excitation remained conscious, it would soon limit consciousness's capacity for receiving new stimulation.[43] He thus postulates that consciousness arose in place of a memory trace, as a kind of external layer so modified by stimulation that it was no longer capable of being further modified by the depositing of memory traces but instead developed the most favorable conditions for the reception of perceptions from the external world and from the mental apparatus while also relieving stimuli of their original intensity as they passed through into the underlying layers of the psyche.[44] Consciousness thus emerged as a form of protection against stimuli.

Benjamin notes that Theodor Reik, Freud's student, drew a distinction between memory (*Gedächtnis*) and recollection (*Erinnerung*) based on Freud's theory. Memory, according to Reik's view, serves to protect impressions, that is, Freud's external stimuli that leave unconscious traces; recollection, by contrast, since it is conscious, aims at their dissolution.[45] Applying this process to Proust's distinction between involuntary and voluntary memory (or *mémoire d'intelligence*), Benjamin writes, "this means that only what has not happened to the subject as an isolated experience (*Erlebnis*) can become a component of *mémoire involuntaire*."[46]

It is *Erfahrung*, the poetic quilting together of a sequence of events, that, although it is associated with conscious recollection, protects involuntary memory and allows for its appearance. Thus Benjamin, too, identifies the importance of Proust's style in the form of the doublet, the metaphorical pairing

that allows for the unconscious trace to be resuscitated along with the conscious, linguistic narrative. It is in the linkage of collective and individual experience that memory can be regained.

Kristeva quotes Proust in calling this kind of experience a "transubstantiation."[47] In Proust, we encounter a highly modified narrative structure: sentences are elongated, metaphors multiply exponentially, characters cross over between life and the story. Kristeva writes:

> I venture that these changes in the narrative have as their basis, or purpose, to cross through repression where the language of canonical narration operates, thus enabling a real surge of sensorial experience—its "indexation" or its "equation" found within words, or even, according to the Freudian model, in a return of "word-presentations" to "thing-presentations." Proust himself points to this exorbitant change of language in his narrative—"words" becoming "things"—explaining that the purpose of literature is to create the "transubstantiation" proclaimed by the Catholic Mass.[48]

Just as the bread and wine, according to Catholic doctrine, transform into the total substance of the body and blood of Christ in being consecrated and consumed during Mass, Proust's words or word presentations are designed to transform themselves into the sensations of experience proper, that is, experience as impression, as thing presentation, for the reader as it was for the narrator. Retroactively, then, the reader designates an experience that she reads as her own; the experience indicated in the narrative will have been my own when I have finished reading it. This experience of transubstantiation does not involve the fantasy of the possibility of transmitting a pure sensory experience immediately from one perceiver to another. Transubstantiation suggests that the experience will always have to be mediated through the symbolic: through bread and wine, or through words.

ART, SUBLIMATION, AND WORKING THROUGH

In a section entitled "Proust, or the Power of Sublimation," Kristeva accords literature and other artistic endeavors a potentially liberatory effect: "the power of sublimation is often neglected as a retake of the trauma, emptying out and evidencing trauma."[49] This wording seems to put literary writing, or sublimation, very close to the activity of working through in analysis. Working through is a form of nonidentical repetition, in which a repressed memory,

perhaps of a traumatic event, that has been repeating itself through neurotic symptoms is remembered and repeated in a way that is fundamentally modified by interpretation (by the analyst), ideally resulting in a capacity in the analysand to accept certain repressed elements and eventually to be freed from the cause of the debilitating repetition. Freud writes that the process of working through allows the patient to pass from mere intellectual acceptance of a resistance she has to a particular interpretation to what Freud calls a conviction based on lived experience (*Erlebnis*) of the repressed instincts that are "feeding the resistance."[50] This would be the kind of flashing up that Kristeva associates with experience, and in integrating this new awareness within one's self-understanding, one would bring it together in the kind of totality that Benjamin describes as *Erfahrung*. In living through the experience of the repression, brought about by the intervention of the analyst and the particular interpretation she has put forth, the patient is able to continue with the process of working through and potentially free herself from the debilitating repetition compulsion.

However, in another passage, Kristeva writes:

> Sublimation is not necessarily a process of working through, even though many passages of *In Search of Lost Time* testify to a conscious awareness of the ambivalent link that makes the asthmatic child cling to his mother, for example, or of the homosexual bedrock of jealousy, etc. We come across this in analytic treatment; before any "understanding" or "intellectualization," the mere fact of naming affect in order to return it to the other/the analyst is a mediation/meditation that mitigates its death instincts, and renders them bearable, livable, perhaps even agreeable and pleasant.[51]

Here sublimation seems have the same relation to working through that the unconscious has to consciousness. If Freud and Lacan seem to equate literature and art with sublimation, Kristeva characterizes Proust's process in *In Search of Lost Time* as more of a process of working through, one that has both unconscious and conscious elements. Indeed, Kristeva argues that Proust endeavors, as closely as possible, to give expression through language to the inexpressible, the unrepresentable, that is, to the feelings and drives that both motivate and threaten him.[52] It is in this sense that the work of art is a sublimation; like the theory of the sublime in eighteenth- and nineteenth-century aesthetic theory, sublimation makes present, through means that mask and are necessarily inadequate to it, that which by nature is unpresentable.

As an example of the distinction between and continuity of working through and sublimation, we might consider the two steps Kristeva details at length in Proust's process of transforming his own experiences into literature. First, hiring Céleste Albaret as a housekeeper gave Proust a sublimatory surface (like that of the analyst) against which to bounce his experiences and memories, a surface that did not respond: "he spoke to her and his words rebounded. There was no dialogue, for she simply activated his monologue by relaying it and starting it up again. He forgot her; he took her in; she vanished just as he did. There were no longer any 'selves,' just the *I* that spoke through her."[53] Like the soundproof seal of cork around his bedroom, Céleste's ear "guaranteed the hermetic seal of the sheltered universe where involuntary memory remade and undid its sprawling sentences and searched for sounds, colors, and tastes."[54] Second, the narrator Marcel furtively enjoys the pleasure of observing sadomasochistic sex, which he subsequently works through, displaces, and translates into the language of the text.

Kristeva refers to Proust's peculiar form of sublimation as a "profanation," insofar as it concerns, as she reads it, "the destruction of the divine."[55] The divine here is associated with the paternal image, the phallus, the name of the father, and the paternal law, and profaning it results in "the metaphor of the capacity to represent—which characterizes human nature at the highest level: of our capacity to hallucinate/imagine/talk/symbolize."[56] Understood as such, the divine of our own time "still confronts the analyst," although it is in the guise of "an extremely complex, heterogeneous, and multilayered capacity" comprising both the unconscious and the conscious, both the imaginary and the symbolic realms. If the aim of psychoanalytic treatment is to overcome resistance, to optimize psychic life, to enhance sublimation, then Proust undertakes this aim through a fragmentation of the divine understood as the capacity to represent. Extreme sorrow is the only means by which certain ideas reach our consciousness. Furthermore, this shattering, although necessary, can subsequently be drawn into a kind of unity, into a narrative work.[57]

Yet the narrative unity presented by Proust is not an ordinary linear narrative. The confusion that results from the proliferation of metaphor, the undecidability of multiple subordinate clauses, the fluidity of certain characters who seem to interchange qualities with one another, all give rise to: "The feeling and thought, which are a true *experience* of holding the divine—in the sense of possessing the *aptitude for making sense*, both in the possible eclipse, and its threatening nullification, and in its polyphonic magnificence."[58] This is certainly a very radical sense of the divine, one that can be sustained while being threatened with nullification, just as the kind of language that Proust

uses is, arguably, a radical profanation of the symbolic order that can be shattered and simultaneously maintained. Kristeva refers to this process as a kind of atheism, a sublimity that would result not, as in the Kantian version, in a reconciliation of the supersensible and the sensible but in a process of "exploding the divine, on the edge of the risks that threaten psychic integrity, as do all the great adventures of contemporary art." The divine would then encompass the shattering of meaning that is nonetheless "still contained in the polyphony of [Proust's] poetic narrative."[59] At the same time, the sorrow evoked would be the means for an idea that is "not of the order of time" to arrive in consciousness.

The dissolution of the paternal function would not simply be the result of an arbitrary literary act; Proust's atheism is not a purely personal one. Rather, the willed nullification of the capacity to represent mirrors a decline that is already taking place, a historical and cultural decline that Proust refers to as "the spectacle." The ascendance and subsequent hegemony of science and capitalism, together with the decline of the Catholic Church, gives rise to a new sensibility as well as a new sense of temporality. Hereafter, language itself reflects this transformation. Proust's metaphors and sentence structure both mimic and subvert this temporality of infinite exchange and constant upheaval, the dynamic of the new that replaces itself eternally, the pursuit of the ever-changing entertainment of the spectacle.

A HISTORY OF THE CONCEPT OF SUBLIMATION

In 1910, Freud published an essay on Leonardo da Vinci in which he argued that Leonardo exemplified the healthiest and happiest fate of the infantile drive toward sexual research after the developmental point when the sexual drive and the drive for knowledge have been separated. I will argue in this section that Proust's literature exemplifies a similar "happy fate" on Kristeva's reading. According to Freud, in children the sexual drive and the instinct for research or knowledge are bound together, with the instinct for research working in the service of sexual interests. When the period of infantile sexual research (epitomized in the question "where do babies come from?") comes to an end through the inevitable sexual repression that comes with age, three vicissitudes are open to the instinct for research that is bound to the sexual drive. In the first possible vicissitude, the instinct for research might be repressed along with sexuality perhaps because of religious inhibition, resulting in a form of neurosis. If intellectual development in the individual is sufficiently strong, however, the instinct for research might resist repression yet still remain

imbricated with the repressed sexual drive, aiding it in its own attempt to avoid repression and thereby "allowing suppressed sexual activities to return from the unconscious in a form of compulsive brooding," resulting in a sexualization of thinking.[60] In this second form, research becomes a sexual activity evading any possible solution or resolution and also completely avoiding explicitly sexual themes. We might recognize Proust and Kristeva's characterization and critique of the spectacle in this second vicissitude. Third, in the vicissitude of which Leonardo da Vinci is a model type, the libido avoids repression altogether by being sublimated from the outset into curiosity and becoming attached to the instinct for research as a reinforcement rather than a goad. In this form of sublimation, research becomes a substitute for sexual activity without remaining attached to infantile sexual research.[61]

Freud implies that it is the very precociousness of Leonardo's inclination toward sexual curiosity, its inability, thanks to his early age, to become clearly fixated on an object, that allowed for such a large portion of his sexual drive to be sublimated into a general urge to know.[62] Leonardo's artistic inclinations, which manifested themselves secondarily to his drive for knowledge, eventually gave way to his original sublimation of the sexual drive into the drive for research; while initially his investigations were in the service of art, eventually they led him away from art.[63]

At the end of the essay, Freud admits that the nature of the artistic function is ultimately inaccessible to psychoanalysis, given its links to the drives. He indicates that only biological research can give insight into artistic achievements. Nevertheless, Freud continued to discuss sublimation in his theoretical works, albeit never at great length. In his earliest published use of the term "sublimation," in the 1905 *Three Essays on the Theory of Sexuality*, Freud speaks of the shift in the consideration and the progressive concealment of the body with the advance of civilization. The progressive concealment of the body keeps sexual curiosity alive and ultimately results in the diversion of the sexual drive away from the genitals toward the body as a whole. This diversion, or "sublimation," leads to the concept of beauty, which, Freud speculates, has its roots in sexual excitation but eventually came to signify a disinterested enjoyment of aesthetic form.[64]

By 1908 Freud was defining sublimation as "the capacity [of the sexual instinct] to exchange its originally sexual aim for another one, which is no longer sexual but which is psychically related to the first aim," a capacity with particular value for civilization.[65] Yet in one of his 1909 lectures on psychoanalysis given at Clark University he equivocates, calling sublimation a process in which "the energy of the infantile wishful impulses is not cut off but

remains ready for use—the unserviceable aim of the various impulses being replaced by one that is higher, and *perhaps* no longer sexual."[66] I emphasize this equivocation because it is often summarily assumed that sublimation is de-eroticization, and I want to argue, through Kristeva and drawing support from the arguments of André Green, Leo Bersani, and Joan Copjec, that this may not be unambiguously the case and that the art or literature that results from sublimation may give rise to a pleasure that would not inaccurately be called erotic, even if it is not directly sexual.

In particular, it seems to me that Kristeva's argument about melancholic writing that we examined in chapter 1 can be bolstered through her use of the term "sublimation" to characterize the narrative of Proust's *In Search of Lost Time*. There, we saw how she argued that in order for a melancholic to come back to signification, a certain re-erotization of existence, and precisely an erotization of suffering, might be effected through art. I will ultimately also consider the relationship between melancholia and sublimation in Freud's account of ego formation. In many places in Kristeva's writings we can discern a strange alliance between eroticization and sublimation, to the extent that they seem to share the same logic, a logic of deflecting the death drive or, through a process of muted sexuality, an eroticization that is no longer individual but intersubjective, directed back, from the shelter of the symbolic position, toward the lost maternal bond, taking the edge of the destructive drive complex aimed at the ego.

Sublimation Between Eros and Thanatos

In his "Recommendations to Physicians Practising Psycho-analysis" (1912), Freud writes that sublimation is one of the primary ways in which patients suffering from neurosis might be brought to a healthier psychic existence. The temptation for many analysts, Freud writes, might be to prescribe sublimation as a direction for the employment of psychic energy that might be released through the lifting of neurotic inhibitions. However, Freud writes:

> The doctor should hold himself in check, and take the patient's capacities rather than his own desires as guide. Not every neurotic has a high talent for sublimation; one can assume of many of them that they would not have fallen ill at all if they had possessed the art of sublimating their instincts. If we press them unduly towards sublimation and cut them off from the most accessible and convenient instinctual satisfactions, we shall usually make life even harder for them than they feel it in any case. . . . It

must further be borne in mind that many people fall ill precisely from an attempt to sublimate their instincts beyond the degree permitted by their organization and that in those who have a capacity for sublimation the process usually takes place of itself as soon as their inhibitions have been overcome by analysis. In my opinion, therefore, efforts invariably to make use of the analytic treatment to bring about sublimation are, though no doubt always laudable, far from being in every case advisable.[67]

If sublimation is the most successful cure for neurosis, nevertheless, not every patient is capable of sublimating. The purpose of analysis is to lift inhibitions and overcome repressed memories, but the liberated psychic energy needs somewhere to go once it is released. Thus working through (or the process of analysis) and sublimation are related to each other in that without working through there can be nothing to sublimate, yet sublimation is not the inevitable result of the process of working through.

In *A General Introduction to Psychoanalysis,* a series of twenty-eight lectures that Freud gave at the University of Vienna in the years 1915 through 1917, he attempts to delineate the characteristics of a true artist and also to understand how an artist manages to create pleasure for others through his or her exploration of his or her own fantasy life. A true artist, Freud writes, "understands how to elaborate his day-dreams, so that they lose that personal note which grates upon strange ears and become enjoyable to others." Moreover, the artist also "knows how to attach to his reflection of his phantasy-life so strong a stream of pleasure that for a time at least the repressions are out-balanced and dispelled by it."[68] The artist's activity gives the spectators or audience a means to "find a way back to" their own unconscious sources of pleasure, offering them comfort and consolation for what they have given up and thereby garnering their admiration and gratitude. Through this process the artist may also gain, then, those things that previously were the objects of his fantasy: honor, power, and the love of women.[69]

It was not until the publication of *The Ego and the Id* in 1923 that Freud's discussion of sublimation took on a new, more metapsychological significance in the account of ego formation through the transformation of object libido into narcissistic libido. In "On Narcissism" (1914), Freud had aligned secondary narcissism with the self-preservative, or ego, drives, rather than the sexual drives, because it withdraws energy from objects and invests it instead into itself.[70] Freud distinguishes this secondary form of narcissism from the autoerotism of the infant, which is objectless and does not distinguish between id and ego, in identifying it as the result of "something added to auto-

erotism—some new operation in the mind" that allows for the formation of the ego.[71] Secondary narcissism coincides with the awareness of the infant of her mother and especially of her differentiation from the mother, and it is a normal developmental process.

The development of the ego thus occurs through a transformation of erotic libido into ego libido,[72] a "desexualization," that is a form of sublimation. The ego "forces itself," as it were, on the id as a love object, and by sublimating some of the libido that is causing tension for the id, aids the id in mastering that tension.[73] Defusing the erotic and death instincts, sublimation gives the death instincts in the id assistance in gaining control over the libido; in doing so an inclination to aggression and destruction is released, which ultimately results in the formation of the superego, which is also a result of this sublimatory action.[74] As Sara Kofman writes in *The Childhood of Art*, "sublimation . . . finds its condition of possibility in the plastic nature of the sexual drive, a plasticity which stems from the death drive inhibiting the aim of the sexual drive and dividing it originally into partial drives."[75] Nevertheless, Freud insisted that sublimation is a product of Eros, albeit one that opens the ego up to Thanatos as well. This is because in *The Ego and the Id* Freud assigned to Eros not only the uninhibited sexual drive proper but also the aim-inhibited self-preservative instinct of the ego derived from it.[76] Sublimation is, thus, in a strange way, erotic, although only in the sense of a transformation and redistribution of energy.[77]

According to Kofman's reading, art provides the beautiful form that is needed in order to divert the attention of the ego when what is required is the lifting of inhibition and the possibility of discharge of excess energy. The work of the artist thus effects a release of energy *tout court*, without its being relocated or reinvested elsewhere.[78] Kofman argues that the artist tries to repeat what the child does in play, that is, to repeat ever differently. Calling sublimation a "little death" in that it effects a separation and thus partial liberation of the death drive, Kofman argues that culture is possible only through regression, that is, through a liberation of death forces,[79] a "mimicking death in life."[80] The relation of sublimation to ego formation (the transformation of object libido into narcissistic libido) means that "the artist is not really the 'father' of his works . . . that it is instead the works that engender their father and are constitutive of his identity."[81]

Kofman emphasizes the narcissistic pleasure that is both a motivation for the creation of art and an effect of the experience of artworks. She cites André Green's description of the artwork as a "transnarcissistic object," in that both artist and public can share in the narcissistic pleasure it arouses.[82] The

artist repeats herself, doubles herself in her work, implying "a nonpresence to oneself, an originary dissatisfaction, death immanent in life, and the absence of any simple and full origin."[83] Furthermore, the double of art can also be linked to the repetition compulsion and the death drive as its "principle of intelligibility."[84]

In *Tales of Love* Kristeva also explores the art in relation to narcissism, in particular developing Freud's idea of the "father of individual prehistory," which "offers itself to me as a *model*" or as a pattern to be imitated.[85] Following Freud, Kristeva calls this "model" an "imaginary father"; it is imaginary because it precedes object relations, and therefore is immediate and direct, and a "father" because it is a model outside of the fused relationship with the mother, and it thereby precisely represents that which is the object of the mother's desire as something other than the infant. This "father" is an odd locution because "there is no awareness of sexual difference during that period, and such a 'father' is the same as 'both parents.'"[86] It is only with the establishment of this secondary narcissism that the child withdraws some of its "libidinal covetousness" toward the mother, a process that allows for the potential for normal, mediate identifications to occur.[87] Identification is conceived of as being always already within the symbolic order, within the realm of language. Therefore primary identification is of necessity metaphorical, since it concerns a nonobject in that it takes place prior to the establishment of object relations.[88] Here Kristeva understands metaphor as "movement *toward* the discernible."[89] This establishment of a metaphorical "object" allows for the psychic split from the maternal container that enables subject formation.[90]

Kristeva seems to be interested, in all her discussions of literature and psychoanalytic transference-countertransference, in identifying a process analogous to this development of secondary narcissism, but at the level of the already constituted subject. In other words, she is concerned with identifying processes or practices in the already constituted subject that she thinks operate analogously to the way the imaginary father functions in presymbolic life, but from within the realm of language. Such processes or practices would effectively translate the imaginary into the symbolic, but without reifying it. In acting in a manner parallel to secondary narcissism, these processes, through sublimation, might succeed in, as it were, retroactively creating that place of immediate identification necessary for successful subject formation, in particular in situations in which it had initially been effected in a way that was damaging to the individual, for example, when fusion with the mother had not been completely overcome or when the mother was introjected in a melancholic fashion. Modifying Lacan's view, developed out of his critique of ego

psychology, that all imaginary identification is based on a process of self-deceptive misrecognition of oneself in an external image that is prior to the entrance into language, Kristeva acknowledges a place for imaginary identification *subsequent* to the subject's orientation in and through the symbolic order.

Kristeva reaches this speculative position through a reading of Melanie Klein and André Green. In her book on Melanie Klein, Kristeva notes Klein's divergence from Freud (for whom a newborn's drives have a source and an aim but no object) in that she posited an object toward which the newborn's drives are directed, namely the maternal breast. Furthermore, for Klein, "even a newborn has the capacity for a rudimentary form of sublimation, which allows it to overcome the pain of the absence of this desired object."[91] In *Envy and Gratitude* Klein describes the first three or four months of life as the "paranoid-schizoid position," in which the child experiences persecutory anxiety from both internal and external sources, including the fear of annihilation stemming from the experience of birth and frustration at the periodic absence of the breast.[92] The breast, at this point strictly speaking only a part object, is split into good (gratifying) and bad (frustrating) and further into an internal, introjected good/bad breast (which Klein calls the core of the superego) and an external good/bad object. These good/bad internal and external objects are the result of the struggle of the destructive or death impulses with libidinal impulses. In the second quarter of the first year of life, the feelings of love and destructive impulses reach an uneasy synthesis, giving rise to what Klein calls the "depressive position," a feeling of guilt and the urge to make reparation to the injured loved object, the good breast. Klein relates this introjection of objects to Freud's description of ego formation as a precipitate of abandoned object cathexes.[93] The drive toward reparation derives from the life drive and therefore "draws on libidinal phantasies and desires," a tendency that "enters into all sublimation."[94] Klein describes the development of a complex psychic life as originating out of the ego's defense against anxiety. "My mother is disappearing, she may never return, she is suffering, she is dead. No, this can't be, for I can revive her."[95]

The depressive position interests Kristeva because it is at the origin of all thought and language, symbolization being the only way in which we can maintain a stable and satisfying relation with objects.[96] Klein believed that the child at six months was capable of experiencing the loss not just of a part object like the breast but of a whole object. This loss coincides with the introjection of the object, which leads to an integration of the ego, now experienced as a whole distinct from others. The feeling of guilt that accompanies the depressive position, guilt at possibly having lost the object through the infant's

own destructiveness, leads to a desire for reparation. The desire for reparation, in tandem with the discovery of the distinction between real things and their symbols, fantasies and external reality, is at the root of the drive to create art, for "the work of art functions as an autoanalytic activity that absorbs guilt as well as the acknowledgment of guilt."[97]

Klein understood sublimation within the context of reparation during the depressive stage, according to Green's reading. While most readers emphasize Freud's articulation of sublimation as desexualization,[98] Klein focuses instead on sublimation's inception in the work of Eros as a "reparative re-binding."[99] Kristeva follows Hanna Segal in noting the proximity of Klein's position to Proust's. Segal writes that Proust's work illustrates the process whereby depressive fantasies give rise to the wish to repair, restore, and recreate the lost object within the ego, which in turn is at the root of later sublimation and creativity.[100] For Proust, "it is only the lost past and the lost or dead object that can be made into a work of art."[101] Segal likens Proust's writing of a book to a work of mourning in which external objects are given up and then reinstated in the ego as they are re-created in the novel. Just as for Freud sublimation is the result of the renunciation (through redirection) of a drive, for Proust writing emerges out of the loss of a world. The realization and symbolic expression of the depression that results from giving up an object necessitates an acknowledgment of the death drive, in all of its destructive aspects, even as it sublimates this position. Segal goes so far as to claim that "to the sensitive onlooker, every work of beauty still embodies the terrifying experience of depression and death," as the artist's experience of detachment is unconsciously relived by the audience.[102] Beauty is nothing more than the fullest expression of both the conflict between and the unity of Eros and Thanatos.

Kristeva writes that "Klein's hypothesis finds unexpected support in none other than Marcel Proust, who wrote 'ideas come to us as the substitutes for griefs.' "[103] But is sublimation inextricably tied to reparation? Several theorists have argued against this interpretation. Green is concerned with questioning, on the one hand, sublimation's equation with desexualization, and, on the other, with the implications of the term "reparation," which suggests that art has a quasi-moral function. Green also provides a corrective to Kofman's reading of sublimation as a transformation of energy or as a detour or deviation of sexuality. He quotes from *The Ego and the Id* to argue that sublimation is an abandonment rather than a diversion of sexual aims, calling it instead a "purification" or "spiritualization" of sexuality.[104]

In *The Work of the Negative*, Green makes the suggestive claim that he "would happily qualify sublimation as 'neg-sexuality,' just as one says neg-

entropy."[105] This definition addresses both the issues of sexuality and of reparation with reference to sublimation. In theoretical physics, the concept of negative entropy is the reverse of entropy, which is the tendency toward disorder or the wasting away of energy. Negative entropy expresses, by contrast, a kind of building up of order or energy such that a system may be mobilized and maintained coherently. Negative entropy, or NegEntropy, is the process by which a system or organism not only avoids the effects of entropy but actually increases order and the productive usage of energy. Death might be considered a state of high(est) entropy; life is a low-entropy or, particularly in its most complex forms, a negative-entropy state. With the term "neg-sexuality" Green seems to imply that these terms are analogous to the forces of Thanatos and Eros in Freud. The death drive would be aligned with entropy, and, as "neg-sexuality" sublimation would be aligned with the death drive as well. However, Green is not content with thinking sublimation merely as the absence of the sexual. Instead, the prefix "neg-" in conjunction with "sexuality" also seems to indicate for him the productive and mobilized energy associated with neg-entropy.

Green writes:

> On the one hand, sublimation appears to be a vicissitude of the sexual drive, a purified form which has its place among other possible vicissitudes but which remains within the patrimony of Eros, and, on the other, sublimation is the adverse counterpart of Eros which, far from serving its aims, sides with those forces which are antagonistic to its purposes (Thanatos). The paradox cannot easily be overcome, and this is the path which Freud's work (the product of his sublimation) will follow.[106]

The larger context of Green's work is a consideration of the concept of the negative within psychoanalysis. Considering Green's influence on Kristeva's thought, this discussion of sublimation can be tied to her interest in negativity. Recall that it is through negation that thought can be generated out of affectivity, both at the developmental level, as in the child undergoing the depressive position and acquiring language as a substitute for the lost maternal object, and on the level of psychoanalysis, where the patient's unconscious can be accessed and verbalized through the intermediary of negation.

Green understands sublimation as a process whereby "sexuality lays siege to thought, involving itself in the partial *jouissance* of looking," yet subjecting the excitation of the original relation to the object to an "intellectual displacement."[107] Citing Jean Laplanche, Green states that in what is sublimated we

are to find "'sexual energy' alone, itself 'desexualized,' dequalified, put at the service of non-sexual activities."[108] Yet in artistic activity, as well as in the formation of the ego through sublimated object attachments, there is not only desexualization but also a kind of "enticement . . . the sublimated desexualized ego does not so much give up satisfaction as it claims to be a 'superior' jouissance."[109] This superior jouissance would be jouissance sublimated in the sense of "preserving while surpassing," of "spiritualization," in a seemingly completely Hegelian sense of Aufhebung.[110] However, Green warns that idealization and sublimation are distinguished in Freud, since idealization concerns the object whereas sublimation is a vicissitude of the drive.[111] It is Klein's position that exacerbates a tendency toward the blurring of the two actions.

Whereas Freud postulates sublimation as a diversion of the libido toward a nonsexual or desexualized aim, Klein postulates the transformation of narcissistic libido into object libido as the process of sublimation. For example, in the case of Leonardo da Vinci, Freud focuses on a childhood memory that da Vinci recounts in one of his scientific notebooks, in which Leonardo recalls being in his cradle as an infant when a bird comes down to him, opens his mouth with its tail, and strikes him many times against the lips.[112] This "memory," which Freud reinterprets as a childhood fantasy formed at a later date and transposed retroactively to childhood, is cited as evidence by Leonardo of his own destiny to be a researcher into the flight of birds. Freud interprets the fantasy as one of being suckled by the mother (an oral, sexual drive) that is transposed into a bird, a symbol for the drive to research via the sexual researches of his childhood into the origin of children.[113] This memory, then, is a clear example for Freud of sublimation, in which the drive is reoriented in a nonsexual way, and object libido becomes narcissistic libido.

Klein, by contrast, interprets the memory in a converse way, emphasizing, as Green puts it, "the ego's predisposition to attract to itself erotic investment in order to transform it into narcissistic investment (by the formation of symbols), by identifying with erotic objects (nipple, penis, and bird's tail in the case of Leonardo)."[114] Rather than exchanging object libido for narcissistic investment, as Freud postulated in The Ego and the Id, Klein emphasizes instead the child's highly developed capacity for object identification. Narcissistic libido is transformed into object libido in the process of sublimation, which involves a kind of mourning as the child gives up the desires of infancy and makes reparation in the face of her guilt at having possibly caused this loss through her own destructiveness, through the acquisition of symbols. Green asks whether one could rightly call this revised form of sublimation a desexualization.[115]

In fact, Green argues that one cannot and that Freud himself gestures in this direction in speculating on the child's identification with the father of individual prehistory.[116] This "paternal" function, that in fact is identical with "both parents," is neither object nor nonobject, preceding object relations yet also the condition for the possibility of their emergence. Green interprets this transition between nonobject and object through D. W. Winnicott's analysis of cultural objects as existing "in the intermediate area between external and internal reality, an area which he defined as accommodating objects and transitional phenomena."[117] Winnicott was concerned with enumerating the characteristics specific to the work of art, which, he argued, cannot be adequately articulated according to the criteria of the judgment of existence, since they are neither, strictly speaking, real nor nonexistent.[118]

Using Klein's concept of the internalized good breast, the breast consumed upon the acknowledgment of the loss of the external breast, Winnicott postulates art as a "salvaging" of the object on the periphery between inside and outside, at the very point at which it might disappear.[119] Just like the blanket or other transitional object a child clutches as something whose appearance and disappearance, unlike that of his mother, he can control, the artwork functions as a transition between an internal realm of fantasy and the external world, or between subjective and objective reality. In Winnicott's words, the transitional object and transitional phenomena, such as babbling and other prelinguistic oral activities, "start each human being off with what will always be important for them, i.e. a neutral area of experience which will not be challenged."[120] This intermediate area of experience "is retained in the intense experiencing that belongs to the arts and to religion and to imaginative living, and to creative scientific work."[121]

Green compares this idea of transitional phenomena with Freud's notion of a father of individual prehistory, which, we recall, Kristeva describes as a "model" or "pattern," a metaphor in that it carries over from the subjective to the objective realm. In this way, he employs the concept of negation, taken from Freud's essay, as paradox, a mode in which the seemingly mutually exclusive oppositions of the Freudian and Kleinian interpretations of sublimation can coexist. This third realm, which Green names the realm of creativity, the mode of existence of sublimated objects, may give rise to a "new pleasure"[122] that is other than the pleasure associated with the directly sexual: "It cannot be denied that sublimation is not only socially appreciated but is genuinely an innovative source of pleasure. And I do not mean to limit the import of this remark to creative, artistic sublimation; it applies to all the forms of sublimation which creativity implies when process of psychical transformation are

brought into play."[123] Here we can see the roots of Kristeva's understanding of the link between the analytic experience and the experience of creating and appreciating art.

Green concludes that sublimation might best be thought of as the work of the negative torn between the psychical forces of life and death, objectalization and disobjectalization.[124] Writing, with the work of Proust being perhaps the most exemplary form of this process, constructs an object of its own, a space that might be best described as transitional in Winnicott's sense. It is impossible to determine whether the reality of the work is one that really exists or ever existed, or whether it is exclusively a product of the author's inner, subjective world.[125] Yet while Green concords with Freud's claim that sublimation is allied with the forces of death, in that art remains continually connected with delusion and is therefore to a certain degree irremediably impotent, he also argues that art stimulates and excites the psyche, exacerbating the conflict between reality and fantasy.[126] Sublimation is both necessary to (even the necessary condition of) symbolic life, which in turn is the condition for human social organization *and* a cause of dissatisfaction.

SUBLIMATION AS RE-EROTICIZATION? LACAN, LAPLANCHE, BERSANI, AND COPJEC

When Lacan considers sublimation in Seminar VII, it is within the context of a discussion of the ethics of psychoanalysis, precisely because of sublimation's linkage with social recognition.[127] For Lacan, the human being's first subjective orientation is to an original "Thing."[128] This orientation is characterized by primary affect, prior to any repression.[129] It is in the "same place," writes Lacan, that "something which is the opposite, the reverse and the same combined, is also organized, and which in the end substitutes itself for that dumb reality which is *das Ding*—that is to say, the reality that commands and regulates."[130] The Thing "only presents itself to the extent that it becomes word" or is symbolized or signified, yet it remains that which is beyond signification. The Thing is the lost object, lost through the inception of language; subsequent to the shift into signification, the lost Mother occupies the place of the Thing. As in Kristeva and Klein, it is through the loss of the Mother/Thing that the human begins to speak, and human endeavors such as science and art are formed around this empty place.

Lacan writes that sublimation takes an object and raises it to the dignity of the Thing.[131] He gives the example of Hans Holbein's *The Ambassadors*, a painting in which a central enigmatic form, a kind of stain on the floor be-

tween the two figures, transforms itself, when looked at from a particular angle, into a death's head. Sublimation organizes form around emptiness in the manner of anamorphosis; Lacan writes that "to a certain extent a work of art always involves encircling the Thing."[132]

Lacan insists that although works of art may imitate objects, they do not seek to represent them, and even the imitation of an object may make something different of it. The artwork presents the object in relationship to the Thing, rendering it both present and absent. Like courtly love, which uses the technique of holding back or suspension of direct erotic contact in order to make the object of love stand out in its ultimate inaccessibility, the artwork, too, "purifies" the object through a series of "repetitive restatements" in order to show that it points at something else that cannot be represented.[133] Sublimation, therefore, is transgression, but it is incorrect to say that it is desexualization. Lacan writes:

> Sublimation is not, in fact, what the foolish crowd thinks; and it does not on all occasions necessarily follow the path of the sublime. The change of object doesn't necessarily make the sexual object disappear—far from it; the sexual object acknowledged as such may come to light in sublimation. The crudest of sexual games can be the object of a poem without for that reason losing its sublimating goal.[134]

Jean Laplanche argues that although sometimes sublimation works in opposition to sexuality, the two may also complement each other, with the result that "sublimation can be linked to a kind of neogenesis of sexuality."[135] Referring to psychoanalysis' almost total neglect of the aesthetic fields of gastronomy and cooking, places where the drive to self-preservation and the sexual drive overlap, Laplanche wonders aloud what difference this would make to the notion that sublimation is always desexualized.

Leo Bersani pursues Laplanche's inquiry into sublimation in his essay "Sexuality and Aesthetics." As Laplanche notes, Freud writes in the discussion of Leonardo da Vinci that sublimation originates when a portion of sexual desire escapes repression and is transformed into intellectual curiosity. Since this component of sexual instinct never attaches to the original complexes of infantile sexual research, Bersani writes, this means that the intellectual interests in whose service it operates cannot be considered *substitutive* formations of the drive to sexual research but rather "in this form of sublimation *sexuality would therefore provide the energy of thought without defining its terms.* Or . . . we would have a *nonreferential version of sexualized thought.*"[136] This situation

would result in a kind of "mobility of thought which somehow makes the statements of thought impotent or inoperative."[137] Nonreferential thought would be thought unmoored from signification without thereby becoming incoherent. We might again compare this process with Keats's "negative capability," in which sexualized thought would tolerate uncertainty and doubt without insisting that its terms being defined. This sexualized energy would be the origin of or equivalent to creative or aesthetic thought.

Here we can refer to two examples for clarification. One, from Lacan, concerns Cézanne's depiction of apples, concerning which, Lacan writes, "everyone knows there is a mystery . . . for the relations to the real as it is renewed in art at that moment makes the object appear purified."[138] Cézanne does not imitate apples but presents them in such a way that it becomes evident that, rather than an illusion of represented-apples-as-real, the painting "aims at something else" through the depiction of apples.

The second example comes from Proust and is presented by Bersani in another essay, "Death and Literary Authority: Proust and Klein."[139] Bersani argues that in In Search of Lost Time Proust does not present art as an essentialized version of "real life" but rather as "an annihilating and redemptive replication of experience . . . a kind of posthumous responsiveness to surfaces."[140] Bersani's point is that to read Proust's novel—and sublimation itself—as merely an annihilation of appearances such that their essence can be manifest in its atemporal significance is to overlook the fact that in the very erasure of lived sensation through the symbolic significance it takes on within the text, it is nonetheless the sensuous surfaces that have the last say. Quoting a striking passage taken from the second volume of In Search of Lost Time, Bersani shows how, in Marcel's very lament about the sorrowful sacrifice of past experiences he has to undergo every day symbolically, what shine through or are particularly "visible" are precisely those phenomenal details whose disappearance is being mourned. There is, then, in the work a simultaneous symbolization and desymbolization (or destabilization of symbolization) operating, in a way that signifies both a profit, in the sense of a purification or essentialization of past experiences that would imply a loss of sensuous detail, and, simultaneously, a loss of Marcel and an unprecedented gain in pure appearance.[141] For Marcel "—but perhaps not only for Marcel—to desymbolize reality may be the precondition for re-eroticizing reality."[142] This desymbolization is a counterpart to Kristeva's description of the semiotic register of language.

Indeed, in The Culture of Redemption, Bersani argues that sublimation at the highest extreme, far from being a transcendence of the sexual, is rather

"grounded in unalloyed sexuality."[143] Here he argues that certain cultural activi-
ties, and above all, art, should be thought of as "nonfixated sexual energy . . .
movements . . . which partially dissolve the materiality of the activity, which
blur its forms and its identity and allow us fleetingly to experience a pure
excitement."[144]

Bersani returns to Freud's "On Narcissism" to consider that "something,"
that new psychical action that must be added on to autoerotism to bring about
the narcissism that is necessary for ego formation.[145] This move back from
object to ego can be thought of, according to Bersani, as a kind of self-shatter-
ing. The need to repeat this experience can in turn be thought of as an origi-
nary sublimation,[146] in that for Freud the transformation of object libido into
narcissistic libido is a desexualization and therefore a kind of sublimation;
there is a move away from an externally oriented drive toward an internally
directed one (which in turn may be redirected toward another aim). The "self-
shattering" is a result of a split in consciousness that will eventually lead to the
distinction between inwardness and outwardness, but it is a paradoxical split
in that it ultimately leads through a process of self-reflexiveness to integration
and a "move from fragmented objects to totalities."[147]

Bersani refers to this originary sublimation as a pure burning; rather than
a transcendence of the sexual it is a refinement of the sexual down to its un-
adulterated quiddity and can be found in the specific "symbolization" of art,
where the symbol refers to nothing external to the work or "in the world" but
rather symbolizes the very libidinal energy with which it is invested.[148] Such a
pure sublimated sexual energy is entirely nonreferential. It is, Bersani writes,
"as if it had become fascinated with the prospect of initiating sexuality through
self-reflection."[149]

Joan Copjec agrees with Bersani's identification of sublimation as the "new
psychical action" that is added to autoeroticism in order to give rise to the
primary narcissism necessary for ego formation, and she concurs that subli-
mation can give rise to a kind of sexual enjoyment but disagrees that sublima-
tion can be objectless.[150] She notes, furthermore, that for Freud the develop-
ment of the ego consists in a *departure from*, rather than directly out of,
primary narcissism.[151] Following Lacan, Copjec interprets the split that occurs
with the positing of primary narcissism as one between the mother and the
breast: "Rather than two objects, mother and child, we have now three: mother,
child, and breast, with the last operating as a strange 'delegate' or 'representa-
tive' of the primordial mother."[152] What is sublimated, then, is the drive that
would demand the mother as its only satisfaction. The breast, in its truncation
from the mother, represents a whole series of "objects of lack" (rather than a

lack of objects), which will stand in for the mother. Thus, as Freud too insists, narcissism is only accessible indirectly, through object cathexes.[153] As an example, the subject who is in love "so wills the object of his or her love that what comes from without, from the beloved, is indistinguishable from what the subject chooses."[154] What we love in the loved object is ourselves, not simply as a reflection of our own image; rather, "one finds . . . in the jouissance loving it affords a corporeal experience of the self."[155]

Returning to Proust, we might interpret *In Search of Lost Time* in the way that Copjec reads Cindy Sherman's *Untitled Film Stills*, as a continual search for oneself through the other, through sublimation, in Proust's case in the form of recollection through the medium of the embellished narrative, the pseudoautobiography. This is not so much a reparation as a creation of oneself as other, through art, through writing. Art is a double, an internal division of the self from the self, a repetition, achieved through the medium of an object that is self-reflective because self-chosen.

Kristeva: Sublimation, Love, and Death

Kristeva reflects on sublimation in both *Black Sun* and in her trilogy *The Powers and Limits of Psychoanalysis*, and she emphasizes the notion of identification/sublimation as repetition. She identifies the "object" of the sublimated narcissistic libido as the imaginary father,[156] although the mother, as the object of the very first mimetic yearnings, shares this space toward which re-eroticization is oriented. This makes sense as a compromise position between Bersani and Copjec, for the imaginary father (and the mother as the prototype of the object prior to the establishment of object relations) is neither a whole object nor an objectless position but lies somewhere in between these two antitheses. Furthermore, although identification with the imaginary father paves the way for full object relations to come about, Freud insists that it "takes place earlier than any object-cathexis."[157] Identification with the father of individual prehistory takes place through sublimation, for it transforms the desire for the mother into an identification with the mother's desire; it acknowledges that the mother desires something other than the infant. It thus turns the infant toward the external world, wresting it from autoeroticism, and enacts a separation from the mother with whom the infant had been psychically fused.

In *Tales of Love* Kristeva makes explicit the relation between sublimation and the imaginary father. She qualifies her description of identification with

the imaginary father as "not of the order of having" but of "being-like."[158] She
further notes the continuity between the incorporating orality of the infant in
the depressive stage and the capacity for language of which it is the substrate.
The "father" of individual prehistory is a model or schema for the speech of
the other, a nonobject that nonetheless leads to a first possibility of unification
with others. To be capable of such an identification a restraint on my libido
must first be effected; "my thirst to devour had to be deferred and displaced to
a level one may well call psychic' . . . in being able to receive the other's
words, to assimilate, repeat, and reproduce them, I become like him."[159] This
primary identification with a metaphorical other and with the schema of lan-
guage allows for the eventual possibility of secondary identifications with
others and with objects. At first the metaphorical identification, the naming
of which Kristeva claims "perhaps represents the condition for sublimation,"[160]
is at the level of the heterogeneous, of the drive, of sensuousness, of sounds
and intonation—the semiotic level, the level of the nonobjectal—that must be
deciphered. This heterogeneity in turn lays the foundation for the symbolic
matrix that will eventually allow the child to interact as a subject within
language.[161]

This "father" is the mother's desire beyond her response to the infant's de-
mands, and indeed her capacity quite simply to refuse them.[162] Kristeva writes:
"The imaginary father would thus be the indication that the mother is not
complete but that she wants . . . Who? What?—the question has no answer
other than the one that uncovers narcissistic emptiness: 'At any rate, not I.' . . .
And it is out of this 'not I' . . . that an Ego painfully attempts to come into be-
ing."[163] Primary narcissism emerges out of this struggle as a defense against
the void of separation, along with a host of images, representations, identifica-
tions, projections, and ultimately words, which become the consolation for
the subject who is in this version of the depressive position. But this narcissism
is a form of desexualization, a sublimation, therefore, that opens the newly
formed ego up to the death drive in unbinding Eros and Thanatos.[164]

The sublimatory process that gives rise to language and art is thus pro-
foundly ambivalent. Kristeva calls the Freudian account of the emergence of
thought out of this sublimation of libido and resulting liberation of the death
drive—which in turn will menace the newly formed narcissistic ego—dialec-
tical, Hegelian, pertaining to *signifiance*, the dynamic meaning-producing
register of language. She writes: "The human being is one who speaks inhab-
ited by Eros-Thanatos and by a third constituent which is neither language
nor drive, but which overdetermines both of them: *signifiance*. The two

scenes of conscious and unconscious are adjoined to a third, that of the extra-psychical."[165]

In identifying sublimation as the psychical action that effects the passage from autoeroticism to primary narcissism, Freud tells us in effect that the death drive is implicated in the process of subject constitution from the outset, in the transformation of drive into *signifiance*, which in turn leads to the possibility of imagining, signifying, thinking, and speaking. The thought process is thus always set in motion at the price of the unbinding of the death drive, which threatens the integrity of the speaking subject.[166] As Kristeva writes, "the psyche is founded by [sublimation] through and through, for it is the capacity of *signifiance* (representation-language-thought) based on sublimation that structures all the other psychical manifestations."[167]

The most striking evidence of this threat lies in the link Freud exposed between melancholia and sublimation: left to itself, sublimation disintricates the drives and in so doing exposes the ego to melancholia. The root of art, sublimation, is also often the cause of melancholia. What, then, allows some artists not to succumb to melancholia? The answer, Kristeva writes, as she had in *Black Sun*, is that certain artists are able to resexualize or re-eroticize sublimated activity in such a way that the unbinding is not simply reversed but instead that a secondary, not directly sexual pleasure can arise. This might take place through the recounting of erotic fantasies, through the creation of images, or through a richness or intensity of language itself.

Or through love. The psychical state of being in love, Kristeva writes, returns us to, or is an "archaic reduplication" of, the state of identification with the father of one's individual prehistory, prior to any object cathexis. Furthermore, the "love" present in the analytic situation allows the analyst provisionally to occupy the site of the symbolic Other, the field in which every person is constituted as a speaking subject, insofar as he or she is the metaphorical object of the analysand's identification.[168]

The provisionality of this position can be related to Kristeva's reading of the poetic imaginary as allegorical, which simultaneously eschews classical and religious stability and nonetheless remains desirous of creating new meaning, a temporary salvation.[169] Sublimation, she writes in a reading of Nerval's poetry, "is a powerful ally of the Disinherited, provided, however, that he can receive and accept another one's speech."[170] Sublimation in this homeopathic sense is, then, a love directed back toward the mother through the protective filter of the imaginary father, or through language. What is re-eroticized is the maternal bond, but it is a bond renewed and transformed through its immersion in the symbolic order.

Conclusion: The Novel, the Imaginary, and Forgiveness

At the end of her volume on Proust, Kristeva posits the idea of writing as forgiveness. If for Dostoevsky forgiveness drives the narrative as an explicit theme and brings it to a close, with Proust, "forgiveness is turned into a novel."[171]

No longer a thematized theological pardon for crime or for human finitude, in Proust forgiveness is transubstantiation, endowing "what is infinitely small—or infinitely abject—with signification."[172] The novel translates the smallest and seemingly most insignificant moments of memory and of sensation, and of the borderline between the two, "not by drawing attention to such phenomena but by breathing new life into them."[173]

Here Kristeva returns to the idea of the imaginary as allegorical, but this time she writes that the imaginary is novelistic, in Proust's sense.[174] The "image" that constitutes the imaginary is not a copy of an external object but rather in the novel is a "discourse" or a "vision." For Proust, a vision is "an indefinite construction of signs that descend on one another to become impressions and sensations."[175] The temporality of the imaginary is an "always ahead of itself," but ahead of itself in multiple branching ways, the imaginary of a polyphonous "I."[176] This "I" can come back to itself only in language; it is an imaginary "I."

The imaginary *I* seduces the reader because it embodies what Kristeva calls a "chiasmus of incarnation," neither as a fully individuated subjectivity (the "I" of a particular person), nor as the pure I, the anonymous universality common to all persons.[177] The imaginary *I* occupies a place between the object and the concept. It operates between "natural" time as a measurable sequence of uniform "nows" and the time of impressions or of the subject. Proust's novel manifests two distinct temporalities, that of the immediate temporality of the events that constitute the plot and those of the narrator's involuntary memory, which reverse time and return as if by magic to the past, reconstituted in the present. Kristeva speculates that Proustian time "seeks to reveal the essence of the novelistic imaginary by forming a union between an ontological temporality and an ontic time."[178]

The imaginary narrator evades the ontic/ontological distinction. It remains in an intermediary stage, "neither in the *status corruptionis* of the drunken sin or in the *status integratatis* of a pacified conceptual understanding, but rather in the *status gratiae*."[179] This "state of grace" evokes the Greek word *charis* in that it connotes an intense regeneration.[180] Our time has lost faith in religion and in revolutionary fervor; where religion and political passion exists, it seems

to have succumbed to the emptiness and repetitiveness of the spectacle and of technical prowess and commodity culture. The only space in which an alternative temporality exists today, according to Kristeva, is in the space of the imaginary:

> The imaginary space remains the only one that harbors the unattainable singularity that is always fleeing ahead of itself and against itself. The polymorphous imaginary offers an alternative to sublime pages (as long as they are accessible) and to stutterings or eruptions of banality that drown a world hereafter poised in front of a video screen, in front of a "sight" without "knowledge." It paves the way for a third option, one that lies between the impatience of a history whose promises and disasters we reject, on the one hand, and the passion of bodies reduced to utilitarian languages that forgo metaphors and subtleties, on the other. The imaginary-novel incarnates us and displaces us; it takes us in and pushes us away. We wander off, becoming increasingly lost and then found again. We are diverse, divergent, and authentically inappropriate. . . . We are all new patients of the imaginary; we are the basically lucid or distraught subjects or consumers of this mode of speaking and being that has transferred Being into grace.[181]

5

THE "ORESTES COMPLEX"

THINKING HATRED, FORGIVENESS, GREEK TRAGEDY, AND THE CINEMA OF THE "THOUGHT SPECULAR" WITH HEGEL, FREUD, AND KLEIN

Without repeating life in imagination, you can never be fully alive; "lack of imagina-
tion" prevents people from "existing."
— Hannah Arendt, *Men in Dark Times*

One cannot hope to understand Freud's contribution, in the specific field of psy-
chiatry, outside of its humanistic and Romantic filiation.
— Julia Kristeva, *Strangers to Ourselves*

KRISTEVA'S DISCUSSIONS OF FORGIVENESS IN *BLACK SUN* AND *Time and Sense* revolve around the imaginary constructions of literature, spe-
cifically in Dostoevsky, who makes forgiveness an explicit theme of *The Idiot,
Crime and Punishment, The Devils,* and *The Brothers Karamazov,* and in
Proust, whose very writing style performs the "forgiveness" of transubstantia-
tion, turning sorrows into words. In later works, however, she focuses instead
on the ambivalent presence of hatred within the structure of forgiveness or
"par-don." In this chapter I will examine this new conception of forgiveness
with reference to Kristeva's readings of Hegel, Freud, and Klein. In her most
recent work published in English, namely, *Hatred and Forgiveness* and *This
Incredible Need to Believe,* Kristeva takes Hegelian themes from the end of the
Phenomenology of Spirit and transforms them through her reading of Freud
and Klein. At the same time, she insists that Freud himself cannot be under-
stood apart from his romantic and idealistic heritage.

I will argue in this chapter that Kristeva's concept of forgiveness, in partic-
ular what she calls "aesthetic pardon," emerges from her dual commitment to
Freud and to Hegel but is given its specific character through her reading of
Klein. In particular, I will show the importance of forgiveness or pardon as a
structural, transitional phenomenon rather than a psychological or agential
action in Hegel, Klein, and Kristeva. Hegel's use of forgiveness as the negative

principle of dialectical movement translates into Klein's description of the transition between the paranoid-schizoid and the depressive positions, and Kristeva's understanding of pardon as what brings a depressed patient, perhaps despite herself, out of her condition of being affectively frozen or stuck; what distinguishes Kristeva's par-don and Klein's reparation from Hegel's forgiveness is the formers' foregrounding of unconscious psychic elements. I will illustrate this continuity and distinction through Hegel, Klein, and Kristeva's readings of Aeschylus' *Oresteia*, all three of whom take the trilogy to illustrate the movement from parceling, revenge, and disabling repetition, on the one hand, to integration and signification on the other. For Kristeva, in addition, the "Orestes complex" that is manifest in contemporary art can both indicate and point the way out of current maladies of the soul. At the end of the chapter I will examine her analysis of the cinema of the thought specular as a form of Oresteian revolt relevant for today's audiences.

At the very end of *Strangers to Ourselves* Kristeva insists on the importance of romanticism and Hegelian negativity as stages on the way to Freud's discovery of the unconscious. She writes that she does not intend to show the genealogy of psychoanalysis from Kant to Freud but rather to focus on Hegel's account of foreignness and the Other, in particular in his analysis of Diderot.[1] In addition to Hegel, the German romantic preoccupation with the mystical, the exotic, and the fantastic provided Freud's most notable examples in his essay on the uncanny. Freud's work, as we have seen, inspired Kristeva to take this "foreigner," who is a separate character in *Rameau's Nephew* and in E. T. A. Hoffman's *The Sandman* and to conceptualize it as an integral part of the psyche, both in a biological and in a symbolic sense.

Although Freud thought the notion of introducing forgiveness into psychoanalytical discourse and practice would be absurd, Kristeva claims that "pardon" in a new, nonpsychological and nonagential sense describes the analytic session and its interaction between psychoanalyst and patient, in particular the bonds of transference and countertransference that emerge between them. She also characterizes a process of writing and creativity as forms of a relationship to self that can be conceptualized in the language of forgiveness. Both of these senses of forgiveness are self-relations enabled by something external such as an aware interlocutor or a creative act of writing (or composing or designing) rather than any overt act of forgiveness on the part of another person.

Kristeva quotes a text not usually associated with the concept of the uncanny, namely, Freud's treatise on religion, *The Future of an Illusion*, in part to point out Freud's acknowledgment that at times aesthetics (and even philosophy) must step in to fill in where analysis leaves off. Kristeva points out

that here we see Freud, who wrote this essay and the related *Civilization and Its Discontents* relatively late in his career, shifting from an analysis of either individual symptoms or artistic projects (as in the case of the uncanny) to the work of *Kulturarbeit*,[2] a process that she, too, undertakes in the progressive development of her intellectual work.

In this book Freud remarks that religion forms part of a drive toward civilization through the "great common task" of humanity to preserve itself against the superior power of nature.[3] An important first stage of this task is the humanization of nature. By assigning a personlike status to forces and fates that seem to control our destiny, humans attain the ability to imagine that everywhere in nature and in the spiritual world exist beings of a kind that we can recognize. Because of this belief, "we can breathe freely, can feel at home in the uncanny and can deal by psychical means with our senseless anxiety."[4] Such a replacement of natural science by psychology, Freud writes, provides immediate relief but also points the way to further mastery of the situation. Eventually humans attribute superhuman powers to these "persons" who are embodiments of the force of nature, in line with the overpowering impression natural forces make upon them;[5] this is the origin of the concept of the gods.

Whereas Freud describes civilization as a deliberate process of humanizing nature, Hegel's systematic philosophical project can be described as a natural process whereby the human observer comprehends and thus contributes to the way in which nature in and of itself has already begun the process of becoming progressively humanized through giving rise to natural beings that have the capacity to become self-conscious and thereby to work and transform the natural world into a spiritual one. For Hegel this process is more than a human projection of psychological qualities onto nature; rather, it is a circular self-production by nature of its other, spirit (in humanity), with which it will ultimately become unified.

For Kristeva too, as we have seen, the natural being of the human individual—her constitution not only through care, thought, and deliberative action but also through the contradictory and conflicting economy of drive motility that Freud identified—informs a similar circle of self-production, although one that will never be fully unified or integrated. Negativity, for both Hegel and Kristeva, provides the driving force of and the organizing principle of this process. Forgiveness or par-don, I will argue, is a form of negativity, a dissolving and transforming power.

For Hegel and for Kristeva forgiveness is not primarily an intentional performative act of an agent. Rather, forgiveness is a structural phenomenon, a kind of transubstantiation that gives rise to new possibilities. What Kristeva

refers to as the transformative capacity of the Hegelian conception of negativity in her earliest works[6] becomes the phenomenon of forgiveness in her later ones. I will examine this phenomenon first in Hegel, where I will argue that forgiveness as a structural phenomenon appears far earlier in the *Phenomenology of Spirit* than its manifestation as a concrete act of human agency late in the "Spirit" section of the text. In fact, forgiveness drives the dialectic from the earliest stages on, and this is why it can be seen to illustrate concretely the phenomenon of the negative, even for Hegel. Negativity, for Hegel, does not function merely by dissolving particular static states but enacts a dynamic concrete or content-full reversal and transformation.

In his essay "The Spirit of Christianity and Its Fate" and in the *Phenomenology of Spirit*, forgiveness, while it is linked explicitly (at least in the early essay) to Christianity, functions more broadly as a kind of focal point or privileged example of the work of sublation (*Aufhebung*). At three key transitions in the *Phenomenology* Hegel uses forgiveness to illustrate a kind of "paradigm shift" from a unidimensional or abstract version of the particular moment in question toward a more complex moment informed by reflection or directedness back into the self. I will parse out these crucial transitions, showing both their parallels and the progressive enrichment of the figure of forgiveness as the dialectic moves toward more complex shapes of self-consciousness and spirit. For Hegel forgiveness functions as *the* privileged figure for the closure of a particular shape of spirit that, as the very life force of the dialectic, simultaneously opens up new possibilities and a new, more complex shape of spirit. More importantly, forgiveness has a temporal dimension in that, specifically in contrast to revenge or retributive punishment, it is a form of interiorization, one that allows for an interruption in and transformation of the flow of time understood as a sequence of identical units as well as the opening up of a new form of temporality.

Kristeva takes up the Hegelian dialectical understanding of forgiveness in her later writings but transforms it by virtue of the Freudian and Kleinian lens through which she reads it. In *Intimate Revolt* she defines forgiveness as "the logical possibility of a relief—Hegel's *Aufhebung*: non-sense and sense, a positive jolt integrating its possible nothingness."[7] Forgiveness in this context does not refer to the possibility of simply overcoming a trauma and leaving it behind but rather to dealing with the traumatic situation or memory in a new way. Forgiveness performs a paradigm shift that allows one to go on when one is nearly paralyzed by grief or regret. In addition, forgiveness enacts a crucial form of self-restriction that is required for humans to live ethically together.

Forgiveness as Transformative Sublation in Hegel

Hegel's early theological writings have an ambivalent relation to the redemptive side of Christian doctrine. His essay "The Spirit of Christianity and Its Fate" portrays Jesus as a revolutionary but also tragic figure, one whose divinely inspired mission fails. The essay depicts the Christian religion as introducing an alternative to Judaism's adherence to what Hegel describes as a rigid, purely "positive" law-governed conception of morality. Forgiveness and love, which Hegel associates with Jesus's doctrine, introduces progression and fluidity into the stasis of law. In this section I will trace the concept of forgiveness through Hegel's early writings to its crucial function in not one but three key transitions in the *Phenomenology of Spirit*.

In his early writings Hegel presents forgiveness as a reconciliation of the infinite chain of opposition brought about by retributive justice. In "The Spirit of Christianity" the action of an aggressive revengeful action taken by an individual in a wrongheadedly antagonistic stance against another individual or group in turn rebounds against the perpetrator in the form of avenging fate: to act retributively against a wrong is to bring harm down upon oneself in addition to one's opponent, awakening the vengeful Fates. Retributive justice only results in universal enmity, and in such a context "there is nothing left save physical dependence, an animal existence which can be assured only at the expense of all other existence."[8]

Judaism introduces into this primitive "state of nature" a completely nonsensible ideal (God and law) that has as its rigidly separated counterpart a sensible nature that must be mastered and given meaning. Hegel describes this relationship as analogous to the Kantian moral imperative, which is counterpoised to the world of life and inclination. The word of god on this view is prior to and thus beyond the realm of sensible evidence.[9] Positive law appears to be a solution to the problem of hostile nature, but Hegel argues that this lawfulness, which results in an unsurmountable dualism, merely reproduces the hostility and even exacerbates it by depriving the natural world, the realm of life, of any intrinsic worth.

Jesus's doctrine of reconciliation, love, and forgiveness is introduced in order to overcome the self-defeating nature of positive law, according to Hegel's reading. Jesus opposed "the subjective in general" to purely objective commands, which, as expressions of pure duty, of "ought" versus inclination, are irrevocably oppositional.[10] The Sermon on the Mount, with its injunction to reconcile with one's opponents and love one's neighbors, teaches an attitude

that fulfills the law by advocating a unification of inclination with law, thereby also canceling the law by making it superfluous. Hegel also calls this movement one by which "the concept is displaced as life."[11] Life refers to growth, fluidity, and the possibility of overcoming opposition.

On Hegel's reading Jesus makes the "cancellation of one's hostile fate" a condition for the forgiveness of one's own sins. This means giving up the quest for revenge against one's enemies or retribution for their acts. In doing so the heart not only reconciles with the other but "reconciles the divine to itself."[12] The heart recognizes the divine within it and thereby its own self-legislation. To see the divine as outside of oneself is to understand justice as mere equity rather than as life and thus to be fundamentally estranged from life, on Hegel's view. In this early essay life just *is* the divine as externalized and embodied in humans' spiritual actions. Faith actualized is a mutual knowledge of kindred spirits. Without this development, one remains at the level of bare faith, or the beautiful soul's withdrawal from the world. To be reconciled with the other and with the world is the "cancellation of lordship in the restoration of the living bond."[13] Such a movement overcomes the restrictions of the *Verstand* (or merely analytical understanding) that Hegel associates with Kantian philosophy, and no longer posits an irreducible division between the finite and the infinite. Rather, in each human "there is light (*phos*) and life . . . not illumined by a light in the way in which a dark body is when it borrows a brightness not its own"; rather, each human "burns with a flame that is his own."[14] Hegel writes that the distinction between bare life (*zoe*) and life understood (light, truth, *phos*) will be overcome in this movement of nature becoming consciousness.[15]

The figure of forgiveness, with its religious scaffolding removed, reappears at every major transition point of the *Phenomenology of Spirit*. From this repetition we can see, perhaps, that for Hegel Christianity mattered less in the details of its theological doctrine than in the logic of development of its central figure of nature becoming consciousness. In what follows I will briefly trace the three major transitional moments of the *Phenomenology of Spirit* where forgiveness plays a key role, in order to draw out the complexity of Hegel's concept of forgiveness.

Forgiveness first appears in the early section "Force and the Understanding," where Hegel traces the path of consciousness from its early naïveté, or common-sense approach concerning the world, to a more sophisticated Kantian/Newtonian stance that understands invisible forces to be the supersensible "reality" underlying and manifesting itself in sensible appearances. Hegel describes the posited realm of forces underlying and purportedly forming the

cause of the realm of appearances as the "tranquil kingdom of laws." However, human consciousness eventually comes to realize that the concepts in its understanding are actually identical to concepts posited as inherent in things; force as understanding and force as effecting the thing perceived are indistinguishable from this perspective. This new realization results in the inversion of the inert realm of laws, which is now understood as the dynamic interaction between the concept as conceived and the concept within reality; the oscillation between the two perspectives is effected by attraction and repulsion, like a magnet.

To understand what has transpired within consciousness's understanding of the relationship between itself and the world, Hegel offers up, beyond the magnet comparison, an analogy from experience. Interestingly, the example he gives stems neither from the realm of Newtonian physics nor from Kantian theoretical philosophy. Rather, Hegel writes, this magnetic relationship of shifting between positive and negative poles can be understood with reference to an example from a completely different context:

> In another sphere, revenge on an enemy is, according to the *immediate law*, the supreme satisfaction of the injured individuality. This law, however, which bids me confront him as himself a person who does not treat me as such, and in fact bids me destroy him as an individuality—this law is *turned round* by the principle of the other world into its opposite: the reinstatement of myself as a person through the destruction of the alien individuality is turned into self-destruction. If, now, this inversion, which finds expression in the punishment of crime, is made into a *law*, it, too, again is only the law of one world which is confronted by an *inverted* supersensible world where what is despised in the former is honored, and what in the former is honored, meets with contempt. The punishment which under the law of the *first* world disgraces and destroys a man, is transformed in its inverted world into the pardon which preserves his essential being and brings him to honor.[16]

Here Hegel aligns the stance of the metaphysical dualist, who unfavorably compares the realm of appearances to a truer and eternal supersensible realm, with the harsh judgment of one who considers a just punishment to consist in rigid parity, an eye for an eye. By contrast, the one who has understood the identity of concepts in the understanding, on the one hand, and concepts that inhere in reality, on the other, is compared to the administer of pardon or forgiveness.

If we consider this transformation superficially, the new inverted world seems to be merely the opposite of the first; however, according to Hegel, in the new inverted world there are no longer two separately subsisting substances, just as negative and positive poles are both simultaneously present in the same magnet.[17] Only in this way does the second supersensible world overarch the first and incorporate it, becoming itself and its opposite in one unity. Its difference is now internal, rather than external to it; it is now difference as infinity, or a "difference which is no difference."[18]

It is this transition to infinity that marks the beginning of self-consciousness; in the identity of consciousness (in explanation itself) with the forces it is describing, consciousness is essentially communing with itself.[19] The human desire to know the world, to understand its own boundless significance within its finite existence, and to find its place in the world, as well as to shape and reflect itself within that world, is the most basic kind of absolute or infinite. It is only in the moment of self-consciousness, which comes about in a way that is analogous to forgiveness, that this realization can happen.

Here forgiveness functions formally as the shape consciousness undergoes in order to become self-consciousness; although forgiveness plays an important analogical role in allowing the reader to conceptualize this transformation, its content is not integral to the transition. This will not be the case once consciousness has actually made the transition to self-consciousness, when forgiveness will come to have an explicit significance for its own self-conception. In "Force and the Understanding," forgiveness remains, despite its exemplarity at this stage, abstract and one-sided when examined in relation to other, more sophisticated transitional moments in the text. Forgiveness here represents an infinity that becomes preliminarily unified with the human understanding that it initially opposed, albeit in an uncomprehending way.

The second and third transitions in the *Phenomenology* where a version of forgiveness plays a pivotal role are both much more well known. The master/slave dialectic, probably the most studied section of the entire book, leads into the standoff of the unhappy consciousness, internally divided between a stoical consciousness, where the "master" universal human will or universal controls the "slave" particular of physiological existence and its vicissitudes, on the one hand, and a skeptical consciousness, where the purely particular "slave" consciousness simply rejects the "master" universal position altogether. These two unsatisfactory shapes of spirit are ultimately resolved in a third position, the "mediator," also referred to as a "priest," who allows the individual to find itself in "spirit," where it "becomes aware of the reconciliation of its particu-

larity with the universal."[20] Here, forgiveness is styled as a personal reconciliation of the finite individual with the unchangeable universal. There is at least a rudimentary understanding on the part of consciousness of the fact that in its very particularity it implicitly carries within itself absolute being; this realization marks the transition to Reason (*Vernunft*). Nonetheless, the fact that an external mediator has to effect the reconciliation between the two sides of the unhappy consciousness signals the inadequacy of this shape of spirit. Its "forgiveness" is the result of outside mediation rather than of explicit self-reflection and comprehension.

Finally, at the end of the section on Spirit, Hegel discusses forgiveness explicitly in a manner that has also been discussed extensively in the literature.[21] In the transition to Religion, consciousness renounces its self-divisiveness and its withdrawal from worldly existence, "makes itself into a superseded particular consciousness," and thereby "displays itself as a universal."[22] Through forgiving the other it also renounces its "unreal" existence; correlatively, its language of reconciliation, its spoken word, becomes "objectively existing spirit,"[23] a concrete medium through which human individuals come together rather than being alienated from one another. Spirit is thus definitely no longer isolated in singularity but now concretely manifest in human language and action, as part of a network of rational intersubjectivity. This is the very meaning of the good conception of infinity for Hegel: the identity of particular and universal is manifest in a constantly self-renewing interchange, a process that forgiveness exemplifies.

Forgiveness's explicit appearance at this stage of the Hegelian historical dialectic should not be taken as the manifestation of a completely new phenomenon but rather as the full actualization of a concept that has been present all along. Without the first opening up of the figure of pardon at the conclusion of "Consciousness," a moment that appears to be simply an illustrative example but which in fact signals the move from consciousness to self-consciousness, forgiveness as it appears at the end of spirit does appear to be the act of an agent, that is, of the acting consciousness or of the beautiful soul. Yet as we have seen, each step, from inversion to external mediation to full-fledged forgiveness, is not a paradigm shift but rather a gradual actualization of a concept that was present from the beginning. Forgiveness drives the dialectic and is the privileged figure of sublation, the transition that preserves and lifts up one moment of human development into the next, transforming it yet guaranteeing the continuity and coherence of the process as a whole.

FORGIVENESS AND CIVILIZATION IN FREUD AND KRISTEVA

Kristeva's conception of forgiveness, while it stems from Freudian psycho-
analysis rather than from any explicit engagement with Hegel, nonetheless
bears some important similarities to Hegel's vision of forgiveness in its charac-
ter as a transitional, structural process. Furthermore, Kristeva's conception of
forgiveness, like Hegel's, marks and binds together all the facets of her thought.
This seems rather puzzling at first blush, for we noted the historically Chris-
tian implications of the use of the term "forgiveness," which make it a concept
that we can intuitively align with Hegel much more readily than with Freud.
Indeed, in Hegel's "The Spirit of Christianity," forgiveness is often used to
describe the definitive difference between Christianity and Judaism.[24] Freud,
by contrast, famously wrote, "just suppose I said to a patient: 'I, Professor Sig-
mund Freud, forgive thee they sins.' What a fool I should make of myself."[25]
So what can Kristeva mean by introducing forgiveness as a psychoanalytical
process?

First, it is most important to underline that for Kristeva, just as for
Hegel, forgiveness provides the condition for intersubjectivity; as Kelly Oliver
puts it, intersubjectivity is an effect, rather than a cause, of forgiveness.[26]
Kristeva writes, quoting Thomas Aquinas, that forgiveness is the "act of 'be-
stowing a gift' that 'prevails over judgment,'"[27] that is, over the kind of calcu-
lative rationality or discernment that often seems to be equated with agency
and that also fuels revenge. It thus goes beyond an act of the ego, and though
it remains an act, it is not linked, in her primary sense, to deliberative agency.
Second, Kristeva calls forgiveness a "temporary suspension of the time of the
ego,"[28] which, as we will see, also aligns her conception of forgiveness with
that of Hegel.

Third, Kristeva conceptualizes forgiveness as a self-renewing interchange,
or as interpretation.[29] As we have seen, Kristeva links the re-eroticization of
sublimation with intersubjectivity, in particular through the trope of forgive-
ness, which she initially reads within the context of Dostoevsky's novels. In
Intimate Revolt, Kristeva compares the network of shared language and sym-
bolic forms (the Lacanian symbolic order) to Kant's notion of the enlarged
mind that is capable of thinking from the standpoint of everyone else as well
as to the Freudian work of civilization building and thus to the inception of a
transformed sense of freedom.[30]

According to social contract theory, of which Freud's *Civilization and Its
Discontents* can perhaps be considered an example, the human being in the
state of nature has a kind of basic freedom, that is, the freedom to roam freely,

to take what she needs, and to undertake any action to preserve her life. This kind of freedom can be characterized negatively, as an absence of constraint. The only hindrances to the natural human's freedom come from the superior strength of natural forces or other animals and the limitations of her own body. When human beings enter into social bonds, however rudimentary, they necessarily agree to give up some of their negative freedom in order to gain the protection and other benefits of the group. The formation of social bonds and, eventually, of a civilization allows for the experience of a new kind of freedom, one that has been called positive freedom. This new concept of freedom relies upon the social bonds to give humans the necessary protective and nurturing structure out of which they may gain self-mastery or autonomy and the possibility of what Kristeva, quoting Kant, calls "the possibility of 'self-beginning,' *Selbstanfang*."[31]

Thus one kind of restriction (the limitation of individual negative freedom in order to protect others in the community and the community's own needs as a whole) opens up another, positive kind of freedom, namely the freedom of intersubjectivity, of family bonds and political ties. Freud points out that the development of civilization seems to entail self-restriction both because insofar as a desire is thought and spoken, it involves "the necessity to accept the death of the other as well as of oneself,"[32] and because without the first kind of constraint the second kind of freedom, or "self-beginning," cannot come about.[33] This interdependence of the two kinds of freedom can be illustrated through the Hegelian notion of the inverted world, in which the second freedom, the freedom of pardon and reformation, is achieved through an "inversion" of the first freedom, or the unrestricted freedom to avenge oneself. This inversion opens up into the possibility of forgiveness and infinitely self-related universality.

If we specifically compare this Hegelian inversion to Freud's notion of the self-restriction that must take place in order for civilization to arise, we can see that what Hegel calls revenge is comparable to the action of the raw life-preserving or self-gratifying drive (Eros) that Freud describes, whereas forgiveness involves a complex binding of the primary drives of Eros (desire) and Thanatos (aggression). This binding allows for the emergence of ethical life, but at the same time, according to Freud, it makes us unhappy or discontent. The discontents that Freud thought were a self-evident result of civilization mark perhaps the biggest difference of his description from that of Hegel. This discrepancy can be tempered, however, by noting that Freud lived in the twentieth century and witnessed not only world war but also the decline of the human belief in inevitable progress.

Kristeva notes that *Selbstanfang*'s inception in the community links it to the enlarged mentality of the *sensus communis* that Kant describes in the *Critique of Judgment*. Yet at the same time that she celebrates the positive conception of freedom in its contribution to the achievements of Western civilization, she also bemoans the reemergence and preponderance, in the late twentieth and early twenty-first centuries, of the archaic sense of negative freedom. In late capitalism, this freedom is reconfigured as "the capacity to adapt to a 'cause' always outside the 'self,' and which is less and less a moral cause, and more and more an economic one."[34] We once again have become victims of a logic of the bad infinite, but this time in terms of the desire always to possess and express the new in the form of products, fashion, and so on.

The only way to combat the reemergence of this primitive, negative conception of freedom is through critique and a cultivation of the positive sense of freedom, and it is this effort that Kristeva thinks psychoanalysis and art can nurture. At some level it is this hoped-for renewed transition from negative to positive freedom that Kristeva references in her chosen title of *Hatred and Forgiveness*; we might want to read it as *from* hatred *to* forgiveness. At the same time that this dialectical movement goes on at the level of the formation of civilization, however, Kristeva also describes it at the level of the development of the individual in her relation to culture, and the child's ambivalent development in relation to its mother.[35] The analytical situation, in which a patient works through her trauma with the help of a skilled listener, is one that "neither judges nor calculates," in the sense of the reason that leads to retributive justice, but "is content to untangle and reconstruct, in the sense of pardon. Only such a process can renew the unconscious and confront hate, which, in its self-generating circularity, is the other side of desire."[36]

Aesthetic Forgiveness

Although Kristeva describes forgiveness or par-don (through or *thorough* giving) as a continuation of theological pardon's promise of a "re-birth of the subject in a new temporality" and in terms of relations with others, she nonetheless insists that it is "post-moral."[37] Where religion promised rebirth in the sense of an eternity beyond death and morality might advocate forgiveness for the sake of social harmony in the here and now, forgiveness in a Freudian sense addresses the psychological need for an "opening up of psychic space" within the temporality of the finite but also relating back to the timelessness of the unconscious.[38] This forgiveness may be given in art; indeed, Kristeva writes that all forgiveness is essentially, and in the first place, aesthetic in the

sense of a "setting up of a form," a *poiesis*.[39] The etymology of "forgiveness," however, ties it to letting go, or exhalation, so the setting up of a form is also a setting free.

Forgiveness is always a kind of excess; Jacques Derrida calls true forgiveness "hyperbolic," in that it gives without any expectation of a return.[40] In *Black Sun*, Kristeva writes: "*Forgiveness*: giving in addition, banking on what is there in order to revive, to give the depressed patient (that stranger withdrawn into his wound) a new start, and give him the possibility of a new encounter."[41] The "giving in addition" would be a *par-don*, a gift that goes beyond what is required, therefore a gift in the true sense of the word. True forgiveness thus may be the condition for the possibility of all other symbolic encounters, an idea we will develop more in the next section.

In *Black Sun*, Kristeva discusses Gerard de Nerval's *Aurelia*, a work in which the poet evokes a network of melancholic streams like molten metal that crisscross the world in the manner of blood vessels in the brain. The poet's perception of this "transparent network" of correspondences is, in Kristeva's interpretation, a "transposition of drives and their objects into destabilized and recombined signs" that, through their transfiguration, allow the writer to share his sorrows and his joys with others, by letting them live through these experiences as their own.[42] This network will closely resemble her analysis of the "thought specular" in contemporary film, a subject we will examine toward the end of this chapter.

Dostoevsky, too, ventured his own melancholic subjectivity to the point of losing his identity, "down to the threshold of evil, crime, or asymbolia," not merely to represent these stages "but in order to work through them and to bear witness . . . from elsewhere," speaking or writing violence rather than committing it.[43] This working through would definitively separate aesthetic from religious forgiveness. Aesthetic forgiveness takes up where religion no longer has power; rather than lifting the "sinner" beyond her sin, it "identifies with abjection in order to traverse it, name it, expend it," and be reborn again from it.[44] Kristeva writes that there is "no beauty outside the forgiveness that remembers abjection and filters it through the destabilized, musicalized, resensualized signs of loving discourse."[45] This semiotically informed inscription allows the writer to alternate between the unsurpassability of suffering, on one hand, and flashes of forgiveness, on the other; the "eternal return" of their alternation constitutes the entirety of the writer's work.[46]

The "time" of forgiveness is neither an eternity removed from this life nor a pursuit of retribution to redress one's suffering. It is a time that keeps suffering and injustice in mind, that does not allow it to be forgotten or erased, but

"without being blinded as to its horror, banks on a new departure, on a re-
newal of the individual."[47] Kristeva calls forgiveness a "renewal of the uncon-
scious," which is "constituted by preverbal self-sensualities that the narcissistic
or amorous experience returns to me."[48] This forgiveness operates both on the
level of the unconscious, which knows no time, and on the level of love, which
inaugurates a new relation with the other through a rebuilding or rebirth.[49]

Although she does not elaborate very much on the idea, Kristeva suggests
that we live a new kind of temporal existence in the late twentieth and early
twenty-first centuries, one characterized by pathological repetition of identi-
cal time segments, in the manner of a machine. In this "modern age," psychic
space and psychical time are "threatened with destruction by the rise of tech-
nology."[50] The psyche, she writes in New Maladies of the Soul, "represents"
the bond between the "soul" (from the Greek psyche) and the image, in par-
ticular with reference to the speaking being's relation to the other. In the psy-
choanalytic situation, the speech of the analysand and the analyst, too, "in-
corporate different series of representations." However, modern life outside of
the analyst's office has for the most part dispensed with the representation of
psychic life. Contemporary men and women attend instead to a series of dis-
tractions: they "spend money, have fun, and die."[51] Instead of representations
of psychic life, people sate their need for images with mindless entertainment,
advertisements, and mundane alternate realities that merely repeat the com-
mercially informed world in other guises. Forgiveness suspends time and al-
lows for a new beginning and a new "intersubjective configuration."[52]

This double relation takes place thanks to a separation of the psyche from
the tyranny of the unconscious, through the activity of a transference to a new
other (the analyst) or a new ideal (the artwork, the imaginary "I"). Forgiveness
constitutes from the outset a schema, the barest of outlines: the idea that mean-
ing, however indeterminate, does exist. Forgiveness allows the subject the pos-
sibility of identifying with a loving, imaginary "father" or of becoming recon-
ciled with a new symbolic law.[53] This process is a "transubstantiation" that
allows the artist and perhaps the reader/spectator to live a "second life," one of
forms and meaning.[54] It exceeds a merely psychological transformation in that
it requires language, the act of naming and of composing the narrative form.[55]
Writing conveys affects without repressing them, transposing them in what
Kristeva calls a "threefold, imaginary, and symbolic bond."[56] The writer trans-
lates forgiveness as an emotional impulse into a tangible form: affect becomes
effect.[57]

André Green analyzes the relationship between representation and the
feminine in his essay on Greek tragedy and specifically on Aeschylus's Ores-

teia, a tragic trilogy that I will discuss in the next section to illustrate the Hegelian and Kristevan dialectic of transgression and pardon. Green defines representation in a way that is also helpful in understanding Kristeva's use of the term: as "the process . . . which consists in performing an action constructed around a fable or story."[58] This process may be external, as in the theater, or internal, as when the mind figurally reproduces some situation or previously perceived object in order to bring it back into consciousness. Thus "representation is that delegation by which the activity of the drives is manifested so that it assumes a form through which it becomes known."[59] This definition of the process could therefore equally well describe what ideally goes on in an analytic situation, as the analyst helps the analysand to the point where she can articulate, and thus know, unconscious factors that are affecting her conscious life. In Greek tragedy, in some cinema, and in psychoanalysis, desire is given representation, which accounts for the emotional response all of them may arouse.[60]

Green points out that in *Moses and Monotheism* Freud interpreted the *Oresteia* in a classical way as a representation of the transition from a matriarchal social order to a patriarchal one.[61] For Green, and Klein, Kristeva, and even for Hegel, the tragedy represents a more complex interaction of forces and outcome. We now turn to these interpretations to see what Green means when he calls tragedy "the representation of representation itself."

TRAGIC FORGIVENESS: FROM THE ERINYES TO THE EUMENIDES

Aeschylus's *Oresteia* arguably enacts a kind of a translation of affect through representation into symbol, or the inception of a third. The trilogy tells the story of a family curse, a chain of impassioned murder and revenge that is passed down from family member to family member and that only comes to an end when retributive justice is transformed into the first court of law. This tragedy constitutes an important cultural reference for Hegel, Klein, and Kristeva, for its explicit thematization of the theme of a transformation from nature into culture, from particular and immediate revenge into mediated and universal law, from matricide into symbolic life, and from hatred into forgiveness. The "third" that is created is the realm of law and symbolic life.

The story of the *Oresteia* is of a generations-long family curse. The house of Atreus, the site of the family curse, traces its origin back to Tantalus, famous for having endured eternal punishment in Hades by remaining eternally thirsty yet just out of reach of drink. Aeschylus traces the curse to Atreus

and his brother Thyestes, the sons of Pelops and grandchildren of Tantalus, who quarrel after Thyestes has an affair with Atreus's wife Aerope. Banished from the kingdom, Thyestes plies Atreus to allow him to return and reconcile, and Atreus appears to agree, but at the banquet with which he welcomes his brother home, he serves him the roasted bodies of Thyestes' own two slaughtered sons. Horrified upon being informed of this treachery, Thyestes leaves the country again, cursing Atreus and his house. In Aeschylus's account, Thyestes' one infant son survives. This son, Aegisthus, returns to Argos upon the departure of Atreus's son Agamemnon for the Trojan War and becomes the lover of Agamemnon's wife Clytemnestra. The *Oresteia* tells the story of the family's multiple deaths: of Iphegenia, the daughter of Agamemnon and Clytemnestra, sacrificed to the gods by Agamemnon in order to allow his ships to sail to Troy; of Agamemnon, murdered at the hands of his wife upon his return in retribution for her daughter's death; and of Aegisthus and Clytemnestra, killed by Orestes, Agamemnon and Clytemnestra's son, for her murder of his father. It is only when Orestes, pursued by the Erinyes, or Furies, for the crime of matricide, seeks refuge with Athena, the goddess of justice, that the curse is brought to an end by the instantiation by Athena of the legal system of Athens that will henceforth adjudicate matters of life and death through law rather than revenge.

Green makes the dramatic claim that the *Oresteia*, along with the *Oedipodeia*, constitutes an essential archetype "in which the problematic of all tragedy—and perhaps of all human endeavor—is situated,"[62] precisely because of this movement from affect to symbol, from retribution to law, and from drive to representation. It is notable, however, that in the *Oresteia* truth comes from the lips of a woman (Cassandra), whereas in the *Oedipodeia* it issues from the lips of a man (Teiresias), both divinely possessed. In fact, in Green's words, "in the *Oresteia*, everything proceeds from the women," from Helen's infidelity to Artemis's restraint on Agamemnon's ships, to the sacrifice of Iphigenia, the wrath of Clytemnestra, the incitement of Electra, and the concluding judgment of Athena.

In particular, Green links Clytemnestra's prophetic dream, prior to being killed by her son Orestes, of a snake nursing at her breast and bringing forth a clot of blood to Klein's discussion of the mother's good breast/bad breast. This would put Clytemnestra, symbolically speaking, in the place of the mother whose matricide would give rise to a replacement or consolation in symbolic life. According to Green, representation plays a double role in the *Oresteia*: on the one hand, the conclusion of the tragedy clearly privileges thought over representation, the law of the father over the image of the mother. Green

writes that "this opposition overlaps that of the imaginary and symbolic, as set out by Lacan."[63]

At the same time, however, this truth of thought's victory over representation is itself presented in the tragedy by means of representation, or rather the "representation of representation": "representation is born from the absence of the object; the representation of representation gives the object more life, embodies it and gives it a new existence."[64] Tragedy exists "at the crossroads of this opposition between the sensible and the intelligible . . . yet belongs to neither."[65] Representation brings the unconscious to consciousness, and this is what allows for the emergence of symbolic life; representation performs the transition from unconscious to image to word. Quoting Hegel inexactly, Green says that the tragic hero "externalizes the internal essence."[66] It is in the *Oresteia* that this process is first made explicit. The trilogy is "the theatre of a number of overlapping oppositions": the feminine against the masculine, the family against the city, and representation against speech. It is in this sense that the *Oresteia* and, in particular, the final tragedy, the *Eumenides*, might be seen as the foundation or touchstone for the story of forging a head in order to forge ahead.

Hegel's discussion of the *Oresteia* follows a similar trajectory. For Hegel, however, the trilogy provides the stage for a conflict that is broader and more universal than the individual oppositions mapped out by Green; he argues that the tragedies bear witness to the inevitable discrepancy between the spirit of a particular people and the absolute spirit that appears within it. The residue, also called "fate," or "the inorganic," is the element of necessity with which the individual and the community must ultimately be reconciled. Hegel characterizes the history of natural law, a discussion of which is the context for his evocation of the *Oresteia*, as a tragic one:

> there is nothing else but the performance, on the ethical plane, of the tragedy which the Absolute eternally enacts with itself, by eternally giving birth to itself into objectivity, submitting in this objective form to suffering and death, and rising from its ashes into glory. The Divine in its form and objectivity is immediately double-natured, and its life is the absolute unity of these natures.[67]

He then refers to the final scene of the *Eumenides* as a particularly illuminating exemplification of this performance of birth, death, and rebirth.

As I have discussed elsewhere,[68] Hegel's early writing on natural law uses the *Eumenides* as a privileged example of the inception of the law, which is

accomplished symbolically with a vote, when the people of Athens judge be-
tween Apollo and the Erinyes in deciding whether Orestes is to be considered
justified in having killed his mother (in order to avenge his father) or whether
he is to be condemned as having committed the unforgivable crime of matri-
cide. When the result is a draw, however, Athena, the patron goddess of Ath-
ens, steps in to break the tie, siding with Orestes in order to put an end to the
cycle of perpetual retribution and to restore the living to an existence freed
from the past. Just as in the *Phenomenology of Spirit*, forgiveness performs a
paradigm shift whereby the interconnectedness and interdependence of hu-
man lives is recognized, here the instantiation of a judicial system allows the
individual to transcend the need to destroy the one who has injured him (an
act which will only assure his own self-destruction in return).

In her short essay "Some Reflections on the *Oresteia*," Melanie Klein aligns
the family curse of the house of Atreus with the Hellenic term *hubris*, which
she defines, quoting (the translator of the *Oresteia*) Gilbert Murray, "the typi-
cal sin which all things, so far as they have life, commit."[69] For Klein, the acts
of retributive justice carried out by Thyestes, Clytemnestra, and Orestes can
be aligned with human life, or existence in its most fundamental form. Hu-
bris "grasps at more, bursts bounds, and breaks the order."[70] When the order
has been broken, hubris is followed by *Dike*, or Justice, which reestablishes
order. Gilbert argues that the "rhythm—*hubris-Dike*—Pride and its fall, Sin
and Chastisement—is the commonest burden of those philosophical lyrics
which are characteristic of Greek tragedy."[71]

Klein writes that hubris can be aligned with certain emotions within an
individual that are felt to be dangerous to the self and others. This kind of
emotion may be sensed at a very early developmental stage by a child as an
insatiable desire that is accompanied by the expectation of being punished by
the mother for wanting too much of her.[72] Klein compares this archaic greed
to the Greek concept of *moira*, elucidated by Murray as "the portion allotted
to each man by the gods."[73] In the *Oresteia*, the story of the family curse is not
only a story of wrongdoing and retribution but also a story of envy, sibling ri-
valry, and the primeval desire to destroy others or to have what is theirs, ac-
companied by an anxiety or fear of punishment should this desire be acted
on.[74] Klein sees this set of affects in child development, where the child wants
to possess the attributes first of the mother, then of the father and its own sib-
lings. Coextensive with this envy and desire to appropriate what the other has,
the child feels what Klein appears to think is a healthy anxiety that she is re-
sponsible for any trouble or illness which might befall the envied other. "This
leads to a constant fear of loss which increases persecutory anxiety and under-

lies the fear of punishment for *hubris.*" Klein quotes Clytemnestra to the effect that "who feareth envy, feareth to be great."[75]

In the first play of the trilogy *Oresteia*, *Agamemnon*, Agamemnon displays a great degree of hubris; returning triumphant from the Trojan wars, to which he embarked by sacrificing his own daughter, Iphigenia, in order to give his ships favorable winds, he feels pride in having destroyed Troy and in having brought back a captive lover, Cassandra. He feels no apparent sorrow, however, for having left his people and his family alone for ten years in order to avenge the insult against his brother Menelaus at the elopement of Menelaus's wife Helen with Paris, prince of Troy.

Considering this excess of hubris, Klein writes, "Clytemnestra in a sense is the tool of justice, *dike.*"[76] Yet at the moment that she kills Agamemnon, Clytemnestra, too, begins to suffer from hubris, and it is her son Orestes who in turn will act as the agent of *dike* in murdering her. But this repetition of hubris-*dike* is a pathological rhythm. It gives sterile birth again and again only to life-destroying hubris. Orestes must undergo a dramatic change in order to become the agent of a transformative act that stops the repetitive cycle and gives birth to a new, life-affirming shape of human life.

According to Klein, it is Orestes' emergent feeling of guilt for having killed his own mother that allows him to be helped by Athena in the end.[77] While Orestes feels no guilt over the murder of Aegisthus, his mother's lover, he is in severe inward conflict over the death of his mother. He had wanted to avenge his father, with whom he identified, but not explicitly to triumph over his own mother.

Klein identifies the transitions through which Orestes passes in the course of the *Eumenides* with her own articulation of the stages of child development, as a movement from hatred and parceling through depression, guilt, and desire for reparation. She writes:

> In my view he shows the mental state which I take to be characteristic of the transition between the paranoid-schizoid and the depressive position, a stage when guilt is essentially experienced as persecution. When the depressive position is reached and worked through—which is symbolized in the Trilogy by Orestes' changed demeanour at the Areopagus—guilt becomes predominant and persecution diminishes."[78]

Orestes is able to overcome the need for retribution and self-recrimination because he never ceases to attempt to purify himself by making reparations after his crime and because he continues to consider the position of the people

of the kingdom over whom he presumably intends to rule justly in the future.[79] This desire to make reparations, along with his act of flinging himself upon the mercy and protection of Athena, is a kind of implicit plea for forgiveness. Athena's act of founding a court of justice—and sparing Orestes from punishment by death on the condition that he accept the rule of law and of the people—is a kind of pardon that allows him to return to Argos.[80]

Klein argues that the "demon" or curse of the house of Atreus "comes to rest when Orestes is forgiven and returns to Argos":

> It is of interest that the demon, who since Pelops' time exerted a reign of terror in the royal house of Argos, comes to rest—so the legend goes— when Orestes has been forgiven and suffering no more, returns, as we may assume, to a normal and useful life. My interpretation would be that guilt and the urge to make reparation, the working through of the depressive position, breaks up the vicious circle, because destructive impulses and their sequel of persecutory anxiety have diminished and the relation to the loved object has been re-established.[81]

Aeschylus himself seems to support such a reading in a passage Klein quotes from the *Oresteia*:

> Man by suffering shall learn
> So the heart of him, again
> Aching with remembered pain
> Bleeds and sleepeth not, until
> Wisdom comes against his will[82]

Although it may seem far from his analysis of the *Oresteia* in *Natural Law*, Hegel's description of the movement from desire to self-consciousness in the *Phenomenology of Spirit* has an analogous implicit meaning to the one outlined by Klein here. Hegel's word for what Klein calls hubris, or greed for life (a human quality that, while it might be deemed sinful, is also inevitable, since it is what "all things, so far as they have life, commit"), is "desire," a drive to consume and make the world a part of oneself. Desire is what characterizes life, for Hegel, but it is not until one desiring individual comes up against another that this hubris is transformed, through the struggle that ensues, into *dike*, or, as Hegel calls it, self-consciousness. Self-consciousness's constitution through a face-to-face encounter also paves the way for the inception of intersubjectivity and ethical life, the beginning of the "'I' that is

'We' and the 'We' that is 'I.' "[83] As Klein puts it, Athena "achieves a change in the Furies towards forgiveness and peacefulness. This attitude expresses the tendency towards reconciliation and integration."[84]

KRISTEVA, ORESTES, AND THE "THOUGHT SPECULAR"

Kristeva's discussions of the *Oresteia* mainly filter through her reading of Jean-Paul Sartre, whose play *The Flies* is a modern version of the *Eumenides*, set in the context of World War II France. In her book on Melanie Klein, Kristeva also discusses Klein's essay on the *Oresteia*, however. It is here that Klein answers the question why we have symbols at all, according to Kristeva. The answer: because the mother is insufficient. The message of symbols, Kristeva writes, were they able to talk, would be that they come to fill in where the mother's care breaks off. The murder of Clytemnestra and the restitution of Orestes' subjectivity in the establishment of a court of law is itself a symbolic enactment of this substitution of symbolic life for the mother's care. Of course, the point is not to kill one's mother.[85] Indeed, "crimes and other aggressive actings out are merely failures of the symbol; they represent a failure of the imaginary matricide that, by itself paves the way to thought."[86] In other words, psychic life is no longer fully represented in a great deal of writing and in art. Instead, we have portrayed in both popular culture and in countless contemporary media accounts a spate of gratuitous killings and "mindless robots without a soul." The failure of resolution of what we might call the "Orestes conflict"—the lack of guilt in our pleasure in such gratuitous violence—results in one of the "new maladies of the soul" that Kristeva and Klein have documented, those patients whose psychic realm has been broken into bits.[87]

In her reading of Sartre's *The Flies*, Kristeva analyzes the contemporary message of the play to be that freedom is antinature, if nature is the mother. The human can only attain freedom by wresting itself from nature and asserting itself as antinature.[88] Kristeva describes this antinatural quality as a kind of alienation or foreignness, citing Sartre's speech where Orestes addresses Zeus:

> Foreign to myself—I know it. Outside nature, against nature, without excuse, beyond remedy except what remedy I find within myself. But I shall not return under your law. I am doomed to have no other law but mine.[89]

Sartre's Orestes denies both the mother (nature) and the law of the father, relying only on himself. Kristeva reads this as the fragmentation of the subject,

a phenomenon she discerns in not only serial killers and perpetrators of gratu-
itous violence but also in some contemporary art, such as that of Francis Ba-
con.[90] Her account falls between Klein's reading of the *Oresteia* as a perfor-
mance of the conditions for the possibility of thought and symbolic life
and Green's reading of the Orestes complex as manifesting the symptoms of
psychosis.[91]

Unlike Green, Kristeva does not see the tendency toward fragmentation in
an entirely negative light. Psychoanalysis, she writes, may be wise to turn its
attention to Orestes given current social crises and the manifestation of bor-
derline states not only within individuals but on a social and cultural level.
The predominance of fragmentation in so-called avant-garde art and litera-
ture may be a symptom of social crisis, but it also signals a new "freedom to be
foreign." Orestes as the "culmination of Oedipus, the completion of his rebel-
lious logic and the announcement of an unthinkable foreignness" is a "social-
ized psychosis" rather than an individual one; although it poses personal and
political risks, it also heralds the possibility of a "civilization of freedom."[92]

What remains is to articulate the difference between this foreign, frag-
mented art, which puts forward an image commensurate with yet potentially
transformative of the society of the spectacle, and the spectacle itself. In *Inti-
mate Revolt* Kristeva insists that the proliferation of vampires and massacres in
popular film effects a new kind of catharsis, one that "no longer occurs through
Oedipus, Electra, or Orestes"; moreover, "the stupider it is, the better."[93]
Kristeva argues that the attraction of the medium of film for today's troubled
subjects lies in its capacity to transform a flat image (a denotative sign) into a
symptom (a specular),[94] a logic of fantasy in form if not in content.

Borrowing the term *lekton*, or "expressible," from the Stoics in order to de-
note this "subjective alchemy" of image into phantasmic form, Kristeva none-
theless distinguishes between the lektonic efficacy of films of popular culture
and those of Eisenstein, Alfred Hitchcock, and Jean-Luc Godard. While films
like the *Twilight* saga, on the one hand, and slasher films, on the other, pres-
ent foreignness or violence in their bare denotative form, other styles of cine-
matic representation effect catharsis in subtler and richer ways, through con-
notation, the production of aesthetic ideas, and alternation of the ruthless and
monotonous rhythms of daily life.

Whereas most popular films merely expresses the specular directly, the
films of the "thought specular" form a version of the specular that, as we have
seen, distances itself from itself, creating a logic of "visible signs that designate
fantasy and denounce it as such."[95] All specular is fascinating, Kristeva writes,
"because it bears the trace—in the visible—of . . . aggression, of this nonsym-

bolized, nonverbalized, and thus nonrepresented drive."[96] This explains the allure of unmediated images of violent and sexual aggression. But the thought specular goes beyond mere fascination, "capturing" these signals, cutting them up, and arranging them "in such a way that the phantasmatic thought . . . invites you first to locate your own fantasies and then to hollow them out."[97] In this mode of the thought specular, fantasies "exercise their power of fascination while at the same time mocking their fascinating specular."[98]

The cinema of the thought specular displays the logic of the semiotic, or the "lektonic traces" that put into play those parts of signification that are supplemental to it yet always underlie it. The interplay of these lektonic traces closely resembles the logic of fantasy, the "energies of the pulsing, desiring body."[99] At the same time, the films that Kristeva considers do have a recognizable narrative and are full of denotative images. It is in the interplay of these two registers that Kristeva finds the capacity of the cinema to "hollow out" fantasy in the manner of "Orestian revolt."

For example, she discusses a seminar of the famous Russian director Eisenstein, where a scene of confrontation is being mapped out by the director and his students. On the one hand, there is a clearly recognizable conflict: a soldier returns home from a long time at war (in the manner of Agamemnon) to find his wife pregnant. Eisenstein organizes the space of the scene along two tendencies, "a straightforward, frontal tendency and an oblique, diagonal tendency."[100] The pattern created by the cross-deployment of these two tendencies creates, where successful, a spatially organized rhythm in which one can dynamically apprehend the signifier "not in the cold sign of phenomena, but . . . in the innumerable multiplicities of its particular, ever-changing manifestations." In so doing, "the signifier rids itself of its indirect character of plodding word play or deadly symbol."[101]

We can see that the same effect is created by Aeschylus's trilogy. The repeated violence against close family members creates an agonizing tension, but at the same time, the visible also organizes itself along a countertendency that eventually leads Orestes to Athena and to the creation of a court of law. The straightforward narrative is also crisscrossed with the rhythmic tones and chants of the chorus and the eruption of the Erinyes. The lektonic traces, which signify something real yet neither material, representational, nor conceptual, add a "rhythmic, plastic dimension" to the plainly visible, thereby encoding the anxiety of the tragic structure in a way that elicits that of the viewer more profoundly than would a linear narrative or a series of denotative images or "image information" that stares the viewer in the face.[102] Such a process invites the spectators "first to locate [their] own fantasies and then to

hollow them out."[103] This "hollowing out" (évider) evokes the ancient Greek aesthetic concept of tragic catharsis.

Indeed, the transformation of the Erinyes into the Eumenides provides an almost perfect exemplification of the lektonic transfer that takes place in the audience of the tragedy. Whereas the affect the Erinyes evoke is fear, aggression, and horror (the "nonsymbolized death drive" as the end result of the specular),[104] when transformed into the Eumenides, spirits who retain a ruling influence on the "city" yet who are kept "underground" or safely harnessed, they "hold the spectator—still plunged in fantasy—at a distance from fascination." Rather than a repressed sadomasochistic fantasy, the tragedy enacts a demystification of fantasy[105] that provides a therapeutic "hollow" for their own self-injuring fantasies.

In our own day, the cinema of the thought specular performs the same function as did the tragedy in ancient Greece. It purges the viewer of anxieties that terrorize every human being by virtue of developing up and away from the "mother" and toward a symbolic life. The *Eumenides*, the final tragedy of the *Oresteia*, performs this movement, beginning with the waking of the sleeping Erinyes (Furies) by the ghost of the slain Clytemnestra, who demands vengeance. The Erinyes represent, arguably, the conflicted feelings of Orestes himself. He has killed his mother, committed an unspeakable crime, and he feels the need to punish himself. The externalization of these superegoic pangs in the form of the newly awoken Erinyes is sternly repudiated by Apollo, who cries:

> There is no place for you in this house, you have no right here
> You belong where justice slaughters men for their crimes,
> Where heads are cut off and eyes gouged out,
> Where a man's seed is killed by castration.[106]

Here the Erinyes are aligned with castration and decapitation, just as Orestes is labeled a matricidal murderer, one who has taken justice into his own hands and interpreted it purely retributively. At the end of this third play of the trilogy, however, the Erinyes will have been transformed into the Eumenides, benevolent goddesses of fertility, and Orestes will be restored to his rightful throne with the backing of an official and universal court of law. The madness of Orestes and the madness of the Erinyes both cease; as George Devereux puts it, "the exoneration of Orestes and the appeasing of the Erinyes represent . . . a kind of ritual 'psychotherapy' which appeases the rage of *both* the killer and the avenger."[107]

Most importantly for our thesis in this book, the story of the *Oresteia*, in particular the conclusion in the *Eumenides*, is a story of matricide followed by pardon and the forging of something creative out of that wound. Symbolically, the story of Orestes' murder of Clytemnestra and his "rebirth" through the surrogate or substitute "mother" Athena represents the story of forging a new head out of the severing of the old one, and it is the Erinyes that accomplish the severing and the Eumenides who create the new head (though of course they are the "same" entities). Through Athena's par-don of Orestes, he is granted a second beginning through language and law rather than through retribution (which, though natural, is also destructive of others and of self). He kills his mother then rediscovers her in symbolic life.

It is significant that Orestes decapitates both Aegisthus and Clytemnestra. Aegisthus, as the false father who has usurped the throne of the real father, must be killed in order to eliminate a false path, and Orestes does so summarily. It is much more difficult for Orestes to kill Clytemnestra, his real mother. To shield his eyes from his own deed, he puts his cloak between his sword and his mother and stabs her neck through it. In inciting him to this deed, the chorus urges him to behead Clytemnestra in the way that Perseus beheaded Medusa the Gorgon.[108] Both Perseus and Orestes carry out their tasks with the help of Athena, who shielded the vision of Perseus against the gaze of Medusa, which turned men into stone. Likewise here the cloak shields Orestes from the vision of his own matricide. He is tormented by his deed, first inwardly, by himself, then outwardly by the Furies; unlike his slaying of Aegisthus, he does not take matricide lightly but cries that from now on he will be an eternal foreigner, welcome at no hearth.[109]

The pardon that Athena effects allows for the establishment of a legal system, a symbolic realm common to all, where justice will be meted out not individually and retributively but according to a commonly agreed upon code. The figure of decapitation is not, on Kristeva's reading, one of pure violence and fragmentation. It marks a severance, but one that will be productive of an enriched form of subjectivity and culture. At the same time, decapitation's lineage in a kind of state of nature where wrongs are addressed through violence cannot be denied.

In *By Blood*, a 2012 novel by Ellen Ullman, a comparable transformation takes place. The narrator of *By Blood*, who becomes a kind of life enabler despite being initially depicted as creepy or sick, is an eavesdropper and a covert stalker. A university professor, on leave while a charge against him of misconduct toward a student is investigated (one which seems to involve an obsessive stalking to the point that the student has disappeared), the unnamed

eavesdropper has rented an office in an old building next to a psychoanalyst's office and happens one day to listen in on the conversation of the analyst and a patient who, disliking the white-noise machine used to mask such conversations, asks for it to be turned off.

The overheard conversations open up into an interchange, continued in each weekly session, in which the patient, who is adopted, recounts her search for her birth mother. Feeling alienated and somewhat rejected from her adoptive mother, who keeps her at arm's length, she searches melancholically for the absent mother who, she thinks, may be able to fill in the lack she feels in her being. The search, encouraged by the analyst, leads her to adoption agencies that took postwar Jewish children abroad to England and the United States and ultimately to an origin saturated not only in personal but also in collective trauma. She learns that her mother was Jewish, but her search seems stymied at this point, with no further information available on her identity.

Here the professor, who has come to listen furtively to the patient's session every week in his darkened office, uses his professional researching skills to help the patient, eventually sending her an anonymous letter purporting to be from one of the adoption agencies, in order to inform her of further details and, ultimately, the name of her birth mother. The patient's discovery of her mother then opens up onto the trauma of the Holocaust and the lasting personal identity attached to the ethnic heritage of Judaism through it.

Parallel to this story of searching for the mother and for one's cultural heritage, and engaging with the traumatic elements of one's place in the world, the professor is also gradually coming to terms with his own personal demons, his furies. He is, in fact, engaged in writing a lecture on Aeschylus's *Eumenides*. He refers repeatedly to the "furies" that haunt him, in particular at those times when he cannot listen in on the patient's sessions. At the start of the novel, which begins at the end then flashes back to the narrative arc that preceded it, the narrator suggests that the vicarious process of listening in on and engaging with another's analysis and dissipation of trauma has also allowed him to work through his own demons. He says, "I did not cause her any harm. This was a great victory for me. At the end of it, I was a changed man. I am indebted to her; it was she who changed me, although I never learned her name."[110] His Erinyes are transformed, at least provisionally, into Eumenides. Yet the real end of the story is unknown, for at the denouement, the patient realizes that she has received the information about her mother from an unknown source, and the analyst finally begins to suspect an eavesdropper in the adjacent office. The white-noise machine is turned back on, and it de-

scends like a curtain between the reader and the ultimate conclusion, just as it always is for both analysand and analyst in the therapeutic session.

By Blood is a story of a traditional psychoanalytic "talking cure" with an unexpected effect by and on a third person, but the reference to Aeschylus's *Eumenides* and in particular to the furies opens up the story onto a rhythmic counterpart, the rhythm of the ecstatic chorus of Greek tragedy. Friedrich Nietzsche, in his analysis of Greek tragedy, insisted that in ancient music-drama there were always "two worlds" of the senses: the world of the eyes (vision), found in the narrative of the tragedy, and that of the ears (tone, rhythm), found in the choral interludes. These two "worlds" coexisted in the tragedy with no attempt made to mediate them; rather, precisely and only in their sharp confrontation could the "truth" of the drama be revealed. Nietzsche writes that Euripides tried to tame the rhythm of the Dionysian dithyramb, from which the tragedy evolved and which remains in the chorus in older versions of tragedy, into words.[111] Such a reconciliation brought about the decline of tragedy, since by definition the ecstatic dithyramb articulated nonverbal content through music and dance. In Aeschylus, by contrast, the tragedy is simultaneously *dythrambikos* and *esukastikon*, the "incomparable convulsive power of tones" brought into an "architecture" that recalls the Kristevan lektonic skeleton, allowing for a translation of rhythm into images.[112]

The self-distancing involved in this stance—Nietzsche also describes the Aeschylean Dionysian aesthetic as "something like, when one dreams and at the same time [that is, within the dream] recognizes the dream as a dream"[113] and adds that "In such a way the servant of Dionysos must be in rapture and simultaneously lie lurking behind himself as observer."[114]—marks the experience as one of "self-aestheticization," as Molly Rothenberg has described it.

Through the gesture of self-aestheticization, Rothenberg writes, the "acephalous subject" (to use Žižek's terminology,[115] particularly appropriate here) "does not seek to act on the social field but rather to reveal its true relation *to* the social field . . . by explicitly appearing as the excessive dimension in itself and making visible what cannot be accommodated within the encyclopedia of the situation."[116] The subject accepts her constitution through others but also "frames" or brackets her ontic properties in such a way that they can be appropriated for new meanings.

In a 2012 paper Rothenberg illustrates this process of self-aestheticization in her account of an individual analysand's treatment, in which the patient recounts a dream in which she sees her traumatic memories individually outlined in the sky, in frames that she is able to reach out and pluck down one by

one. In the dream she now has a book of photos "in her hand that she could open, flip through, and close at will. From this time on, she would be free of her nightmares and no longer have dissociative episodes. We began to make significant progress in the analysis."[117] The images can now be directly examined and eventually discarded, whereas before their appearance in memory or dream caused the patient to flinch and look away. Nietzsche writes, similarly: "that which we call 'tragic' is exactly that Apollonian clarification of the Dionysian: if we lay those interwoven sensations that the rapture of the Dionysian creates beside each other like a row of pictures, this row of pictures would express what is to be clarified, the 'tragic.' "[118]

Nietzsche's a account of tragic rhythm and temporality uncannily evokes the relationship of the professor and his "dear patient" who is almost an extension of himself, another person stained "by blood" and trying to work out the ramifications of heritage and subjectivity in their individual existence, and also the limits of calculation in bringing this about (the professor acts as a medium of revelation for the patient, and likewise the patient's discourse and situation bring about a correlative transformation in the professor, though they never intend this outcome, meet, or, even, at least on the patient's side, know of the other's existence). The experience of the artwork, Nietzsche implies, brings about a conscious awareness of the ineluctable ambiguity of the human condition, as simultaneously actor and spectator, agent and medium of her own life.[119]

In *Beyond the Pleasure Principle* Freud notes something he had earlier established, namely, that the study of dreams may be "the most trustworthy method of investigating deep mental processes."[120] He remarks upon, in particular, dreams that repeatedly bring a patient back into her traumatic experience, even when she is not necessarily much occupied with it in waking life.[121] The persistent repetition in dreams of a traumatic event seems to provide evidence of the unconscious' unproductive reworking of a blockage that cannot come to consciousness. Here, repetition appears to be only a symptom of obstruction.

Simple repetitive rhythmic alterations can have therapeutic effects, however. This can be seen in Freud's famous observation of a child's coming to terms with his mother's periodic absence for stretches of time, by playing a game in which he rolls or throws away and then retrieves a spool or any other small object, accompanying the retrieval with a loud drawn-out "o-o-o-o" and other signs of satisfaction. Repeated observation of this activity, which became well known as the *fort-da* game, caused Freud to note that simple rhythmic repetitions can aid children and adults in coping with stress and even

trauma by turning a passive experience (being left by the mother) into an active one (throwing the object away and retrieving it). Freud notes that children's play often involves repetition of activities, such as being examined by a doctor, that were unpleasant or even painful when they were actually experienced.

He goes on to note that "artistic play and artistic imitation carried out by adults, which, unlike children's are aimed at an audience, do not spare the spectators (for instance, in tragedy) the most painful experiences yet can be felt by them as highly enjoyable."[122] Freud takes this phenomenon to be proof that there are ways in which even unpleasurable and painful experiences can be made into subjects that are capable of being recollected and worked over in the mind.[123] There are two kinds of repetition associated with trauma, therefore: one that diabolically or obsessively replays the trauma, rendering the subject a passive victim of it, and one in which the subject masters (and herself creates) the repetition in such a way as to process and overcome it.

The contemporary psychologist Francine Shapiro has taken this idea in its simplest, nonaesthetic sense to initiate a relatively new form of therapy, called "eye movement desensitization and reprocessing," or EMDR, in which, under the guidance of a doctor, a patient will learn how to decode and reprocess repressed memories that produce in them a feeling that something is holding them back in life and causing them to think, feel, and behave in ways that don't serve them well.[124] The process of decoding and reprocessing the memory involves a series of doctor-guided rapid eye movements back and forth, left and right, that take place while the patient is training her attention on a sensation of anxiety or depression that can be located and focused on corporeally, even if the patient is unsure of its exact origin in a particular life experience. The apparent simplicity of this process belies its effectiveness.

Shapiro recounts how the idea for EMDR came to her. She was completing a doctorate in English literature at New York University when she was diagnosed with cancer. One day, she went for a walk to take a break from and to try to shake the depression and disturbing thoughts she began feeling as a result of this life-threatening diagnosis. She writes: "Previous experience had taught me that disturbing thoughts generally have a certain 'loop' to them; that is, they tend to play themselves over and over until you consciously do something to stop and change them. What caught my attention that day was that my disturbing thoughts were disappearing and changing without any conscious effort."[125] What Shapiro came to theorize was that when disturbing thoughts came into her mind, her eyes spontaneously started moving very rapidly back and forth in an upward diagonal, and that when she did this the

strength of the thoughts would dissipate and even disappear. The walking may have contributed to this effect, as others who have subsequently studied the techniques of EMDR have argued.[126]

What is especially interesting to me in this story is the combination of Shapiro the literature student, a self-professed believer that she was doing the important work of one who "shed light on our culture and literature—with its delicate nuances, rich textures, and the intricate lives of characters,"[127] and Shapiro the behavioral psychologist (she later earned another Ph.D., in clinical psychology). While the technique of EMDR seems to be purely mechanical and contentless, it nonetheless has something in common with the process Shapiro describes of creating characters that, if "drawn true to life and set loose . . . then create their own plots."[128] It seems to me that this is precisely the way in which one could describe the process of "creating a head," in Kristeva's sense. To "lose one's head" is to lose the sense that one springs forth fully determined to be who one is and to recognize one's responsibility for acknowledging one's wounds and finding a way to heal them through the "creation" of a "plot." This process has both a cognitive, intentional component, and one that is bodily, rhythmic, and perhaps triggered by processes that we can neither fully know nor completely master. We must learn to repeat the past, not in the debilitating, passive manner of one seized by a traumatic memory that one cannot escape and that haunts one with relentless persistence of the "loop" (as in Hegel's discussion of revenge and Nietzsche's articulation of *ressentiment*) of disturbing thoughts described by Shapiro, but in the transformative, aesthetic sense explored by Kristeva that we discussed in chapter 2. This aesthetic repetition shares the attempt at mastery found in the *fort-da* game and in artworks that engage with, rather than try to avoid, suffering and that in doing so sometimes manage to give rise to pleasure through the suffering.[129] To do so is to forgive ourselves and others for the inevitable ways in which we the fabric of our existence will inevitably be rent.

CONCLUSION
FORGING A HEAD

But this is what matters least to me since I have been among people: to see that this one lacks an eye and that one an ear and a third a leg, while there are others who have lost their tongues or their noses or their heads.
—Friedrich Nietzsche, *Thus Spoke Zarathustra*

Could Medusa be the patron goddess of visionaries and artists?
—Julia Kristeva, *The Severed Head*

A YOUNG WOMAN GOES TO THE STUDENT HEALTH CENTER FOR counseling. She has lost a close childhood friend, killed in an accident. She seeks a safe place to narrate her loss and someone to receive it with quiet and patience, someone who will not be waiting to pass on to the next subject of conversation, as even a close friend might, but who can linger with her in her pain. She seeks a place to talk of her friend who has died and perhaps to lament his passing in anger, expressing the injustice of a life cut short in its prime. She is offered an antidepressant on her second visit, when the therapist, not out of impatience or from an inability to console but as part of a routine procedure, judges her unable to deal with her loss. The student leaves, frustrated, and throws the prescription into the trash on her way out. The mourning process will continue, but it has hit a snag, temporarily obstructed by annoyance at a system that thinks grief should never be excessive.

Another woman visits a therapist, devastated over the end of her marriage, baffled at the sudden turn her life has taken, unable to deal for the moment with the stresses of everyday life. Before the first session has ended, the woman's tears have provoked the therapist to suggest immediate commencement of an antidepressant, because "you can't handle this pain right now." The suffering is interfering with work, with parenthood, with everyday tasks, yet the

patient came to the psychologist with a need to talk through her pain, to come to an understanding and to heal herself. The woman leaves, frustrated, and interrupts therapy until she can find someone who is willing to talk and listen and nothing more.

There are many people today who cannot get out of bed, whose depression impedes them from leading a normally active life. There are many subjects whose depression is a clear result of a chemical imbalance in the brain, and they benefit enormously from progressive improvements in drug therapy. But what of those others, a far greater number, it would seem, who want to take their depression in hand in other ways, addressing its source rather than subduing its symptoms?

A *New York Times* opinion essay asks, "where have all the neurotics gone?," noting the almost complete disappearance of neurosis as a meaningful term for the average American. A generation ago, the essay states, neurosis meant something: "It meant being interesting (if sometimes exasperating) at a time when psychoanalysis reigned in intellectual circles and Woody Allen reigned in movie houses."[1] Today, writes the author Benedict Carey, a science reporter at the *New York Times*, even professors of psychology rarely use the term, which has been replaced with "anxiety" or "depression," when in fact neurosis covers both of these. Carey makes two very important observations.

First, neurosis, in its heyday, functioned not only as a descriptor of a certain personality type but also as a kind of alert on the cultural level. In losing the conceptual range of neurosis from our cultural consciousness, "in the process we've lost entirely the romance of neurosis, as well as its physical embodiment — a restless, grumbling, needy presence that once functioned in the collective mind as an early warning system, an inner voice that hedged against excessive optimism." In effect, the essay argues, the presence of neurosis in the collective mind served a kind of inoculatory effect, in the manner that I earlier described as "spiritual".[2] "In today's era of exquisite confusion—political, economic and otherwise—the neurotic would be a welcome guest, nervous company for nervous days, always ready to provide doses of that most potent vaccine against gloominess: wisecracking, urbane gloominess." Today happiness, or at least the absence of anxiety and depression, seems to be a demand and an expected result from medical science. But perhaps the neurotic psyche—at both an individual and a cultural level—served an important purpose, one that should not be so easily dismissed or forgotten. Perhaps we have lost something in becoming so successful in eliminating the symptoms of psychic suffering. At least this seems to be implied in Kristeva's discussion of melancholic art, which addresses melancholia precisely through melan-

cholia, vaccinating itself against itself, and always retaining its small dose of "urbane gloominess."

Second, and following from this, we tend to forget that neurosis is both a mental and a bodily affliction. Carey quotes the historian of mental illness Edward Shorter:

> "We've lost this view of nervous illness as an illness of the whole body, and now call it a mood disorder," Dr. Shorter said. "And sad to say, telling people they have a mood disorder misleads them. They think it's all in their head, when in fact they feel it in their body; they're fatigued, they have these somatic aches and pains, the pit in the stomach—it's experienced in the whole body."

The bodily effects and causes of psychic suffering must be addressed in conjunction with their mental counterparts. In analogy with the body's upright stance, rising up from the earth—with the brain, or the mind's seat, lodged only at its vertical apex—the body and bodily chemistry must be addressed from the ground up and not from the top down; that is, for thought and self-sustaining psychic life to transpire, what is called for is not simply the tamping down of symptoms (a negative approach) but the positive provision to the body of what it needs to corporeally thrive.

This book has sought to explore in depth one philosopher/psychoanalyst's engagement with depression and other social maladies not only at the level of the individual but also at the level of culture. Kristeva suggests, like Nietzsche in "On Redemption," that the problem is not that most humans are, in a psychic sense, "cripples and beggars."[3] To be a human is to be damaged, vulnerable, and finite, and each of us is defined, as Lacan has shown, by a constitutive lack. Indeed, in Lacan's famous formulation, anxiety rather arises when "the lack is lacking" or, as Nietzsche puts it, in those who "lack everything, except one thing of which they have too much."[4] Kristeva's formulation of the one who has "lost her head" is a description of all of us, as simultaneously embodied and intersubjective beings interacting with one another through language and other forms of symbolic life. But how do we "forge" a "new" head? The suggestion that I have been pursuing throughout this book, following Kristeva, is that one productive way might be through aesthetic activity that engages with and through, rather than trying to suppress, anxiety and depression, those two cornerstones of neurosis.

The figure of the severed head is a particularly carnal and jarring one. The severed head has been portrayed in visual art repeatedly and graphically,

exposing a whole range of unexpected affects and registers of meaning, all of which Kristeva addresses in *The Severed Head*. One aspect she spends less time on in that work, however, is the sheer fleshiness of the severed head, the way in which it immediately conveys to the viewer a sense of the pure and final interruption of life. This sense of the severed head is addressed, rather, in Kristeva's detective novels.

In concluding, I want to pursue this theme of vulnerable aesthetic embodiment that appears sporadically in Kristeva, so that we cannot say she neglects it entirely or even at all, yet which she does not foreground as part of the therapeutic process of addressing disabling depression and anxiety. This is the dimension of bodily life and bodily treatment. Kristeva's discussions of the body circle around the phenomena of pregnancy and birth, those simultaneously most carnal and most spiritual of experiences for the maternal body.

We can see the register of meanings of pregnancy and birth in the themes that we have discussed in this book: the melancholia that characterizes the necessary separation from the maternal body and the depressive phase that is the condition for the possibility of symbolic life; the iconoclastic cut that "takes into account *birth* and *void*," the double movement of birth into materiality and history through the mother's body, and annihilation or kenosis into thought;[5] the uncanny experience of harboring an other, a foreigner, within oneself in pregnancy[6] or in our relationship with our unconscious; suffering the loss of the mother as the condition for the possibility of sublimation; and the necessity of matricide, the emptying out of the maternal womb (catharsis), and pardon for matricide for the emergence of representation, law, and language.

In Almodóvar's film *Talk to Her*, Benigno is the consummate caregiver; not content with merely keeping Alicia alive and comfortable, he talks to her, massages her, paints her nails, does her makeup, and cuts her hair, keeping her as beautiful as he knows her to be. As the story unfolds, we begin to realize that Benigno, far from being a family friend or even acquaintance of Alicia prior to her accident, knew her only from voyeuristically following her movements in the ballet studio across the way from his apartment. Benigno is also accused, eventually, of impregnating Alicia in her comatose state, and we are led to believe that he did rape her, albeit out of love and the belief that she has become his true spiritual partner through the care he has given her over the years. Despite this unnerving revelation, the protagonist, Marco, continues to believe in Benigno, visits him in jail, and arranges for his defense, and the audience continues to sympathize with Benigno. While Benigno eventually commits suicide in jail in the mistaken belief that Alicia has died in childbirth, and Lydia, the bullfighter, also dies, the real transformation in the

film takes place in Marco and symbolically in Alicia herself. Alicia awakens from her coma, apparently through the trauma of childbirth (during which the child dies but she is resuscitated). Marco's transformation is subtler; it is implied that Lydia did not do as well as Alicia partly because of Marco's inability to care for her in the way that Benigno cared for Alicia: he did not talk to her (the injunction of the title) and only rarely even touched her.

Benigno's soothing massages, care of the beauty of the body, and one-sided conversations carried on as if there are two in dialogue open up a potentiality for healing that is never present as a possibility for Lydia. Marco is closed off emotionally and psychically, despite his covert tears at the ballet, and it is not until his extended encounter with Benigno that he can become a person who can emotionally extend himself and enter into a real love relationship (which, the end of the film suggests, he will initiate with Alicia, similarly awakened).

The medical profession is coming to recognize the effectiveness of touch as an integral part of the healing process. Like the archaic spiritual healer or the country doctor, there is a place for the "laying on of hands" that can complement and further treatment with drugs or supplements. The flourishing of chiropractic therapy, the name of which comes directly from the Greek *chiro*, or "hand," and *praktikos*, and means a practical healing "by hand," attests to this development or, rather, reawakening of ancient knowledge. As I sit here and write this conclusion, for example, I am cognizant of the fact that it is the manual stretching and manipulation of my back and neck by my chiropractor that made it possible for me to work without a debilitating headache. Intellectual work is strongly tied to the body's well-being, and simply suppressing the pain with drugs works far less effectively than manual stretching and repositioning, helping the academic body to relearn its habitual stances (hunching over a computer, peering at a book, craning in thought) in a less damaging physiology of thought.

Richard Kearney writes of carnal hermeneutics, arguing that even textual interpretation has an ineluctably carnal dimension. He writes that "to say that understanding is incarnate is to say that it answers to the life of suffering and action. Its application to human embodiment is its original and ultimate end. And here we return to its diagnostic role as a caring for lived existence—a listening to the pulse of suffering and solicitation between one human being and another."[7] On a more directly therapeutic level a group of physicians write in "Self-Care of Physicians Caring for Patients at the End of Life" of the practice of "exquisite empathy" among doctors caring for dying patients, naming touch as a way for the caregiver literally to remain connected to the patient and not to become drained or depleted by end-of-life care.[8]

In *Talk to Her* not only talking but also touching, in the form of holding hands, massaging, and putting lotion on the body of Alicia, all contribute to the "exquisite empathy"[9] given to her by Benigno that eventually brings her back to life. Rhythm and touch share a close proximity to the body, to its repetitive processes that sustain life, and to its contours that abut the world. From her earliest work Kristeva has consistently been engaged with the interaction between body and meaning, between the semiotic and the symbolic. What art makes manifest is a more fundamental region, what Kristeva calls the last vestige of the sacred: the capacity for representation.

At the end of *The Severed Head*, Kristeva discusses modern art's "belief in the body" or, rather, the belief, common to Rodin, Degas, and Cézanne, in "their own way of figuring the economy of bodies and being." This conviction allows these artists to "abandon the spectacle, infiltrate the borders of appearances, and find there a *kind of face* that has not yet found its *face*, that never will, but that never stops seeking a thousand and one ways of seeing."[10]

What would a face that has not yet found its face look like? This "inner face" requires a "transubstantiation" that in turn necessitates a "beheading," a belief affirmed by Georges Bataille in his quest for inner experience. Bataille's journal *Acéphale* (literally, "Headless") articulated the attempt of its contributors to experience a kind of life that would sever the head of any sovereignty, whether religious, political, or academic. Bataille writes:

> Man escaped his head like a prisoner escapes prison. Beyond himself he found, not God who is the prohibition of crime, but a being who does not know prohibition. Beyond what I am, I encounter a being who makes me laugh because he is headless, who fills me with anguish because he is made up of innocence and crime: he holds an iron weapon in his left hand, flames like a Sacred Heart in his right hand. In a single refinement he reunites Birth and Death. He is not a man. Neither is he a god. He is not me, but he is more than me: his belly is the maze in which he loses his way, loses me with him and in which I find myself again being him, that is to say, a monster.[11]

For Kristeva, *Acéphale* "recalls the power of desires against which our capacity for representation stands firm."[12] Referencing Bataille's interest in human sacrifice as the ultimate inner experience, but also the very structure of human experience as sacrifice, and the idea that it is sacrifice that opens up onto the sacred, Kristeva suggests instead that it is the capacity for representation that allows access to the sacred, to whatever residue of it is left for us.

Removing the head, she argues, allows for the only resurrection still possible for us today, that is, that of representation.[13] "All vision is capital vision," she writes at the very beginning of the catalogue for the exhibition. We need the "liberating utopia of ecstatic freedom" that this power of representation can offer us, particularly now, "in order not to die of virtual boredom before our computers, plugged into the true-false crashes of the stock markets: might we attain this not in the sacrifice represented by Acéphale, but . . . in the virtuosity, infinite and void, of representation itself, when it is devoted to envisioning the sacrifice that we inhabit?"[14] Life is suffering, Kristeva acknowledges, but she also shows us that this suffering can promise and enable creativity: losing a head opens up the possibility of creating a head, whether it be through melancholic art, negative presentation, tarrying with the foreign, sublimating the drives that threaten to overwhelm us, or engaging with the other in a manner that avoids the master/slave struggle.

Hegel once wrote that "knowledge heals the wound that it itself is,"[15] an admirably terse version of the Kristevan insight into spiritual inoculation, although the wound never completely heals in Kristeva's and Benjamin's version, and it is art and melancholic philosophy rather than knowledge that are the ingredients of the salve. Samuel Beckett writes in *Worstward Ho*, his late rumination on human existence and art: "Ever tried. Ever failed. No matter. Try again. Fail again. Fail better." This may be the most powerful message we can gain from Kristeva's reflections on art and philosophy in depressed times. It is not a matter of getting over the depression once and for all but of finding a way to live, write, create in and through it. Kristeva herself refers to Beckett in her piece on Louise Bourgeois. Discussing Bourgeois's sculpture *Topiary IV*, a striking work in which a decapitated female figure sprouts a bejeweled tree from her neck, Kristeva calls it "the resurrection into paradise of Samuel Beckett's *Not I*."[16] *Not I* is a dramatic monologue that takes place on a pitch-black stage, with a spotlight fixed on the mouth of the sole speaker, an aging woman, as she spews forth a logorrhea of tangled and fragmented sentences recounting a loveless, traumatized existence from birth to the present, a performance of depressed life, in which color, meaning, and passion have been drained from existence. She moves, in the monologue, from believing that her unhappiness is the result of a punishment from God, to an assumption of her own guilt for her existence, to the belief that if she continues to recount her life eventually she will stumble upon the necessary event or fault for which she can then seek forgiveness. At the same time the narrator continually insists that the event she describes never happened to her. Beckett traced the genesis of the piece to the image of the mouth of an old woman spectator in Caravaggio's

painting *The Beheading of Saint John the Baptist*,[17] one watching a beheading transformed into one lamenting her own beheading.[18]

Bourgeois's sculpture, which Kristeva links to the Beckett monologue, presents the female figure in a shapeless shift that could be a young girl's dress or an old woman's housecoat; she stands on only one leg, with a crutch propped under one tree-branch arm, clearly indicating a handicap that, to Kristeva, appears as the unabashed existential need for support. At the same time, the "head," or what appears in place of it, is a flourishing and beautiful tree adorned with jewels, making no pretense of being natural or a simulacrum of a real head. Kristeva writes, in an uncharacteristically personal and lyrical way:

> Of all beings on earth, after birds, I prefer trees. Flowers that have grown and grown; not content to defy beauty, they defy the storms of time. They seem to embody the best of what humans desire. *Topiary IV* is a tree-woman, the perfect anti-siren. Instead of exchanging the lower half of her body for a fish-tail dreaming of fresh water, the tree-woman knows that one day her legs will fail; she will need a crutch before dying. But she keeps the lower half of her body as it was; she even dresses it, with the satin dress of a young girl blossoming into puberty—and adds a proliferating head. Her sap has risen to the top and, defoliated though she now is, this tree-woman can seduce nonetheless through the tufts of jewels put forth from the tips of her branches. . . . The artist is man or woman—but certain women artists easily attain the psychic plasticity that transforms their ageing body into a blossoming tree. . . . The trunk and branches may be dry, but the thing proliferates nonetheless, ascends, ramifies, buds—not in juicy flavours, but in emerald jewels. The seduction of crystallization.[19]

The meaning and personal significance of this piece, for Kristeva, is clear. The figure, like Bourgeois, is a transplanted foreigner who has effected a rebirth into a new medium; bereft of her head, she nonetheless crafts for herself a new existence in which she is not immortalized but rather comes to terms with the specificities of her own finitude. Through her psychic plasticity she is able to ascend, ramify, bud; she has forged a head.

NOTES

INTRODUCTION: LOSING OUR HEADS

1. For a version of this story in children's literature, see *In a Dark, Dark Room and Other Scary Stories*, retold by Alvin Schwartz (New York: Harper Collins, 1999). Some interesting historical facts have been linked by other commentators to this story and its enduring fascination. One explanation of its inception connects it to the fashion that arose during the French Revolution of dressing for so-called *bals des victimes*, fashionable balls to which entrance was accorded only to relatives of victims of the guillotine. Women would accessorize their outfits with thin red ribbons tied tightly around their necks, signifying the cut of the guillotine. This also, apparently, is the origin of the necklace called the "choker," which became popular far beyond the borders of France. The fashion signifies sympathy with the victims of the Terror, as well as a kind of acknowledgment of human suffering and finitude generally. See Ronald Schechter, "Gothic Thermidor: The *Bals des Victimes*, the Fantastic, and the Production of Historical Knowledge in Post-Terror France," *Representations* 61, Special Issue: Practices of Enlightenment (Winter 1998): 78–94. See also Aileen Ribeiro, *Fashion in the French Revolution* (New York: Holmes and Meier, 1988), 122.

2. Julia Kristeva, *The Severed Head: Capital Visions*, trans. Jody Gladding (New York: Columbia University Press, 2012).

3. Ibid., 6.

4. This argument will be developed in chapter 3.

5. Julia Kristeva, *Colette*, trans. Jane Marie Todd, Female Genius: Life, Madness, Words, vol. 3 (New York: Columbia University Press, 2004), 239.

6. Julia Kristeva, *Melanie Klein*, trans. Ross Guberman, Female Genius: Life, Madness, Words, vol. 2 (New York: Columbia University Press, 2001), 89.

7. Julia Kristeva, *Tales of Love*, trans. Leon Roudiez (New York: Columbia University Press, 1987), 5.

8. I will discuss this transition in the *Oresteia* at length in chapter 5.

9. When I use the term "symbolic order," I am referring to Jacques Lacan's term for the links of language and law that precede and constitute subjects and their connections to one another (intersubjectivity).

10. Hélène Cixous, "Castration or Decapitation?," trans. Annette Kuhn, *Signs* 7, no. 1 (1981): 42.

11. Lacan argues that all speaking subjects, masculine and feminine, are "castrated" by their entrance into the symbolic order.

12. Cixous, "Castration or Decapitation?," 43.

13. Cixous, "Castration or Decapitation?," 49.

14. Julia Kristeva, "Dialogue with Julia Kristeva," *Parallax* 4, no. 3 (1998): 6. See also Hannah Arendt, *The Human Condition* (Chicago: University of Chicago Press, 1971), 177–178.

15. Ibid., 6.

16. Ibid., 7.

17. Ibid., 6.

18. See Julia Kristeva, *Revolution in Poetic Language*, trans. Margaret Waller (New York: Columbia University Press, 1984).

19. See Jacques Lacan, "The Mirror Stage," in *Écrits*, trans. Bruce Fink (New York: Norton, 2007).

20. Julia Kristeva, *Intimate Revolt*, trans. Jeanine Herman (New York: Columbia University Press, 2002), 139–140.

21. Guy Debord, *Society of the Spectacle*, trans. Donald Nicholson-Smith (New York: Zone, 1994).

22. See Immanuel Kant, *Critique of Judgment*, trans. Werner Pluhar (Indianapolis, Ind.: Hackett, 1987), AK 316.

23. Julia Kristeva, *Proust and the Sense of Time*, trans. Stephen Bann (New York: Columbia University Press), 70.

24. Kristeva, "Dialogue with Julia Kristeva," 7.

25. Ibid.

26. Julia Kristeva, "From Symbols to Flesh: The Polymorphous Destiny of Narration," *International Journal of Psycho-Analysis* 81 (2000): 778.

27. Ibid.

28. Julia Kristeva, "The Paradise of the Mind," interview with Rubén Gallo, in *Paradiso/Inferno*, catalogue for the photography exhibit curated by Alfredo Jaar (Stockholm: Riksutställningar, 2000).

29. Ibid., 1.

30. Kristeva, *The Severed Head*, vii.

31. I will examine Kristeva's discussion of the iconoclastic tradition in religion and its relation to contemporary art in chapter 2.

32. Kristeva, "Dialogue with Julia Kristeva," 8.

33. Julia Kristeva, interview by Nina Zivancevic, Paris, March–April 2001, found on Verve Fine Art Gallery Facebook page, May 20, 2011.

34. I will examine the history of the psychoanalytical concept of sublimation, including Kristeva's unique version of it, in greater depth in chapter 4.

35. Kristeva, "Dialogue with Julia Kristeva," 13.

36. Ibid., 12.

37. Julia Kristeva, *Revolt, She Said*, trans. Brian O'Keefe (New York: Semiotext(e), 2002), 55.

38. Ibid.

39. Ibid., 55–56.

40. Ibid., 57.

41. Sigmund Freud, "Mourning and Melancholia," in *The Standard Edition of the Complete Psychological Works of Sigmund Freud*, ed. James Strachey (London: Hogarth, 1981), 14:237–258.

42. I will discuss this parallel in chapter 1.

43. Among them, Andrew Samuels, a psychoanalyst at the University of Essex, discusses events that are immediately relevant to the contemporary context of the twenty-first century. Samuels writes that "the West is stuck in a profound cultural depression caused in part by its own strength, just as depressive anxiety in an individual is fuelled by . . . fantasies of destroying someone or something." Andrew Samuels, "War, Terrorism, Cultural Inequality and Psychotherapy," http://www.andrewsamuels.com.

44. See Sigmund Freud, *Civilization and Its Discontents*, trans. and ed. James Strachey (New York: Norton, 1989).

45. Julia Kristeva, "A New Type of Intellectual: The Dissident," in *The Kristeva Reader*, ed. Toril Moi (London: Wiley-Blackwell, 1986), 300.

46. Hannah Arendt, *The Human Condition* (Chicago: University of Chicago Press, 1971), 193–194.

47. Hannah Arendt, *Life of the Mind* (San Francisco: Harcourt Brace Jovanovich, 1978), 103.

48. Ibid., 110–111.

49. Ibid., 109.

50. Kristeva, "Dialogue with Julia Kristeva," 11.

51. I will consider Kristeva's reading of Arendt and Kant in greater depth in chapter 3.

52. Hannah Arendt, *Lectures on Kant's Political Philosophy*, ed. Ronald Beiner (Chicago: University of Chicago Press, 1989).

53. See Elaine Miller, "The Sublime Time of Art in Kant and Nietzsche," *Eidos* (June 1997).

54. Julia Kristeva, "Louise Bourgeois: From Little Pea to Runaway Girl," in *Louise Bourgeois*, ed. Frances Morris (New York: Rizzoli, 2008), 12.

55. This theme of willfully remaining foreign will also be the subject of chapter 3.

56. Julia Kristeva, *Revolution in Poetic Language*, trans. Margaret Waller (New York: Columbia University Press, 1984).

57. Cited in Kristeva, "Louise Bourgeois," 249.

58. Ibid.

59. Melancholia and its "treatment" through "poetic revolution" will be the theme of chapter 1.

60. See Sigmund Freud, *Beyond the Pleasure Principle*, ed. James Strachey (New York: Norton, 1990).

61. See Walter Benjamin, "Little History of Photography," in *Selected Writings*, 2:507–530 (Cambridge, Mass.: Harvard University Press, 1999). I will discuss Benjamin's philosophy of photography in chapters 2 and 3.

62. Angelica Rauch, "Post-Traumatic Hermeneutics: Melancholia in the Wake of Trauma," *Diacritics* 28, no. 4 (Winter 1998): 113.

63. Donald Winnicott, "Transitional Objects and Transitional Phenomena," in *Playing and Reality* (London: Tavistock, 1971). See also Kristeva, *Revolution in Poetic Language*.

64. I will discuss the phenomenon of the "countermemorial" in Germany in chapter 1.

65. G. W. F. Hegel, *Lectures on Aesthetics*, vol. 1, trans. T. M. Knox (Oxford: Oxford University Press), 31.

66. Julia Kristeva, *Time and Sense: Proust and the Experience of Literature*, trans. Ross Guberman (New York: Columbia University Press, 1996), 168.

67. This is, of course, a reference to Søren Kierkegaard's critique of Hegelian dialectic in *Fear and Trembling* and *Repetition*. However, this parallel is not discussed further.

68. I use the Kantian term "aesthetic ideas" throughout to designate a singular image whose connotations proliferate and resonate with our capacity for cognition and conceptualization in general in a relation that Kant refers to as "spirit" (a term that would become incredibly important for German idealism after him) rather than denoting any particular determinative representation or concept. Kant writes that the aesthetic idea is a "presentation of the imagination which is conjoined with a given concept and is connected, when we use imagination in its freedom, with such a multiplicity of partial presentations that no expression that stands for a determinate concept can be found for it. Hence it is a presentation that makes us add to a concept the thoughts of much that is ineffable, but the feeling of which quickens our cognitive powers and connects language, which otherwise would be mere letters, with spirit." Immanuel Kant, *Critique of Judgment*, trans. Werner Pluhar (Indianapolis, Ind.: Hackett, 1987), 316.

1. KRISTEVA AND BENJAMIN: MELANCHOLY AND THE ALLEGORICAL IMAGINATION

1. Julia Kristeva, *Black Sun: Depression and Melancholia*, trans. Leon S. Roudiez (New York: Columbia University Press, 1989), 3.

2. Julia Kristeva, "Dialogue with Julia Kristeva," *Parallax* 4, no. 3 (1998): 16.

3. Kristeva, *Black Sun*, 100.

4. I have been using melancholia and depression interchangeably, which Kristeva also does in *Black Sun*. However, we must necessarily conceptually separate the melancholia at the origin of language, imagination, and even thought from the disabling depression that affects so many today, even while recognizing that Kristeva addresses both structural melancholia and the psychic disorder.

5. Julia Kristeva, *New Maladies of the Soul*, trans. Ross Guberman (New York: Columbia University Press, 1995), 7.

6. Ibid., 8.

7. Ibid., 9.

8. This phenomenon might be compared to what Benjamin calls habitual distracted perception in "The Work of Art in the Age of Its [Mechanical] Reproducibility," second version, in *Selected Writings* (Cambridge, Mass.: Harvard University Press, 2002), 3:120.

9. Kristeva, *Black Sun*, 9.

10. Ibid., 5.

11. The idea of a depressive position as part of infantile development was put forward by Melanie Klein. The depressive position, which is posited to be reached at about the fourth month of life and overcome over the course of the first year, is conceived of as analogous to the clinical picture of depression. It is correlated with a series of developmental changes that affect the relationship between the ego and the object. At this stage the mother begins to be perceived as a whole, separate person; the relationship between the infant and the mother loses its exclusiveness; and the child begins to enter the early stages of the Oedipus complex. See J. Laplanche and J. B. Pontalis, *The Language of Psycho-Analysis*, trans. Donald Nicholson-Smith (New York: Norton, 1973), 114–116.

12. Kristeva, *Black Sun*, 6.

13. Ibid.

14. I discuss this idea, based on Melanie Klein's positing of a "depressive position" at the origin of language, at greater length in chapter 4.

15. Kristeva, *Black Sun*, 6.

16. Ibid., 7.

17. Ibid., 22.

18. Ibid., 97.

19. Julia Kristeva, *Revolution in Poetic Language*, trans. Margaret Waller (New York: Columbia University Press, 1984), 25.

20. Ibid., 50.

21. Ibid., 13.

22. Ibid., 70.

23. Ibid., 70, 79.

24. In her conversation with the audience at the conference "Julia Kristeva: 1966–1996," Kristeva stated that it is her preoccupation with language that distinguishes her theoretical consideration of melancholia from Freud's. She writes, "In certain cases, the discourse of the melancholic is so impoverished that one wonders on what could one base an analysis. . . . The first task of the cure, therefore, is to reestablish the bond with language." Kristeva, "Dialogue with Julia Kristeva," 16.

25. Kristeva, *Black Sun*, 6.

26. Ibid., epigraphs.

27. Ibid., 100.

28. Ibid., 101.

29. Sigmund Freud, "Mourning and Melancholia," in *The Standard Edition of the Complete Psychological Works of Sigmund Freud,* ed. James Strachey (London: Hogarth, 1981), 14:237.

30. See Kristeva, *Black Sun,* 9–10; see also Eric Santner, *Stranded Objects: Mourning, Memory and Film in Postwar Germany* (Ithaca, N.Y.: Cornell University Press, 1990), 2–3.

31. Freud, "Mourning and Melancholia," 243.

32. Freud, "Mourning and Melancholia," 251.

33. Ibid., 249.

34. Sigmund Freud, *The Ego and the Id,* trans. Joan Riviere (New York: Norton, 1960), 24.

35. Ibid., 24.

36. Frantz Fanon, *Black Skin, White Masks,* trans. Richard Philcox (New York: Grove, 1967), 142.

37. Ibid., 143.

38. Ibid., 149.

39. Ibid., 202.

40. See Kristeva, *New Maladies of the Soul.* In an online interview, Kristeva also identifies the cultures of Eastern Europe as "stuck and depressed." See the interview with Josefina Ayerza at http://www.lacan.com/perfume/kristeva.htm.

41. Theodor W. Adorno, *Minima Moralia: Reflections on a Damaged Life,* trans. E. F. N. Jephcott (New York: Verso, 2005), 15.

42. Walter Benjamin, *The Origin of German Tragic Drama,* trans. John Osborne (New York: Verso, 1998), 139. I have changed the translation of the word *Trauer* from "mourning" to "melancholia" because it seems more appropriate in this context. Benjamin does not make the conceptual psychoanalytical distinction between melancholia and mourning in this work.

43. Sigmund Freud, *Civilisation, War, and Death,* ed. John Rickman (London: Hogarth, 1968), 2.

44. Ibid., 97.

45. Ibid.

46. Arguably, terrorism has provoked this kind of cultural trauma, most notably, perhaps, in the U.S. reaction to the events of 9/11. Where there is an acknowledgment of trauma, efforts are often made to mourn too quickly, but too-successful mourning can be as disabling as melancholia. Sometimes a traumatic event is left behind or memorialized in a triumphant fashion that betrays almost a complete absence of working through the trauma. Following the bombing of the World Trade Center, David Eng notes that "in [U.S.] attempts to repress any reckoning with the future, the mania of nationalism incited by the politics of state mourning reduce[d] the globe to an 'us' and a 'them,' while producing a truly unprecedented New World Order of American sovereignty" that is paranoid in its intensity—you are either with us or against us. David Eng, "The Value of Silence," *Theatre Journal* 54, no. 1 (2002): 87.

47. Freud, "Mourning and Melancholia," 174 (McMillan 1963 ed.).

48. Julia Kristeva, "Diversité, c'est ma dévise," http://www.kristeva.fr/diversite.html. My translation.

49. Walter Benjamin, "Berlin Childhood Around 1900," in *Selected Writings* (Cambridge, Mass.: Harvard University Press, 2002), 3:344.

50. Ibid.

51. Ibid.

52. Kristeva, *Black Sun*, 42.

53. Santner, *Stranded Objects*, 147.

54. Ibid., 7.

55. Theodor W. Adorno, *Aesthetic Theory*, trans. Robert Hullot-Kentor (Minneapolis: University of Minnesota Press, 1997), 132.

56. Kristeva, "Dialogue with Julia Kristeva," 14.

57. Ibid., 15.

58. G. W. F. Hegel, *Lectures on Aesthetics*, trans. T. M. Knox (Oxford: Oxford University Press, 1975), 1:96–97.

59. Ibid. See also Rebecca Comay, "The Sickness of Tradition: Between Melancholia and Fetishism," in *Walter Benjamin and History* (New York: Continuum, 2006), 90.

60. Benjamin, *The Origin of German Tragic Drama*, 159.

61. Ibid., 160; G. W. F. Hegel, *Phenomenology of Spirit*, trans. A. V. Miller (Oxford: Oxford University Press, 1977), 383–384.

62. Hegel, in *Lectures on Aesthetics*, uses this kind of language (perfect adequacy of form to content) to describe postsymbolic, or classical Greek, art, which he took to be the apotheosis of art. Benjamin, in *The Origin of German Tragic Drama* (160), uses Hegelian language to critique what he considers to be the typically romantic conception of both art and the subject. He writes that "its heart is lost in the beautiful soul," a locution Hegel also used to criticize the romantics. See also Hegel, *Phenomenology of Spirit*, 383–384. It is important to note that (1) Hegel does criticize romanticism, but for reasons that oppose Benjamin's, just as (2) Hegel does critique symbolic art, but again, for reasons opposing Benjamin. For Hegel, symbolic art is art in which the form is not adequate to the content. Romantic art is art in which the content exceeds all possible form. Thus, for Hegel, neither symbolic art nor romantic art, for different reasons, insists on an indivisible unity of form and content.

63. Benjamin, *The Origin of German Tragic Drama*, 160.

64. Ibid.

65. Ibid., 161.

66. Ibid., 162.

67. Ibid., 165.

68. Ibid., 166.

69. Ibid., 183.

70. Ibid., 193.

71. Ibid., 224.

72. Ibid., 224.

73. Walter Benjamin, "Central Park," in *Selected Writings* (Cambridge, Mass.: Harvard University Press, 2003), 4:164.

74. Ibid., 4:171.

75. Ibid.

76. Ibid., 4:173.

77. Ibid., 4:174.

78. Ibid., 4:183.

79. Ibid., 4:186.

80. Max Pensky, *Melancholy Dialectics: Walter Benjamin and the Play of Mourning* (Amherst: University of Massachusetts Press, 1993), 165–166. See all of his chapter 4 for a comprehensive reading of Benjamin on melancholia and modernity, in particular on the allegorical writing of Baudelaire.

81. Benjamin, *The Origin of German Tragic Drama*, 209.

82. Rebecca Comay, "Materialist Mutations of the *Bilderverbot*," in *Walter Benjamin and Art*, ed. Andrew Benjamin (New York: Continuum, 2005), 47.

83. Ibid., 45.

84. Benjamin, *The Origin of German Tragic Drama*, 183.

85. Ibid., 193.

86. Ibid., 183–184.

87. Ibid., 184.

88. Ibid., 185.

89. Kristeva, *Black Sun*, 99.

90. Ibid., 100.

91. Ibid., 101.

92. Ibid., 102.

93. Ibid., 98.

94. Ibid., 99.

95. Ibid.

96. Ibid., 102.

97. Ibid., 65.

98. Ibid., 43. Cited in Ewa Plonowska Ziarek, "Kristeva, Levinas: Mourning, Ethics, and the Feminine," in *Ethics, Politics, and Difference in Julia Kristeva's Writings*, ed. Kelly Oliver (New York: Routledge, 1993), 72.

99. Ziarek, "Kristeva, Levinas," 73.

100. Kristeva, *Black Sun*, 102.

101. Ibid., 103.

102. Ibid., 128, my emphasis.

103. Ibid., 129–130.

104. Ibid., 130. In analogy to the infantile depressive moment, presumably; here, the depressive moment involves separation from the divine.

105. Ibid.

106. Ibid., 132.

107. Ibid., 133.

108. Ibid., 131.

109. Ibid., 136.

110. Hegel, *Phenomenology of Spirit*, 476.

111. Kristeva, *Black Sun*, 136.

112. Ibid., 136–137.

113. Ibid., 137.

114. Ibid., 138.
115. Julia Kristeva, *Desire in Language*, trans. Leon S. Roudiez (New York: Columbia University Press, 1980), 265.
116. Julia Kristeva, *Revolt, She Said*, trans. Brian O'Keefe (New York: Semiotext(e), 2002), 55.
117. Of course, Kristeva is not referring to the most pathological form of melancholia when she discusses melancholic artworks. Melancholia in its strongest form would be disabling and preclude the use of language or the creation of artworks, so there is a tension in the very name "melancholic artwork."
118. Kristeva, *Black Sun*, 19.
119. I would like to acknowledge and thank Emily Zakin for her help in formulating this notion of re-erotization.
120. Kristeva, *Black Sun*, 19.
121. Ibid.
122. Adorno, *Aesthetic Theory*, 1978.
123. Ziarek, "Mourning, Ethics, and the Feminine," 73.
124. See chapter 2.
125. Adorno, *Aesthetic Theory*, 189–190.
126. Ibid., 166–167, my emphasis.
127. Ibid., 104.
128. Benjamin, *The Origin of German Tragic Drama*, 176.
129. Julia Kristeva, in *The Portable Kristeva*, ed. Kelly Oliver (New York: Columbia University Press, 1997), 367.
130. See Jean-François Lyotard, *Lessons on the Analytic of the Sublime*, trans. Elizabeth Rottenberg (Stanford, Calif.: Stanford University Press, 1994), 459.
131. Julia Kristeva, *The Sense and Non-Sense of Revolt*, trans. Jeanine Herman (New York: Columbia University Press, 2000), 60.
132. Kristeva, *Black Sun*, 100.
133. Kristeva, *The Sense and Non-Sense of Revolt*, 10.
134. Ibid.
135. Ibid.
136. Ibid.
137. Robert Musil, *Posthumous Papers of a Living Artist*, trans. Peter Wortsman (Hygiene, Colo.: Eridanos, 1987), 61.
138. Friedrich Nietzsche, *On the Advantage and Disadvantage of History for Life*, trans. Peter Preuss (Indianapolis, Ind.: Hackett, 1980), 22.
139. Slavoj Žižek, *For They Know Not What They Do* (New York: Verso, 1991), 272.
140. Ibid., 273.
141. Ibid., 273.
142. The question quite naturally arises as to why no American artist has proposed—or at least been supported in an effort to construct—a countermonument to a comparable moment of the country's shameful past, such as the institution of slavery or the mass killing of American Indians.
143. Bartomeu Mari, "The Art of the Intangible," in *Rachel Whiteread: Shedding Life* (London: Thames and Hudson, 1997), 64.

144. Roland Barthes, *Camera Lucida: Reflections on Photography*, trans. Richard Howard (New York: Hill and Wang, 1982), 93.

145. Rosalind Krauss, "X Marks the Spot," in *Rachel Whiteread: Shedding Life* (London: Thames and Hudson, 1997), 77–78.

146. Rachel Whiteread, *Rachel Whiteread: Shedding Life* (London: Thames and Hudson, 1997), 33.

147. Kristeva, *The Sense and Non-Sense of Revolt*, 60.

148. Ibid.

149. Ibid., 61.

150. Ibid., 59–60.

151. Ibid., 60.

2. KENOTIC ART: NEGATIVITY, ICONOCLASM, INSCRIPTION

1. See G. W. F. Hegel, *Phenomenology of Spirit*, trans. A. V. Miller (Oxford: Oxford University Press, 1977), 19. It should be acknowledged, as it is by Kristeva, that Hegel's own philosophy does indicate a place for the unconscious, even if Hegel only begins the description of the trajectory of spirit with consciousness. In the *Encyclopedia*, Hegel's discussion of the feeling soul as that part of the individual soul whose "determinations develop into no conscious and understandable content" articulates an unconscious realm that is the foundation and condition for the possibility of (individual) consciousness and (collective) spirit. See G. W. F. Hegel, *Philosophy of Mind*, trans. A. V. Miller (Oxford: Oxford University Press, 1971), §403f. Kristeva also refers to Hegel's discussion of Denis Diderot's nephew in *The Phenomenology of Spirit*. For more on this subject, see Jon Mills, *The Unconscious Abyss: Hegel's Anticipation of Psychoanalysis* (Albany, N.Y.: SUNY Press, 2002).

2. Julia Kristeva, *Strangers to Ourselves*, trans. Leon S. Roudiez (New York: Columbia University Press, 1991), 169–170.

3. Christoph Menke refers to Adorno's aesthetics as "aesthetic negativity" for its dual claim that (1) the relationship between art and nonart is negative because it conceives of art as a critique of nonaesthetic reality and (2) because it sees art as a place where the intensity of lived experience is increased vis-à-vis that of nonaesthetic reality. See Christoph Menke, *The Sovereignty of Art: Aesthetic Negativity in Adorno and Derrida*, trans. Neil Solomon (Cambridge, Mass.: MIT Press, 1999), 4. However, Menke sets these claims up only in order to refute them, calling them at the outset "misconceptions" because they do not, according to Menke, explain the concept of aesthetic autonomy. I will be arguing against this position, reading Adorno's aesthetic negativity instead through his materialist reading of the ban on graven images. See Theodor Adorno, *Negative Dialectics*, trans. E. B. Ashton (New York: Continuum, 2005), 207.

4. Theodor W. Adorno and Max Horkheimer, *Dialectic of Enlightenment* (New York: Continuum, 1994), 23–24.

5. G. W. F. Hegel, *Lectures on Aesthetics*, trans. T. M. Knox (Oxford: Oxford University Press, 1975), 1: 72.

6. Ibid., 1:70.
7. Ibid.
8. Ibid., 1:175.
9. Ibid., 1:11.
10. Ibid., 1:421.
11. Ibid., 1:517.
12. Ibid., 1:252.
13. Ibid.
14. Ibid., 1:255.
15. Ibid., 1:518.
16. Ibid.
17. Donald Kuspit, "The Will to Unintelligibility in Modern Art: Abstraction Reconsidered," in *Signs of Psyche in Modern and Postmodern Art* (Cambridge: Cambridge University Press, 1993), 114–115.
18. Donald Kuspit, "Sincere Cynicism: The Decadence of the 1980s," in *Signs of Psyche in Modern and Postmodern Art* (Cambridge: Cambridge University Press, 1993), 273–274.
19. Donald Kuspit, "Contemporary Iconoclasm," in *The Intellectual Conscience of Art, L & B*, ed. Annette W. Balkema and Henk Slager (Amsterdam: Rodopi, 1996), 11:84–85.
20. Donald Kuspit, "Visual Art and Art Criticism: The Role of Psychoanalysis," in *Signs of Psyche in Modern and Postmodern Art* (Cambridge: Cambridge University Press, 1993), 304.
21. The French psychoanalyst André Green, whose work has deeply influenced Kristeva's own, refers to this transformative capacity of the negative in terms of Keats's "negative capability," a capacity described by Keats in a letter as a situation in which "a man is capable of being in uncertainties, mysteries, doubts without any irritable reaching after fact and reason." Keats, letter to George and Thomas Keats, December 21, 1817, quoted in André Green, "The Primordial Mind and the Work of the Negative," *International Journal of Psycho-Analysis* 79 (1998): 657. The aim of analysis, according to Green, citing Wilfred R. Bion as the originator of this thought, is not to claim to reach anything beyond approximation (ibid.). To grasp too eagerly for readymade solutions is a symptom of psychic immaturity or dysfunction. Kristeva's embrace of iconoclasm implies a similar judgment concerning some political positions.
22. Diana Coole, *Negativity and Politics: Dionysus and Dialectics from Kant to Poststructuralism* (New York: Routledge, 2000), 11.
23. Adorno, *Negative Dialectics*, 204.
24. Ibid., 205.
25. Ibid., 204.
26. Ibid., 205.
27. Ibid.
28. Ibid., 206.
29. Ibid., 207.
30. Theodor W. Adorno, *Aesthetic Theory*, trans. Robert Hullot-Kentor (Minneapolis: University of Minnesota Press, 1997), 54.

31. Adorno, *Negative Dialectics*, 207.

32. Ibid., 205.

33. For a comprehensive account of Adorno's appropriation and materialist transforma-
 tion of the theological ban on images, see Elizabeth Pritchard, "*Bilderverbot* Meets
 Body in Theodor Adorno's Inverse Theology," *Harvard Theological Review* 95,
 no. 3 (2002): 291–318. Adorno makes references to the ban on graven images
 throughout his work, including in "Reason and Revelation," *Dialectic of Enlight-
 enment*, and *Minima Moralia*.

34. Freud, "Negation," in *General Psychological Theory: Papers on Metapsychology*,
 ed. Philip Rieff (New York: Collier, 1963), 216.

35. Ibid., 213.

36. Jean Hyppolite, "A Spoken Commentary on Freud's *Verneinung*," in Jacques
 Lacan, *Écrits*, trans. Bruce Fink (New York: Norton, 2007), 749.

37. Freud, "Negation," 216.

38. Ibid., 214–215.

39. Hyppolite, "A Spoken Commentary on Freud's *Verneinung*," 751.

40. Ibid. See also Freud, "Negation," 215.

41. Julia Kristeva, *Revolution in Poetic Language*, trans. Margaret Waller (New York:
 Columbia University Press, 1984), 69.

42. Ibid., 109.

43. Ibid., 113.

44. Ibid., 109.

45. Ibid.

46. Ibid., 124.

47. Ibid., 69.

48. Ibid.

49. Ibid.

50. Ibid., 155.

51. Ibid., 163.

52. Ibid., 118.

53. Ibid., 159.

54. Ibid., 163.

55. Ibid., 164. For the specifically political implications of Kristeva's concept of nega-
 tivity, see Coole, *Negativity and Politics*; and Cecilia Sjöholm, *Kristeva and the
 Political* (New York: Routledge, 2005).

56. Kristeva, *Revolution in Poetic Language*, 123.

57. Julia Kristeva, *Time and Sense: Proust and the Experience of Literature*, trans. Ross
 Guberman (New York: Columbia University Press, 1996), 242.

58. Julia Kristeva, *Powers of Horror*, trans. Leon S. Roudiez (New York: Columbia
 University Press, 1982), 57.

59. Ibid., 58.

60. Kristeva writes of defilement rites that they "effect an abreaction of the pre-sign
 impact, the semiotic impact of language" in ibid., 73.

61. Ibid., 58. Freud, too, calls the ban on images of the divine a "triumph of intellectu-
 ality over sensuality . . . an instinctual renunciation, with all the necessary conse-

quences." Sigmund Freud, *Moses and Monotheism*, in *The Origins of Religion*, ed. Albert Dickson, trans. James Strachey et al. (New York: Penguin, 1990).

62. Kristeva, *Powers of Horror*, 61.

63. Ibid., 104.

64. Ibid.

65. Ibid., 105.

66. Ibid., 61.

67. Ibid. See also Freud, "Negation," 215; and Hyppolite, "A Spoken Commentary on Freud's *Verneinung*," 751.

68. Kristeva, *Powers of Horror*, 62.

69. Jean-Joseph Goux, "Vesta, or the Place of Being," *Representations* 1 (February 1983): 91.

70. Ibid., 95.

71. "What distinguishes the poetic function from the fetishist mechanism is that it maintains a *signification*. . . . No text, no matter how 'musicalized,' is devoid of meaning or signification; on the contrary, musicalization pluralizes meanings." Kristeva, *Revolution in Poetic Language*, 65. To claim that poetic language falls under the category of fetishism would be to say that the poet recognizes the castration of the mother (in language) but nonetheless cannot believe it; the mother's missing penis would then be displaced onto nonsignifying language.

72. Again, we can recognize the appeal to the "negative capability" of Keats advocated as a healthy psychic attitude by Bion, Green, and, presumably, Kristeva. See note 21, above.

73. Julia Kristeva, *New Maladies of the Soul*, trans. Ross Guberman (New York: Columbia University Press, 1995), 122.

74. Julia Kristeva, *Tales of Love*, trans. Leon Roudiez (New York: Columbia University Press, 1987), 38.

75. Ibid., 26.

76. Ibid., 27.

77. Kristeva, *New Maladies of the Soul*, 121.

78. Ibid.

79. Kristeva, *Tales of Love*, 202.

80. Marie-José Mondzain, *Image, Icon, Economy: The Byzantine Origins of the Contemporary Imaginary*, trans. Rico Franses (Stanford, Calif.: Stanford University Press, 2005).

81. Julia Kristeva, *Crisis of the (European) Subject*, trans. Susan Fairfield (New York: Other Press, 2000), 153.

82. Kristeva also points to Hans Holbein's position between iconoclasm and representation in *Black Sun* (New York: Columbia University Press, 1989), 124–125.

83. Ibid., 211.

84. Julia Kristeva, *The Severed Head: Capital Visions*, trans. Jody Gladding (New York: Columbia University Press, 2012), 55.

85. This is a continuity that we might call Hegelian, and Kristeva does make this connection.

86. Kristeva, *The Severed Head*, 59.

87. Ibid., 58.
88. Ibid., 57–58.
89. Ibid., 59.
90. Ibid.
91. See chapter 3.
92. Denis Diderot, *Oeuvres esthétiques*, referred to in Kristeva, *The Severed Head*, 61.
93. Kristeva, *The Severed Head*, 62.
94. Ibid., 63.
95. Diderot, *Oeuvres esthétiques*, cited in Kristeva, *The Severed Head*, 64.
96. Kristeva, *The Severed Head*, 64.
97. Kristeva, *Revolution in Poetic Language*, 55.
98. Kristeva's description here is very close to Kant's notion of aesthetic ideas. Kant writes that when we "use imagination in its freedom, with such a multiplicity of partial presentations that no expression that stands for a determinate concept can be found for it . . . it is a representation that . . . quickens our cognitive powers and connects language, which otherwise would be mere letters, with spirit." Immanuel Kant, *Critique of Judgment*, trans. Werner Pluhar (Indianapolis, Ind.: Hackett, 1987), AK 316.
99. Kristeva, *Revolution in Poetic Language*, 56.
100. Ibid., 57.
101. Ibid., 58.
102. Ibid., 61.
103. Ibid.
104. Kristeva, *Crisis of the (European) Subject*, 154.
105. Mondzain, *Image, Icon, Economy*, 92.
106. Adorno, *Negative Dialectics*, 207.
107. For further reading on Benjamin and photography, see Diarmuid Costello, "Aura, Face, Photography: Re-Reading Benjamin Today," in *Walter Benjamin and Art*, ed. Andrew Benjamin (New York: Continuum, 2005), 164–184; David Ferris, "The Shortness of History, or Photography in Nuce: Benjamin's Attenuation of the Negative," in *Walter Benjamin and History*, ed. Andrew Benjamin (New York: Continuum, 2005), 19–37; and Shierry Weber Nicholson, *Exact Imagination, Late Work: On Adorno's Aesthetics* (Cambridge, Mass.: The MIT Press, 1997).
108. Walter Benjamin, "Little History of Photography," in *Selected Writings* (Cambridge, Mass.: Harvard University Press, 1999), 2:518.
109. Ibid., 2:517.
110. Ibid., 2:518.
111. Ibid., 2:507.
112. Ibid., 2:508.
113. Walter Benjamin, "The Work of Art in the Age of Its Technological Reproducibility," second version, in *Selected Writings* (Cambridge, Mass.: Harvard University Press, 2002), 3:104–105.
114. Benjamin, "Little History of Photography," 2:508.
115. Ibid., 2:510.
116. Ibid.

117. See Benjamin, "On the Image of Proust," in *Selected Writings* (Cambridge, Mass.: Harvard University Press, 1999), 2:237–247, for more on this comparison. Here Benjamin also calls Proust the only writer to reveal correspondences in our everyday life (244).

118. Freud himself makes the connection between *Nachträglichkeit* and the photograph when he compares the unconscious to the photographic negative, which may be developed immediately, much later, or not at all, in *Moses and Monotheism*.

119. Benjamin, "Little History of Photography," 510.

120. Benjamin, "The Work of Art in the Age of Its Technological Reproducibility," 117.

121. Benjamin, "Little History of Photography," 511–512.

122. Ibid., 510.

123. "The enlargement of a snapshot does not simply render more precise what in any case was visible, though unclear: it reveals entirely new structural formations of the subject. So, too, slow motion not only presents familiar qualities of movement but reveals in them entirely unknown ones which, far from looking like retarded rapid movements, give the effect of singularly gliding, floating, supernatural motions. Evidently a different nature opens itself to the camera than opens to the naked eye—if only because an unconsciously penetrated space is substituted for a space consciously explored by man. Even if one has a general knowledge of the way people walk, one knows nothing of a person's posture during the fractional second of a stride. The act of reaching for a lighter or a spoon is familiar routine, yet we hardly know what really goes on between hand and metal, not to mention how this fluctuates with our moods. Here the camera intervenes with the resources of its lowerings and liftings, its interruptions and isolations, it extensions and accelerations, its enlargements and reductions. The camera introduces us to unconscious optics as does psychoanalysis to unconscious impulses." Benjamin, "The Work of Art in the Age of Its Technological Reproducibility," 117.

124. Walter Benjamin, "On the Mimetic Faculty," in *Selected Writings* (Cambridge, Mass.: Harvard University Press, 1999), 2:722.

125. Roland Barthes, *"Rhetorique de l'image,"* cited in Rosalind Krauss, *The Originality of the Avant-Garde and Other Modernist Myths* (Cambridge, Mass.: The MIT Press, 1984), 217–218.

126. Walter Benjamin, "Doctrine of the Similar," in *Selected Writings* (Cambridge, Mass.: Harvard University Press, 1999), 2:696.

127. Ibid.

128. Rebecca Comay, "Materialist Mutations of the *Bilderverbot*," in *Walter Benjamin and Art*, ed. Andrew Benjamin (New York: Continuum, 2005), 56.

129. Walter Benjamin, *The Arcades Project*, trans. Howard Eiland and Kevin McLaughlin (Cambridge, Mass.: Harvard University Press, 1999), 325; J 54,2.

130. Comay, "Materialist Mutations of the *Bilderverbot*," 49.

131. Ibid., 50–56.

132. In this sense we could align Kristeva's notion of the image with Benjamin's conception of the symbol in *The Origin of German Tragic Drama*, and Kristeva's icon with Benjamin's conception of the allegory, in which there can be no ultimate

reconciliation between visual being and spiritual meaning. See Walter Benjamin, *The Origin of German Tragic Drama*, trans. John Osborne (New York: Verso, 1998), esp. 159–160; Kristeva, *Crisis of the (European) Subject*, 153–154.

133. Benjamin, "Little History of Photography," 2:518.
134. Ibid.
135. Ibid., 2:519.
136. Ibid.
137. Ibid., 2:527.
138. Benjamin, *The Origin of German Tragic Drama*, 105.
139. Benjamin, "Little History of Photography," 2:527.
140. Julia Kristeva, "Visible Language: Photography and Cinema," in *Language: The Unknown*, trans. Anne M. Menke (New York: Columbia University Press, 1989), 44.
141. Alfredo Jaar, *Paradiso/Inferno* catalogue for photography exhibit, curated by Alfredo Jaar (Stockholm: Riksutställningar, 2000), 1.
142. Kant, *Critique of Judgment*, AK 316.
143. Kristeva, *New Maladies of the Soul*, 8.
144. Shierry Weber Nicholson argues otherwise in "Adorno and Benjamin, Photography and the Aura," in her *Exact Imagination, Late Work*. I will discuss her argument in the chapter on the uncanny. I agree that Adorno's commentary on Benjamin's "Little History of Photography" and his essays on Kafka demonstrate that Adorno valued the metaphor of the photographic negative as a way of thinking about redemptive art. However, it is unclear that he would say the same of actual photographs.
145. Cited in Michael Taussig, *Walter Benjamin's Grave* (Chicago: University of Chicago Press, 2006), 190. Thanks to Joann Martin for bringing this artist's work to my attention.
146. Thanks to Sina Kramer for this formulation.
147. Lacan, *Écrits*, 258.
148. Ibid., 259.
149. The thought specular expresses the dual nature of critical film in that it both manifests the drives in images (fantasy) but also includes critical reflection in the form of the symbolic. See Julia Kristeva, *Intimate Revolt*, trans. Jeanine Herman (New York: Columbia University Press, 2002), 68–80.
150. http://www.deflamenco.com on 4/16/2012. As the website states, this article originally appeared in December 1969 in the *Flamenco Information Society Letter* 2, no. 12, and was edited for Deflamenco.
151. http://www.timenet.org/detail.html.
152. Cited in Marsha Kinder, "Pleasure," in *Blood Cinema: The Reconstruction of National Identity in Spain* (Berkeley: University of California Press, 1993), 37.
153. Kristeva, *Intimate Revolt*, 74.
154. Ibid., 75.
155. Sergei Eisenstein, "The Rhythmic Drum," in *Method*. Cited in a note to "The Psychology of Art," in *The Psychology of Composition*, ed. and trans. Alan Upchurch (London: Methuen, 1988), 102n16.

156. It is interesting that ten years after the production of *Talk to Her*, the German director Wim Wenders, who created a documentary of Pina Bausch's work, recounts that he, too, was brought to tears the first time he watched a performance of her work, to which he was unwillingly dragged by a friend. See http://entertainment.time.com/2011/12/29/wenders-pina-dance-crazy/#ixzz1rMOBTYbT.

157. Ibid.

158. Ibid.

159. Raimund Hoghe, "Für Pina Bausch," in Detlef Erler, *Pina Bausch: Fotografien von Detlef Erler* (Zürich: Edition Stemmle, 1994), 12–13, my translation.

160. John Lechte, "Julia Kristeva and the Trajector of the Image," in *Psychoanalysis, Aesthetics, and Politics in the Work of Julia Kristeva*, ed. Kelly Oliver and S. K. Keltner (Albany, N.Y.: SUNY Press, 2009), 81.

161. Kristeva, *Intimate Revolt*, 78.

162. Ibid., 78.

163. Kristeva, *Black Sun*, 122.

164. Ibid., 125.

3. To Be and Remain Foreign: Tarrying with *L'Inquiétante Étrangeté* Alongside Arendt and Kafka

1. Note again the parallel structure Kristeva assumes between individual and state.

2. Hannah Arendt, *Lectures on Kant's Political Philosophy*, ed. Ronald Beiner (Chicago: The University of Chicago Press, 1989).

3. Ewa Plonowska Ziarek, "The Uncanny Style of Kristeva's Critique of Nationalism," *Postmodern Culture* 5, no. 2 (January 1995).

4. Arendt, *Lectures on Kant's Political Philosophy*, 67.

5. Immanuel Kant, *Critique of Judgment*, trans. Werner Pluhar (Indianapolis, Ind.: Hackett, 1987), 59, Ak. 216.

6. Arendt, *Lectures on Kant's Political Philosophy*, 103.

7. Kant, *Critique of Judgment*, 103–126.

8. Sigmund Freud, "The 'Uncanny,'" in *The Standard Edition of the Complete Psychological Works of Sigmund Freud*, ed. James Strachey (London: Hogarth Press and the Institute of Psycho-analysis, 1981), 17:219.

9. Ibid., 17:220.

10. Ibid., 17:245.

11. Ibid., 17:241.

12. Julia Kristeva, *Strangers to Ourselves*, trans. Leon S. Roudiez (New York: Columbia University Press, 1991), 192.

13. Ibid.

14. Ibid., 2.

15. Ibid., 3.

16. In his 2004 review of Astrid Deuber-Mankowsky's book on Benjamin and Cohen, *Der frühe Walter Benjamin und Hermann Cohen: Jüdische Werte, Kritische Philosophie, vergängliche Erfahrung* (Berlin: Verlag Vorwerk 8, 2000). http://www.iaslonline.lmu.de/index.php?vorgang_id=2201.

17. Julia Kristeva, *Nations Without Nationalism*, trans. Leon S. Roudiez (New York: Columbia University Press, 1993), 27.

18. Kristeva, *Strangers to Ourselves*, 133.

19. Kristeva, *Nations Without Nationalism*, 29.

20. Kristeva, *Strangers to Ourselves*, 4.

21. Ibid., 3.

22. Kristeva, *Nations Without Nationalism*, 28.

23. Kristeva, *Strangers to Ourselves*, 5.

24. Ibid., 9–10.

25. Ibid., 7.

26. Ibid., 10.

27. Ibid.

28. Ibid., 133.

29. Ibid., 133–134.

30. Theodor W. Adorno, *The Culture Industry: Selected Essays on Mass Culture*, ed. J. M. Bernstein (London: Routledge, 1991), 89.

31. G. W. F. Hegel, *Lectures on Aesthetics*, trans. T. M. Knox (Oxford: Oxford University Press, 1975), 1:607.

32. Hegel primarily has the German romantic writers Friedrich and August Wilhelm Schlegel, who explicitly embraced irony, in mind here.

33. Julia Kristeva, *The Sense and Non-Sense of Revolt*, trans. Jeanine Herman (New York: Columbia University Press, 2000), 213–214.

34. Ibid., 212.

35. Ibid., 214.

36. Roland Barthes, preface to *Sade, Fourier, Loyola*, trans. Richard Miller (Baltimore, Md.: Johns Hopkins University Press, 1997), 502; cited by Kristeva in ibid., 212.

37. Kristeva, *Sense and Non-Sense*, 214.

38. As Kristeva writes, following Lacan: "language, constituted as symbolic through narcissistic, specular, imaginary investment, protects the body from the attack of drives by making it a place—the place of the signifier—in which the body can signify itself through positions; and if, therefore, language, in the service of the death drive, is a pocket of narcissism toward which this drive may be directed, then fantasies remind us, if we had ever forgotten, of the insistent presence of drive heterogeneity." Julia Kristeva, *Revolution in Poetic Language*, trans. Margaret Waller (New York: Columbia University Press, 1984), 49. See also Jacques Lacan, *Écrits*, trans. Bruce Fink (New York: Norton, 2007), 301.

39. Kristeva, *Strangers to Ourselves*, 139.

40. Cited in ibid.

41. Julia Kristeva, *Black Sun: Depression and Melancholia*, trans. Leon S. Roudiez (New York: Columbia University Press, 1989), 138, my emphasis.

42. Kristeva, *Nations Without Nationalism*, 35.

43. Kristeva, *Strangers to Ourselves*, 10.

44. Ibid., 147.

45. See, for example, Bonnie Honig's critique in *Democracy and the Foreigner* (Princeton, N.J.: Princeton University Press, 2001), 62–67.

46. Kristeva, *Strangers to Ourselves*, 146.

47. Anna Smith, *Julia Kristeva: Readings of Exile and Estrangement* (New York: St. Martin's Press, 1996), 20.

48. G. W. F. Hegel, *Hegel's Philosophy of Right*, trans. T. M. Knox (Oxford: Oxford University Press, 1952), 43.

49. Karl Marx, "Private Property and Communism," in *The 1844 Economic and Philosophic Manuscripts*, trans. Martin Milligan (New York: Prometheus, 1988), 214.

50. Marx's notion of property revises the common, crude, or one-sided understanding of property as having, rather than Hegel's conception of property. Hegel, too, distinguishes between mere possession and property in the *Philosophy of Right*, 42. For Hegel, "the fact that I make something my own as a result of my natural need, impulse, or caprice, is the particular interest satisfied by possession. But I as free will am . . . an actual will, and this is the aspect which constitutes the category of property, the true and right factor in possession" (ibid.). Hegel considers mental aptitudes, artistic skill, talents, and so on to be things that can be considered my property in the sense of *propre*, ownness. In addition, Hegel understands that property implies a social reality. However, at this stage of the philosophy of right (abstract right), consciousness is not yet aware of this reality.

51. Marx, "Private Property and Communism," 214.

52. Ibid., 215.

53. Ibid.

54. Ibid.

55. Kristeva, *Revolution in Poetic Language*, 137.

56. Kristeva, *Strangers to Ourselves*, 181.

57. Ibid., 182.

58. Ibid., 183.

59. Julia Kristeva, "Giotto's Joy," in *Desire in Language*, trans. Leon S. Roudiez (New York: Columbia University Press, 1980).

60. Ibid., 210.

61. Ibid., 218.

62. Ibid., 220.

63. Ibid.

64. Kant, *Critique of Judgment*, 120, Ak. 261.

65. Kristeva, "Giotto's Joy," 221.

66. Ibid.

67. Ibid., 222.

68. Julia Kristeva, *Tales of Love*, trans. Leon Roudiez (New York: Columbia University Press, 1987), 234–235.

69. Ibid., 249.

70. Ibid., 234.

71. Ibid., 252–254.

72. Ibid., 252.

73. Ibid., 253.

74. Kristeva, *Strangers to Ourselves*, 187.

75. "Wiesengrund Adorno to Benjamin, Berlin 17.12.1934," in Theodor Adorno and Walter Benjamin, *The Complete Correspondence, 1928–1940*, ed. Henri Lonitz, trans. Nicholas Walker (Cambridge, Mass.: Harvard University Press, 1999), 66.

76. Walter Benjamin, *The Arcades Project*, trans. Howard Eiland and Kevin McLaughlin (Cambridge, Mass.: Harvard University Press), 462; N2a4.

77. Ibid., 465; N3,1.

78. Walter Benjamin, "Franz Kafka: On the Tenth Anniversary of His Death," in *Selected Writings* (Cambridge, Mass.: Harvard University Press, 1999), 2:807.

79. Ibid.

80. Benjamin, *Arcades Project*, 462; N2a4.

81. Walter Benjamin, "Goethe's Elective Affinities," in *Selected Writings* (Cambridge, Mass.: Harvard University Press, 1996), 1:315.

82. Ibid.

83. Walter Benjamin, "Paris, the Capital of the Nineteenth Century," in *Selected Writings* (Cambridge, Mass.: Harvard University Press, 2002), 3:33.

84. Ibid., 3:33–34.

85. For a much more in-depth discussion of the fairy tale motif in Benjamin, see Susan Buck-Morss, *The Dialectics of Seeing: Walter Benjamin and the Arcades Project* (Cambridge, Mass.: The MIT Press, 1989), esp. chap. 8.

86. Buck-Morss (ibid., 253) writes that Benjamin's "theory is unique in its approach to modern society because it takes mass culture seriously not merely as the source of the phantasmagoria of false consciousness, but as the source of collective energy to overcome it."

87. Benjamin, *Arcades Project*, 458; N1, 10.

88. Ibid., 470; N 7, 7.

89. Ibid., 470; N7, 6.

90. Ibid., 470; N 7,5.

91. Ibid., 470; N 7,2.

92. Walter Benjamin, "On the Concept of History," in *Selected Writings* (Cambridge, Mass.: Harvard University Press, 2003), 4:391.

93. Ibid.

94. Walter Benjamin, "Franz Kafka: Beim Bau der Chinesischen Mauer," in *Selected Writings* (Cambridge, Mass.: Harvard University Press, 1999), 2:498.

95. Benjamin, "Franz Kafka: On the Tenth Anniversary of His Death," 2:810.

96. Ibid., 2:811.

97. Freud, "The 'Uncanny,'" 244.

98. Adorno and Benjamin, *Complete Correspondence*, 66.

99. Shierry Weber Nicholson, *Exact Imagination, Late Work: On Adorno's Aesthetics* (Cambridge, Mass.: The MIT Press, 1997), 183.

100. Ibid., 187.

101. See David S. Ferris, "The Shortness of History, or Photography in Nuce: Benjamin's Attenuation of the Negative," in *Benjamin and History*, ed. Andrew Benjamin (London: Continuum, 2005), 31.

102. Rosalind Krauss, *The Originality of the Avant-Garde and Other Modernist Myths* (Cambridge, Mass.: The MIT Press, 1984), 203.

103. Ibid.
104. Walter Benjamin, "Little History of Photography," in *Selected Writings* (Cambridge, Mass.: Harvard University Press, 1999), 2:510.
105. See Ferris, "The Shortness of History."
106. Walter Benjamin, "Paralipomena to 'On the Concept of History,'" in *Selected Writings* (Cambridge, Mass.: Harvard University Press, 2003), 4:405.
107. Adorno and Benjamin, *Complete Correspondence*, 67.
108. Theodor Adorno, *Prisms*, trans. Samuel Weber and Shierry Weber (Cambridge, Mass.: The MIT Press, 1967), 269. We could compare this locution to Adorno's materialist inversion of the ban on graven images, which Comay describes as an "unholy marriage of theology and materialism." Rebecca Comay, "Materialist Mutations of the *Bilderverbot*," in *Walter Benjamin and Art*, ed. Andrew Benjamin (New York: Continuum, 2005), 32–33. See also Theodor Adorno, *Negative Dialectics*, trans. E. B. Ashton (New York: Continuum, 2005), 207. Adorno himself calls Kafka an upholder of such a ban.
109. Adorno, *Prisms*, 269.
110. Ibid.
111. Ibid., 253.
112. Ibid., 256.
113. Ibid., 253.
114. Ibid., 252.
115. Ibid.
116. Ibid., 253.
117. Ibid., 257.
118. Elizabeth Pritchard, "*Bilderverbot* Meets Body in Theodor Adorno's Inverse Theology," *Harvard Theological Review* 95, no. 3 (2002): 309.
119. Adorno, *Prisms*, 264.
120. Benjamin, "Franz Kafka: On the Anniversary of His Death," 2:810.
121. Ibid., 2:808.
122. Adorno, *Negative Dialectics*, 207.
123. Adorno consistently links the theological ban on images to the promise of immortality or the resurrection of the soul after death. In the materialist reinterpretation of this ban, what is assured is only the resuscitation of the bodily (see chapter 2).
124. Adorno, *Prisms*, 271.
125. Walter Benjamin, "Surrealism: The Last Snapshot of the European Intelligentsia," in *Selected Writings* (Cambridge, Mass.: Harvard University Press, 1999), 2:210; my emphasis.
126. Ibid., 2:210.
127. Ibid., 2:208.
128. Ibid., 2:216.
129. Ibid., 2:218.
130. Theodor Adorno, *The Culture Industry: Selected Essays on Mass Culture*, ed. J. M. Bernstein (London: Routledge, 1991), 87.
131. Ibid., 89.
132. Ibid.

133. Ibid.
134. Ibid., 90.
135. Ibid., 88.
136. Hegel, *Lectures on Aesthetics*, 1:31.
137. Helga Geyer-Ryan, "Effects of Abjection in the Texts of Walter Benjamin," *Modern Language Notes* 107, no. 3 (1992): 499–520. Although this is a tempting distinction, I think it is too simplistic.
138. Ibid., 502.
139. Geyer-Ryan argues that Benjamin's writing is also transgressive in this latter sense.
140. Kafka's diary from February 2, 1922, cited in Kristeva, *Revolution in Poetic Language*, 107.
141. Franz Kafka, diary entry of January 31, 1922, in *The Diaries of Franz Kafka, 1883–1924*, trans. Martin Greenberg (New York: Schocken, 1948–49), 217.
142. Adorno, *The Culture Industry*, 88.
143. Ibid.
144. Kristeva, *Revolution in Poetic Language*, 134.
145. G. W. F. Hegel, *Phenomenology of Spirit*, trans. A. V. Miller (Oxford: Oxford University Press, 1977), §174.
146. Kristeva, *Revolution in Poetic Language*, 134.
147. Ibid., 135.
148. Ibid., 136.
149. Ibid., 139.
150. These include taking as correct Arendt's identification of critical taste in Kant with the physical sense of taste, and identifying plurality with sociability.
151. It should be noted that I take as established the influence of Kant's third Critique on Hegel in G. W. F. Hegel, *Faith and Knowledge* (Albany, N.Y.: SUNY Press, 1977).
152. Julia Kristeva, *Hannah Arendt*, trans. Ross Guberman, Female Genius: Life, Madness, Words, vol. 1 (New York: Columbia University Press, 2001), 141.
153. Ibid., 183.
154. Hannah Arendt, *The Human Condition* (Chicago: University of Chicago Press, 1971), 183.
155. Ibid., 187.
156. Kristeva, *Hannah Arendt*, 85–86.
157. Ibid., 105.
158. Ibid., 194–195.
159. Julia Kristeva, in her speech accepting the Hannah Arendt Prize for Political Thought, December 2006. http://www.kristeva.fr/Arendt_en.html.
160. Arendt, *The Human Condition*, 169.
161. Ibid.
162. Ibid., 173.
163. Kant gives an example of the mathematical sublime the consideration of the "Milky way system" in comparison with the earth, in Kant, *Critique of Judgment*, 256. Although this may seem very close to Adorno's example, the latter focuses on the perspective of the Earth from space, that is, on a view of something close and

familiar from a perspective that is radically out of the ordinary and that thus produces the feeling of the uncanny. Today, however, arguably the two experiences could be said to be commensurable.

164. Kristeva, *Hannah Arendt*, 64.

165. See Jason Alber, "Force of Nature: Artist Puts Petal to the Metal for Electrifying Images," *Wired* 17, no. 7 (June 22, 2009). http://www.wired.com/culture/art/magazine /17-07/pl_art.

166. http://www.pbs.org/art21/artists/antoni/clip2.html.

167. Ibid.

168. Freud, "The 'Uncanny,'" 243.

169. Ibid., 244.

170. Ibid.

171. Julia Kristeva, "Motherhood According to Giovanni Bellini," in *Desire in Language*, trans. Thomas Gora, Alice Jardine, and Leon Roudiez (New York: Columbia University Press, 1980), 247.

172. Julia Kristeva, *Time and Sense: Proust and the Experience of Literature*, trans. Ross Guberman (New York: Columbia University Press, 1996), 241.

173. Kristeva, "Motherhood According to Giovanni Bellini," 240.

4. SUBLIMATING MAMAN: EXPERIENCE, TIME, AND THE RE-EROTIZATION OF EXISTENCE IN KRISTEVA'S READING OF MARCEL PROUST

1. Julia Kristeva, *Time and Sense: Proust and the Experience of Literature*, trans. Ross Guberman (New York: Columbia University Press, 1996), 168.

2. Ibid., 171.

3. Julia Kristeva, "From Symbols to Flesh: The Polymorphous Destiny of Narration," *International Journal of Psycho-Analysis* 81 (2000): 771.

4. Ibid., 772.

5. Ibid., 773.

6. Ibid., 772.

7. Ibid., 775.

8. See chapter 2.

9. Kristeva, "Symbols to Flesh," 775.

10. Ibid., quoting from her own "La fille au sanglot: du temps hystérique," *L'Infini* 54 (Spring 1996): 27–47.

11. Kristeva, "Symbols to Flesh," 772–773.

12. Ibid., 775.

13. Ibid., 774.

14. Ibid., 777.

15. Ibid., 773.

16. Ibid.; see also Julia Kristeva, *Melanie Klein*, trans. Ross Guberman, Female Genius: Life, Madness, Words, vol. 2 (New York: Columbia University Press, 2001), 144.

17. Kristeva, "Symbols to Flesh," 774; see also Kristeva, *Melanie Klein*, 145.

18. See, for example, Theodor W. Adorno, *Negative Dialectics*, trans. E. B. Ashton (New York: Continuum, 2005); see also Walter Benjamin, "On Some Motifs in Baudelaire," in *Selected Writings* (Cambridge, Mass.: Harvard University Press, 2003), 4:313–355.

19. Martin Heidegger, *Being and Time*, trans. John Macquarrie and Edward Robinson (New York: Harper Perennial, 1962), 46n1.

20. Kristeva, *Time and Sense*, 133.

21. Ibid.

22. Ibid.

23. Ibid., 194.

24. Ibid., 196.

25. Benjamin, "On Some Motifs in Baudelaire," *Selected Writings*, 4:313–355 (Cambridge, Mass.: Harvard University Press, 2003), 319.

26. Because Kristeva assumes the subject who is a stranger to herself, that is, the co-presence of consciousness and the unconscious in the subject, her conception of *Erlebnis* actually avoids Benjamin's concern and also contains this shock element.

27. Benjamin, "On Some Motifs," 316.

28. Walter Benjamin, *The Arcades Project*, trans. Howard Eiland and Kevin McLaughlin (Cambridge, Mass.: Harvard University Press, 1999), 802.m2a4.

29. Kristeva, *Time and Sense*, 194.

30. Ibid.

31. Ibid.

32. Ibid., 196.

33. Julia Kristeva, *Tales of Love*, trans. Leon Roudiez (New York: Columbia University Press, 1987), 37. In *Tales of Love* Kristeva is discussing metaphoricity in terms of identification with the imaginary father. Recall that this preoedipal father of individual prehistory is the guarantor of identity and the bridge by which the child succeeds in leaving behind its fusion with the mother and moving toward an identification with the formal paternal function associated with language and law.

34. Kristeva, *Time and Sense*, 194.

35. Ibid., 195–196.

36. Ibid., 198.

37. Ibid.

38. Ibid.

39. Ibid.

40. Benjamin, "On Some Motifs," 329.

41. Ibid., 319.

42. Ibid., 321.

43. Sigmund Freud, *Beyond the Pleasure Principle*, ed. James Strachey (New York: Norton, 1990), 27–28.

44. Ibid., 29–30.

45. Benjamin, "On Some Motifs," 317.

46. Ibid.

47. Kristeva, "Symbols to Flesh," 777.

48. Ibid., 777–778.

49. Ibid., 778.
50. Sigmund Freud, *Standard Edition of the Complete Psychological Works of Sigmund Freud* (abbreviated *SE*, with volume number), 24 vols., ed. James Strachey et al. (London: Hogarth Press and the Institute of Psycho-analysis, 1981), 12:155.
51. Kriseva, "Symbols to Flesh," 778.
52. Ibid.
53. Kristeva, *Time and Sense*, 182.
54. Ibid.
55. Kristeva, "Symbols to Flesh," 781.
56. Ibid.
57. Ibid., 782.
58. Ibid.
59. Ibid.
60. Sigmund Freud, "Leonardo da Vinci and a Memory of His Childhood," in *Sigmund Freud 14: Art and Literature*, ed. Albert Dickson, trans. James Strachey et al. (New York: Penguin, 1985), 170.
61. Ibid.
62. Ibid., 225.
63. Ibid., 226.
64. Sigmund Freud, *Three Essays on the Theory of Sexuality*, trans. James Strachey (New York: HarperCollins, 1962), 22.
65. Freud, *SE* 9:187.
66. Freud, *SE* 11:54, my emphasis.
67. Freud, *SE* 12:119.
68. Sigmund Freud, *A General Introduction to Psychoanalysis*, trans. Joan Riviere (New York: Washington Square Press, 1960), 384–385.
69. Ibid., 385.
70. Sigmund Freud, *General Psychological Theory: Papers on Metapsychology*, ed. Philip Rieff (New York: Collier, 1963), 57–58.
71. Ibid., 59.
72. Sigmund Freud, *The Ego and the Id*, trans. Joan Riviere (New York: Norton, 1960), 45.
73. Ibid., 47.
74. Ibid., 56.
75. Sarah Kofman, *The Childhood of Art*, trans. Winifred Woodhull (New York: Columbia University Press, 1988), 161.
76. Freud, *Ego and the Id*, 37.
77. Kofman, *Childhood*, 161. Freud himself makes this point explicitly in *The Ego and the Id* (44) when he writes that "sublimated energy . . . would still retain the main purpose of Eros—that of uniting and binding—in so far as it helps towards establishing the unity, or tendency to unity, which is particularly characteristic of the ego."
78. Kofman, *Childhood*, 111.
79. Ibid., 130.
80. Ibid., 128.
81. Ibid., 127.

82. Ibid., 118.

83. Ibid.; see also Freud, *SE* 15:99.

84. Kofman, *Childhood*, 130.

85. Freud, *The Ego and the Id*, 26; Kristeva, *Tales of Love*, 25.

86. Freud, *The Ego and the Id*, 26n; Kristeva, *Tales of Love*, 26.

87. Kristeva, *Tales of Love*, 27.

88. Ibid., 29.

89. Ibid., 30, my emphasis.

90. Ibid., 31.

91. Kristeva, *Melanie Klein*, 12.

92. Melanie Klein, *Envy and Gratitude and Other Works, 1946–1963* (London: International Psycho-Analytical Library, 1975), 61–62.

93. Ibid., 67; see also Freud, *Ego and the Id*, 24.

94. Klein, *Envy and Gratitude*, 75.

95. Ibid., 75; see also Julia Kristeva, *Black Sun: Depression and Melancholia*, trans. Leon S. Roudiez (New York: Columbia University Press, 1989), 43, where Kristeva specifies that this revival or retrieval takes place *through language*.

96. Kristeva, *Melanie Klein*, 73.

97. Ibid., 188.

98. Freud, *The Ego and the Id*, 44.

99. André Green, *The Work of the Negative*, trans. Andrew Weller (London: Free Association Press, 1999), 233.

100. Hannah Segal, "A Psychoanalytic Approach to Aesthetics," in *The Work of Hannah Segal* (London: Free Association Books, 1986), 206–207.

101. Ibid., 208.

102. Ibid., 219.

103. Kristeva, *Melanie Klein*, 77.

104. Green, *Work of the Negative*, 223; see also Freud, *Ego and the Id*, 25.

105. Green, *Work of the Negative*, 223.

106. Ibid., 219.

107. Ibid., 218.

108. Ibid., 222; see also J. Laplanche, *Problématiques* III (1980), cited in ibid., 111.

109. Green, *Work of the Negative*, 226.

110. Ibid., 216.

111. Ibid., 232.

112. Freud, "Da Vinci," 172.

113. Ibid., 178–183.

114. Green, *Work of the Negative*, 233.

115. Ibid.

116. Ibid., 234.

117. Ibid.

118. Ibid., 235.

119. Ibid., 236.

120. Donald Winnicott, "Transitional Objects and Transitional Phenomena," *International Journal of Psycho-Analysis* 34, no. 2 (1953): 95; cited in J. Laplanche and J. B.

Pontalis, *The Language of Psycho-Analysis*, trans. Donald Nicholson-Smith (New York: Norton, 1973), 465.

121. Winnicott, "Transitional Objects and Transitional Phenomena," 97.

122. Green, *Work of the Negative*, 238.

123. Ibid., 239.

124. Ibid., 240.

125. Ibid., 250.

126. Ibid., 251.

127. Jacques Lacan, *The Ethics of Psychoanalysis* [Seminar VII], trans. Dennis Porter (New York: Norton, 1992), 107.

128. Lacan takes an initially Kantian perspective, for he perceives a proximity of his own concept of *das Ding*, as the "beyond-of-the-signified," to Kant's *Ding-an-sich*.

129. Lacan, *Ethics of Psychoanalysis*, 54.

130. Ibid., 55. It is to this opposite Thing that Lacan compares Kant's Thing-in-itself, and in both cases it will be the focal point according to which a moral action can be qualified.

131. Ibid., 112.

132. Ibid., 141.

133. Ibid.

134. Ibid., 161.

135. J. Laplanche, "To Situate Sublimation," in *Discipleship: A Special Issue on Psychoanalysis*, trans. Richard Miller, *October* 28 (1984): 23–24.

136. Leo Bersani, *The Freudian Body: Psychoanalysis and Art* (New York: Columbia University Press, 1986), 45.

137. Ibid., 45.

138. Lacan, *Ethics of Psychoanalysis*, 141.

139. Leo Bersani, *The Culture of Redemption* (Cambridge, Mass.: Harvard University Press, 1990), 7–28.

140. Ibid., 243.

141. Ibid., 242.

142. Ibid., 243.

143. Ibid., 37.

144. Ibid.

145. Ibid.; see also Freud, *Metapsychology*, 59.

146. Bersani, *Culture of Redemption*, 37.

147. Ibid.

148. Ibid., 18.

149. Ibid., 37–38.

150. Joan Copjec, *Imagine There's No Woman: Ethics and Sublimation* (Cambridge, Mass.: The MIT Press, 2002), 57–58.

151. Ibid., 54.

152. Ibid.

153. Ibid., 66.

154. Ibid., 64.

155. Ibid., 79.

156. Julia Kristeva, *The Sense and Non-Sense of Revolt*, trans. Jeanine Herman (New York: Columbia University Press, 2000), 54.

157. Freud, *Ego and the Id*, 26.

158. Kristeva, *Tales of Love*, 26.

159. Ibid.

160. Ibid., 45.

161. Ibid., 27.

162. Ibid., 40.

163. Ibid., 41.

164. Kristeva, *Sense and Non-Sense*, 47.

165. Ibid., 59.

166. Ibid., 55.

167. Ibid., 56.

168. Kristeva, *Tales of Love*, 25.

169. Kristeva, *Black Sun*, 170–171.

170. Ibid., 172.

171. Kristeva, *Time and Sense*, 331.

172. Ibid.

173. Ibid.

174. Ibid., 319.

175. Ibid.

176. Ibid., 311.

177. Ibid., 308.

178. Ibid., 307.

179. Ibid., 319.

180. Ibid.

181. Ibid., 325.

5. The "Orestes Complex": Thinking Hatred, Forgiveness, Greek Tragedy, and the Cinema of the "Thought Specular" with Hegel, Freud, and Klein

1. See chapter 3.

2. See Julia Kristeva, *Strangers to Ourselves*, trans. Leon S. Roudiez (New York: Columbia University Press, 1991), 189.

3. Sigmund Freud, *The Future of An Illusion*, trans. James Strachey (New York: Norton, 1961), 19.

4. Ibid., 20.

5. Ibid., 21.

6. See Julia Kristeva, *Revolution in Poetic Language*, trans. Margaret Waller (New York: Columbia University Press), 1984.

7. Julia Kristeva, *Intimate Revolt*, trans. Jeanine Herman (New York: Columbia University Press, 2002), 20.

8. G. W. F. Hegel, "The Spirit of Christianity and Its Fate," trans. T. M. Knox (Philadelphia: University of Pennsylvania Press, 1971), 192.

9. Ibid., 196.

10. Ibid., 209.

11. Ibid., 215.

12. Ibid., 237.

13. Ibid., 266.

14. Ibid., 241.

15. Ibid., 258.

16. G. W. F. Hegel, *Phenomenology of Spirit*. trans. A. V. Miller (Oxford: Oxford University Press, 1977), 97.

17. Ibid., 98.

18. Ibid., 99.

19. Ibid., 101.

20. Ibid., 128. Translation altered.

21. See in particular Jay Bernstein, "Confession and Forgiveness: Hegel's Poetics of Action," in *Beyond Representation: Philosophy and Poetic Imagination*, ed. Richard Eldridge (Cambridge: Cambridge University Press, 1996); Kelly Oliver, *The Colonization of Psychic Space: A Psychoanalytic Social Theory of Oppression* (Minneapolis: University of Minnesota Press, 2004); and Shannon Hoff, "On Law, Transgression, and Forgiveness: Hegel and the Politics of Liberalism," *Philosophical Forum* 42, no. 2 (Summer 2011): 187–210.

22. Hegel, *Phenomenology of Spirit*, 407.

23. Ibid., 408.

24. Kristeva writes in *The Feminine and the Sacred*, that Judaism is not unfamiliar with collective sin but that the Bible "metamorphoses it into election, that is, into the rite of love." Julia Kristeva and Catherine Clement, *The Feminine and the Sacred* (New York: Columbia University Press, 2001), 96.

25. Sigmund Freud, "Letter from Sigmund Freud to Oskar Pfister, November 25, 1928," *International Psychoanalytical Library* 59 (1928): 125.

26. See Oliver, *The Colonization of Psychic Space*, 185–194.

27. Julia Kristeva, *Hatred and Forgiveness*, trans. Jeanine Herman (New York: Columbia University Press, 2005), 192.

28. Ibid.

29. Kristeva and Clement, *The Feminine and the Sacred*, 165.

30. Kristeva, *Intimate Revolt*, 228. See also Immanuel Kant, *Critique of Judgment*, trans. Werner Pluhar (Indianapolis, Ind.: Hackett, 1987), 160.

31. Kristeva, *Hatred and Forgiveness*, 14.

32. Kristeva, *Intimate Revolt*, 228.

33. Kristeva, *Hatred and Forgiveness*, 14.

34. Ibid., 15.35. Melanie Klein, *Love, Hate, and Reparation*, trans. Joan Riviere (New York: W. W. Norton, 1964), 4. Klein describes love and hate as the fundamental tendencies that all humans have within them.

36. Kristeva, *Hatred and Forgiveness*, 194.

37. Ibid., 372.

38. Ibid., 371–372.

39. Kristeva, *Black Sun: Depression and Melancholia*, trans. Leon S. Roudiez (New York: Columbia University Press, 1989), 206.

40. See Jacques Derrida, "On Forgiveness," trans. Michael Collins Hughes, in *On Cosmopolitanism and Forgiveness* (New York: Routledge, 2001).

41. Kristeva, *Black Sun*, 189.

42. Ibid., 170.

43. Ibid., 200.

44. Ibid., 190.

45. Ibid., 206.

46. Ibid., 195.

47. Ibid., 203. See also Hannah Arendt, *The Human Condition* (Chicago: University of Chicago Press, 1971), 240n7.

48. Kristeva, *Black Sun*, 205.

49. Julia Kristeva, *Time and Sense: Proust and the Experience of Literature*, trans. Ross Guberman (New York: Columbia University Press, 1996), 326.

50. Kristeva, *Hatred and Forgiveness*, 193.

51. Julia Kristeva, *New Maladies of the Soul*, trans. Ross Guberman (New York: Columbia University Press, 1995), 7.

52. Kristeva, *Hatred and Forgiveness*, 16.

53. Kristeva, *Black Sun*, 207. See also Kristeva, *Intimate Revolt*, 20.

54. Kristeva, *Black Sun*, 207–208.

55. Ibid., 214.

56. Although Kristeva is referring here to Lacan's "trinity" of Real, Imaginary, and Symbolic, she discusses it within the context of the Orthodox understanding of the Christian trinity as both unified and contradictory, that is, polyphonic. Kristeva attributes her notion of forgiveness to the Orthodox tradition, which deeply influenced Dostoevsky and in which she herself was steeped due to her Bulgarian upbringing. See ibid., 208–214.

57. Ibid., 217.

58. André Green, *The Tragic Effect: The Oedipus Complex in Tragedy*, trans. Alan Sheridan (Cambridge: Cambridge University Press, 1979), 70.

59. Ibid.

60. Ibid., 70–71.

61. Ibid., 73.

62. Ibid.

63. Ibid., 75.

64. Ibid.

65. Ibid., 76.

66. Ibid., 77.

67. G. W. F. Hegel, *Natural Law*, trans. T. M. Knox (Philadelphia: University of Pennsylvania Press, 1975), 104.

68. See Elaine P. Miller, "Tragedy, Natural Law, and Sexual Difference in Hegel," in *Bound by the City*, ed. Denise McCoskey and Emily Zakin (Albany, N.Y.: SUNY Press, 2010), 149–176.

69. Melanie Klein, *Envy and Gratitude and Other Works, 1946–1963* (London: International Psycho-Analytical Library, 1975), 29.
70. Gilbert Murray, cited in ibid., 29.
71. Ibid.
72. Ibid.
73. Ibid.
74. Ibid., 30.
75. Ibid.
76. Ibid., 33.
77. Ibid., 34.
78. Ibid., 37–38.
79. Ibid., 38.
80. Ibid., 48.
81. Ibid.
82. Aeschylus, *Agamemnon*, lines 175–181, in *Oresteia*, trans. Peter Meineck (Indianapolis, Ind.: Hackett, 1998).
83. Hegel, *Phenomenology of Spirit*, §177.
84. Klein, *Envy and Gratitude*, 51.
85. Julia Kristeva, *Melanie Klein*, trans. Ross Guberman, Female Genius: Life, Madness, Words, vol. 2 (New York: Columbia University Press, 2001), 133.
86. Ibid., 134.
87. Ibid., 135.
88. Julia Kristeva, *The Sense and Non-Sense of Revolt*, trans. Jeanine Herman (New York: Columbia University Press, 2000), 160.
89. Cited in ibid., 161.
90. Ibid., 161–162.
91. Green, *Tragic Effect*, 84.
92. Kristeva, *Sense and Non-Sense*, 163.
93. Kristeva, *Intimate Revolt*, 77.
94. Ibid., 74.
95. Ibid.
96. Ibid.
97. Ibid.
98. Ibid.
99. Ibid., 75.
100. Sergei Eisenstein, *Complete Works*, vol. 4:60, cited in Kristeva, *Intimate Revolt*, 76.
101. Kristeva, *Intimate Revolt*, 76.
102. Ibid., 76.
103. Ibid., 74.
104. See ibid., 79.
105. Ibid., 80.
106. Aeschylus, "The Furies," lines 184–188, in *Oresteia*.
107. George Devereux, *Dreams in Greek Tragedy: An Ethno-Psycho-Analytical Study.* (Oxford: Blackwell, 1976), 160.

108. Aeschylus, "The Libation Bearers," line 835, in *Oresteia*.

109. Ibid., line 1039.

110. Ellen Ullman, *By Blood* (New York: Farrar, Strauss, and Giroux, 2012), 3.

111. Friedrich Nietzsche, "The Birth of Tragedy out of the Spirit of Music" (draft), in *Kritische Studienausgabe* (Berlin: Walter de Gruyter, 1999), 7:277. My translation.

112. Friedrich Nietzsche, "The Dionysian Worldview," in *Kritische Studienausgabe* (Berlin: Walter de Gruyter, 1999), 1:557. My translation.

113. Ibid., 555. In other words, the Dionysian cannot be understood as a "reality" that lies "behind" the dream as appearance. Rather, the Dionysian implies a radicalization of individuation. Nietzsche criticizes Schopenhauer, even before he writes *The Birth of Tragedy*, for positing a dualistic structure of being in which the greater "reality" (the will) can only be described in opposition to what is accessible, namely representation.

114. Ibid. The same formulation is found in "The Birth of Tragic Thought," in Friedrich Nietzsche, *Kritische Studienausgabe* (Berlin: Walter de Gruyter, 1999), 1:583.

115. The "acephalous" or "headless" subject is described by Žižek as the "properly political subject," one who loses her "head" in order to "assume the position of the object." This transforms the subject from one who acts intentionally or calculates a position in order to bring about the future she desires into rather a Möbius topology where the subject encounters the objective dimension and identifies with the excess of the situation, a genuinely revolutionary position. Although the terminology of the "acephalous" subject obviously resonates with Kristeva's consideration of decapitation and recapitation, it is outside the bounds of this project to engage with it further. Slavoj Žižek, *Organs Without Bodies* (New York: Routledge, 2004), 76.

116. Molly Ann Rothenberg, *The Excessive Subject: A New Theory of Social Change* (Malden, Mass.: Polity, 2010), 186.

117. Molly Ann Rothenberg, "Picturing the Past: Aestheticization in the Treatment of Trauma in a Chinese Analysand," 13, paper presented at the conference After the Unthinkable: Trauma, Nachträglichkeit, and Coming to Terms, Boston College, 2012.

118. Friedrich Nietzsche, *Kritische Studienausgabe* (Berlin: Walter de Gruyter, 1999), 7:192.

119. For more on the existential and even cosmic rhythm of life with respect to Nietzsche's work see Amittai F. Aviram, *Telling Rhythm: Body and Meaning in Poetry* (Ann Arbor: University of Michigan Press, 1994), esp. chapter 8, "Meaning, Form, and the Nietzschean Sublime." Aviram ties Nietzsche's discussion of rhythm to the psychoanalytic theories of Freud, Lacan, and Kristeva. For more on the ambiguity of the human condition, see Simone de Beauvoir, *The Ethics of Ambiguity*, trans. Bernard Frechtman (New York: Citadel, 1948).

120. Sigmund Freud, *Beyond the Pleasure Principle*, ed. James Strachey (New York: Norton, 1990), 11.

121. Ibid., 12.

122. Ibid., 17.

123. Ibid.

124. "Consults: Experts on the Front Line of Medicine," *New York Times* blog (February 27, 2012).

125. Francine Shapiro, *Eye Movement Desensitization and Reprocessing: Basic Principles, Protocols, and Procedures* (New York: Guilford, 2001), 71.

126. See, for example, Thom Hartman, *Walking Your Blues Away: How to Heal the Mind and Create Emotional Well Being* (Rochester, Vt.: Park Street, 2006).

127. Shapiro, *Eye Movement Desensitization and Reprocessing*, xi.

128. Ibid.

129. I have also discussed this kind of transformation of repetition with reference to Simone de Beauvoir's work in "Saving Time: Temporality, Recurrence, and Transcendence in Beauvoir's Nietzschean Cycles," in *Beauvoir and Western Thought from Plato to Butler*, ed. Shannon Mussett and William Wilkerson (Albany, N.Y.: SUNY Press, 2012).

CONCLUSION

1. Benedict Carey, "Where Have All the Neurotics Gone?" *New York Times* (April 1, 2012).

2. See chapter 1.

3. Friedrich Nietzsche, *Thus Spoke Zarathustra*, trans. Walter Kaufmann (New York: Penguin, 1978), 137.

4. Ibid., 138.

5. Julia Kristeva, *The Severed Head: Capital Visions*, trans. Jody Gladding (New York: Columbia University Press, 2012), 54.

6. Julia Kristeva, *Tales of Love*, trans. Leon Roudiez (New York: Columbia University Press, 1987).

7. Richard Kearney, "What Is Diacritical Hermeneutics?" *Journal of Applied Hermeneutics* (2011): 9.

8. Michael Kearney et al., "Self-Care of Physicians Caring for Patients at the End of Life: 'Being Connected . . . A Key to My Survival.'" *Journal of the American Medical Association* 301, no. 11 (2009): 1161.

9. "Exquisite empathy" is a term coined by trauma therapists, defined as "highly present, sensitively attuned, well-boundaried, heartfelt empathic engagement" carried out by the caregiver, care that allows him or her to be "invigorated rather than depleted by their intimate professional connections with traumatized clients" and thereby protected against "compassion fatigue and burnout." See ibid., 1162.

10. Kristeva, *The Severed Head*, 127.

11. Georges Bataille, "Le labyrinthe," *Acéphale* 1 (January 24, 1936). Cited in ibid., 128–129.

12. Kristeva, *The Severed Head*, 129.

13. Ibid., 130.

14. Ibid.

15. G. W. F. Hegel, *Lectures on the Philosophy of Religion*, vol. 3: *The Consummate Religion*, ed. Peter C. Hodgson (Berkeley: The University of California Press, 1998), 106.

16. Julia Kristeva, "Louise Bourgeois: From Little Pea to Runaway Girl," in *Louise Bourgeois*, ed. Frances Morris (Rizzoli, 2008), 251.

17. Deirdre Bair, *Samuel Beckett: A Biography* (New York: Harcourt Brace Jovanovich, 1978), 622.

18. The murder victim of Kristeva's own novel *Possessions* seems likely also based on Beckett's character, given her garrulous nature and her beheading. Kristeva also refers to Beckett's play when discussing the "Not I" of the metaphorical positing of the imaginary father in *Tales of Love*, 41.

19. Kristeva, "Louise Bourgeois," 251–252.

BIBLIOGRAPHY

Aeschylus. *Oresteia*. Translated by Peter Meineck. Indianapolis, Ind.: Hackett, 1998.

Adorno, Theodor W. *Aesthetic Theory*. Translated by Robert Hullot-Kentor. Minneapolis: University of Minnesota Press, 1997.

——. *The Culture Industry: Selected Essays on Mass Culture*. Edited by J. M. Bernstein. London: Routledge, 1991.

——. *Minima Moralia: Reflections on a Damaged Life*. Translated by E. F. N. Jephcott. New York: Verso, 2005.

——. *Negative Dialectics*. Translated by E. B. Ashton. New York: Continuum, 2005.

——. *Prisms*. Translated by Samuel Weber and Shierry Weber. Cambridge, Mass.: The MIT Press, 1967.

Adorno, Theodor W., and Walter Benjamin. *The Complete Correspondence, 1928–1940*. Translated by Nicholas Walker. Cambridge, Mass.: Harvard University Press, 1999.

Adorno, Theodor W., and Max Horkheimer. *Dialectic of Enlightenment*. New York: Continuum, 1994.

Alber, Jason, "Force of Nature: Artist Puts Petal to the Metal for Electrifying Images." *Wired* 17, no. 7 (June 22, 2009), http://www.wired.com/culture/art/magazine/17-07.

Arendt, Hannah. *The Human Condition*. Chicago: University of Chicago Press, 1971.

——. *Lectures on Kant's Political Philosophy*. Edited by Ronald Beiner. Chicago: University of Chicago Press, 1989.

——. *Life of the Mind*. San Francisco: Harcourt Brace Jovanovich, 1978.

Barthes, Roland. *Camera Lucida: Reflections on Photography*. Translated by Richard Howard. New York: Hill and Wang, 1982.

Beckett, Samuel. *The Complete Dramatic Works*. London: Faber and Faber, 1986.

Benjamin, Walter. *The Arcades Project*. Translated by Howard Eiland and Kevin McLaughlin. Cambridge, Mass.: Harvard University Press, 1999.

———. "Berlin Childhood Around 1900." Final version. In *Selected Writings*, 3:344–413. Cambridge, Mass.: Harvard University Press, 2002.

———. "Central Park." In *Selected Writings*, 4:313–355. Cambridge, Mass.: Harvard University Press, 2003.

———. "Doctrine of the Similar." In *Selected Writings*, 2:694–698. Cambridge, Mass.: Harvard University Press, 1999.

———. "Franz Kafka: *Beim Bau der Chinesischen Mauer*." In *Selected Writings*, 2:494–500. Cambridge, Mass.: Harvard University Press, 1999.

———. "Franz Kafka: On the Tenth Anniversary of His Death." In *Selected Writings*, 2:794–822. Cambridge, Mass.: Harvard University Press, 1999.

———. "Goethe's Elective Affinities." In *Selected Writings*, 1:297–360. Cambridge, Mass.: Harvard University Press, 1996.

———. "Little History of Photography." In *Selected Writings*, 2:507–530. Cambridge, Mass.: Harvard University Press, 1999.

———. "News About Flowers." In *Selected Writings*, 2:155–157. Cambridge, Mass.: Harvard University Press, 1999.

———. "On Some Motifs in Baudelaire." In *Selected Writings*, 4:313–355. Cambridge, Mass.: Harvard University Press, 2003.

———. "On the Concept of History." In *Selected Writings*, 4:389–400. Cambridge, Mass.: Harvard University Press, 2003.

———. "On the Image of Proust." In *Selected Writings*, 2:237–247. Cambridge, Mass.: Harvard University Press, 1999.

———. "On the Mimetic Faculty." In *Selected Writings*, 2:720–722. Cambridge, Mass.: Harvard University Press, 1999.

———. *The Origin of German Tragic Drama*. Translated by John Osborne. New York: Verso, 1998.

———. "Paris, the Capital of the Nineteenth Century." In *Selected Writings*, 3:32–49. Cambridge, Mass.: Harvard University Press, 2002.

———. "Surrealism: The Last Snapshot of the European Intelligentsia." In *Selected Writings*, 2:207–224. Cambridge, Mass.: Harvard University Press, 1999.

———. "The Work of Art in the Age of Its Mechanical Reproducibility." 2nd version. In *Selected Writings*, 3:101–133. Cambridge, Mass.: Harvard University Press, 2002.

Benveniste, Émile. "The Notion of 'Rhythm' in Its Linguistic Expression." In *Problems in General Linguistics*, trans. Mary Elizabeth Meek, 281–288. Coral Gables, Fla.: University of Miami Press, 1971.

Bernstein, Jay. "Confession and Forgiveness: Hegel's Poetics of Action." In *Beyond Representation: Philosophy and Poetic Imagination*, edited by Richard Eldridge. Cambridge: Cambridge University Press, 1996.

Bersani, Leo. *The Culture of Redemption*. Cambridge, Mass.: Harvard University Press, 1990.

———. *The Freudian Body: Psychoanalysis and Art*. New York: Columbia University Press, 1986.

Buck-Morss, Susan. *The Dialectics of Seeing: Walter Benjamin and the Arcades Project.* Cambridge, Mass.: The MIT Press, 1989.

Chanter, Tina. *The Picture of Abjection: Film Fetish and the Nature of Difference.* Bloomington: Indiana University Press, 2008.

Cixous, Hélène. "Castration or Decapitation?" Translated by Annette Kuhn. *Signs* 7, no. 1 (1981): 41–55.

——. "The Laugh of the Medusa." In *New French Feminisms*, ed. Elaine Marks and Isabelle de Courtivron. New York: Schocken, 1987.

Comay, Rebecca. "Materialist Mutations of the *Bilderverbot*." In *Walter Benjamin and Art*, ed. Andrew Benjamin. New York: Continuum, 2005.

——. "The Sickness of Tradition: Between Melancholia and Fetishism." In *Walter Benjamin and History*. New York: Continuum, 2006.

Coole, Diana. *Negativity and Politics: Dionysus and Dialectics from Kant to Poststructuralism.* New York: Routledge, 2000.

Copjek, Joan. *Imagine There's No Woman: Ethics and Sublimation.* Cambridge, Mass.: The MIT Press, 2002.

Costello, Diarmuid. "Aura, Face, Photography: Re-Reading Benjamin Today." In *Walter Benjamin and Art*, ed. Andrew Benjamin, 164–184. New York: Continuum, 2005.

Debord, Guy. *Society of the Spectacle.* Translated by Donald Nicholson-Smith. New York: Zone, 1994.

Derrida, Jacques. "On Forgiveness." Translated by Michael Collins Hughes. In *On Cosmopolitanism and Forgiveness.* New York: Routledge, 2001.

Devereux, George. *Dreams in Greek Tragedy: An Ethno-Psycho-Analytical Study.* Oxford: Basil Blackwell, 1976.

Eng, David. "The Value of Silence." *Theatre Journal* 54, no. 1 (2002): 85–94.

Fanon, Frantz. *Black Skin, White Masks.* Translated by Richard Philcox. New York: Grove, 1967.

Ferris, David. "The Shortness of History, or Photography in Nuce: Benjamin's Attenuation of the Negative." In *Walter Benjamin and History*, ed. Andrew Benjamin, 19–37. New York: Continuum, 2005.

Freud, Sigmund. *Beyond the Pleasure Principle.* Edited by James Strachey. New York: Norton, 1990.

——. *Civilisation, War, and Death.* Edited by John Rickman. London: Hogarth, 1968.

——. *Civilization and Its Discontents.* Translated and edited by James Strachey. New York: Norton, 1989.

——. *The Ego and the Id.* Translated by Joan Riviere. New York: Norton, 1960.

——. *The Future of an Illusion.* Translated by James Strachey. New York: Norton, 1961.

——. *A General Introduction to Psychoanalysis.* Translated by Joan Riviere. New York: Washington Square, 1960.

——. *General Psychological Theory: Papers on Metapsychology.* Edited by Philip Rieff. New York: Collier, 1963.

——. "Leonardo Da Vinci and a Memory of His Childhood." In *Sigmund Freud 14: Art and Literature*, ed. Albert Dickson, trans. James Strachey et al., 143–231. New York: Penguin, 1985.

——. "Letter from Sigmund Freud to Oskar Pfister, November 25, 1928." *International Psychoanalytical Library* 59 (1928): 125–126.

——. *Moses and Monotheism*, in *The Origins of Religion*, ed. Albert Dickson, trans. James Strachey et al. New York: Penguin, 1990.

——. "Mourning and Melancholia." In *The Standard Edition of the Complete Psychological Works of Sigmund Freud*, ed. James Strachey, 14:237–258. London: Hogarth, 1981.

——. "Negation." In *General Psychological Theory: Papers on Metapsychology*, ed. Philip Rieff, 213–217. New York: Collier, 1963.

——. *Three Essays on the Theory of Sexuality*. Translated by James Strachey. New York: HarperCollins, 1962.

——. "The 'Uncanny.'" In *The Standard Edition of the Complete Psychological Works of Sigmund Freud*, ed. James Strachey, 17:217–256. London: Hogarth, 1981.

Geyer-Ryan, Helga. "Effects of Abjection in the Texts of Walter Benjamin." *Modern Language Notes* 107, no. 3 (1992): 499–520.

Goethe, Johann Wolfang Von. *Scientific Studies*. Edited and translated by Douglas Miller. New York: Suhrkamp, 1988.

Goux, Jean-Joseph. "Vesta, or the Place of Being." *Representations* 1 (February 1983): 91–107.

Green, André. "The Primordial Mind and the Work of the Negative." *International Journal of Psycho-Analysis* 79 (1998): 649–665.

——. *The Tragic Effect: The Oedipus Complex in Tragedy*. Translated by Alan Sheridan. Cambridge: Cambridge University Press, 1979.

——. *The Work of the Negative*. Translated by Andrew Weller. London: Free Association Press, 1999.

Hartman, Thom. *Walking Your Blues Away: How to Heal the Mind and Create Emotional Well Being*. Rochester, Vt.: Park Street, 2006.

Hegel, G. W. F. *Hegel's Philosophy of Right*. Translated by T. M. Knox. Oxford: Oxford University Press, 1952.

——. *Lectures on Aesthetics*. Vol. 1. Translated by T. M. Knox. Oxford: Oxford University Press, 1975.

——. *Natural Law*. Translated by T. M. Knox. Philadelphia: University of Pennsylvania Press, 1975.

——. *Phenomenology of Spirit*. Translated by A. V. Miller. Oxford: Oxford University Press, 1977.

——. *Philosophy of Mind*. Translated by A. V. Miller. Oxford: Oxford University Press, 1971.

——. *The Spirit of Christianity and Its Fate*. Translated by T. M. Knox. Philadelphia: University of Pennsylvania Press, 1971.

Heidegger, Martin. *Being and Time*. Translated by John Macquarrie and Edward Robinson. New York: Harper Perennial, 1962.

Hoff, Shannon. "Identification, Alienation, and Forgiveness: Hegel's Theory of Law in the *Phenomenology of Spirit*." Ph.D. diss. Stony Brook University, 2005.

Hyppolite, Jean. "A Spoken Commentary on Freud's *Verneinung*." In *Écrits*, by Jacques Lacan, trans. Bruce Fink, 746–755. New York: Norton, 2007.

Jaar, Alfredo. *Paradiso/Inferno*. Catalogue for photography exhibit. Curated by Alfredo Jaar. Stockholm: Riksutställningar, 2000.

Kafka, Franz. *The Diaries of Franz Kafka, 1883–1924*. Translated by Martin Greenberg. New York: Schocken, 1948–1949.

Kant, Immanuel. *Critique of Judgment*. Translated by Werner Pluhar. Indianapolis, Ind.: Hackett, 1987.

Kearney, Michael, et al. "Self-Care of Physicians Caring for Patients at the End of Life: 'Being Connected . . . A Key to My Survival.'" *Journal of the American Medical Association* 301, no. 11 (2009): 1155–1165.

Kearney, Richard. "What Is Diacritical Hermeneutics?" *Journal of Applied Hermeneutics* (2011).

Kinder, Marsha. *Blood Cinema: The Reconstruction of National Identity in Spain*. Berkeley: University of California Press, 1993.

Klein, Melanie. *Envy and Gratitude, and Other Works, 1946–1963*. London: International Psycho-Analytical Library, 1975.

——. *Love, Hate, and Reparation*. Translated by Joan Riviere. New York: W. W. Norton, 1964.

Kofman, Sarah. *The Childhood of Art*. Translated by Winifred Woodhull. New York: Columbia University Press, 1988.

Krauss, Rosalind. *The Originality of the Avant-Garde and Other Modernist Myths*. Cambridge, MA: MIT Press, 1984.

——. "X Marks the Spot." In *Rachel Whiteread: Shedding Life*, by Rachel Whiteread, 74–81. London: Thames and Hudson, 1997.

Kristeva, Julia. *Black Sun: Depression and Melancholia*. Translated by Leon S. Roudiez. New York: Columbia University Press, 1989.

——. *Colette*. Translated by Jane Marie Todd. Female Genius: Life, Madness, Words, vol. 3. New York: Columbia University Press, 2004.

——. *Contre la dépression nationale*. Paris: Textuel, 1998.

——. *Crisis of the European Subject*. Translated by Susan Fairfield. New York: Other Press, 2000.

——. *Desire in Language*. Translated by Leon S. Roudiez. New York: Columbia University Press, 1980.

——. "Dialogue with Julia Kristeva." *Parallax* 4, no. 3 (1998): 5–16.

——. "Diversité, c'est ma Devise." In *Diversité et culture*, edition bilingue. Paris: Cultures France, 2007.

——. "A Father Is Beaten to Death." In *The Dead Father: A Psychoanalytic Enquiry*, 175–187. London: Routledge, 2008.

——. "La fille au sanglot: du temps hystérique." *L'infini* 54 (Spring 1996): 27–47.

——. "From Symbols to Flesh: The Polymorphous Destiny of Narration." *International Journal of Psycho-Analysis* 81 (2000): 771–787.

——. *Hannah Arendt*. Translated by Ross Guberman. Female Genius: Life, Madness, Words, vol. 1. New York: Columbia University Press, 2001.

——. *Hatred and Forgiveness*. Translated by Jeanine Herman. New York: Columbia University Press, 2005.

——. Interview by Nina Zivancevic. Paris, March–April 2001. Found on Verve Fine Art Gallery Facebook page, May 20, 2011.

——. *Intimate Revolt.* Translated by Jeanine Herman. New York: Columbia University Press, 2002.

——. *The Kristeva Reader.* Edited by Toril Moi. London: Wiley-Blackwell, 1986.

——. "Louise Bourgeois: From Little Pea to Runaway Girl." In *Louise Bourgeois,* ed. Frances Morris. New York: Rizzoli, 2008.

——. *Melanie Klein.* Translated by Ross Guberman. Female Genius: Life, Madness, Words, vol. 2. New York: Columbia University Press, 2001.

——. *Nations Without Nationalism.* Translated by Leon S. Roudiez. New York: Columbia University Press, 1993.

——. *New Maladies of the Soul.* Translated by Ross Guberman. New York: Columbia University Press, 1995.

——. "A New Type of Intellectual: The Dissident." In *The Kristeva Reader,* ed. Toril Moi. London: Wiley-Blackwell, 1986.

——. "On the Melancholic Imaginary." *new formations* 3 (Winter 1987): 5–18.

——. "The Paradise of the Mind." Interview with Rubén Gallo. In *Paradiso/Inferno,* catalogue for photography exhibit curated by Alfredo Jaar. Stockholm: Riksutställningar, 2000.

——. *The Portable Kristeva.* Edited by Kelly Oliver. New York: Columbia University Press, 1997.

——. *Powers of Horror.* Translated by Leon S. Roudiez. New York: Columbia University Press, 1982.

——. *Proust and the Sense of Time.* Translated by Stephen Bann. New York: Columbia University Press, 1993.

——. *Revolt, She Said.* Translated by Brian O'Keefe. New York: Semiotext(e), 2002.

——. *Revolution in Poetic Language.* Translated by Margaret Waller. New York: Columbia University Press, 1984.

——. *The Sense and Non-Sense of Revolt.* Translated by Jeanine Herman. New York: Columbia University Press, 2000.

——. *The Severed Head: Capital Visions.* Translated by Jody Gladding. New York: Columbia University Press, 2012.

——. *Strangers to Ourselves.* Translated by Leon S. Roudiez. New York: Columbia University Press, 1991.

——. *Tales of Love.* Translated by Leon Roudiez. New York: Columbia University Press, 1987.

——. *Time and Sense: Proust and the Experience of Literature.* Translated by Ross Guberman. New York: Columbia University Press, 1996.

——. "Visible Language: Photography and Cinema." In *Language: The Unknown,* trans. Anne M. Menke, 315–317. New York: Columbia University Press, 1989.

——. *Visions Capitales.* Paris: Editions de la Réunion des musées nationaux, 1998.

Kristeva, Julia, and Catherine Clément. *The Feminine and the Sacred.* New York: Columbia University Press, 2001.

Kuspit, Donald. "Contemporary Iconoclasm." In *The Intellectual Conscience of Art, L & B,* vol. 11. Edited by Annette W. Balkema and Henk Slager. Amsterdam: Rodopi, 1996.

——. "Sincere Cynicism: The Decadence of the 1980s." In *Signs of Psyche in Modern and Postmodern Art*, 273–281. Cambridge: Cambridge University Press, 1993.

——. "Visual Art and Art Criticism: The Role of Psychoanalysis." In *Signs of Psyche in Modern and Postmodern Art*, 300–312. Cambridge: Cambridge University Press, 1993.

——. "The Will to Unintelligibility in Modern Art: Abstraction Reconsidered." In *Signs of Psyche in Modern and Postmodern Art*, 114–120. Cambridge: Cambridge University Press, 1993.

Lacan, Jacques. *Écrits*. Translated by Bruce Fink. New York: Norton, 2007.

——. *The Ethics of Psychoanalysis*. Translated by Dennis Porter. The Seminar of Jacques Lacan VII (1959–1960). New York: Norton, 1992.

Laplanche, J. *Problématiques* III, 111 (1980).

——. "To Situate Sublimation." Translated by Richard Miller. *October* 28 (1984): 7–26.

Laplanche, J., and J. B. Pontalis. 1973. *The Language of Psycho-Analysis*. Translated by Donald Nicholson-Smith. New York: Norton.

Lyotard, Jean-Jacques. *Lessons on the Analytic of the Sublime*. Translated by Elizabeth Rottenberg. Stanford, Calif.: Stanford University Press, 1994.

Mari, Bartomeu. "The Art of the Intangible." In *Rachel Whiteread: Shedding Life*, by Rachel Whiteread, 74–81. London: Thames and Hudson, 1997.

Marx, Karl. *The 1844 Economic and Philosophic Manuscripts*. Translated by Martin Milligan. New York: Prometheus, 1988.

Menke, Christoph. *The Sovereignty of Art: Aesthetic Negativity in Adorno and Derrida*. Translated by Neil Solomon. Cambridge, Mass.: The MIT Press, 1999.

Miller, Elaine P. 2008. "Negativity, Iconoclasm, Mimesis: Kristeva and Benjamin on Political Art." *Idealistic Studies* 38, nos. 1–2 (2008): 55–74.

——. "The Sublime Time of Art in Kant and Nietzsche." *Eidos* (June 1997).

——. "Tragedy, Natural Law, and Sexual Difference in Hegel." In *Bound by the City*, ed. Denise McCoskey and Emily Zakin, 149–176. Albany, N.Y.: SUNY Press, 2010.

Mills, Jon. *The Unconscious Abyss: Hegel's Anticipation of Psychoanalysis*. Albany, N.Y.: SUNY Press, 2002.

Musil, Robert. *Posthumous Papers of a Living Artist*. Translated by Peter Wortsman. Hygiene, Colo.: Eridanos, 1987.

Nietzsche, Friedrich. *Kritische Studienausgabe*. 15 vols. Berlin: Walter de Gruyter, 1999.

——. *On the Advantage and Disadvantage of History for Life*. Translated by Peter Preuss. Indianapolis, Ind.: Hackett, 1980.

——. *Thus Spoke Zarathustra*. Translated by Walter Kaufmann. New York: Penguin, 1978.

Nicholson, Shierry Weber. *Exact Imagination, Late Work: On Adorno's Aesthetics*. Cambridge, Mass.: The MIT Press, 1997.

Oliver, Kelly. *The Colonization of Psychic Space: A Psychoanalytic Social Theory of Oppression*. Minneapolis: University of Minnesota Press, 2004.

——. *Reading Kristeva: Unraveling the Double Bind*. Bloomington: Indiana University Press, 1993.

——, and S. K. Keltner. *Psychoanalysis, Aesthetics, and Politics in the Work of Julia Kristeva*. Albany: State University of New York Press, 2009.

Pensky, Max. *Melancholy Dialectics: Walter Benjamin and the Play of Mourning*. Amherst: University of Massachusetts Press, 1993.

Pritchard, Elizabeth. "*Bilderverbot* Meets Body in Theodor Adorno's Inverse Theology." *Harvard Theological Review* 95, no. 3 (2002): 291–318.

Proust, Marcel. *Finding Time Again*. New York: Penguin, 2003.

Rauch, Angelica. "Post-Traumatic Hermeneutics: Melancholia in the Wake of Trauma." *Diacritics* 28, no. 4 (Winter 1998): 111–120.

Reineke, Martha. *Sacrificed Lives: Kristeva on Women and Violence*. Bloomington: Indiana University Press, 1997.

Ribeiro, Aileen. *Fashion in the French Revolution*. New York: Holmes and Meier, 1988.

Rothenberg, Molly Ann. *The Excessive Subject: A New Theory of Social Change*. Malden, Mass.: Polity, 2010.

——. "Picturing the Past: Aestheticization in the Treatment of Trauma in a Chinese Analysand." Paper presented at the conference "After the Unthinkable: Trauma, *Nachträglichkeit*, and Coming to Terms," Boston College, 2012.

Santner, Eric. *Stranded Objects: Mourning, Memory, and Film in Postwar Germany*. Ithaca, N.Y.: Cornell University Press, 1990.

Schechter, Ronald. "Gothic Thermidor: The Bals des Victimes, the Fantastic, and the Production of Historical Knowledge in Post-Terror France." *Representations* 61 (Winter 1998): 78–94.

Segal, Hannah. "A Psychoanalytic Approach to Aesthetics." In *The Work of Hannah Segal*. London: Free Association Books, 1986.

Shapiro, Francine. *Eye Movement Desensitization and Reprocessing: Basic Principles, Protocols, and Procedures*. New York: Guilford, 2001.

Sjöholm, Cecilia. *Kristeva and the Political*. New York: Routledge, 2005.

Smith, Anna. *Julia Kristeva: Readings of Exile and Estrangement*. New York: St. Martin's Press, 1996.

Taussig, Michael. *Walter Benjamin's Grave*. Chicago: University of Chicago Press, 2006.

Ullman, Ellen. *By Blood*. New York: Farrar, Strauss, and Giroux, 2012.

Whiteread, Rachel. *Rachel Whiteread: Shedding Life*. London: Thames and Hudson, 1997.

Winnicott, Donald. "Transitional Objects and Transitional Phenomena." In *Playing and Reality*. London: Tavistock, 1971.

Ziarek, Ewa Płonowska. "Kristeva, Levinas: Mourning, Ethics, and the Feminine." In *Ethics, Politics, and Difference in Julia Kristeva's Writings*, ed. Kelly Oliver. New York: Routledge, 1993.

——. "The Uncanny Style of Kristeva's Critique of Nationalism." *Postmodern Culture* 5, no. 2 (January 1995).

Žižek, Slavoj. *For They Know Not What They Do*. New York: Verso, 1991.

——. *Organs Without Bodies*. New York: Routledge, 2004.

INDEX

Aaron and Moses (Schönberg), 85
Abgar of Edessa, 68
absorption, 37
abstract art, 59
abstraction, 56
Acéphale (Bataille), 188
acephalous subject, 222n115
Adorno, Theodor, 29, 33, 43–44, 49, 54, 56, 71, 78–79, 94; aesthetic negativity and, 200n3; aesthetics of, 8; iconoclasm of, 58–59; images and, 75; Kafka and, 103–4, 108–11; nonidentical mimesis and, 17; surrealism and, 112. *See also specific works*
"Adorno and Benjamin, Photography and the Aura" (Nicholson), 206n144
Aeschylus, 4, 20, 154, 166, 172, 175, 178, 179
aesthetic forgiveness, 164–67
aesthetic idea, 6, 18, 20, 78, 122, 174, 194n68, 204n98
aesthetic judgment, 45, 62, 88, 115
aesthetic negativity, 200n3

aesthetic pardon, 153
aesthetics, 154; of Adorno, 8, 57–58; of Benjamin, 17, 34, 197n62; of Freud, 134; of Hegel, 18, 33, 54–56, 94, 113, 197n62; of Kant, 8, 88–89; of Lacan, 144; of Marx, 97–98; self-aestheticization, 179; of uncanny, 89, 113
aesthetic theory, 131
Aesthetic Theory (Adorno), 58
Africa, 90
afterwardness. *See Nachträglichkeit*
Agamemnon (Aeschylus), 171
Albaret, Céleste, 132
allegory, 17, 26, 32, 38–42, 205n132; Benjamin and, 32, 35–38, 43–44, 205n132; contemporary art and, 42–45; figurism and, 69; imaginary and, 38, 151; melancholia and, 33–38
Allen, Woody, 184
Almodóvar, Pedro, 81–83, 186
Ambassadors, The (Holbein), 144
American Indians, 16, 199n142

anamorphosis, 145

Antoni, Janine, 119

après coup, 79

Aquinas, Thomas, 162

Arcades Project (Benjamin), 104, 105, 205n128, 210n76, 210n80, 210n87, 214n28

archetype. *See Urbild*

Arendt, Hannah, 18, 153, 212n150; art and, 116; body and, 118; estrangement and, 87, 115–16; forgiveness and, 19; imagination and, 153; Kant and, 12, 87–90, 115; Kristeva's reappropriation of Kant and, 115–17; natality and, 5, 7, 78; thinking and, 12. *See also specific works*

Artaud, Antonin, 113

asymbolia, 10, 14, 22, 25, 27, 32, 37

Atget, Eugène, 72, 76–77

atheism, 133

Athena (goddess), 3–4

Auerbach, Erich, 69, 70

Aufhebung (sublation), 60, 63, 69, 142, 156

Augustine (saint), 8, 33; cosmopolitanism and, 91; natality and, 5; second birth and, 7, 19

aura, 36, 62, 72–74

Aurelia (Nerval), 165

Ausstossung (rejection), 59

autoerotism, 136, 147–48, 150

avant-garde, 56, 78–79, 121, 174

Bacon, Francis, 174

bals des victimes, 191n1

ban on images, 17–18, 54–55, 58–59, 63–66, 75, 85, 91, 111, 200n3, 202n33, 202n61, 211n108, 211n123

Baroque allegory, 36–37, 43

Barthes, Roland, 74, 79, 82, 94

Bataille, Georges, 188

Baudelaire, Charles, 19, 35–36, 129

Bausch, Pina, 83–84, 207n156

beauty, 8, 22, 34, 45, 54, 140; contemporary art and, 46; Freud and, 39; love of, 89; sublime judgment of, 12

Beauvoir, Simone de, 223n129

Beaver, The (film), 14–15

Beckett, Samuel, 58, 189, 190, 224n18

Beheading of Saint John the Baptist, The (Caravaggio), 190

Being and Time (Heidegger), 125

Bellini, Giovanni, 120

Benjamin, Walter, 26, 28, 43–44, 54, 79, 86, 195n8, 197n62; allegory and, 17, 35, 37–38; Baudelaire and, 19, 36; experience and, 126; images and, 71–77; Kafka and, 103–11; materialism and, 37; melancholia and, 30; modernity and, 34; photography and, 14, 18, 71–77; poetic processes and, 129; spiritual inoculation and, 22, 31–33; symbols and, 205n132. *See also specific works*

"Berlin Childhood Around 1900" (Benjamin), 32

Bersani, Leo, 135, 145–48

Beyond the Pleasure Principle (Freud), 127, 129, 180

Bible, 219n24

Bilderflucht (flight from images), 75

birth, 186; second, 5, 7–8, 19

Black Skin, White Masks (Fanon), 28–29

Black Sun (Kristeva), 17, 21, 23–24, 26, 39, 150, 194n4; beauty and, 46; forgiveness and, 153, 165; Holbein and, 85; sublimation and, 148

"Bodies" (exhibition), 118

body, 3, 32, 70, 80–81, 96, 98, 118–19; Adorno and, 43; Arendt and, 118; art and, 47, 50, 83–84, 117, 119–20, 126, 175; Christianity and, 68–69, 130; foreigner and, 95; Freud and, 134; Hegel and, 34, 97; humors, 11; illness and, 185, 187, 188; language and, 4, 24, 42, 62, 84, 102, 113, 127–28, 208n38; Marx and, 97–98; materialism and, 61–62; mother and, 43, 113; negation and, 57; neurosis and, 185; philosophy and, 95; pregancy and, 102, 186; transubstantiation and, 130

Body of the Dead Christ in the Tomb, The (Holbein), 40, 42

boundary-subject, 96

Bourgeois, Louise, 12–13, 189–90

breast, 139, 143, 147

Brecht, Bertolt, 59

Breton, Andre, 111

Brothers Karamazov, The (Dostoevsky), 153

Buck-Morss, Susan, 107, 210n86

Bueltman, Robert, 118

By Blood (Ullman), 177–79

"Café Müller" (Bausch), 84

Candide (Voltaire), 93

capitalism, 164; industrial, 36

caprice, 94

Caravaggio, 189–90

"Cares of a Family Man, The" (Kafka), 108

Carey, Benedict, 184–85

carnal hermeneutics, 187

castration, 2–4

"Castration or Decapitation?" (Cixous), 4

catharsis, 8; tragic, 176

Catholicism, 67, 130, 133

Céline (novelist), 26, 45

"Central Park" (Benjamin), 35

Cézanne, Paul, 101, 146, 188

chiasmus of incarnation, 151

Childhood of Art, The (Kofman), 137

children, 1–3, 29, 66, 124, 141–43, 170–71, 180–81; imaginary and, 7; language and, 23–24; paranoid-schizoid position and, 139; psychoanalysis of, 78; sexual drive and, 133

chiropractic therapy, 187

choker (necklace), 191n1

chora, 24, 62, 64, 70, 84, 96

Christianity, 40–41, 55, 66, 69, 75, 156; Catholicism, 67, 130, 133; forgiveness and, 157–58, 162; maternity and, 102; medieval, 35

cinema and film, 54, 72–73, 79, 109, 167; Adorno and, 58; language and, 77; thought spectacular and, 18, 174–76. *See also specific films*

Civilization and Its Discontents (Freud), 11, 28, 155, 162

Cixous, Hélène, 4

Clark University, 134

classicism, 35

classless society, 106

Clytemnestra, 171

cognitive psychology, 124

Colette (French writer), 2–3

collective memory, 126

collective psyche, 11

collective sin, 219n24

collective unconscious, 104, 106

color, 99–101

Comay, Rebecca, 37, 75, 211n108

commercial globalization, 92

commercial photography, 73

commodity, 36, 56–57, 152

common sense, 88, 90

Communist Manifesto (Marx), 111

consciousness, 63, 99, 115; death drive and, 25; dialectic of, 61; forgiveness and, 158–61; image character of, 59; materialism and, 58; modern, 94; negation and, 60; origin of, 129; unconscious and, 13, 95, 98, 131–32, 169. *See also* self-consciousness

consumer culture, 119

contemporary art, 8, 54, 71; allegory and, 42–45; beauty and, 46; examples of, 78–85; foreignness and, 88; iconoclasm and, 56–57; modernity and, 18; uncanny in, 18, 117–20; violent images and, 7

Contre la dépression nationale (Kristeva), 28–29

Coole, Diana, 57

Copjec, Joan, 135, 147–48

Corte de Florero (Echavarría), 80

cosmopolitanism, 91

countermonuments, 17, 47–51, 199n142

countertransference, 64, 138

Crazy Horse statue, 16

creative drive, 30

Crime and Punishment (Dostoevsky), 153

Crisis of the (European) Subject
 (Kristeva), 67
critical taste, 212n150
Critique of Judgment (Kant), 18, 87–88,
 115, 164
cultural mourning, 47
Culture of Redemption, The (Bersani), 146

Dante Alighieri, 77
Das Unbehagen in der Kultur (Freud).
 See Civilization and Its Discontents
Dauthendey, Karl, 74, 107
da Vinci, Leonardo, 133–34, 142, 145
death, 118, 141; drive, 25, 31, 43, 51, 95,
 122, 149–50; of God, 40–41; of Jesus
 Christ, 40–42; language as, 25;
 photography and, 74, 82; sublimation
 and, 148–50
"Death and Literary Authority: Proust
 and Klein" (Bersani), 146
Debord, Guy, 5, 6
decapitation, 1–2, 4, 177
defilement, 64, 202n60
Degas, Edgar, 188
depressed collective, 11
depression, 1–2, 5, 8–11, 15–16, 42, 140, 184,
 194n4; language and, 3, 21–24;
 national, 17, 28–31; negativity of, 26;
 social, 29; suicidal, 27. *See also*
 melancholia
depressive position, 3, 9, 17, 23, 139, 195n11
Derrida, Jacques, 165
desexualization, 137, 140, 142, 145, 147
desire, 167, 172
desymbolization, 146
Devereux, George, 176
Devils, The (Dostoevsky), 153
dialectical images, 104
dialectical materialism, 61
"Dialogue with Julia Kristeva" (Kristeva),
 195n24
Diderot, Denis, 45, 70, 91, 93, 95, 154
disobjectalization, 144
Divine Comedy (Dante), 77
"Doctrine of the Similar" (Benjamin), 74

Dostoevsky, Fyodor, 39, 81, 113, 121,
 220n56; death of Jesus Christ and, 40;
 depression and, 22; forgiveness and,
 151, 153, 162, 165. *See also specific works*
double articulation, 68
double negation, 60, 62
dreams, 180; images, 60, 104, 107, 112–13
dual drive element, 101
Duras, Marguerite, 39
Dürer, Albrecht, 11
dythrambikos, 179

Eastern Europe, 90, 196n40
Eastern Orthodox Church, 67–68, 70,
 85, 220n56
Echavarría, Juan Manuel, 80
economic depression, 9
economy, of divine presence, 67–68
ego, 27–29, 60, 100–101, 115, 139, 142;
 development of, 137; formation of,
 135–36, 147
Ego and the Id, The (Freud), 28, 66,
 136–37, 140
*1844 Economic and Philosophic
 Manuscripts* (Marx), 97
Einstein, Albert, 11, 30
Eisenstein, Sergei, 83, 85, 174, 175
Eléments de physiologie (Diderot), 95
Eliot, T. S., 47
elitism, 58
EMDR. *See* eye movement
 desensitization and reprocessing
Encyclopedia (Hegel), 200n1
end-of-life care, 187
Eng, David, 196n46
Enlightenment, 11, 70, 91, 94, 96, 112–13
Entäusserung, 97–103
entropy, negative, 141
Envy and Gratitude (Klein), 139
epistemology, 58
Erfahrung (experience), 125–27, 129, 131
Erinnerung (recollection), 129
Erlebnis (experience), 125–29, 131,
 214n26
Eros, 96, 101, 122, 137, 140–41, 163

estrangement, 57, 76, 93, 115, 117; Arendt and, 115; art and, 110; Hegel and, 93, 96; Marx and, 97

esukastikon, 179

eternal recurrence, 66

Eucharist, 41

Eumenides (Aeschylus), 169, 171, 176–79

Europe, 16, 30, 90, 196n40. *See also* France

Exact Imagination, Late Work (Nicholson), 206n144

experience, 124–30. *See also Erfahrung; Erlebnis*

expressible. *See lekton*

expressionist painting, 110

exquisite empathy, 187–88, 223n9

eye movement desensitization and reprocessing (EMDR), 181–82

face. *See visage*

Fairy Queen (Purcell), 84

fairy tales, 103

family, 28–29

Fanon, Frantz, 11, 28–29

fantasy, 123, 175

father, 3, 41; imaginary, 66–67, 138, 148, 166, 214n33; of individual prehistory, 66, 138, 143, 148–49

feeling soul, 200n1

Female Genius trilogy (Kristeva), 2, 115

Feminine and the Sacred, The (Kristeva), 219n24

femininity, 4, 166, 192n11

feminism, 56

fetishism, 203n71

figurism, 69

film. *See* cinema and film

flamenco, 81–82

Flies, The (Sartre), 173

flight from images. *See Bilderflucht*

"Flower Vase Cut, The" (Echavarría), 80

Fontana, Lucio, 71, 79, 85

"Force and the Understanding" (Hegel), 158, 160

foreignness, 18, 87–92, 114, 154, 173–74; *Entäusserung* and, 97–103; irony and,

93–97; self-estrangement and, 93–97; uncanny and, 97–103; worrisome, 87

forgiveness, 19, 151–56; aesthetic, 164–67; Freud and, 162–64; tragic, 167–73; as transformative sublation, 157–61

formalism, 56

fort-da game, 180, 182

For They Know Not What They Do (Žižek), 48

Foster, Jodie, 14

fragmentation, 174; of temporality, 122

France, 9–10, 29, 87, 90, 96–97, 173

"Franz Kafka: On the Tenth Anniversary of His Death" (Benjamin), 105

freedom, 163–64, 173

Frege, Gottlob, 59

French Revolution, 191n1

Freud, Sigmund, 7, 119, 127, 167, 205n118; beauty and, 39; consciousness and, 129; cosmopolitanism and, 91; da Vinci and, 133–34; death drive and, 25, 51, 150; decapitation and, 3–4; dreams and, 180; father of individual prehistory and, 66, 138, 143; forgiveness and, 153–54, 162–64; judgment of existence and, 61; judgments of attribution and, 123; melancholia and, 10–11, 27–28, 34, 37; narcissism and, 147–50; negation and, 54, 57, 61–62, 90; prelinguistic bodily experiences and, 60; rejection and, 59; sublimation and, 39, 51, 135–37, 140, 142–45, 150; uncanny and, 2, 89–90, 101, 108; unconscious and, 13, 53, 78, 99, 102. *See also* psychoanalysis; *specific works*

"Function and Field of Speech and Language in Psychoanalysis, The" (Lacan), 80

fundamentalism, 31

Future of an Illusion, The (Freud), 154

Gallo, Rubén, 78

Gedächtnis (memory), 125, 129

General Introduction to Psychoanalysis, A (Freud), 136

Genet, Jean, 45
"Germania" (Haacke), 47
German tragic drama, 30, 38
Gerz, Esther Shalev, 48
Gerz, Jochen, 48
Geyer-Ryan, Helga, 113
Gilmore, Kate, 120
Giotto, 99
globalization, commercial, 92
glossolalia, 70
God, death of, 40–41
Godard, Jean-Luc, 174
Goethe, Johann Wolfgang von, 35, 104–5
Goux, Jean-Joseph, 65, 79
graven images, 63–66, 85, 91, 111, 211n108;
 Judaism and, 55; materialism and, 58;
 mimesis and, 17–18, 54
Greeks, 65; tragedy, 166–67, 179
Green, André, 19, 135, 168, 174, 201n21;
 representation and, 166–67;
 sublimation and, 140–44;
 transnarcissistic object and, 137
Greuze, Jean-Baptiste, 70

Haacke, Hans, 46, 47
habitual distracted perception, 195n8
Hannah Arendt: Action as Birth and
 Estrangement (Kristeva), 115
Hatred and Forgiveness (Kristeva), 153, 164
healing process, 187
Hegel, Georg Wilhelm Friedrich, 33, 53,
 59, 93–96, 112–14, 197n62, 200n11;
 aesthetics and, 18, 54–56; allegory and,
 37; death of Jesus Christ and, 41–42;
 desire and, 172; Entäusserung and,
 97–103; forgiveness and, 19, 153–54,
 156, 157–61; melancholia and, 34;
 mourning and, 17; negativity and,
 57, 61, 63; romanticism and, 34;
 self-consciousness and, 114; tragedy
 and, 167, 169. See also specific works
Heidegger, Martin, 125
Herder, Johann Gottfried, 53
Hestia (goddess), 65–67, 79–80, 85
Hitchcock, Alfred, 85, 174

Hoffman, E. T. A., 154
Holbein, Hans, 22, 39–40, 42, 85, 144
Holocaust, 32, 178
Holocaust Memorial (Whiteread), 50
homeopathy, 22
House (Whiteread), 50
hubris, 170–71, 172
Human Condition, The (Arendt), 115–16
humanism, 98
humanization, of nature, 155
humors, bodily, 11
Husserl, Edmund, 59
hyperbolic productivity, 9
Hyppolite, Jean, 60–61

iconoclasm, 54, 68, 75, 79; of Adorno,
 58–59; contemporary art and, 56–57;
 foreigners and, 91; Hestia and, 65–67
iconography, 68
iconophilia, 65–66, 69, 75
idealism, 37, 59, 194n68
identity politics, 116
Idiot, The (Dostoevsky), 40, 153
images, 5–8, 14; abstract meaning and,
 35; Benjamin and, 71–77; dialectical,
 104; divine, 75; dream, 60, 104, 107,
 112–13; epistemology and, 58; of Jesus
 Christ, 67–69; of Virgin Mary, 67–68;
 wish, 106. See also graven images;
 photography
imaginary, 5, 7, 151–52; experience, 127;
 father, 66–67, 138, 148, 166, 214n33
imagination, 6, 26, 38, 40, 65, 89
immigration, 90
impartiality, 89
incest, 64
industrial capitalism, 36
Inferno/Paradiso (Kristeva), 7, 77–78
inscription, 70–71, 77, 80–81
In Search of Lost Time (Proust), 18, 32,
 122, 135, 146, 148; experience and, 125;
 spectacle and, 6; sublimation and, 131
intellectual judgment, 60, 62
Intimate Revolt (Kristeva), 156, 162, 174
inverse theology, 110

involuntary memory, 78–79, 104, 126, 129, 132, 151

irony, 93–97

Islam, 55

Jaar, Alfredo, 77–78

jazz music, 58, 78

Jesus Christ, 55, 157–58; death of, 40–42; images of, 67–69

jouissance, 2, 141–42

Joyce, James, 45, 99, 123

Judaism, 69, 75, 91, 178, 219n24; defilement and, 64; forgiveness and, 157, 162; graven images and, 55

judgment, 105; aesthetic, 45, 115; of attribution, 60, 123; of existence, 61; intellectual, 60, 62; linguistic, 61; political, 89; somatic, 61; sublime, 12; of taste, 89

Julia Kristeva: Readings of Exile and Estrangement (Smith), 97

Kafka, Franz, 58, 62, 103–11, 113–15, 123

Kant, Immanuel, 53, 154, 158–59, 163–64, 194n68, 204n98; aesthetic idea and, 6, 18, 78; aesthetic judgment and, 45, 115; Arendt and, 12, 87–90, 115; morality and, 94; reappropriation of, 115–17; sublime and, 100. *See also specific works*

Kaplan, Gregory, 91

Kearney, Richard, 187

Keats, John, 57, 146, 201n21, 203n72

kenosis (self-emptying), 68

kenotic art, 71

Klein, Melanie, 3, 17, 19, 23, 139–40, 142–43, 170, 172–73, 195n11; depressive position and, 3, 17, 154; forgiveness and, 153–54; Greek tragedy and, 170–73; narration and, 123; protophantasy and, 124; psychoanalysis and, 23, 123, 139; thought phantasy and, 125

Kofman, Sarah, 137, 140, 148

Krauss, Rosalind, 50, 109

Kulturarbeit, 99, 155

Kuspit, Donald, 56

Lacan, Jacques, 2, 4–5, 7, 80–81, 124, 138, 185; language and, 2; psychoanalysis and, 49; sublimation and, 144–46, 147; symbolic order and, 138

language, 127, 149–51, 161, 195n24, 208n38; aesthetic idea and, 6; allegory and, 39; appropriation of, 2; asymbolia, 10, 14, 22, 25, 27, 32, 37; depression and, 3, 21–24; of forgiveness, 154; negativity of, 94; poetic, 15, 24–25, 62–63, 65, 99, 203n71; of radical modern art, 44; rapportive, 128; revolt and, 5; self and, 100; semiotic, 25, 65, 99, 101, 146; shared, 162; symbolic, 25, 51; thought phantasy and, 125; visual, 77; word flesh, 102

Language: The Unknown (Kristeva), 77

Laplanche, Jean, 141, 145

Lars and the Real Girl (film), 14–15

Lechte, John, 84

Lectures on Aesthetics (Hegel), 33, 55, 94, 113, 197n62

Lectures on Kant's Political Philosophy (Arendt), 88

Lectures on the Philosophy of Religion (Hegel), 41

lekton (expressible), 174

lektonic traces, 175

le Pen, Jean-Marie, 96

libido, 137, 142, 149; beauty and, 39; narcissistic, 136, 147–48; repression and, 134

"Lick and Lather" (Antoni), 119

linguistic functions, 25

linguistic judgment, 61

l'inquiétante étrangeté (worrisome foreignness), 87. *See also* uncanny

literary narration, 123

literary writing, 7, 22, 121

literature, 3, 11, 97, 110, 121, 174

"Little History of Photography" (Benjamin), 77, 106, 206n144

lost time, 63
"Louise Bourgeois" (Kristeva), 87
Louvre, 2, 18
love, 66–67, 83, 92, 150; of beauty, 89;
 courtly, 145; experience and, 126;
 forgiveness and, 166; hate and, 129,
 139; Hegel and, 157; maternal, 102–3,
 125; narcissism and, 148
loving identification, 66–67

Mallarmé, Stéphane, 99
mandylion of Abgar, 68–69
mania, 31
Marx, Karl, 61, 97–98
Marxism, 5, 59, 97–103
masculinity, 4, 192n11
master/slave dialectic, 160
materialism, 37, 58–59; demythologization
 of, 75; dialectical, 61
maternal space, 120
maternity, 102
mathematical sublime, 89
Matisse, Henri, 101
meaning: abstract, 35; generation of, 63;
 of mimesis, 64; negativity and, 52;
 resuscitation of, 37; symbolic, 46;
 systems of, 57; transfer of, 40
medieval Christianity, 35
melancholia, 10–11, 17–18, 21, 23, 185, 186,
 194n4, 199n117; allegory and, 33–38;
 contemporary art and, 42–43; death
 drive and, 51; intellectual thought
 and, 24; modernity and, 33–38;
 mourning and, 27–28; national
 depression and, 28–31; perpetual
 transience and, 92; as protest, 39;
 spiritual inoculation and, 31–33;
 therapeutic treatments of, 26
Melancholia (Dürer), 11
melancholy tension, 26
mémoire d'intelligence, 129
memorials, 15–17
memory, 16, 47, 85, 125, 142; consecrated,
 49; imagination and, 22, 50;
 involuntary, 78–79, 104, 126, 129, 132,

151; pace of, 123; photography and, 77;
 repressed, 63, 116, 130
"Memory/Loss" (Wilson), 47
Men in Dark Times (Arendt), 153
Menke, Christoph, 200n3
metaphor, 12, 69, 102, 127–28
metaphysics, 158
Middle East, 90
mimesis, 6, 18, 58, 69, 75, 85, 111;
 iconography and, 68; meaning of, 64;
 nonidentical, 17, 54, 79; poetic, 70
Minima Moralia (Adorno), 29
Mnemosyne, 116
model. See Vorbild
modern art, 44–45, 54, 56, 101–3, 188–89
modernity, 1, 17–19, 22, 31, 72;
 melancholia and, 33–38; poetic
 processes and, 129
Mondrian, Piet, 101
Mondzain, Marie-José, 67, 68, 71
Monglond, André, 109
Montesquieu, 91, 93
Monument Against Fascism and War for
 Peace (Gerz, J. and Gerz, E. S.), 48
monuments, 47–48
Moses and Monotheism (Freud), 167,
 205n118
mother, 64–68, 113, 125, 168, 195n11;
 body and, 118–19; Christianity and,
 102; dream image of, 60; loss of, 13,
 23–24, 27, 40, 92, 144, 186; narcissism
 and, 137–38, 147–48; separation from,
 2–3, 17
"Motherhood According to Giovanni
 Bellini" (Kristeva), 42
Mount Rushmore, 16
mourning, 10, 17, 26, 31, 34, 196n46;
 cultural, 47; Holocaust and, 32;
 melancholia and, 27–28; social
 dimension of, 33
"Mourning and Melancholia" (Freud), 11,
 27, 39
multiculturalism, 56
murder taboo, 64
Murray, Gilbert, 170

music, 103; flamenco and tango, 81–82; jazz, 58, 78
Musil, Robert, 47
mysticism, 56

Nachträglichkeit (afterwardness), 14, 73, 80, 82, 205n118
narcissism, 136–38, 147–50; art and, 119
narration, 115, 117, 122–24
natality, 5, 7, 78
national depression, 17, 28–31
National Front, 10, 96
National Socialism, 16
nation-state, 90
Nations Without Nationalism (Kristeva), 96
naturalism, 98
natural law, 169
Natural Law (Hegel), 172
natural science, 155
nature, 43; humanization of, 155; primal phenomena in, 105
negation, 39, 40, 54, 57, 59–63, 65, 67, 74, 79, 90, 114, 123, 141, 143; double, 60, 62; photography and, 74
"Negation" (Freud), 59–61
negative capability, 57, 146, 201n21, 203n72
Negative Dialectics (Adorno), 58
negative entropy, 141
negative sexuality, 141
negative space, 17, 50–51
negativity, 17–18, 26, 31, 34, 52–54, 114, 155–56; Adorno and, 57, 59, 200n3; aesthetic, 101, 200n3; cutting edge of, 98; of depression, 26; foreignness and, 91–92; Hegel and, 57, 59, 61, 63, 154, 156; iconoclasm and, 54; Kafka and, 114; of language, 94–95; meaning and, 52; poetic language and, 62–63
Nerval, Gérard de, 150, 165
neurosis, 135–36, 184–85
New Maladies of the Soul (Kristeva), 22, 28, 66–67, 78, 166
Newton, Isaac, 158–59

New York Times, 184
New York University, 181
Nicephorus, 67, 68–69
Nicholson, Shierry Weber, 79, 108, 206n144
Nietzsche, Friedrich, 48, 66, 179–80, 182–83, 185, 222n113
nonidentical mimesis, 17, 54, 79
nonreferential thought, 146
nonrepresentational art, 44, 59
Not I (Beckett), 189, 224n18

objectalization, 144
object cathexes, 148
Odradek (fictional character), 108
Oedipal complex, 3, 66, 123–24, 195n11
Oedipodeia (Aeschylus), 168
Old Testament, 65
"O Let Me Weep, For Ever Weep" (Purcell), 84
Oliver, Kelly, 162
One Hundred Spaces (Whiteread), 50
"On Narcissism" (Freud), 136, 147
"On Redemption" (Nietzsche), 185
"On the Concept of History" (Benjamin), 107
"On Transience" (Freud), 39
optical unconscious, 72–73, 77, 103, 109
Oresteia trilogy (Aeschylus), 4, 20, 154, 166–72, 175–77
Orestes complex, 154
originary sublimation, 147
Origin of German Tragic Drama, The (Benjamin), 32, 76, 104, 197n62, 205n132
Orthodox Church, 67–68, 70, 85, 220n56

paradigm shift, 156, 170
paranoid-schizoid position, 139, 154
pardonner (to forgive), 19
"Paris, the Capital of the Nineteenth Century" (Benjamin), 106
Pascal, Blaise, 25
paternal function, 133, 143
patriarchal culture, 4

Pensky, Max, 36
perpetual transience, 92
Persian Letters (Montesquieu), 93
petite madeleine, 128
phallic stage, 123
Phenomenology of Spirit, The (Hegel), 19,
 41, 93, 156–58, 160, 172
Philosophy of Right (Hegel), 97
photography, 13–14, 18, 54, 77–79, 86, 103,
 205n118; Benjamin and, 14, 18, 71–77;
 death and, 74, 82; Kafka and, 103–11;
 surrealism and, 111–13
Plato, 33, 84
poetic language, 15, 24–25, 62–63, 65,
 99, 203n71
poetic mimesis, 70
poetic processes, 129
poetry, 39, 116–17
poiesis, 165
political judgment, 89
popular culture, 7, 14, 107, 174
Possessions (Kristeva), 224n18
postsymbolic art, 197n62
Powers and Limits of Psychoanalysis,
 The (Kristeva), 148
Powers of Horror (Kristeva), 64–65, 113
preclassic art, 55
pregnancy, 102, 186
prelinguistic bodily experiences, 60
primal history. *See Urgeschichte*
primal phenomena, 105
primary narcissism, 147, 149–50
Prisms (Adorno), 110
profanation, 132–33
property, 97–98, 209n50
prose of human condition, 33
protest, melancholia as, 39
protophantasy, 124
Proust, Marcel, 5–7, 18–19, 32–33, 45, 113;
 experience and, 124–30; forgiveness
 and, 151, 153; involuntary memory and,
 79; psychoanalysis and, 122–24; Segal
 and, 140; sublimation and, 121, 131–33,
 146, 148; writing and, 144. *See also*
 specific works

"Proust, or the Power of Sublimation"
 (Kristeva), 130
Prozess (Kafka), 62
pseudoautobiography, 148
psychic apparatus, 78
psychoanalysis, 19–20, 30, 78, 115–16, 134,
 141, 174; allegory and, 32; desire and,
 167; emergence of, 53; ethics of, 90,
 144; father of individual prehistory
 and, 66; forgiveness and, 154, 162;
 imaginary and, 5; Klein and, 23,
 123; Lacanian, 49; literature, 3, 11;
 Nachträglichkeit and, 14; negative
 expression and, 54; prelinguistic
 bodily experiences and, 60; Proust
 and, 122–24; sacrifice and, 64; short
 sessions of, 80–81; talking cure, 21,
 25, 179. *See also* unconscious
psychology, 155; cognitive, 124
publicity, 88–89
Purcell, Henry, 84
purification rites, 63–64

quasi-narration, 124

racism, 31
radical modern art, 44
Rameau's Nephew (Diderot), 93–96, 154
rapportive language, 128
reason. *See Vernunft*
recapitation, 3
recollection, 107, 129
"Recommendations to Physicians
 Practising Psycho-analysis" (Freud), 135
re-erotization, 42, 121, 135, 199n119; of
 affect, 45; of creative drive, 19; of
 psychic life, 31; spiritual inoculation
 and, 45; sublimation and, 144–48, 162;
 of suffering, 43; of symbolic
 structures, 25
Reflecting Absence (memorial), 16
regaining time, 127
reification, 114
Reik, Theodor, 129
rejection, 59, 61, 62, 63, 123

reparation, 140, 141
repetition, 66, 180, 182, 223n129
representation, 166–67, 169
ressentiment, 182
retributive justice, 157
retrospective return, 33
revolt, 5, 46, 79–80, 154, 175
Revolt, She Said (Kristeva), 9, 21, 28
revolution, 5, 7, 13, 30, 46, 62, 78–79
Revolution in Poetic Language (Kristeva),
 23–24, 54, 59, 66, 70, 84, 113–14
rhythm, 83; tragic, 179–80
Rodin, Auguste, 188
Roman Catholic Church, 67
Romans, 65
romantic art, 56, 197n62
romantic irony, 94
romanticism, 34–35, 53, 154
Rothenberg, Molly, 179
Rothko, Mark, 101
Rousseau, Henri, 110

Sade, Marquis de, 45
Samuels, Andrew, 193n43
Sandman, The (Hoffman), 154
Santner, Eric, 32–33, 48
Sartre, Jean-Paul, 59, 173
schizophrenia, 114
Schlegel, August Wilhelm, 208n32
Schlegel, Friedrich, 208n32
Schönberg, Arnold, 85
Schopenhauer, Arthur, 222n113
secondary narcissism, 137–38
second birth, 5, 7–8, 19
second-degree thetic, 24, 51
second immediacy, 20
Segal, Hanna, 140
Selbstanfang (self-beginning), 163–64
self-aestheticization, 179
self-beginning. *See Selbstanfang*
"Self-Care of Physicians Caring for
 Patients at the End of Life" (Kearney
 et al.), 187
self-consciousness, 27, 156, 160, 172; death of
 Jesus Christ and, 41; negativity and, 114;

photography and, 74; unconscious
 and, 54
self-emptying, 68
self-estrangement, 93–97
self-restriction, 163
Seminar VII (Lacan), 144
semiotic dimension of language, 3, 25, 38,
 43, 45–46, 51, 53, 59, 62, 64–67, 70–71,
 79–84, 94–96, 99, 101–3, 120, 127, 146,
 149, 165, 175, 188
Sense and Non-Sense of Revolt, The
 (Kristeva), 46, 51
sense of community, 88
senses, 98
sensus communis, 45, 117, 164
September 11, 2001, terrorist attacks, 9,
 15–16, 196n46
Sermon on the Mount, 157
Severed Head, The (Kristeva), 1, 7, 18, 23,
 53, 87, 183, 186, 188; decapitation and,
 2; iconoclasm and, 67–68
sexuality, 133–35, 140–42, 145–47
"Sexuality and Aesthetics" (Bersani), 145
Shapiro, Francine, 181–82
Sherman, Cindy, 148
Shorter, Edward, 185
shroud of Turin, 68
signifiance, 149–50
sin, collective, 219n24
skariphasthai (to scratch an outline), 80
Sleeping Beauty, 107
Smith, Anna, 97
social contract theory, 162–63
social depression, 29
society of the spectacle, 5–6
Socrates, 33, 52
somatic judgment, 61
spectacle, 5–6, 9, 16–17, 19, 117
"Spirit in Self-Estrangement" (Hegel), 93
"Spirit of Christianity and Its Fate, The"
 (Hegel), 156, 157, 162
spiritual inoculation, 17, 22, 31–33, 45,
 189
"Stabat Mater" (Kristeva), 102
Stoics, 91, 174

Stranded Objects (Santner), 32

Strangers to Ourselves (Kristeva), 53, 87, 90, 93, 97, 153–54

structural anthropology, 64

sublation. *See Aufhebung*

sublimation, 8, 18, 39, 51, 121–22, 124, 130–33, 135–44; death and, 148–50; ego formation and, 136; history of concept, 133–35; love and, 150; neurosis and, 135–36; re-erotization and, 144–48, 162

sublime, 100–101; judgment, 12; mathematical, 89

suffering, 43, 184–85, 189

suicidal depression, 27

surrealism, 104, 108, 111–12

"Surrealism: The Last Snapshot of the European Intelligentsia" (Benjamin), 111

survival therapy, 12

symbolic art, 55–56

symbolic language, 25, 51

symbolic meaning, 46

symbolic order, 4, 25, 40, 50, 62, 66–67, 100–101, 124, 133, 138–39, 150, 162, 192n9

symbolic time, 126

symbolization, 139, 146–47

symbols, 35, 173, 205n132

Tales of Love (Kristeva), 66, 127, 138, 148, 214n33

talking cure, 21, 25, 179

Talk to Her (film), 83–84, 186–88, 207n156

tango, 81–82

taste: critical, 212n150; judgment of, 89

temporality, 7, 47, 50, 104, 133, 180; fragmentation of, 122; imaginary and, 151–52; of mass production, 36; nonlinear, 22; of photography, 13, 71, 73–77, 79, 103–7; of Proust, 19; of symbol, 35; tragic, 179–80

terrorism, 9, 15–16, 31, 196n46

Thanatos, 96, 101, 137, 140, 141, 163

thing presentation, 99–100, 130

This Incredible Need to Believe (Kristeva), 153

thought phantasy, 125

thought specular, 18, 81, 83, 174–76, 206n149

thought-things, 115

Three Essays on the Theory of Sexuality (Freud), 134

Thus Spoke Zarathustra (Nietzsche), 183

time, 63, 126–27, 165

Time and Sense (Kristeva), 121–22, 153

Time Regained (Proust), 121

Topiary IV (Bourgeois), 189–90

totemism, 64

tout d'un coup, 79

tragedy, 180; catharsis, 176; forgiveness, 167–73; German drama, 30, 38; Greek, 166–67, 179

transference, 64, 116, 123, 138

transitional objects, 14–15

transubstantiation, 127, 130, 153, 155, 166, 188

Trauerspiel (Benjamin), 26, 35, 37

Ullman, Ellen, 177

uncanny, 2, 45, 87–90, 108, 154–55; in contemporary art, 18, 117–20; foreignness and, 97–103; politics of, 92; surrealism and, 113

"Uncanny, The" (Freud), 119

unconscious, 18, 52–53, 57, 63, 71, 85, 87, 99, 102, 119, 200n1; collective, 104, 106; consciousness and, 13, 95, 98, 131–32, 169; discovery of, 61, 91, 154; dream images and, 113; foreignness and, 90; identification, 27; nonlinear temporality and, 22; optical, 72–73, 77, 103, 109; photography and, 73–75, 78, 205n118; renewal of, 166; rhythm and, 83; self-consciousness and, 54; timelessness of, 164

Unheimlich, 87, 110. *See also* uncanny

United States, 9–10, 15–16, 87

University of Essex, 193n43

University of Vienna, 136

Untitled Film Stills (Sherman), 148
Urbild (archetype), 105
Urgeschichte (primal history),
 104–7

Venice Biennale (1993), 46, 47
verisimilitude, 70
Vernunft (reason), 161
Verwerfung (foreclosure), 59
violent images, 6–7
Virgin Mary, 42, 67–68
visage (face), 69–70
Visions capitales (Kristeva). *See Severed Head, The*
visual language, 77
Voltaire, 93
voluntary memory, 129
Volver (film), 81–82, 84
Vorbild (model), 105

war, 30, 47–48
"Waste Land, The" (Eliot), 47
Wenders, Wim, 84, 207n156
Whiteread, Rachel, 17, 50–51

Wilson, Robert, 46–47
Winnicott, D. W., 14, 143
wish images, 106
women, 4, 120
word flesh, 102
word presentation, 99, 130
"Work of Art in the Age of Its
 Technological Reproducibility, The"
 (Benjamin), 73, 195n8, 205n123
Work of the Negative, The (Green), 140
World Trade Center, 9, 16
World War II, 173
worrisome foreignness. *See l'inquiétante étrangeté*
Worstward Ho (Beckett), 189
writing, 144, 154, 166; as forgiveness, 151;
 literary, 7, 22, 121

xenophobia, 31, 96

Zadig (Voltaire), 93
Zakin, Emily, 199n119
Ziarek, Ewa Płonowska, 39–40, 44, 88
Žižek, Slavoj, 48–49, 179, 222n115

COLUMBIA THEMES IN PHILOSOPHY, SOCIAL CRITICISM, AND THE ARTS

Lydia Goehr and Daniel Herwitz, eds., *The Don Giovanni Moment:
Essays on the Legacy of an Opera*

Robert Hullot-Kentor, *Things Beyond Resemblance: Collected Essays on
Theodor W. Adorno*

Gianni Vattimo, *Art's Claim to Truth*, edited by Santiago Zabala,
translated by Luca D'Isanto

John T. Hamilton, *Music, Madness, and the Unworking of Language*

Stefan Jonsson, *A Brief History of the Masses: Three Revolutions*

Richard Eldridge, *Life, Literature, and Modernity*

Janet Wolff, *The Aesthetics of Uncertainty*

Lydia Goehr, *Elective Affinities: Musical Essays on the History of Aesthetic Theory*

Christoph Menke, *Tragic Play: Irony and Theater from Sophocles to Beckett*, translated
by James Phillips

György Lukács, *Soul and Form*, translated by Anna Bostock and edited by
John T. Sanders and Katie Terezakis with an introduction by Judith Butler

Joseph Margolis, *The Cultural Space of the Arts and the Infelicities of Reductionism*

Herbert Molderings, *Art as Experiment: Duchamp and the Aesthetics of Chance,
Creativity, and Convention*

Whitney Davis, *Queer Beauty: Sexuality and Aesthetics from Winckelmann
to Freud and Beyond*

Gail Day, *Dialectical Passions: Negation in Postwar Art Theory*

Gerhard Richter, *Afterness: Figures of Following in Modern Thought and Aesthetics*

Boris Groys, *Under Suspicion: A Phenomenology of the Media*, translated by
Carsten Strathausen

Michael Kelly, *A Hunger for Aesthetics: Enacting the Demands of Art*

Stefan Jonsson, *Crowds and Democracy: The Idea and Image of the Masses from
Revolution to Fascism*